Elizabeth Nourse, *1859–1938*
A Salon Career

MARY ALICE HEEKIN BURKE
with a contribution by LOIS MARIE FINK

Published for the NATIONAL MUSEUM OF AMERICAN ART
and the CINCINNATI ART MUSEUM
by the SMITHSONIAN INSTITUTION PRESS
WASHINGTON, D.C., 1983

Published on the occasion
of an exhibition
jointly organized by the
NATIONAL MUSEUM OF AMERICAN ART
and the
CINCINNATI ART MUSEUM
and shown at
NATIONAL MUSEUM OF AMERICAN ART
Smithsonian Institution
January 14–April 17, 1983
and
CINCINNATI ART MUSEUM
Cincinnati, Ohio
May 12–July 3, 1983

Library of Congress Cataloging
in Publication Data

Burke, Mary Alice Heekin.
Elizabeth Nourse (1859–1938) a salon career.

Includes a catalogue of the exhibition organized and
shown at the National Museum of American Art,
Smithsonian Institution, Jan. 14–Apr. 17, 1983,
and at the Cincinnati Art Museum, Cincinnati, Ohio,
May 12–July 3, 1983.
Bibliography: p. 253.
Includes index.
Supt. of Docs. no.: SI 62:N85
1. Nourse, Elizabeth, 1859–1938. 2. Artists—
United States—Bibliography. 3. Nourse, Elizabeth, 1859–
1938—Exhibitions. I. Nourse, Elizabeth, 1859–1938.
II. Fink, Lois Marie. III. National Museum of American
Art (U.S.) IV. Cincinnati Art Museum. V. Title.
N6537.N68B87 1983 709'.2'4 [B] 82–600496

Cover: *Les heures d'été*, 1895,
cat. no. B–59.

Editor: Carroll S. Clark, assisted
by Margy P. Sharpe, National
Museum of American Art

For sale by the Superintendent of Documents,
U.S. Government Printing Office
Washington, D.C. 20402
Stock number: 047-000-00389-0

Photographic Credits

Contents

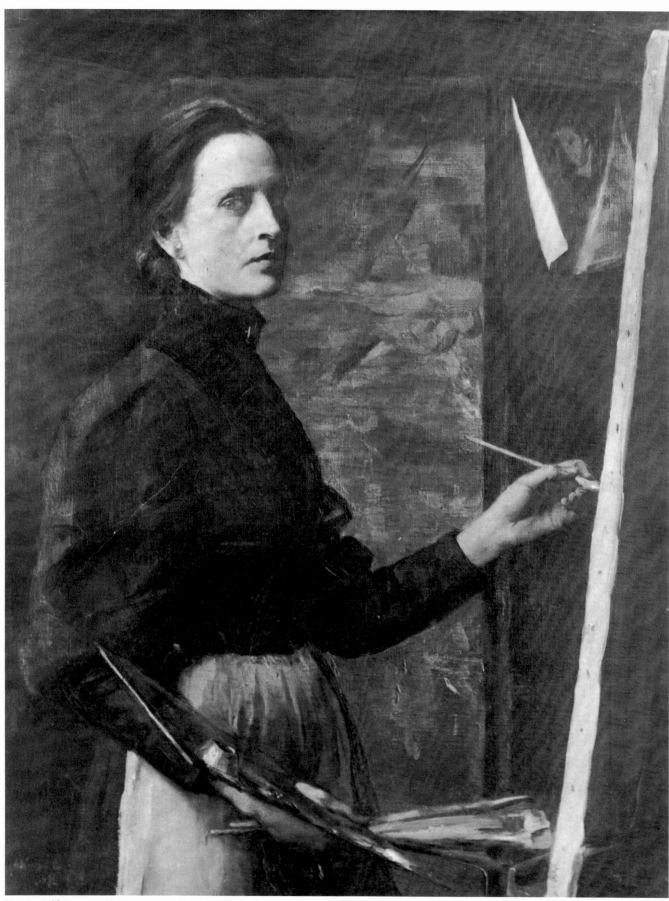

Fig. 1 *Self Portrait,* 1892, cat. no. C–80.

Foreword

Charles C. Eldredge
Director
National Museum of American Art

La belle France, the land of Bourbons and Bretons, of art and revolution, became in the late nineteenth century the primary destination for increasing numbers of Americans drawn to the Continent for pleasure and study. Among the travelers and students were numerous artists, whose introduction to the French ambience and fervid aesthetic debate altered permanently the face of American art.

Today the best known of our pilgrims to Paris are the American Impressionists, whose subtle productions won for them ready acceptance among patrons and an enduring place in the histories of our national art. Not every sojourner, however, aspired to be "ami de Monet" or "amie de Degas." The Impressionists' ranks were equaled, even surpassed, by legions of other young Americans drawn to the ateliers and Salons of fin-de-siècle France. The vicissitudes of taste and patronage have treated these men and women less kindly; some were lionized in one generation, only to be consigned to oblivion in the next. Yet among them are some of the most accomplished painters, sculptors, and draftsmen of their time, artists whose appeal and acclaim have only been rediscovered in recent years. Such is the case with Elizabeth Nourse.

Although born in Cincinnati, which was then (1859) still the center of trans-Allegheny culture, Nourse's maturity and recognition came in France, to which she moved in 1887, and where, except for a brief visit to America in 1893–94, she continued to work thereafter. During her long and prolific career, Nourse reflected many of the changing attitudes of her eventful times, but her independent approach aligns her with no single school or mentor. Hers was an individual achievement, which in her lifetime was acclaimed in America as well as France. That her oeuvre has been largely forgotten since her death is characteristic of a fate that befell many American artists of the turn of the century; and among such artists, our talented women have until lately been particularly neglected.

The National Museum of American Art is especially pleased to present this exhibition, the first major review of Nourse's work since 1893. I hope that a new generation of American art students and gallery visitors may rediscover here the subtle charms of Elizabeth Nourse's moving evocations of French life that so captivated her own generation.

Acknowledgments

So many people have assisted me in my research during the last four years that it is, unfortunately, impossible to list them all. I am particularly grateful to Anita and Linda Ellis, who suggested this study to me, and to Dr. Francis X. Grubar of the George Washington University and William H. Truettner of the National Museum of American Art, who first recognized the merits of an exhibition of Nourse's work. I also wish to thank the directors of the National Museum of American Art and the Cincinnati Art Museum for their joint sponsorship of this retrospective exhibition.

The assistance and guidance of many staff members of both museums has been invaluable, particularly that of William Truettner, Robin Bolton-Smith, Margy P. Sharpe, Melissa L. Kroning, Carroll S. Clark, Jane McAllister, and Katharine Fox of the National Museum of American Art; and of Denny Carter Young, Anita Ellis, Kenneth R. Trapp, Kathryn Taulbee, Elizabeth Batchelor, Grace Keam, Carole Schwartz, and Edward Farrell of the Cincinnati Art Museum. In addition, the staff of the Cincinnati Historical Society was extremely helpful.

I am deeply grateful to all the collectors and museums who have loaned their paintings to the exhibition and to all the Nourse relatives and friends who shared their correspondence and recollections with me. In particular, the information that Jackie Thompson, Happy Williams, and Ann Kennedy Thomas shared with me was absolutely indispensable to this study. Mme. Hilaire Merle, Mrs. Nathan Horowitz, and Mme. Isabelle Decroisette deserve special thanks for providing insight into the character of Nourse and information about her life in France.

Among those to whom I am especially indebted are Mary Blum, David Bowen, Barbara Boyd, Jeffrey Brown Fine Arts gallery, Martha and Walter Bunker, Stanley Cohen, W. Roger Fry, Mrs. John Z. Herschede, John D. Kysela, Ann McCullough, Mrs. James Magrish, Mrs. John H. Marble, Jean Meader, Midwestern Galleries, Katie O'Conor, Ran Gallery, F. J. Rinn, Betty Bone Schiess, William E. Wiltshire III, and Gilbert Young. Finally, I would like to thank my children, Tom, Roby, Peter, Dan, and Steve, for their encouragement and their help in obtaining photographs across the United States and in France.

M. A. H. B.

For helpful assistance with my research on Elizabeth Nourse, I wish to express my appreciation to Mary Alice Heekin Burke; to the staffs of the Cincinnati Art Museum, the Cincinnati Historical Society, and the Library of the National Museum of American Art/National Portrait Gallery, Smithsonian Institution. My appreciation is also extended to my colleagues at the National Museum of American Art, William Truettner and Margy Sharpe, and—especially—to James Yarnall, who was my efficient research assistant, and Susan Grant, who gave invaluable help with research on the Paris Salons. Special thanks are also due to Judith Houston and Patricia H. Chieffo, who assisted with other office duties so that I could have time for research.

L. M. F.

Introduction

William H. Truettner
Curator, Eighteenth and Nineteenth
Century Painting and Sculpture
National Museum of American Art

As the German army advanced toward the Marne in the fall of 1914, Americans who for years had been comfortably settled in Paris, following a familiar expatriate routine, suddenly departed for the safety of neutral shores. Theirs had been an aesthetic and cultural attachment of the sort that filled the novels of Henry James, but it was not to be sustained in the face of a war that most Americans, in 1914, still believed was a problem that Europeans had made for themselves. To be sure, it was not only these self-conscious types who fled, but many others who feared the very real threat of German military power. Under the circumstances, almost everyone who had a home to return to did so, and thus it seems even more an act of faith and courage that Elizabeth Nourse and her sister Louise, who would have been welcomed back to Cincinnati by any number of friends and admirers, chose to remain. As Louise Nourse, who often spoke for both sisters, rather succinctly observed, "I should feel like an ungrateful wretch to run away—as though I had fled from some hospitable roof when smallpox breaks out."

Yet the situation that Louise speaks of, the "hospitable" environment the sisters had found in France, is not one we can rediscover easily today. In fact, their letters and information from other sources reveal little about their circle of friends abroad, Elizabeth Nourse's professional associations, or even her impression of other prominent Americans whom she must have known of, if she was not particularly attracted to, during the almost fifty years she remained in Paris. It comes as a mild shock to find Gertrude Stein holding forth during some of those years just around the corner from Nourse's studio on the rue d'Assas. Whistler, an equally improbable neighbor, lived close by in the mid-1890s, as did Elizabeth Gardner, the companion, and later wife, of Adolphe Bouguereau. Yet all we learn about this neighborhood, which must have included many more talented individuals, is that Nourse painted a portrait of a friend of Alice B. Toklas's and once visited Elizabeth Gardner's studio. Edith Wharton's circle would have been much too elegant for Nourse's taste and Natalie Barney's much too decadent, but again the absence of commentary remains puzzling, especially in view of Elizabeth's growing reputation in the years before the First World War and her close association with Natalie's mother, Alice Pike Barney. Indeed, except for Mary Cassatt, from whom she received a pastel in 1899, and her membership in several professional societies, one is at a loss to explain Elizabeth's connections in France and

11

where the roots of her affection lay, except among the simple folk and members of religious orders with whom she lived and worked during the summer months.

Elizabeth Nourse had the uncommon task of supporting herself and her sister in a foreign country, of enlarging her talent and perfecting her craft in a system that demanded a ready supply of exhibitable paintings. She apparently had little time for herself, less for others, and seems to have revealed her thoughts only to a group of long-standing intimate friends, most of whom she had known since student days in Cincinnati. These friends, with whom she traveled during the summers, who visited her regularly in her Paris studio, who promoted and sold her work in the United States, were those upon whom she most depended all her life. But if that explains why her emotional ties to Cincinnati remained strong, and why she neither had nor needed such a network in France, it hardly tells us why her affection for her adopted country remained steady through the long and difficult war years.

What kept her in France, then, was not the sort of domestic web that we might suspect two talented and intelligent sisters to spin. Rather, it seems to have been a genuine attachment to the people and to the land, an attachment Nourse felt more deeply than most of the first generation that came abroad to sample artistic opportunities in France. Some took advantage of the training available in numerous Parisian ateliers and of the Salon apparatus, which enabled the more facile painters to establish a reputation quickly. Some seemed content simply to immerse themselves in the ferment of artistic activity for a few years and then return home to sort it out. Others found the range of subject matter available in Paris and the French countryside the most stimulating factor—those subjects of cosmopolitan life or rustic charm that seemed a refreshing change from detailed accounts of the American wilderness or wholesome views of rural life. What had been sacrosanct to an earlier generation of artists, subjects that reflected Americans' pride in the beauty of their native land and in the strength and bounty of the young Republic, was no longer held in such high regard in the 1870s and 1880s. The picturesque circumstances of Europe—the age, tradition, and color of local scenery and customs—were what seemed to interest the young Americans who came abroad.

If Nourse benefited from all these factors and was particularly successful working within the Salon framework, it was the French countryside and the ancient fabric of rural life in other European locations that most stimulated her artistic imagination. The range of her travels, her knowledge of local traditions and customs, the variety of subjects she painted were as extensive as those of any of her American colleagues who sought an artistic education on the Continent. The checklist of known works at the back of this publication—more than 700 items that document Nourse's travels to Russia, Italy, Austria, Holland, North Africa, Spain, southern France, Brittany, and Normandy—is not only a tribute to the perseverance of Mary Alice Heekin Burke, but it comprises the broadest survey of Euro-

pean subject matter yet recovered from an American artist of this period. It reminds us of the sites most favored by Nourse's contemporaries and, more immediately, of the extent of her technical accomplishment—the assortment of dazzling portrait, landscape, and still-life studies, in a variety of media, that surround her major figure paintings. In fact, the need to find artistic solutions for the different subjects she encountered, the impetus to experiment with color, light, and design and technical problems, must have been an essential by-product of her travels. The gains she made were reflected in a growing sureness of execution, and in the discreet authority with which she began adjusting her work for Salon exposure.

Nourse must have sensed early in her career that she required an environment different from the one she had left in America and subjects that could not be found in Paris studios to fulfill her artistic needs. If the frontier no longer sufficed, neither did the self-conscious atmosphere of the French capital. Her world, at least the one she chose to paint, was not one of inner doubts and struggles, or fine shades of meaning. It depended upon a wider selection of immediate and tangible experience that could be directly translated into visual images. These she found on her travels, but more directly in the French countryside, where the simple pattern of life, perceived as an innocent mixture of tradition, piety, and poverty, seemed to cast a holy shroud over field and farm. Conditioned by Barbizon sentiments and by her own close association with peasant families, Nourse came to regard their habits and customs as the chief virtue of rural existence. What she painted, however, was not the numbing, impersonal toil engaged in by Millet's subjects but more intimate domestic scenes that measured the strength and skill, if less directly the hardship, of peasant life. Once into her subject, however, Elizabeth rarely compromised, nor did she concern herself with the more typical images of Jules Bastien-Lepage, Jules Breton, and numerous American counterparts. Indeed, among her many virtues were a technique and style that were an honest and open reflection of both her personal sympathies and her shared experience with working-class women.

Nourse arrived in Paris at a time when no one artistic theory was dominant either inside or outside Salon circles. Those outside—the Impressionists, the Symbolists, and individual experimenters of the 1890s—did not immediately affect her; but those she tapped as her mentors, Jean-Charles Cazin, Pascal Dagnan-Bouveret, and Léon Lhermitte, went through various changes in the years following that must have both strained her allegiance and inspired her to follow. Somewhere between the poles of academic realism and Impressionism she found her métier, although it is not an easy one to describe nor did she remain in a fixed position for long. If her work had the dark and studied look of studio interiors during her first years in Paris, by the end of the century she had aquired a brighter palette and a bolder technique, and was busily producing her own studies of indoor and outdoor light. On occasion, during the first decades of the twentieth century, she went beyond to experiment with patterns

of line and color that indicate her eye was more advanced than she wished to admit.

Perhaps the difficulty today in defining Nourse's style is that we insist on categories that would have seemed arbitrary to painters of that era. She considered both Claude Monet and Jean-François Raffaelli "pronounced" realists, and the combination of artists included in the Loan Collection of modern French painting at the World's Columbian Exposition—Cazin, Besnard, and Raffaelli, as well as Edgar Degas, Pierre-Auguste Renoir, and Monet—undoubtedly puzzles us more than it would have Nourse's contemporaries. Having recently discovered, however, that the "true" path to the twentieth century does not necessarily lead through the major Impressionists, and that Americans abroad were often more interested in the artists who most influenced Nourse, we begin to understand why her painting *La rêverie* (fig. 62) of 1910 corresponds closely to works by the Boston Impressionists, Edmund Tarbell and Joseph De Camp, painted about the same time.

Our purpose in presenting this exhibition, then, is to help readjust our framework for evaluating artists such as Nourse, who for too long have been lost among numerous contemporary French and American Salon participants. Twenty years ago we would have dismissed her work because it did not look more like that of Mary Cassatt; today, as Lois Fink perceptively observes, we study it because it does not, because the two moved in artistic circles that scholars have more clearly defined and distinguished in recent years. Mary Cassatt's position remains unassailable, of course. But if there is no need to revise our high estimate of her work, there is great need to bring forth and clarify the achievements of many of her expatriate contemporaries. Solid efforts have already been made by a number of scholars, and more, we hope, will follow.

One final note should be added for the benefit of Washington and Cincinnati audiences. We are pleased that this exhibition can be shared by institutions in the two cities that gave Elizabeth Nourse her most direct support during her lifetime. Washington, for obvious reasons, could not offer as much as Cincinnati, where in 1893 the art museum organized the first (and only) major exhibition devoted exclusively to Nourse's work. But the following year she was given a somewhat smaller exhibition at the V. G. Fischer Art Gallery in Washington, from which twenty-one paintings were sold. The amount she realized (almost $2,000), added to the sales from the Cincinnati exhibition, enabled the Nourse sisters to return to Paris with a considerable nest egg. Encouraged by their success and by the support that continued to come from Cincinnati friends, Elizabeth and Louise never felt the need to return to America. If at times theirs was a lonely compromise, both sisters were quick to realize the nature of its importance. Their debt to their adopted country, and to its artistic resources, was one on which they paid for the rest of their lives.

Cincinnati "Sociétaire"

Mary Alice Heekin Burke I *The Cincinnati Years, 1859–87*

Elizabeth Nourse's considerable reputation as a Salon painter was acquired in Paris during the late nineteenth and early twentieth centuries, when that city was the leading international art center. Nourse was acclaimed by her fellow artists and the public alike, not only for her technical skill but also for the unique personal vision she brought to her subject matter.

She was one of the first American women to be elected a member of the Société Nationale des Beaux-Arts, and she won many awards in the international expositions of the time, in Chicago, Nashville, Paris, Saint Louis, and San Francisco. She was consistently invited to enter the annual juried exhibitions that were a prominent feature of the American art scene—at the Pennsylvania Academy of The Fine Arts, the Carnegie Institute, the Art Institute of Chicago, the Cincinnati Art Museum, and the Corcoran Gallery of Art. As a final accolade the French government bought her painting *Les volets clos* (fig. 61) for its permanent collection of contemporary art to hang in the Musée du Luxembourg with the work of such artists as James Abbott McNeill Whistler, Winslow Homer, and John Singer Sargent.

Nourse's career parallels that of other expatriate artists of the pre–World War I period, but certain aspects of it are unique. With Mary Cassatt and Cecilia Beaux, she was one of the few women painters to achieve international recognition for her work and, like them, faced certain obstacles that a male artist did not encounter. She first had to prove that she was a serious professional since most women painters, no matter how gifted, were considered "Sunday painters" who would eventually marry or become teachers and fail to produce a significant body of work. To acquire professional status she had to be recognized by the all-male juries of the Salons and international exhibitions and to be favorably reviewed by the art critics, who also were mostly men. As a Victorian lady she could not easily advance her career by forming friendships in these groups, as a male artist could; the social interchange of the café, so much a part of the artistic life of Paris in her day, was denied her. To compensate for these disadvantages, she always had the total support of her family and of a large network of women friends who admired her work, publicized it, and bought it.

15

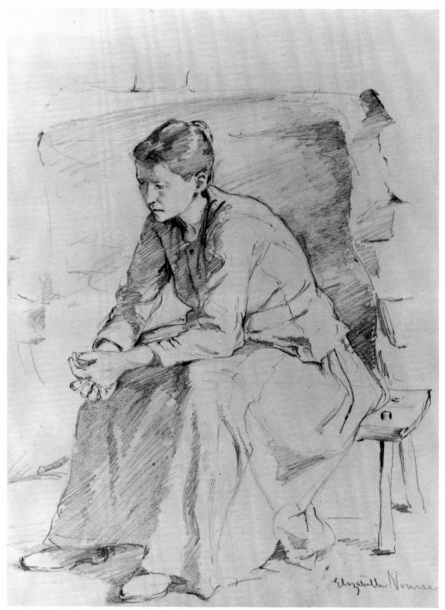

Fig. 2 *Tennessee Woman*, 1885–86, cat. no. H–5.

Unlike Cassatt, Nourse did not have an independent income nor did she teach, as Beaux did.[1] Yet from 1883 until her death in 1938, a period of fifty-five years, she earned her living as a professional artist and supported her older sister, Louise, as well. She was also unusual among both men and women expatriates in being almost entirely American trained. Except for a few months' study in New York and later in Paris at the Académie Julian (where critics told her she needed no further schooling), her style was formed at the Mc-Micken School of Design in Cincinnati.

When Nourse went to Paris in 1887 it was the mecca for all aspiring young artists who hoped to refine their drawing techniques and to absorb the newest ideas in the contemporary art world. French academic training centered on drawing from the nude, and Nourse could already draw a convincing figure when she arrived. A

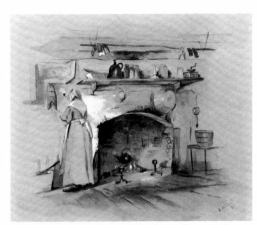

Fig. 3 *Cabin Interior, Millville, Indiana*, 1881, cat. no. B–7. Reproduced in color, p. 146.

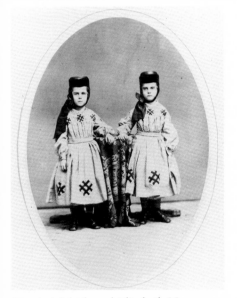

Fig. 4 Adelaide and Elizabeth Nourse, age three, 1862. Photograph from Louise Nourse's Scrapbook 1, p. 10.

sketch of 1885–86, *Tennessee Woman* (fig. 2), proves that she could represent the weight and mass of a figure, place it realistically in space and light, and capture a convincing pose and facial expression. Her sketching technique was based on a strong, but not continuous, outline and on various degrees of loose hatching, often tending toward curving or angular patterns. The importance of tonal values to the artist is apparent in the many different ways she indicated the shading of *Tennessee Woman*.

Nourse had not only developed an individual technique before she went to Paris but had also found her subject matter. Her interest in the peasant themes so popular among the Salon painters of her day was simply an extension of her preoccupation with the simple subjects she had painted in the Midwest—the daily routine of rural folk, especially women at work (fig. 3), mothers and children, portraits of Negro women and girls (fig. 6), and country landscapes.

Like every memorable artist, Nourse was able to express in her work an original personal vision that is immediately evident to the viewer, who may know nothing about her life. Her biography explains, however, why she brought such deep conviction to her portrayal of working people, particularly women; to the importance of motherhood; and to the beauty found in the simplest aspects of daily life and of nature. These subjects, banal in the hands of someone less sincere and less skilled, reflected her basic values and Nourse was able to infuse them with a special sense of their importance and their universal meaning.

The youngest of the ten children of Caleb Elijah Nourse and Elizabeth LeBreton Rogers,[2] Elizabeth and her twin sister Adelaide (fig. 4) were born October 26, 1859, at their parents' summer home in Mount Healthy, Ohio (today a suburb of Cincinnati). Both father and mother were descendants of French Huguenot families who had been pioneer settlers in New England.[3] Caleb Nourse, born in Concord, Massachusetts, counted the famous witch of Salem, Rebecca Nourse, among his forebearers; Elizabeth Rogers had come from Boston to Cincinnati in 1830 to live with her uncle, Samuel Rogers. At that date the Midwest town had been incorporated only twenty-one years and had a population of 24,831.

Young Caleb and Elizabeth were married in 1833 in the beautiful Federal house (now the Taft Museum) in which Samuel Rogers lived at the time. Within four years they became converts to Catholicism after hearing a dramatic debate between Bishop Edward Fenwick, a Roman Catholic, and the Reverend Alexander Campbell, a well-known Baptist minister. Religion was an important force in the lives of the couple and remained a profound influence on their children and on Elizabeth's concerns as an artist.

There were eight older Nourse children—John, William, Samuel, Charles, Mary, Catherine, Julia, and Louise. John, Mary, and Julia died in infancy, and Samuel was but seventeen at his death, three years before the twins were born. Charles married and had five children, but he, too, was to die when Elizabeth and her twin were seventeen. Catherine entered the convent of the Sisters of Notre

Dame de Namur, where she taught music until her death in 1885, and William, who became a Jesuit scholastic, died of consumption when the twins were a year old. The little girls grew up with only one sister, Louise, who was six years older than they.

Caleb Nourse prospered with the growth of Cincinnati and established his own bank in 1856.[4] Benefiting from the steamboat trade, the city experienced a spectacular surge in population between 1830 and 1860 with the arrival of thousands of Irish and German immigrants, who swelled the population to more than 160,000. When the Civil War disrupted the river commerce of this burgeoning border city (the first free stop on the Underground Railroad), many businesses were forced to close and times became hard. The Nourse bank failed and Louise later recalled that the family "went from *very* wealthy to *very* poor."[5]

After the Civil War, Mr. Nourse struggled to support his family as an accountant and insurance broker.[6] They moved frequently from one rented house to another. The longest the family remained at one address was during a period of five years between 1873 and 1878, when they lived in Mount Auburn, the first of Cincinnati's hillside suburbs to be connected to the city center basin by an "incline," a means of public transportation similar to a cablecar. By taking the incline and a horse- or mule-drawn trolley on the level stretches, the twins were able to attend school in the city. No records have survived to indicate whether they completed high school, although Louise is known to have graduated in 1873 as class valedictorian from Woodward High School in Cincinnati.

In view of the family's straitened financial circumstances, Elizabeth was fortunate to have obtained excellent training in art while she was still very young. In 1874, when she was fifteen, Elizabeth (or Lizzie, as she was called) began art studies at the McMicken School of Design, which eventually became the Art Academy of the Cincinnati Art Museum.[7] The school had originally been conceived by a group of women headed by the energetic Sarah Worthington Peter, the daughter of the first governor of Ohio, as the first step toward establishing an art museum in the city.[8] The group had raised nine thousand dollars by holding an exhibition of paintings—primarily landscapes of the Dusseldorf school—owned by Cincinnatians. Charles McMicken had donated the property for the school and had added one thousand dollars for the purchase of plaster casts. Mrs. Peter made several trips to Europe to select the casts, as well as copies of old master paintings, for the proposed school.

Litigation over the McMicken estate and the Civil War disrupted plans for the project and it was not until 1869 that the McMicken School of Design was finally established by a group of prominent Cincinnati men led by Joseph Longworth, Larz Anderson, and George Ward Nichols. The new mentors decided to establish an art school similar to those already existing in Philadelphia and Boston. These stressed technical training in art and design to benefit the city's industries rather than the curriculum for training painters and sculptors advocated by Mrs. Peter's group. Elizabeth was to take

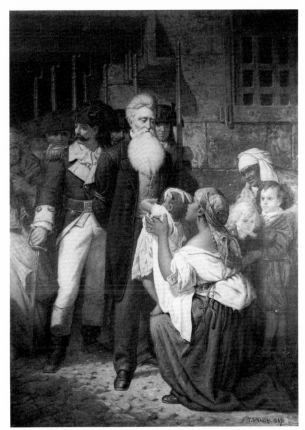

Fig. 5 Thomas J. Noble, *John Brown's Blessing,* 1867, oil on canvas. The New-York Historical Society.

classes at this school for seven years, until her graduation in 1881, then to return for supplementary courses in life drawing in 1885 and 1886.

The first director of the school was Thomas S. Noble (1835–1907), who had become acquainted with Colonel Nichols when both were in Paris studying, respectively, painting and music.[3] Noble was a southern gentleman who had grown up on his father's plantation in Lexington, Kentucky, studied art in New York, and then gone abroad to study first in Munich and later, between 1856 and 1859, in Thomas Couture's atelier in Paris. The French master had a profound influence on the American student, who recalled him later in rather extravagant terms: "My love for him [Couture] was for a lifetime, and I verily believe for eternity. As a man he may have had many weaknesses; as an artist, to me he was adorable, and is and will be so long as I have conscious Being."[10]

After his years in Paris, Noble returned home to serve as a captain in the Confederate Army. Although he was an abolitionist and was to paint many antislavery pictures, he adhered to the South's belief in states' rights. Following the Civil War he took a studio in New York, where he painted the first of his large history paintings, *The Slave Market,* which contained seventy-five figures.[11] By choosing a contemporary theme yet treating it in relatively formal terms, he appears to have sought a Couture-like compromise with the "grand style."

In 1867 Noble exhibited his *John Brown's Blessing* (fig. 5), the life-size figures of which reveal the firm draftsmanship and strong contrasts of light and shadow that Couture emphasized and that Noble taught his students. Nourse's *Head of a Negro Girl* (fig. 6) shows that she had learned to use the same strong outlines and highlights in modeling her figures. She also practiced another of the French master's precepts that Noble stressed at McMicken, that of sketching rapidly to capture the first fresh idea of a subject. She exhibited such a drawing, *Twenty Minute Sketch* (cat. no. C–22), a portrait of her sister Adelaide, in the school's 1880 exhibition.

When Noble came to Cincinnati in 1869 to open the McMicken School of Design, he designed for it a four-year curriculum based on the methods used in Munich, where he had studied with Carl Theodor Piloty before going to Paris.[12] The first year was devoted to "drawing from the flat" (which apparently meant copying etchings, engravings, lithographs, and other drawings), shading, anatomy, and perspective. During the second year the student advanced to drawing from round and solid casts and to composition and design. Only in the third year was color introduced and the student permitted to draw from nature. The same gradual approach was followed in the oil painting class, with the drawing of the subject preceding the application of paint.

By the time Elizabeth entered the school in 1874, it had become part of the municipal University of Cincinnati and tuition was free. The sketch (cat. no. B–1) she was required to submit to qualify for entry evidences the proficiency she had already attained from her lessons with Mary Spencer, a Cincinnati artist who took pupils in her studio.[13] As a result Elizabeth was allowed, beginning in her third year, to undertake a number of special studies that the growing school had begun to offer in wood carving, oil and watercolor painting, etching, and sculpture. In 1877 Joseph Longworth gave the art school an endowment of $59,000 with the condition that the university add another $10,000 to increase the variety of subjects offered to its approximately three hundred pupils.[14]

The McMicken board had originally opposed the inclusion of wood carving in the curriculum, but reconsidered its position after Benn Pitman volunteered his services and provided the tools and equipment for the class, the first of his many contributions to the artistic life of his adopted city.[15] An Englishman and the younger brother of Sir Isaac Pitman, inventor of the method of shorthand writing still in use, he had settled in Cincinnati in 1852 to establish the Phonographic Institute for the dissemination of the Pitman . method. His interest in the decorative arts was strong and he became Cincinnati's most visible and vocal link to the English arts and crafts movement. Imbued with John Ruskin's ideal of "the useful made beautiful," he taught a generation of Cincinnati women to value simplicity and originality in design as applied to interior decoration. For Benn Pitman's unremitting efforts to influence art, Ruskin wrote to him, "I am grateful to you."[6]

Pitman's stated aim was to teach women his ideas of what

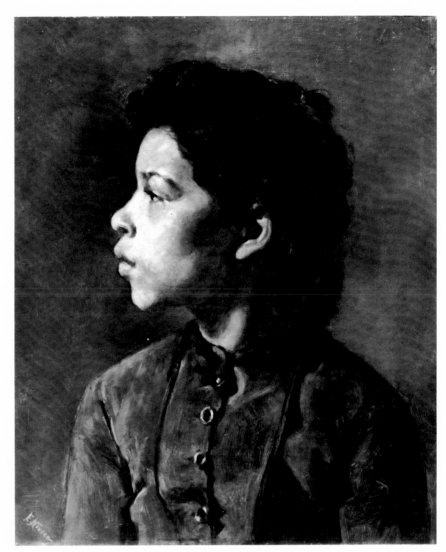

Fig. 6 *Head of a Negro Girl*, ca. 1882, cat. no. C–29.

should constitute American decorative art in the media of wood carving, china painting, mural decoration, and metalworking. His pupils, he believed, would eventually influence public taste through the decoration of their own homes.[17] He organized the first library at McMicken by donating a number of English texts influential in the arts and crafts movement, including works by Ruskin and Augustus Pugin as well as Sir Charles Eastlake's *Hints on Household Taste* and his own twelve-volume folio *Original Designs for Carving.*[18] As taught by this dynamic widower (assisted by his daughter, Agnes) wood carving immediately became one of the most popular classes in the school, particularly among women. Pitman, who was later to become Elizabeth Nourse's brother-in-law, was an important influence in her life.

In 1874 Pitman had also organized a class in china painting at McMicken by hiring Marie Eggers and supplying the materials.[19] The Nourse twins joined this group. Adelaide became very proficient in the art while Elizabeth was more interested in its design as-

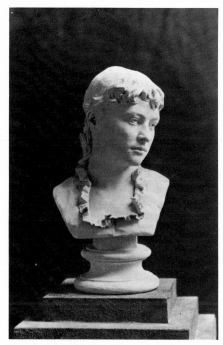

Fig. 7 *Bust of Mary Noonan,* 1880, cat. no. G–6. Photograph from Louise Nourse's Scrapbook 1, p. 10.

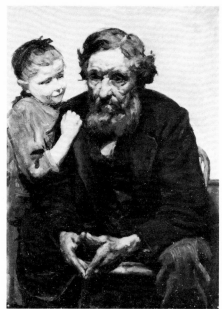

Fig. 8 *Old Man and Child,* by 1887, cat. no. B–11. Reproduced in color, p. 147.

pects. The class included Mary Louise McLaughlin, who was to develop the process of underglaze decoration that later made Rookwood pottery famous. She also organized the Woman's Pottery Club in Cincinnati in 1879 with twelve active and three honorary members. Elizabeth was one of the latter and was still listed as a member in 1890,[20] although by this date she had been living in Paris for several years.

As well as wood carving under Benn Pitman and china painting under Marie Eggers, Elizabeth studied drawing and watercolor under Will H. Humphreys, oil painting under Noble, and engraving. Having completed the basic four-year curriculum, Elizabeth continued her studies at McMicken for three additional years. During her final two years she devoted herself to sculpture, which she studied under Louis Rebisso, best known for his equestrian statues of General Grant in Lincoln Park, Chicago, and General McPherson in McPherson Square, Washington, D.C. In his courses Rebisso followed the same careful progression as that observed in the drawing classes; from copies after antique casts to sculptures and thence to the study of live models. Nourse's first sculptures were done in clay and terra cotta. A later work, *Bust of Mary Noonan* (fig. 7), indicates why Preston Powers, son of Cincinnati's most famous sculptor, Hiram Powers, urged her to give up painting and devote herself to sculpture.[21] Her work in the latter undoubtedly increased the perception of form already so strongly evident in her drawing.

Nourse never studied with Frank Duveneck, Cincinnati's best-known nineteenth-century painter and teacher, but several of her close friends did and must have discussed his classes with her. In 1875 Clement Barnhorn and John Henry Twachtman studied with Duveneck in Cincinnati's first art class to provide study from the nude model (from which, by reason of her sex, Nourse was automatically excluded).[22] The Duveneck life class was so popular that the male students organized one for themselves, thereby forcing McMicken to include such a course in the curriculum—but for male students only.[23] (It was not until 1885 that study from the nude was offered in a separate class for women.)

Duveneck's influence among local artists were pervasive, and although there is no record that Nourse ever consulted with him, she obviously experimented with the bravura brushwork of his early canvases in her *Old Man and Child* (fig. 8) and *Head of a Little Boy* (cat. no. C–42). The layers of pigment with abrupt tonal contrasts on the faces and hands of these subjects is similar to those seen in Duveneck's *Whistling Boy* of 1872, but Nourse set her figures against a light background and restrained her handling of the clothing.

The realism that Duveneck espoused and his early students found innovative seems to have been Nourse's personal form of expression from the very beginning. Her early watercolor, *Old Market Woman* (fig. 9), is typical both of the direct manner in which she saw and portrayed her subjects and of her sympathy for ordinary working people. Only one of her Cincinnati paintings, *Woman with Harp* (fig. 10), has the elevated subject matter and meticulous finish

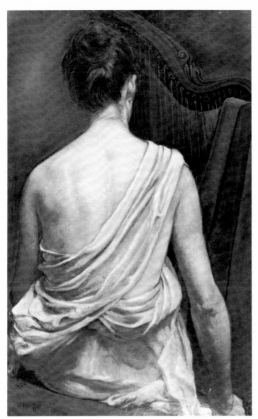

Fig. 10 *Woman with Harp*, 1887, cat. no. C–48.

Fig. 9 *Old Market Woman*, by 1887, cat. no. B–12.

associated with the French academic tradition, and it was painted the year she went to France.

In *Old Market Woman* the subject wears a brown dress with a red shawl and carries a basket filled with boldly brushed green, yellow, and red vegetables. The white paper shows through in the lighter areas of the watercolor but this was not necessarily characteristic. Nourse's technique varied, and in other watercolors, particularly the later ones, she added touches of white gouache for highlights.

In addition to the influence of her teachers, the exchange of

ideas Nourse had with her fellow students must be considered in terms of her artistic development. Cincinnati's Golden Age, so called because of the number of artists of national and international reputation at work in the city, lasted from about 1830 to 1900.[24] During these years Cincinnati attracted professional artists because of the patronage it offered, and art students because of its educational facilities. As a result Nourse experienced far more artistic stimulation from talented fellow students and from her environment than might be expected in a provincial American city of the time.

An article in the *Cincinnati Commercial Gazette* in 1877 noted that a large majority of the pupils at McMicken's were women. The writer described them with the male condescension typical of the times: "with the enthusiasm characteristic of the divine fair sex, they have suddenly thrown rat-and-mice pen wipers, piano thrumming, and pink-eyed cotton rabbits to the winds, and with a mighty resolve to become 'artistic' have suddenly and desperately enrolled themselves in the Cincinnati School of Design."[25] Continuing, he remarked on how pleasant it was to see them "bending their pretty heads and elaborately wasting drawing paper." The writer thought that some of the young ladies had promise "in case they have enough of woman's great lack—perseverance." He did find Elizabeth Nourse one of the most promising because of her versatility, thoroughness, and strength.

Nourse must scarcely have viewed her courses as an alternative for making "rat-and-mice pen wipers." Art, for her, meant helping to pay her way in a family of very limited income. Louise was already contributing her salary as a schoolteacher, and by 1880 the twins, Elizabeth as an artist and Adelaide as a wood-carver, were also helping to supplement the family income.

The Nourse sisters attached great importance to the question of professional activity for women. They had five nieces and one nephew, whom they cherished, and their own experience had taught them that women should be prepared to earn a living. Of all the nieces Mary Nourse (fig. 11), the daughter of their brother Charles, was, perhaps, closest to Elizabeth because she, too, became an artist. Mary, who was only eleven years younger than her aunt, always remembered a visit Elizabeth and Louise had paid her in 1880 on her tenth birthday. They asked her if she had decided what she intended to make of herself. " 'Did I like music? Did I think of becoming adept in woodcarving? Had I an inclination for art?' I was rather frightened by it all, but I chose art. Thereafter, every Saturday, I had my drawing lesson from Aunt Elizabeth."[26]

As the anecdote indicates, the Nourse sisters had an obvious bias toward the arts. Even if their niece should marry, they agreed with Benn Pitman that she should be trained to do artistic work in her home. Mary eventually became an instructor at the Art Academy in Cincinnati and later joined the staff of the Rookwood Pottery, where she remained for fourteen years.

In the fall of 1879 Elizabeth exhibited for the first time at the annual Cincinnati Industrial Exposition, the eighth to be held in the

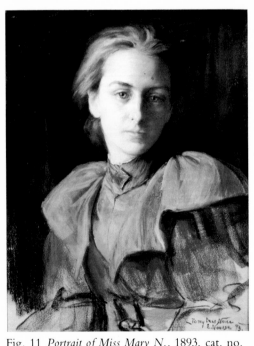

Fig. 11 *Portrait of Miss Mary N.*, 1893, cat. no. C–94.

city. These fairs had been initiated in 1870 by Col. Alfred T. Goshorn with such success that in 1876 he was chosen director of the Centennial Exhibition in Philadelphia and in 1886 the first director of the Cincinnati Art Museum. The exhibitions were originally held in a massive building erected for the National Saengerfest, which always included a fine-arts display. In 1879, for example, the display included paintings by Jules Breton, Camille Corot, Thomas Couture, Julien Dupré, Frank Duveneck, Léon Gérôme, Winslow Homer, Ernest Meissonier, and Constant Tryon, giving the city's art students an opportunity to see works by leading contemporary painters.[27] It also provided a showcase for their own work, and Elizabeth exhibited there annually from 1879 until she went abroad.

Although Elizabeth remained at McMicken another year to study sculpture, her decision to make a career as a painter seems to have been made by 1880. That was the year she found work as an illustrator of magazines and brochures. Her most notable series, produced for the *National Repository,* consisted of historic sights around Old Point Comfort, Virginia (cat. no. D–14) and West Point (cat. no. D–15). Although no illustrations by Nourse dated after 1882 have been found, she must have continued to undertake such commissions inasmuch as she was made an associate member of the Newspaper Artists' Association and Magazine and Book Illustrators' Society in 1904.[28]

The year 1881 was a happy one for Elizabeth. She was twenty-one when she graduated in June from McMicken, where she was generally considered one of the most accomplished students. Indeed, a critic writing about her work in a student exhibition had commented on her remarkable skill in drawing, watercolor, sculpture, oil painting, and engraving and had predicted, "Unless all signs fail, or she marries and buries herself in oblivion, the world will hear more of this girl."[29]

Nourse was offered a position as a teacher of drawing at McMicken but declined it in order to concentrate upon her painting.[30] Her decision indicates how determined she was to succeed as a professional artist and also gives evidence of her characteristic independence. Many of the serious female students at the school, including Agnes Pitman, Laura Fry, and Mary Louise McLaughlin, chose to become carvers or ceramists. Only Nourse's close friend Caroline Lord remained a painter, eventually becoming an instructor at the school after it had become the Art Academy of the Cincinnati Art Museum. For a number of the male students, the story was quite different. Robert Blum, Joseph R. De Camp, and John Twachtman attained national reputations as painters, and Henry Farny and Joseph Henry Sharp are well known today for their portrayals of American Indians. The painters Charles Courtney Curran, Louis Lutz, Lewis Meakin, Edward Potthast, and John Rettig, and the sculptor Clement Barnhorn became particular friends of Nourse's, and in 1882 Farny, Meakin, and Nourse were fellow members of an etching club formed by some of the artists of the city.[31]

In 1882 several events took place that greatly affected Elizabeth

Nourse's life. Her father's death on April 21 was followed by the death of her mother on August 27, the same month that Adelaide married sixty-year-old Benn Pitman in Sandusky, Ohio.[32] Elizabeth was thus forced to separate from her twin, heretofore her devoted companion, the same year she lost both parents.

The Nourse sisters had spent several weeks in Sandusky before the wedding and had enjoyed sailing on Lake Erie with Charles Curran, a McMicken classmate of Elizabeth's and a native of the area.[33] The lake scenery inspired a great number of sketches and watercolors, just as Nourse's later travels in Italy and France would evoke her interest in painting reflections of light on water. Her sketchbook of this journey indicates that the sisters, with their friend Mimi Schmidt, also traveled east through Canada to Washington, D.C., possibly leaving from, and returning to, Sandusky. While on this trip Elizabeth did not fail to sketch Niagara Falls, a popular subject for many nineteenth-century artists.

A fortunate circumstance for Elizabeth during her stay in Sandusky was her acquisition of a patron in the person of Mrs. John Harrison Hudson, a wealthy Ohioan who was herself a watercolorist.[34] Having previously purchased twelve of Nourse's paintings at an exhibition in Cincinnati, Mrs. Hudson decided that summer to make it possible for the young artist to study for a few months in New York City.[35]

Nourse and Mrs. Hudson left for New York during the fall of 1882. It is uncertain how much financial assistance the older woman provided, but during Nourse's visit to the city she did provide chaperonage, an indispensable requirement for a respectable young lady (fig. 12).

In an undated letter to her sisters,[36] Nourse described her first impressions of New York, which she found much cleaner than Cincinnati. She became rather impatient with Mrs. Hudson and her companion, a Mrs. Hubbard, who had decided to take painting lessons from a Mrs. Dillon. Nourse reported that she had not been able to see all the people to whom she had been given introductions because her chaperons were "so pokey and I can't go by myself. . . . Mrs. H. and Mrs. Hub walk so slowly and dawdle along so undecidedly and they have to ride everywhere so that I spend so much that it makes me quite miserable."

Nourse related that she had used a letter of introduction to gain free admittance to an exhibition at Goupil's gallery, which had an entry fee of twenty-five cents. She thought some of the pictures there were splendid, particularly one by Henry Mosler, a Cincinnati genre painter whose Breton oil *Le retour*, shown at the Paris Salon in 1879, had been the first American painting to be purchased for the Musée du Luxembourg. After viewing the exhibition, she confessed, "I don't know whether to feel perfectly discouraged or not, here there are so many good artists in the world so that you are nobody."

She visited a number of studios in New York before selecting a teacher. First she showed her work to the figure painter Douglas Volk at Cooper Union, who told her she was "too bold, but had

talent" and singled out her *Fruit Canning Time* (cat. no. B–8) as particularly well done. She finally decided to study at the Art Students League in a life class with William Sartain, a Philadelphia artist who had studied with Léon Bonnat in Paris and who also taught Cecilia Beaux. She apparently stayed only one term, and one can only surmise that she did not find the class worthwhile because she never included this study in her official biographies.

In enthusiastic letters to her sisters, Nourse described her visits to artists' studios in New York. On a visit to the studio of Edward Moran, she especially admired a Normandy peasant scene painted by his son Leon because it reminded her of a Millet. In spite of her dawdling chaperons, she delivered letters of introduction (probably written for her by John Twachtman) to William Merritt Chase and J. Alden Weir. She gave a glowing description of the new building of the Union League Club,[37] which had opened at its Fifth Avenue location the year before on March 5, 1881, but singled out only one painting in it as notable, Samuel Colman's western genre scene *Ship of the Plains*. "There are two or three pictures by my teacher, Mr. William Sartain," she added, and from her lack of enthusiastic comment, it seems evident that she did not admire Sartain as an artist or as a teacher.

Elizabeth returned to Cincinnati, probably in the early spring of 1883, to live with Louise, who at this time assumed the role she was to play throughout the artist's life, that of surrogate mother, housekeeper, hostess, and full-time business manager. Louise was warm and outgoing—she enjoyed entertaining and kept in touch with innumerable friends and relatives, and she was tireless in promoting her sister's work. She earned some money by her carving, but her great contribution to the career of her shy, reserved sister was her unfailing moral and practical support. It is not known if Elizabeth ever saw Mrs. Hudson again, but she did remain in touch with her until the latter's death in 1910.[38]

Elizabeth now had to confront the problem of supporting herself and her sister. She continued to earn money in a variety of ways, one of which was painting decorative oil panels for Cincinnati homes. Benn Pitman probably secured many of these commissions for her as the interior of the unique Gothic structure he had recently designed and built for his home became the model for many local projects that followed.[39] Pitman's house (cat. no. D–10), inset with carved marble panels and stained glass, was located on a hill overlooking the Ohio River. It was begun in 1874 and was embellished and furnished over a period of several years with the assistance of his daughter Agnes, Adelaide and her sisters, and many of his women students.

On the exotic interior woodwork—cherry, black walnut, ebony, oak, and rosewood—the women carved superb original designs based on local flora and fauna that remain in place today. Elizabeth painted the dining room walls and the panels set above the mantel, and made architectural drawings of the rooms and furniture (cat. no. E–36) so that Pitman could publicize these examples of his Ruskinian

Fig. 12 Photograph of Elizabeth Nourse, 1882, from private collection.

Fig. 13 Painted Decoration on Carved Bedstead, 1883, cat. no. F–14.

formula for American designs and handicrafts.

She also contributed illuminated panels to the furniture her sisters carved. Both Adelaide and Louise exhibited elaborately carved pieces, designed by Benn Pitman, in the Cincinnati Industrial Exposition of 1883. Adelaide carved a bedstead in a relief 4½ inches deep, with side panels inlaid with gold discs on which Elizabeth painted heads representing Night and Morning (fig. 13), with white azaleas and balloon vines as a background. Louise showed a hanging shelf of cherry and walnut on which Elizabeth had painted women's heads on gold discs (cat. no. F–13).

At least one other of Nourse's decorative commissions survives.

This panel, *Flock of Geese* (cat. no. E–39), was commissioned by Alice Pike Barney (fig. 14), a wealthy Cincinnatian who was one of the many interesting women to support the artist.[40] Barney studied with Nourse, whom she commissioned to paint a portrait of her daughters, Laura and Natalie (cat. no. C–32). Encouraged by Nourse, Barney went to Paris for further art study in 1887, the same year the Nourses arrived. In subsequent years she returned repeatedly to Paris, where she maintained a studio between 1898 and 1901, and exhibited her work in the Salons of 1889 and 1897. In the meantime she had moved to Washington, D.C., and there, on Sheridan Circle, built and maintained her elaborate Studio House, which functioned for many years as a local cultural center. Some years after her death in 1931 the building was given to the Smithsonian Institution, together with her art collection, which included four flower paintings by Nourse (cat. nos. E–60, E–63, E–67, E–68) as well as *Flock of Geese,* which she installed over her fireplace, first in Cincinnati and later in Washington. Barney no doubt commissioned these pieces to help her friend financially, for she was not a dedicated collector. Her daughters remained in Paris—Natalie became famous for her salon, where she entertained the poets, writers, and painters of the Symbolist movement, while Laura married Hippolyte Dreyfus and lived a more conventional life. Laura remained in contact with Nourse until her death.[41]

Elizabeth painted a number of flower studies like those bought by Alice Pike Barney because they were apparently very saleable in Cincinnati during the 1880s. She found time, as well, to make visits to the nearby mountains of Tennessee to sketch the simple hill folk, whose rustic surroundings intrigued her and prepared her for the peasants she was to encounter in Italy, Austria, Holland, and France.[42]

Her sketchbooks of this period also contain many drawings of Austin and Walter Schmidt, sons of close friends, as babies, and of Emerson Pitman, the second son born to Adelaide and Benn Pitman. (Their first son, named for another of Pitman's heroes, Ruskin, had died at birth.) In figure 15, a strong but sensitive drawing of Emerson in charcoal and chalk with gouache highlights, she handles the media with an almost painterly touch as she molds the facial structure with bold contours and softly textured shadows. Her interest in painting infants and mothers and children, which she shared with Mary Cassatt, seems to have begun with the births of Walter and Emerson and continued throughout her career. Mary Nourse later explained the understanding and compassion that her aunt brought to these subjects: "Aunt Elizabeth had the greatest sympathy for women of her generation. She often commented on how hard they worked in their homes. Her heart went out to them."[43]

The Nourses had a gift for friendship and remained in contact with their friends and relatives in Cincinnati throughout the years they lived abroad. They welcomed all Cincinnatians who sought them out in Paris, and Louise in particular was a tireless correspondent. But of all the friends with whom the sisters corresponded regu-

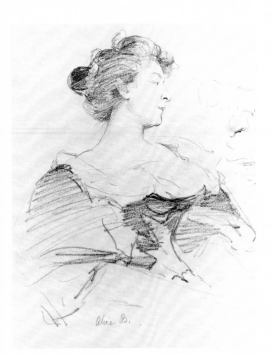

Fig. 14 *Alice Pike Barney,* ca. 1888, cat. no. H–8.

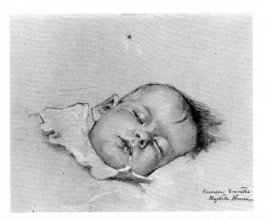

Fig. 15 *Emerson Pitman,* 1885, cat. no. C–34.

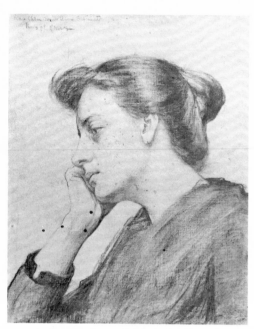

Fig. 16 *Portrait of Anna Seaton Schmidt,* 1890, cat. no. C–58.

larly, perhaps the closest were members of the Schmidt family, two generations of whom were to play important parts in their lives.

Frederick A. Schmidt, a prominent Cincinnati realtor, managed the sisters' business affairs until his death in 1911, at which time his son Walter took charge.[44] Walter's mother, Mimi Schmidt, was a devoted friend who sold Elizabeth's paintings in Cincinnati by showing photographs of them sent by Louise. His aunt, Anna Seaton Schmidt (fig. 16), was a successful writer and lecturer on art who enthusiastically publicized Nourse's work in *International Studio, Art and Progress, Century Magazine,* and other periodicals and newspapers to which she contributed. Anna frequently visited the Nourses in Europe, sometimes accompanied by her sister, Elizabeth Schmidt Pilling of Washington, D.C. The Nourse sisters became "Aunt Elizabeth" and "Aunt Louise" to Mimi's children, Walter, Austin, Elizabeth, and Dorothy, and they corresponded with them as frequently and as warmly as they did with their own beloved nieces. Walter was executor of Nourse's estate after her death in 1938 and arranged for the distribution of some seventy-four paintings from her studio, as well as for a number of the artist's works that his family had bought or that had been gifts to them from Nourse.

In 1885 Elizabeth returned to McMicken to take advantage of the school's first course (under Noble) to offer study from the nude to women. Together with her fellow classmates from four years earlier, Caroline Lord and Laura Fry, she studied in the life class for two years. It should be noted, however, that despite the school's daring departure from tradition in offering such classes to women, a first-year study by Nourse (cat. no. C–36) suggests that the model still remained partially draped, as is the subject of *Woman with Harp* (fig. 10), which she may have conceived in preparation for her study in France.

Like most American artists of her generation, Elizabeth dreamed of studying in one of the famous Paris ateliers; to this end she and Louise studied French and saved money.[45] By 1887 they had accumulated five thousand dollars from the sale of their art and from the residue of their father's estate. They stored their furniture because they planned to return, then sailed on the *Westernland* from New York on July 20th. Elizabeth Nourse was then twenty-eight years old.[46]

During this journey Nourse kept a notebook in which she recorded her thoughts as they departed. "Such a melancholy feeling! There is so much we will see and do before we come back—and then *will we ever come back?"*[47]

II *Salon Painter in Paris, 1887-93*

Arriving in Paris in late August 1887, the Nourse sisters checked into the Villa des Dames, a hotel for women on the Left Bank, and immediately set out to see the mural decorations in the city's churches and public buildings.[48] The very first Elizabeth noted were

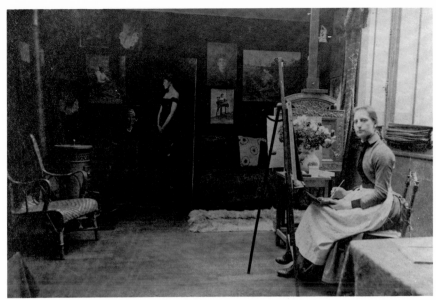

Fig. 17 No. 8, rue de la Grande Chaumière, Nourse's first studio in Paris, 1888. Photograph from Scrapbook 1, p. 16.

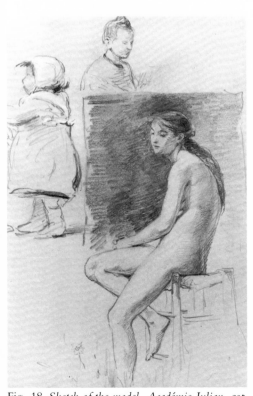

Fig. 18 *Sketch of the model, Académie Julian,* cat. no. H–6.

Thomas Couture's in Saint Eustache, which she pronounced "exquisite." She also studied paintings by artists including Jules Bastien-Lepage, Paul Baudry, Léon Bonnat, Jules Breton, Julien Dupré, Jean-Paul Laurens, and Léon Lhermitte at the Musée du Luxembourg, unaware that she would be showing her work with paintings such as theirs in the 1888 spring Salon of the Société Nationale des Artistes Français.

In a letter written to Thomas Noble in November, Elizabeth described these first impressions:

> I have thought of you so much lately seeing Couture's "Decadence" in the Luxembourg. I like it more and more every time I see it, it is so strong and simple. We saw his tomb in Père Lachaise and his decoration in St. Eustache. I think his work in that church and that of Cabanel and Jean-Paul Laurens in the Panthéon the most beautiful wall painting in Paris.[49]

The Nourses found an atelier at 8, rue de la Grande Chaumière (fig. 17) near the Luxembourg Gardens in the Latin Quarter, where most of the American artists lived. Elizabeth noted that the rent for such a studio was 40 francs (about $8.00) for six weeks. She proceeded to enroll at the Académie Julian for women, where Gustave Boulanger and Jules Lefebvre were teachers.[50]

Rodolphe Julian, the director, had been the first to offer art training in Paris exclusively for women.[51] He was so successful in this enterprise that by 1892 he was operating five different studios, three for women only. The latter offered rooms arranged to satisfy different sensibilities—one for drawing from the nude model, one for working from a draped model, and a third, with a separate entrance and staircase, for those amateurs who did not even wish to glimpse a nude model. Nourse's studied drawing of a class model (fig. 18) in-

31

dicates that she chose the more exacting discipline of drawing from the nude.

Elizabeth made two sketches of Lefebvre in his role as teacher at Julian's with these words issuing from his mouth: "Not bad—not bad at all."[52] She wrote to her sister Adelaide that the French painter thought that in time she could do great things. "Paris is wonderful," she reported, and commented that she found it very stimulating to meet all nationalities at Julian's: English, Poles, Swedes, Russians, Italians, Spanish, Australians, and Chileans. "It is interesting to hear them talk, and to see how little we know about the ways of other countries; you find out how everybody has a different way, and one is as good as the next."[53] She also told Adelaide that she had visited Elizabeth Gardner, the New Hampshire artist who was to marry Adolphe Bouguereau, and that she had met artist Carolus-Duran through Alice Barney and watched him paint a portrait of the Barney children. She was thrilled to see Sarah Bernhardt looking "most gorgeous" at the wedding of her son to a Polish student friend of Elizabeth's at Julian's, Princess Jablonowsky.

After only three months of study at the Académie Julian, Nourse was advised by her teachers to leave and work alone because they found her drawing excellent and felt that too much academic training might interfere with the development of her original style.[54] She immediately set to work on *La mère*, her first Salon entry, and went to Jean-Jacques Henner and Carolus-Duran for criticism.[55] The painting was not only accepted by the jury of the Société Nationale des Artistes Français, but was hung "on the line," a signal honor for a new exhibitor. She signed *La mère* "E. Nourse," as she did all her early work, because she apparently thought it would be more favorably received if the public did not know she was a woman. In 1891 she began to sign her full name, "Elizabeth Nourse," on her Salon entries and this became her standard signature by 1904, except for small canvases on which she must have felt her full name would be obtrusive.

La mère (fig. 19) demonstrates how well Nourse understood the academic standards admired by the jurors of the Salon. First she painted an oil study of the mother's head (cat. no. A–3), for which Louise carved a frame in the Pitman style. She then worked on the major painting, as she had on the study, with small brushstrokes and careful tonal gradations to give both works the finish that the more traditional French painters admired. The result displays her greatest strengths: solid draftsmanship and masterful handling of light and shadow as well as an emotional quality that never becomes sentimental. Nourse placed the two figures close to the picture plane in order to make their gestures and expressions the most important elements of the scene. Yet, the broadly brushed garments and background, with their muted color harmonies, are also effective in establishing the mood of the painting.

For all its rich, dark color and academic finish, *La mère* was modern by nineteenth-century standards in its simplicity and realism. There are no anecdotal details and the oblique view of the figures is

Fig. 19 *La mère,* 1888, cat. no. A–2. Reproduced in color, p. 148.

Fig. 20 *Lavoir, Paris,* 1888, cat. no. B–14.

reminiscent of candid effects made popular by an earlier generation of French painters.

This was an auspicious beginning for the young Cincinnatian in Paris, but the next important step was to sell her work in order to support herself and Louise. It is revealing to trace the history of *La mère* as an example of how this was accomplished. Some seven years and exposure at five exhibitions were required before Nourse sold *La mère,* presumably for $300—an indication of the struggle she had to maintain herself as a professional artist. After the spring Salon of 1888 the painting was exhibited in London at the Continental Gallery under one of the poetic titles the English preferred, *So Dear a Life Your Arms Enfold* (a line from Tennyson).[56] The painting was shown in Liverpool the following year, then in Glasgow, and again in her 1893 retrospective at the Cincinnati Art Museum.[57] It was priced at $300 in Cincinnati and at an exhibition held the following year in Washington, D.C., at the V. G. Fischer Art Gallery, where it was bought by Parker Mann, a local artist.[58] By 1914 it was hanging in the Princeton study of Woodrow Wilson, then governor of New Jersey, along with Mrs. Wilson's own paintings.[59] Mann was the first of a number of artists who purchased Nourse's work—evidence of the high regard she enjoyed among her fellow professionals.

In Elizabeth's continuing struggles to support herself and her sister, Louise was an indispensable assistant. Not only was she a frugal housekeeper but an astute business manager and secretary who took care of all shipping arrangements to the hundreds of exhibitions that Elizabeth entered over the years and handled all related financial details. As a result, Elizabeth was left completely free to devote herself to her work. A rapid painter, she always had a number of works on exhibition at the same time. It should be noted that all of the exhibitions she entered were juried. It was thus a testimony to her stat-

33

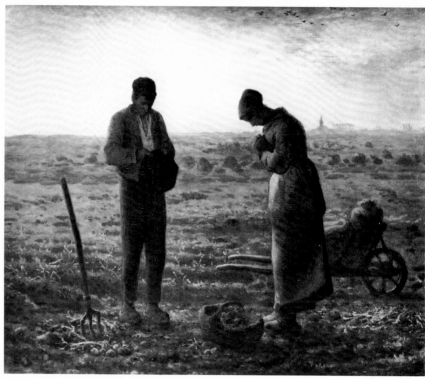

Fig. 21 Jean-François Millet, *The Angelus,* 1855–57, oil on canvas. The Louvre, Paris.

Fig. 22 *La mère Adèle,* Barbizon, 1888, cat. no. H–7.

ure as an artist that her work was concurrently shown all over Europe and the United States.

In 1888, the year that she first exhibited with the Société Nationale des Artistes Français, Nourse painted a watercolor, *Lavoir, Paris* (fig. 20),[60] which depicts a public washhouse in Paris, a subject she later painted several times in the French countryside. In the medium of watercolor her painterly tendencies became even more apparent. Broad strokes of contrasting color and exposed areas of white paper were used in *Lavoir, Paris* to establish light and interior space. Her technique varied, however, in a charming still life of the same date, *Lilacs, Paris* (cat. no. E–55), to which she added many small strokes of gouache to define the petals of the flowers that appear to be dropped casually on a table.

Nourse's first trip outside Paris that summer was in the nature of a pilgrimage, to visit the village of Barbizon, locale of Jean-François Millet, the French artist she most admired and emulated. Deeply attracted to Millet's subject matter and to his simplicity in portraying it, she must have studied his work with care at his retrospective exhibition in Paris earlier that year, for her very first sketch upon arriving in Barbizon was of the cottage in which Millet had lived and worked.[61] She sought out the woman who had been Millet's model for *The Angelus* (fig. 21) and made a fine character sketch of her, inscribed "La mère Adèle" (fig. 22), and even bought the cloak the woman had worn when she posed for Millet, as well as a spinning wheel.[62] Her admiration for the French painter was apparently well known to her friends, several of whom gave her reproductions of his paintings for birthday and Christmas gifts.[63]

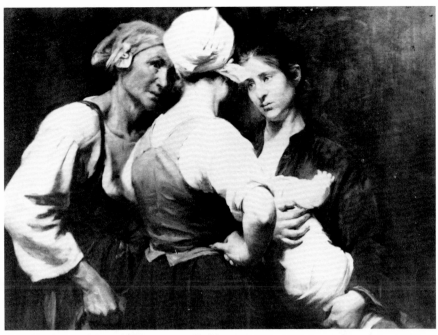

Fig. 23 *Entre voisines,* 1888, cat. no. B–16.

Louise wrote glowing descriptions to her sister Adelaide of the summer in Barbizon where, she said, "Everywhere you look you see a Millet picture."[64] The sisters were delighted to be in the countryside, which moved Louise to exclaim, "Oh the beautiful country, la Belle France! We have found it at last." For many years the Nourses were to spend their vacations in rural places, where Elizabeth enjoyed sketching the country scenery and the peasants and their children at work and at play. Both sisters felt great empathy for peasant life, identifying with its simplicity, piety, familial devotion, and unremitting labor. Describing to Adelaide a peasant woman whom she saw interrupt her work to pray at a wayside shrine, Louise commented, "It seems most natural that people living in the country should be more pious than those in the city, is it not?" Although widespread nostalgia for a preindustrial way of life was shared by many artists who sought out peasant imagery at this time, Louise was expressing the deeper, more spiritual identification with rural values that she shared with Elizabeth.

Entre voisines (fig. 23), an intimate genre scene painted during this stay in Barbizon, was shown in the Salon of 1889. Nourse made only two preliminary sketches (one shown in fig. 24) for this oil, an indication of the assurance with which she worked. Catching the poses with a few strong lines, she described the forms with contours and rapid parallel hatching, and then applied white chalk to emphasize the fall of light. The finished painting provides a closer view of the three figures, which are placed in a more classic triangular composition than in the sketch, with diagonals of white focusing attention on the central figure, the back of which is to the viewer. Subtle shadows and closely modeled features evoke an expressive quality in the faces of the other women.

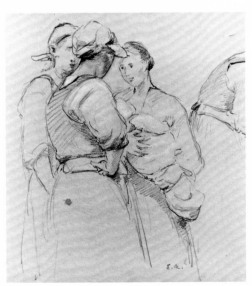

Fig. 24 *Sketch for Entre voisines,* 1888, cat. no. H–8.

In January 1889 Elizabeth took a trip without Louise to Russia with her friend Tolla Certowicz, a sculpture student at the Académie Julian.[65] The two women journeyed to the Certowicz estate near Kiev by way of Warsaw and were six days en route. Elizabeth wrote a vivid account of this adventure to Adelaide.

> *At length we reached the last station, and there we found the sleighs which had been waiting for hours. There were three of them—four horses each, one for us, one for the baggage, and one carrying an immense torch, close to the ground, to drive off the wolves and to show the way. I shall never forget my first arctic night; at least it answered all the purposes of an arctic night. . . . The scene was ravishing, I was perfectly delighted, forgetting all my woes, my hunger, my fatigue, the cold—everything—for there was something intoxicating in that long night's ride. The drivers were so picturesque, the sleighs, the prancing horses, with their hundreds of bells, and then the beautiful blue sky above us, glittering with stars, and the snow, snow covering everything. . . . I was anxious to see some wolves, but probably the torch kept them off. However, it was better not to have been eaten up, although I would rather have liked to be able to describe it afterwards. I was sincerely glad when we had to cross some water, which was considered rather dangerous, and when we lost our way, my joy was complete . . . and when we arrived here the servants all came out to meet us and kissed our hands.*

Elizabeth spent six weeks in the Ukraine and made many sketches and some watercolors there, but she found it impossible to paint the peasants because it was not customary for the landowners to go into their cottages and she herself could not communicate with them. She therefore took some peasant costumes back to Paris and in 1895 fashioned an interior in her studio to resemble a Russian cottage, blocked the light to simulate its small, high windows, and painted *Les fileuses russes* (cat. no. B–57).[66]

During the summer of 1889 Elizabeth and Louise, traveling with Anna Schmidt and her sister, Elizabeth Pilling, went to Picardy, an area much frequented by plein air painters in France.[67] Although Anna Schmidt, who was to become Nourse's major publicist, considered her home to be Washington, D.C., where she lived with the Pillings, she traveled constantly.[68] For a time she lived in London, where she wrote for *International Studio,* and in Boston, where her articles were published in the *Boston Transcript* and the *Atlantic Monthly.* She also spent many summers at the American art colony in Gloucester, Massachusetts, with Mrs. Pilling and the Schmidt family of Cincinnati.

Anna described the manner in which Nourse posed her models in Etaples on bitterly cold and windy autumn days for *Fisher Girl of Picardy* (fig. 25) and recorded its history: Nourse gave the painting as a gift to Mrs. Pilling who, in turn, donated it to the Smithsonian Institution's fine-arts collection.[69] Because of its large scale, the artist must have originally conceived this work as a Salon painting and then abandoned the idea, for it lacks the meticulous finish of her ex-

Fig. 25 *Fisher Girl of Picardy*, 1889, cat. no. A–6.

hibited work of the period. Perhaps she was dissatisfied with her first attempt to capture the gray light of the stormy seacoast or with an attempt to emulate the technique of other painters working in Picardy that summer. Whatever the reason, the canvas is more freely brushed than usual, although the subject—a sturdy young woman and child standing watch on the rugged coast—is eminently characteristic of the period. The upright figure, cut by the strong diagonal of a shellfish net and silhouetted against scudding clouds, is a more dramatic pose than the artist normally selected. The palette is, however, the subdued one—brown, black, and gray relieved by white and a touch of wine red—she favored for her oils.

Another Etaples oil, this one finished for the Salon, was *Dans la campagne* (cat. no. B–20), a painting of a peasant woman weighted down by a yoke supporting heavy milk cans and standing before a vine-covered wall. Reminiscent of a Jules Breton subject, it seems undertaken to show the artist's ability to render the contrasting textures of flesh, metal, wool, stone, and greenery.

During the following January (1890), Anna Schmidt again joined the Nourse sisters on a trip to Italy, where they remained for a year and a half.[70] They traveled south through Provence to Marseilles, then sailed on to Genoa accompanied by two of Elizabeth's friends from the Académie Julian, Mary Wheeler and Beulah Strong. Characteristically, both women were to remain lifelong friends of Nourse's even though they soon returned to work in the United States. Mary Wheeler became superintendent of art instruction in the public schools of Helena, Montana, her native city, and maintained a studio in which she exhibited and sold Nourse's work as well as her own.[71] Beulah Strong joined the art department of Smith College, which subsequently acquired two of Nourse's paintings.[72]

The group separated while the Nourses visited Naples, Pompeii, and Capri, and was reunited in Rome in February 1890.[73] It was there that Elizabeth received an invitation to join the Société Nationale des Beaux Arts—hereafter called the New Salon—a recently formed group of artists that had broken away from the Société Nationale des Artistes Français.[74] Ernest Meissonier led the dissidents in planning a separate Salon, ostensibly because of a dispute over the awards given at the 1889 Salon. In fact, this action was a revolt of the moderns, such as Puvis de Chavannes and Carolus-Duran, against the conservative standards of the established artists who served on the jury of what will henceforth be called the "Old Salon." The latter group included many of the great painter-teachers from the Académie Julian's various schools—men such as Bouguereau, Benjamin Constant, Lefebvre, and Tony Robert-Fleury. A number were also stockholders in Rodolphe Julian's academies, so that in effect, those affiliated with Julian dominated the Old Salon.[75] The younger artists of the New Salon, who espoused the cause of realism, included Albert Besnard, Jean-Charles Cazin, Pascal Dagnan-Bouveret, and Auguste Rodin, all of whom were to become close friends of Nourse's in the years that followed.[76]

Nourse promptly sent the four entries she had intended for the

Old Salon to the new group's exhibition at the Champs de Mars. It took courage for her to turn her back on the prestigious Old Salon, where she had met with success, and join forces with the progressives. As it happened, the New Salon provided her not only with sympathetic associates but with a much greater opportunity to show her work and have it reviewed. (The New Salon originally displayed only one-fifth the number of works exhibited at the Old Salon, where more than five thousand paintings had been hung in the spring of 1889.[77]) She took the risk, however, that the new group might fail to gain public acceptance and that she would lose her opportunity to establish her reputation as a Salon painter. Both European and American collectors of the late nineteenth century considered the approval of a Salon jury necessary to guarantee the quality of their purchases.

In April the Nourses and Anna Schmidt continued on to Florence, where they went sightseeing with a copy of Ruskin's *Mornings in Florence* as their guide.[78] They also spent time in Venice, where Elizabeth, intrigued as always by the play of light on water, painted several watercolors. By the end of July, Anna had left and the two sisters settled in Assisi for about four months while the artist worked on a religious painting and a number of smaller works.[79] On October 26 Elizabeth celebrated her thirty-first birthday in Assisi and received a copy of Ruskin's *Modern Painters* as a gift from Anna.[80]

Assisi was a place of religious pilgrimage for Elizabeth and Louise, both of whom had become members of the Third Order of Saint Francis, a lay group that observes a modified version of the Franciscan rule.[81] Certain religious practices are required, but the primary rule is that members perform acts of personal charity in the spirit of Saint Francis, a requirement the Nourses took very seriously and incorporated into their daily lives. The result was their becoming deeply involved in the lives of Elizabeth's models, feeding their children, helping the sick and elderly in their families, and performing innumerable personal services for them.[82] Because Elizabeth shared in their lives, she was able to portray urban and rural working people with a depth of understanding that eluded artists who knew them only as picturesque models.

Nourse's oeuvre contains only a few religious pictures, of which two were painted in Assisi and Rome, the historic centers of her faith. In a letter from Assisi to her twin, she described one of them, *Le pardon de Saint François d'Assise* (cat. no. B–32), her most ambitious work to date, as "a huge picture in the church with at least twenty models and numerous dabs which represent another twenty."[83] On loan from its owner, a Cincinnati woman, this painting and *Peasant Women of Borst* (fig. 28) were exhibited in the Cincinnati Room (fig. 33) at the World's Columbian Exposition of 1893 in Chicago. Nourse made a single sketch for *Le pardon*, which she outlined and signed in her sketchbook, her method of showing that it was to be the basis for a painting.[84]

The artist began an even larger religious painting in Assisi, *Vendredi Saint (Good Friday)* (fig. 26), which includes nine life-size fig-

Fig. 26 *Vendredi Saint,* 1891, cat. no. B–37.

ures. Her first two sketches indicate that her original idea was simply to show the peasant subjects kneeling at an altar rail.[85] To the final signed and outlined sketch she added the background figures and the central image, a woman kneeling to kiss the crucifix. After she took these sketches to Rome, where professional models were available, poses were changed and the composition was given a stronger Baroque accent. The introduction of the small kneeling girl in the fore-

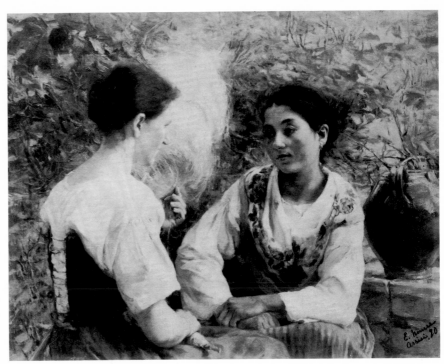

Fig. 27 *A la fontaine,* 1890, cat. no. B–29.

ground, for example, is a device frequently used by seventeenth-century painters to draw the viewer directly into the scene.

For *Vendredi Saint,* Nourse chose a palette of rich browns and blacks relieved by deep blue and red. The light effects appear, however, to have come from a Baroque source. The value contrasts, from the highlights falling across the kneeling women to the murky shadows in the background, are too dramatic and contrived to be related to contemporary studies of interior light in France and Holland. A year or two later, the artist was to experiment with an interior scene, *Le repas en famille* (fig. 29), illuminated by cool natural light filtering through windows in the background, an effect much in vogue at the time.

Nourse's Italian sojourn produced at least twenty-five paintings that she was to exhibit later, including *A la fontaine* (fig. 27). The reception this work received in Paris in 1891 proved that the artist's decision to join the New Salon was a fortunate one. Both *A la fontaine* and *Le pardon de Saint François d'Assise* were illustrated in the Salon's *livret,* an honor that would never have been accorded a young American's entries in the Old Salon.[86] A French review also printed a caricature of *A la fontaine* that showed the head of the woman on the left replaced by the spindle of wool she holds in her hand.[87] Despite the derogatory implications, Elizabeth, like many young artists, doubtlessly preferred to be criticized rather than not mentioned at all.

After a stay of more than seven months in Rome following their Assisi sojourn, Elizabeth and Louise left Italy and journeyed to Borst, a mountain village in southern Austria, in search of different peasant subjects.[88] Borst was so remote that the last part of their

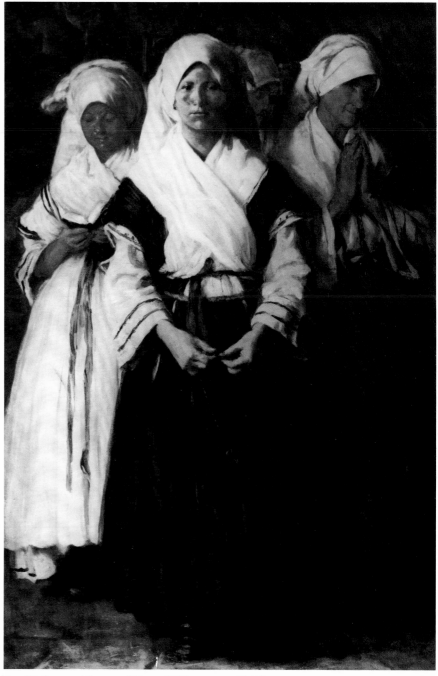

Fig. 28 *Peasant Women of Borst,* 1891, cat. no. B–39.

journey was made by oxcart. The Nourses remained in Borst from July 1 to mid-August 1891. As they were later to do in Brittany, they chose a small Catholic hamlet that offered no hotel accommodations for tourists and enlisted the aid of the local priest to help them find lodgings and models for the artist.[89] In this way they could live very economically and immerse themselves in the life of the village.[90]

Elizabeth's sketches from Borst show that she was as fascinated by the peasants' costumes as she was by their customs. As an accomplished seamstress who enjoyed designing and making her own hats

and clothes, she was able to appreciate the peasants' skills in weaving and embroidery.[91] She painted several oils during her stay, including *Peasant Women of Borst* (fig. 28), an intriguing composition that shows devout villagers approaching the viewer in a religious procession. Her first drawing of the scene and its subsequent watercolor (cat. no. B–41) are almost identical, but several major changes were made when she transferred the composition to canvas. The dramatic impact of the oncoming figures, for example, was enhanced by enlarging them to fill the canvas and by giving greater variety to the circle of women's heads. For the same reason, perhaps, the festive touches of red and blue in the watercolor have been eliminated in the oil, giving the latter a more somber and dignified aspect.

In 1892 seventeen prominent Cincinnati women purchased *Peasant Women of Borst* for their art museum, where it was hung in a carved oak frame donated by Benn Pitman.[92] Many of these women were old friends of the artist's and had been active in forming the Women's Art Museum Association of Cincinnati in 1877 to "advance women's work, more particularly in the direction of industrial art."[93] Their goal had been the establishment of a museum in the city based on the South Kensington model, together with a school for training draftsmen and designers to provide employment for women and to encourage their creativity. Their efforts had culminated in the opening of the Cincinnati Art Museum in 1886, and the following year, of the adjacent Art Academy, which replaced the school in which Nourse had studied. Cincinnati would always prove to be a receptive market for Elizabeth's work, especially among women who consciously set out to promote employment opportunities for their sex.

Louise and Elizabeth returned to Paris in September 1891 after a leisurely journey through Germany that included a boat trip on the Rhine.[94] There the artist sketched a picture of a mother bathing her child on a river bank, which she later used, transposed to a domestic interior, as the basis for one of her 1892 Salon entries, *La toilette du matin* (fig. 81), also purchased by a Cincinnati woman. Nourse's other two entries that year—*Etude* (cat. no. B–48), a compelling portrait of two young peasant girls, and *Le repas en famille* (fig. 29), a sympathetic treatment of a poor family at the dinner table, were also interior scenes. The latter, which was to receive a medal at the World's Columbian Exposition in Chicago two years later, is a challenging study of light filtered through the filmy curtains and glass panes above and behind them. The depiction of light was a problem that proved as absorbing to Nourse throughout her career as her peasant subjects, and one that she addressed in all its varied forms— the various seasons and hours of day and night, both out of doors and in interior scenes.

While noting the skill involved in capturing such fugitive effects, the public considered her subject matter of equal, if not greater, importance than her technical proficiency. *Le repas en famille* was the type of genre painting bought by wealthy Victorians who liked to believe that the poor were humble, virtuous, and, above all,

43

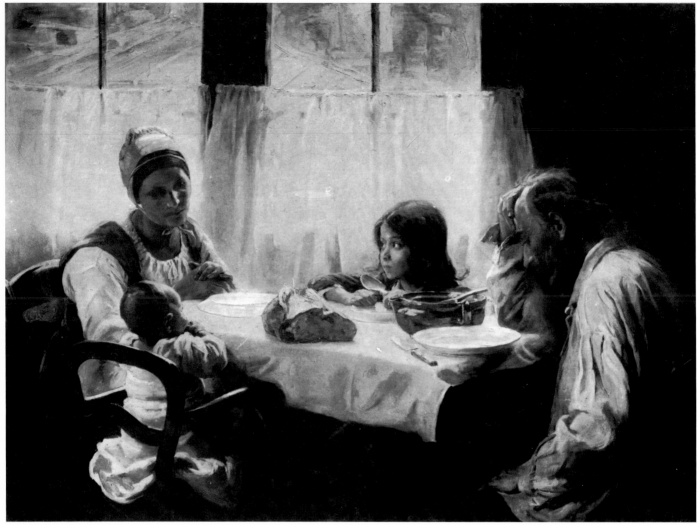

Fig. 29 *Le repas en famille*, 1891, cat. no. B–42.

Fig. 30 *Portrait of Louise Nourse*, 1892, cat. no. C–79.

content with their simple lives. As late as 1910 a review of the work expressed this attitude:

> *Miss Nourse puts into these intimate little scenes the sentiments of goodness, of charity, of devotion and of thankfulness which she herself feels better than any one else, and she reproduced them with an emotion that is always true and which communicates itself perfectly naturally, for she makes appeal to the best in each of us.*[95]

Elizabeth painted her peasant subject with tenderness, if without sentimentality, but her view of herself seems far more severe. An 1892 self-portrait before her studio mirror (fig. 1) has a revealing, businesslike air as she stands, palette in hand, before her easel. Her features are strong and handsome but she makes no concession to vanity by softening her hair or changing her utilitarian dress apron. Five feet five inches tall with brown hair and gray eyes,[96] she was always described as slight and even frail, but in this picture she looks taller, her figure almost filling the shallow format. By comparison Louise, portrayed by Elizabeth the same year (fig. 30), is depicted as

a matronly figure in a fashionable hat and coat with a relaxed and cheerful demeanor.

In July 1892 the Nourses traveled with their Cincinnati friends Henriette and Laura Wachman to Holland and settled in Volendam, a small fishing village on the Zuyder Zee.[97] The picturesque seacoast and costumed villagers had long since attracted numerous artists, and Elizabeth and Henriette, who had trained with her at McMicken as a carver and painter, may well have been following the lead of such prominent American colleagues as Gari Melchers and Walter Mac-Ewen, who also painted on the Dutch coast. The Nourse sisters rented a house on the village dyke with a kitchen shared by the four women, and Henriette and Laura rented a house on the sea that the two painters used as a studio. *Sur la digue à Volendam* (fig. 92) must have been one of the scenes posed on the windswept platform they had constructed outside their studio window. It was described as "cold in tone and color, thus harmonizing with the subject" by Clara T. MacChesney, a friend of Nourse's and a fellow exhibitor at the New Salon who often wrote about Elizabeth's activities.[98] A successful artist in her own right, MacChesney wrote with authority:

> *One is struck by the variety of her subjects . . . her sense of color is good; but perhaps her best quality is her handling of light and shade. Her work stands between the premier-coup of the average Salon picture and the more finished tone-work of the Barbizon school. . . . Her canvases are nearly all large, and painted with a vigor that one seldom sees in a woman's work. She sometimes has the good quality of hardness, which nearly every artist of note has early in his career, but which becomes lost later in life. . . . She is mainly direct in her work, making but few slight sketches first, in pencil and in oil. She paints very rapidly and does not repaint, nor work for tone and quality, but generally carries her first conception through to the end.*[99]

In another major Volendam painting, *Dans l'église à Volendam* (cat. no. B–43), Nourse skillfully records the play of natural light across the seven figures and the polished wood surfaces of a church interior—a variation on a theme much favored by Americans working in Holland. In a plein air painting done the same summer, *Across the Meadows (Dans les champs, Hollande)* (fig. 31), two figures in a shaded foreground are silhouetted against sunny fields that stretch out behind them. Both paintings show that Nourse had adopted a lighter palette of rose, green, and violet under the influence of the Dutch light. In 1895 the outdoor scene was purchased by two Cincinnati women who visited Paris.

Working prodigiously during her happy three months in Holland, Nourse produced some twenty-two small pictures as well as four large ones. She returned to Paris in the fall with Louise and Charlotte Gibson Miller, another friend from her McMicken class who had come to visit. The latter wrote an article for a Cincinnati newspaper describing the new studio at 72, rue Notre Dame des Champs, which the Nourses had rented just before their departure for Volendam.[100] She noted that Whistler had his atelier in the same

45

Fig. 32 *Le goûter*, 1893 (cat. no. A–18), reproduced as *Mother and Children*.

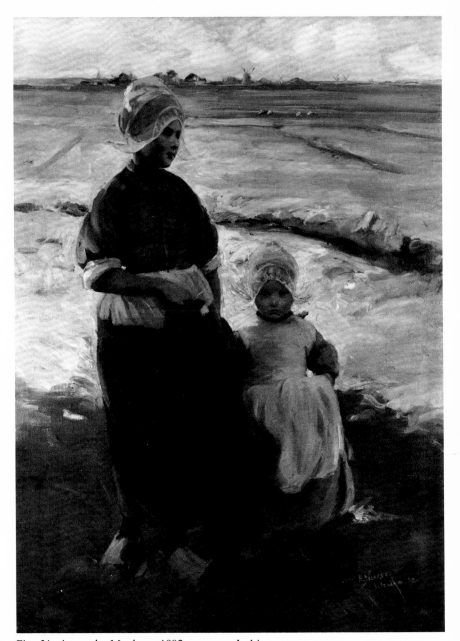

Fig. 31 *Across the Meadows*, 1892, cat. no. A–14.

block, as did Bouguereau and Elizabeth Gardner. Although Nourse's studio was filled with pictures, she proceeded to paint more, including a fine bust of a pensive Breton woman (cat. no. C–65) and *Le goûter* (fig. 32), her first attempt at portraying figures in a lamplit interior. *Le goûter* was eventually donated to the Art Institute of Chicago under the title *Mother and Children*; later it was reproduced on the 1926 cover of *Literary Digest*, the first national American news magazine, and became one of her best-known works.

That winter Louise and Elizabeth planned their return to Cincinnati. The five years they had allotted themselves in Europe had come to an end, but Elizabeth could easily measure the rewards and experience gained during that time: acceptance at both the Old and New

Fig. 33 Cincinnati Room at the World's Columbian Exposition, Chicago, 1893.

Salons, exposure to a cosmopolitan circle of artists in Paris, and extensive European travel. All had served to mark an end to her student years and to add a mature polish to her work. After shipping the three paintings selected for the Palace of Fine Arts at the forthcoming World's Columbian Exposition in Chicago, Elizabeth and Louise left for New York on April 21, 1893.[101]

III *Tragedy and Triumph at Home, 1893–94*

A Cincinnati newspaper article reported the arrival of Miss Lizzie Nourse in Cincinnati in the spring of 1893 to see her sister, Mrs. Addie Pitman, who was "lying very low of consumption."[102] Elizabeth had first stopped in Washington, D.C., to visit Anna Schmidt and the Pillings and, according to the same article, while there "had easily disposed of several hundred dollars worth of paintings." Once in Cincinnati, Elizabeth and Louise stayed at the Pitman home to help care for Adelaide and her children, nine-year-old Emerson, who was to die seven years later, and his sister Melrose, who was four.

At this time most of Nourse's close friends were involved in final preparations for the installation of the Cincinnati Room (fig. 33) in the Woman's Building at the World's Columbian Exposition in Chicago (May 1–Oct. 30, 1893). This building had been conceived by the dynamic Mrs. Potter Palmer of Chicago as a means of promoting women's work and demonstrating that in many industries women could compete successfully with men. One of only three cities to answer the challenge, Cincinnati filled an entire room with the work of local women. The same group that had committed itself to the establishment of the Cincinnati Art Museum and Art Academy,

former associates in the Woman's Art Museum Association of Cincinnati and friends of Nourse's, undertook this project and worked hard to raise funds and to gather carving, pottery, needlework, furniture, sculpture, and paintings for exhibition.

Agnes Pitman painted a wall frieze to decorate the Cincinnati Room, in which her work, as well as carvings by Adelaide Nourse Pitman, Mary Nourse, and Mary Rawson were shown.[103] Two of Elizabeth Nourse's paintings, *Le pardon de Saint François d'Assise* (cat. no. B–32) and *Peasant Women of Borst* (fig. 28) were loaned for the exhibition. These were hung with canvases by Mary Louise McLaughlin, Caroline Lord, Alice Pike Barney, Maria Longworth Nichols Storer, and Henriette Wachman.

Nourse had other reasons to be interested in the Woman's Building. No doubt she wished to see the murals by Mary Cassatt and Mary Fairchild MacMonnies—two of her fellow members in the American Woman's Art Association of Paris—that decorated the building.[104] Too, somewhere on the premises she probably hoped to encounter Sara T. Hallowell, an expatriate Chicagoan who had served as Mrs. Palmer's liaison in Paris to select works of art and crafts by European women.[105] Miss Hallowell was also an official art agent who represented museums in Chicago, Saint Louis, Philadelphia, and Boston; for many years she included Nourse's work among the entries she chose for the annual exhibitions of these museums.[106]

The date on which Nourse visited the exposition is not known. The records indicate that during her visit she received a medal for the three paintings she was exhibiting in the Palace of Fine Arts: *The Reader* (cat. no. B–49); *The Family Meal*, previously exhibited at the 1892 Salon under its French title *Le repas en famille* (fig. 29); and *Good Friday*, exhibited at the 1891 Salon as *Vendredi Saint* (fig. 26).[107] She undoubtedly studied the Loan Collection of modern French painting that Sara Hallowell had assembled from American collectors and museums. This collection included Romantic and Barbizon paintings and a large number of Impressionist works. There were examples by Edgar Degas, Pierre-Auguste Renoir, and Claude Monet, and works that contemporary critics considered equally "modern" by Jean-Charles Cazin, Albert Besnard, Jean-François Rafaelli, and Puvis de Chavannes. Exposure to these advanced painting styles at the exposition must have convinced Nourse that Americans were also ready for the freer, more colorful approach to her own work that she adopted when she returned to Europe.

On September 12, 1893, Adelaide died.[108] Her body was placed in an elaborate oak coffin designed by Benn Pitman and carved by Henry Fry, one of Cincinnati's premier craftsmen, and was then taken to Pittsburgh for cremation—a funerary practice endorsed by her Swedenborgian husband that was not then approved by the Roman Catholic church. Their sister Catherine having died in 1885, Louise and Elizabeth were left by Adelaide's death as the only surviving members of their immediate family. It was a tragic loss for Elizabeth,[109] who had always felt a special closeness to her twin (fig.

Fig. 34 *Portrait of Adelaide Nourse,* 1873, cat. no. C–1.

Fig. 35 *Portrait of Benn Pitman,* 1893, cat. no. C–95.

Fig. 36 *Portrait of Melrose Pitman,* 1893, cat. no. C–96.

34), and her immediate reaction was to lose herself in work. She declared to her niece, Mary Nourse, "I must paint to take my thoughts from this—I will paint you." And so she did—all day long.[110] The result was her wistful *Portrait of Miss Mary N.* (fig. 11), a pastel—the artist's favorite medium for portraiture. This was followed in the next few months by a black-and-white drawing, *Portrait of Benn Pitman* (fig. 35), and another pastel, *Portrait of Melrose Pitman* (fig. 36), which depicted her little niece in a pink coat and bonnet. She was commissioned to do a pastel portrait of Dr. Elmira Howard (cat. no. C–97), the physician who probably attended Adelaide during her illness. Despite their different poses, all four subjects face the viewer in a direct and open manner, a distinctive feature of Nourse's portrait style.

Although the Nourse sisters decided to return to Paris after Adelaide's death, they were immediately occupied with plans for the first large exhibition of Elizabeth's work, which was to open at the Cincinnati Art Museum in November 1893. Louise once again demonstrated her organizational ability by arranging for the shipment of two crates of paintings from Paris, one from London, the paintings from the World's Columbian Exposition in Chicago, and loans from American owners, resolving the while the delicate problem of the order in which prominent women would stand in the receiving line at the opening.[111]

The society reporters of the Cincinnati newspapers gave full coverage to the opening reception at the museum and the extravagant costumes worn by some of the more important guests: "Mrs. Lauretta R. Gibson in violet velvet with magnificent cloak of Russian sables"; "Mrs. Nicholas Longworth, very handsome black toilet, richly jetted."[112] They then proceeded to describe many of the 102 works, but only in terms of their subject matter. The exhibition included thirty-four oils, forty smaller pieces in both oil and watercolor listed as "Pictures and Sketches," thirteen watercolors, six pastels, two tapestry paintings, and five "reproductions."[113] Four of the five reproductions were of paintings shown in the exhibition that Nourse must have added both to sell and because they were an accepted way for an artist to advertise his or her work.[114] Two were engravings by Charles Baude, who often illustrated her work (one represented *Etude,* a painting she had already sold in Paris), and two were photographs.

The artist must have been gratified not only by this tribute in her native city but by the sale of some eighteen canvases. In February 1894 she had even greater success in Washington, D.C., where she had a somewhat smaller exhibition (sixty-one of the works had already been shown in Cincinnati) at the V. G. Fischer Art Gallery at Fifteenth Street, Northwest.[115] There she sold another twenty-one paintings and realized almost two thousand dollars.[116] The Nourses stayed with the Pillings in Washington for six weeks and experienced a gay social life, although Louise wrote that "society tires Elizabeth."[117] They paid formal calls on Mrs. Grover Cleveland at the White House and on Senhor Mendonça at the Brazilian Ministry.

Mendonça's large collection of paintings included three by Nourse recently purchased at the V. G. Fischer Art Gallery exhibition. Elizabeth also found time to execute at least two portrait commissions.

V. G. Fischer's successful exhibition placed him in exclusive company. He became one of two dealers (the other was the Anderson Art Gallery in Chicago) that would represent Nourse in the future.[118] She preferred to sell her paintings through such friends as Mary Wheeler in Helena, Montana, or Mimi Schmidt in Cincinnati. Louise, who often wrote to discuss financial matters with Mimi, whose husband invested Elizabeth's earnings, once told her that "sister does not like to be bothered with any business matters."[119] In 1902 Louise also confided to her niece Melrose that although Anna Schmidt had tried to persuade them to come home for a visit, Elizabeth could not "stand the idea of being obliged to sell her work and of having exhibitions and meeting a lot of people."[120]

Elizabeth and Louise stayed in Washington until the end of March 1894, then spent a week in New York before they sailed for England.[121] They never again returned to the United States. Although Louise regretted this, Elizabeth apparently felt, after the death of Adelaide, that Cincinnati held too many sad memories for her. They always retained their American citizenship and a deep interest in all their Cincinnati friends and relatives, but from this time Paris became their home.

IV *Discovering Brittany and Saint Léger, 1894–1900*

After leaving the United States the Nourses stopped in London for a visit in April 1894 and then returned to Paris to search for a new studio.[122] They could locate nothing suitable, however, and in May went for the first time to Brittany to explore the seacoast that was to become their favorite vacation spot for many years. Settling in the village of Saint Gildas-de-Rhuys in the Morbihan district, they boarded with the Sisters of Charity of Saint Louis, who maintained a school and orphanage in the abbey where Abélard once lived. The nuns took *pensionnaires* during the summer months and set an excellent table for their guests, who were charged a daily rate of five francs ($1.00) for board and room.

Elizabeth wrote enthusiastically about the beauties of Brittany and the hospitality of the many friends she and Louise made among the peasants there.[123] Her Cincinnati friend Maria Longworth Storer, founder of Rookwood Pottery, came to Saint Gildas with her second husband, Bellamy Storer, who was then American ambassador to Belgium. During their visit Mrs. Storer purchased a painting that Nourse had just finished, *La leçon de couture* (cat. no. A–21), a light-filled scene of one of the nuns teaching two girls how to sew. The artist also began at least one plein air painting that summer—*Le repos des faneuses* (cat. no. B–61), a sympathetic portrayal of three Breton women resting from their gleaning—but the weather was so cold

Fig. 37 Nourse studio at 80, rue d'Assas, 1894. Photograph from Louise Nourse's Scrapbook 1, p. 12.

and wet that she was unable to accomplish as much as she had planned.[124]

In October 1894 the sisters returned to Paris and at 80, rue d'Assas found studio accommodations (fig. 37) in which they were to reside for the rest of their lives. The new studio was very near their former quarters but offered the advantage of providing splendid views from the Nourses' fourth-floor quarters. A Cincinnati visitor, Julia Walsh, described the apartment as being divided by a long, narrow hall with, on the left, three domestic rooms that overlooked the placid garden of the Couvent de Sion.[125] On the right, a long studio served as living room and work place. This room had a large window with a low sill that offered a view of the Luxembourg Gardens from almost all parts of the room. Louise showed her visitor the kitchen with the many wooden cabinets she had carved and Elizabeth had decorated, and explained laughingly, "No, we don't eat in the kitchen, we cook in the dining room."

In this setting Elizabeth set to work on the largest oil she ever painted, *La première communion* (fig. 38), a favorite subject of Salon painters and one that she had sketched in Saint Gildas. She began with a simple line drawing of the composition—a nun in rich black as as foil for the filmy white dresses and veils of the two communicants[126]—then made a broad oil sketch from the drawing (cat. no. B–54). She also painted a portrait study of the smaller of the two little girls (cat. no. C–103), a child whose broad, flat features indicate her Breton origin. The final painting is a study of subtly contrasting tones and textures arranged within a shallow interior, and of the refined emotions shared by the two young girls and the devoted nun.

During the winter of 1895 Nourse painted a portrait of the

Fig. 38 *La première communion,* 1895, cat. no. B–53.

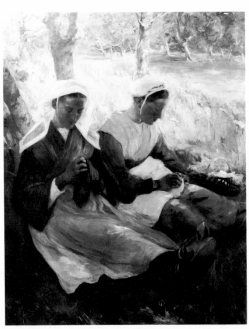

Fig. 39 *Les heures d'été,* 1895, cat. no. B–59. Reproduced in color, p. 149.

sculptor Clement J. Barnhorn (cat. no. C–104) as a gift to her former Cincinnati classmate. Barnhorn had been awarded a scholarship for study abroad by the Cincinnati Art Academy and was to remain in Paris from 1895 to 1900, exhibiting at the New Salon with Nourse.[127] He then returned home and executed many public commissions while teaching at the Cincinnati Art Academy and designing for the Rookwood Pottery. Barnhorn became a well-known and beloved figure in the community and was extremely helpful to Nourse in publicizing her work locally. He also directed to her Paris studio many Cincinnatians who were traveling abroad.[128]

The following spring (1895) Nourse's five entries in the New Salon were well received, and the board voted to make her an *associé,* or associate member.[129] As a result she found her paintings in demand at all of the international exhibitions and received invitations to show at the annual exhibitions of American painting in Chicago and Philadelphia, and at the Carnegie International Exhibition in Pittsburgh. Her work was shown in these cities, as it was in Cincinnati, almost every year until the onset of World War I in 1914. This exposure served to make her name known to the American public even though she did not return periodically to the United States, as many expatriate artists did.

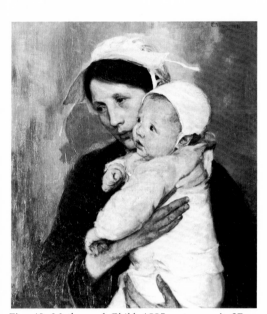

Fig. 40 *Mother and Child,* 1895, cat. no. A–27.

Elizabeth and Louise went back to Brittany for a second visit to Saint Gildas-de-Rhuys during the summer of 1895. This time the weather permitted the artist to complete a large painting, *Les heures d'été* (fig. 39), which shows dappled sunlight falling on two peasant women, who sit in the deep shade of a tree with a brightly hued landscape behind them described in brilliant yellows and greens. The broad brushstrokes that Nourse began to use at this time are evident in all but the faces of the two women. She continued to compromise between a careful academic treatment of facial features and expressions and freer brushwork in all other parts of her paintings until about 1910. *La rêverie* of circa 1910 (fig. 62) is her earliest-known attempt to create the illusion of sunlight dissolving a figure as well as the surrounding scene.

A characteristic *Mother and Child* (fig. 40), painted in 1895, shows Nourse's continuing use of fine brushstrokes on the flesh areas of her figures while adopting a more summary treatment of clothing and background. The expressions on the faces of the mother and baby, the focus of this intimate portrait, are deliberately contrasted: the woman's resigned, weathered features and the baby's soft white skin; her reddened, work-worn hands and the child's white clothes.

For *La leçon de lecture* of 1895 (cat. no. A–24), which as *The Reading Lesson* won a silver medal at the Tennessee Centennial Exposition two years later, Nourse used the same classroom setting at Saint Gildas that she had employed in 1894 for *La leçon de couture* (cat. no. A–21). The study (cat. no. A–25) for the large, unlocated work of 1895 shows only the first three figures on the left, but these are more freely brushed and brightly colored than the figures in her earlier interiors. The *repoussoir* figure has carrot-colored hair and wears a lavender dress accented by a bright green belt and strap across the shoulder. Once again the artist is deeply interested in the play of light on the figures.

Following their stay in Saint Gildas the Nourses visited for a time at Saint Léger-en-Yvelines, a village in the forest of Rambouillet some forty-five miles southwest of Paris, which was to become their favorite country retreat.[130] Over the years Saint Léger became a second home to them, and they eventually chose to be buried in the cemetery adjacent to the village church. They were happiest in the countryside, and living close to nature seemed to stimulate Elizabeth's creativity.

During her first visit to Saint Léger in 1895, Nourse worked on three paintings that were eventually exhibited in the 1897 Salon. All three indicate that she was working toward a bolder, more simplified approach to compositional problems. *Humble ménage* (fig. 41), with its emphasis on geometric shapes and strong light entering a dark room, recalls seventeenth-century Dutch painting even more than an actual Dutch interior she had painted in Volendam (cat. no. B–44). The difference between the clear light that silhouettes these figures and the subdued light of an earlier family scene, *Le repas en famille* (fig. 29), is immediately apparent. The Saint Léger work also includes a reflected image in the mirror above the seated husband, an

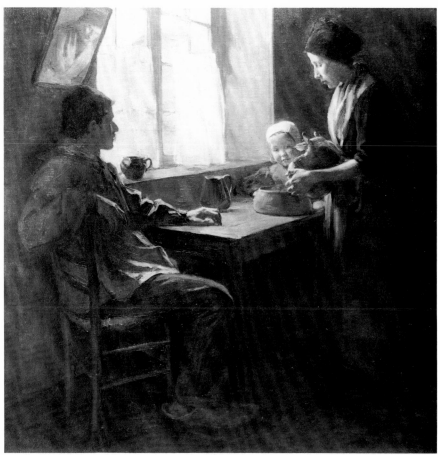

Fig. 41 *Humble ménage,* ca. 1897, cat. no. B–71.

obvious reference to the northern European tradition.

Mère et bébé of 1897 (fig. 80) again demonstrates her technique of showing highlighted figures against a dark background. Nourse painted the appealing child looking directly at the viewer while the mother's head is bent down, a method she almost always used in such compositions to focus attention on the children. In the third work done in Saint Léger, *La fête de grand-père* (fig. 42), two little girls engage our attention as they pose holding bouquets. Here Nourse used a lighter palette of pink and lavender and warm brown against a broadly brushed background of medium and dark greens. Her sketch (fig. 43) for this painting reveals that her first idea was to show full-length figures, but after she had posed her models she chose a closer, more simplified and intimate view.

During the next four summers the Nourses returned to Saint Léger, but in the winter of 1897 they were able to sublet their apartment and embark on a more adventurous trip. In February, at the invitation of the Wachman sisters, who had worked in Africa for several years, they followed a number of contemporary artists to Tunisia, which Elizabeth called "the land of sunshine and flowers and lovely Arabes."[131] Always fascinated by native costumes and crafts, the artist hired an Arab guide to go out with her each day while she made many sketches and watercolors of Bedouins (cat. nos. B–63 through B–69). She also painted a series of small portraits

Fig. 43 *Sketch for La fête de grand-père,* 1897, cat. no. H–12.

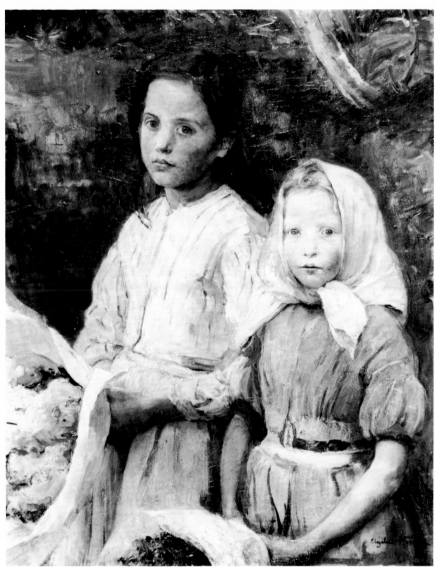

Fig. 42 *La fête de grand-père,* ca. 1897, cat. no. B–70.

in oil on board (cat. nos. C–112 through C–115), which she later exhibited at the Société des Orientalistes at the Grand Palais in 1904 and 1906.[132]

These were far outshone, however, by her virtuoso performance in *Head of an Algerian* (fig. 44), a portrait of richly contrasting colors and textures probably painted while the artist was on a side trip to Biskra, Algeria.[133] The French interest in their newly acquired African colonies reinforced the vogue for *orientalisme* begun earlier in the century, and Nourse gave way to the exotic appeal of her subject. Another example from her journey is *Les toits de Tunis* (cat. no. D–51), which a reviewer considered one of the best versions he had seen of this popular view.[134]

Nourse's three-month sojourn in North Africa undoubtedly reinforced her inclination to adopt a brighter palette. From this time on she tended to use more vivid greens, blues, and violets in her landscapes and showed a preference for lighter shades of blue, lavender, and rose in her other oil paintings.

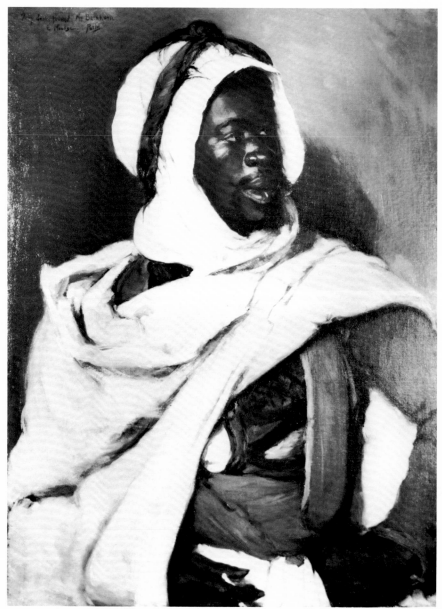

Fig. 44 *Head of an Algerian,* 1897, cat. no. C–108.

Fig. 45 The cottage at Saint Léger rented by Elizabeth and Louise Nourse from the Léthias family.

The following summer the Nourse sisters went back as usual to Saint Léger, where they lived in a simple *chaumière* (fig. 45) that they rented from the Léthias family.[135] Madame Marie Saget-Léthias modeled for Elizabeth and, characteristically, she and Louise became so fond of the unpretentious country woman that their friendship continued through the years to include her children and grandchildren. Marie Saget-Léthias and her son Daniel posed for an 1897 New Salon painting *Maternité* (fig. 77), which the artist repeated in a plein air version (fig. 46) with broader brushwork and brighter colors. Apparently she was willing to conduct such experiments outside the purview of the Salon jury.

When she visited Saint Léger in 1899 Elizabeth briefly resumed her interest in sculpture by modeling two plaster bas-relief profiles, *Louise* (cat. no. G–10) and *Le Père et la Mère Léthias* (cat. no. G–11).

56

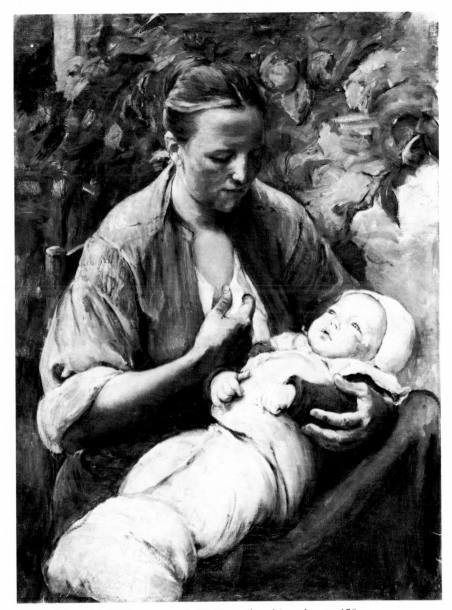

Fig. 46 *Maternité*, 1898, cat. no. A–38. Reproduced in color, p. 150.

She also sketched many cows that year in preparation for *In the Meadow* (cat. no. B–72) and made a number of drawings for *Femme aux fagots* (cat. no. A–37).[136] Both subjects, reminiscent of Millet's, illustrate the hard labor of farm women. Nourse had difficulty in settling on the composition for *Femme aux fagots*—she tried and discarded a horizontal format and a closer view of the figures, then decided on a vertical canvas that emphasized the diagonals of the faggots and the thatched roof.

Elizabeth Nourse led a deeply satisfying life in Saint Léger to judge from the number of fine works she produced there. These include a pastoral view of a mother and child, *Dan le pré* (cat. no. A–30), a lamplit genre scene, *La veillée* (cat. no. A–42), and an unusual composition, *Plein été* (fig. 47), in which the figures of both mother and baby are arranged in contrasting curves, with their backs to the picture plane. Nourse, who usually made only one or two prelimi-

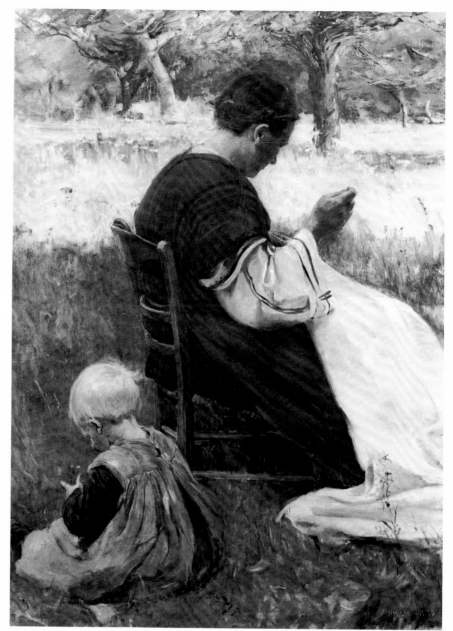

Fig. 47 *Plein été*, 1898, cat. no. A–39.

nary drawings, made some thirteen sketches for this picture before
obtaining the poses she wanted. One of the sketches served as the
basis for still another mother and child painting, *Meditation* (cat. no.
A–57) dated 1902.[137] Nourse was able to bring a variety of changes to
this theme, one frequently chosen by other Salon painters of the day.

For the term 1899–1900 Nourse served as president of the
American Woman's Art Association, a group of women that met at
the American Art Students' Club at 4, rue de Chevreuse, just a block
from her studio.[138] The association's sixth annual exhibition, judged
by American artists Augustus Saint-Gaudens, Alexander Harrison,
Edward Frederick Ertz, and John White Alexander, was held in De-
cember 1899. Mary Cassatt, a member of the club, may have given
her pastel *Baby Charles: Head and Arms* to Nourse at the time in rec-

ognition of her service to the group. It is inscribed, *To my friend/ Elizabeth Nourse/Mary Cassatt.*[139]

During these six years (1894–1900) Nourse concentrated more than ever on rural themes, becoming almost exclusively a painter of peasant women. She rarely emphasized their picturesque qualities despite the different countries and circumstances in which she found her subjects. Instead, her figure paintings show aspects of her subjects' lives common to all cultures—women tending their children, working, or resting after their chores are finished.

V *"Sociétaire" of the New Salon, 1900–1908*

The Nourses were in Paris in April 1900 for the opening of the giant Exposition Universelle, a celebration of the entire century's progress in the arts and sciences that had been ten years in the planning. Elizabeth sketched the Eiffel Tower,[140] that forecast of future design, but the standard of French taste remained more traditional—the Pont Alexandre III erected as a testimony to Franco-Russian friendship and the two new art palaces that housed the exposition's fine arts displays, the Grand Palais and the Petit Palais, were built in the exuberant Baroque style of the Belle Epoque.

The space allotted to American paintings at the exposition was so limited that Nourse was restricted to one entry, *Dans l'église à Volendam* (cat. no. B–43), which was awarded a silver medal. The New Salon found temporary quarters on the Left Bank, however, and the artist was able to show more paintings there. In May 1900 she was featured in the Hearst periodical *Cosmopolitan,* in an article about four expatriate artists at the Salon written by the author and playwright Vance Thompson. With bias typical of the period (the assumption of male creative superiority and the weakness of Mary Cassatt's more progressive style), he extolled the paintings he saw in Nourse's studio:

> . . . *all these pictures you would have said were the work of a man; of one whose tenderness was based on the strength of a man who had Millet's feelings for form and Baudry's sense of color. In any case, a strong man. . . . No American woman artist stands so high in Paris today as Miss Nourse. Indeed, she is one woman painter of our country—for Miss Mary Cassatt has hampered her fine talent with an impressionism that is neither to hold nor to bind—who ranks in the world as a painter and not as a woman who paints.*[141]

Among the fifty million visitors flocking to Paris to attend the Exposition Universelle were many Cincinnatians who came to Elizabeth's studio.[142] The two sisters remained in Paris through the summer, pleased to see old friends and to sell a number of Elizabeth's paintings. "For the first time in two years," Louise reported, "we have been able to put some money in the bank for future rents."[143]

Louise also discussed their finances with Mimi Schmidt in a letter of October 1900:

> . . . we have paid all our expenses so far and have about $1,000 in the bank . . . we have tried our best and put down prices and sold a lot of studies and watercolors—heads, etc., of course, the big picture "La Veillée" brought $600. This will pay our rent and give us $50 a month for a year—then in the meanwhile if we sell any more we will be rich.[144]

La veillée (cat. no. A–42), a lamplit interior painted in Saint Léger, was reproduced in *Century* magazine and subsequently purchased, on the basis of the reproduction, by a woman in Honolulu.[145]

Elizabeth and Louise left Paris in mid-September to visit French friends in Normandy. Although they only remained ten days,[146] Elizabeth completed *Normandy Peasant Woman and Child* (fig. 48), a portrait composed and painted with unusual breadth and simplicity. Once again the young girl's gaze is direct and open while the sturdy woman seems preoccupied with her own thoughts and averts her head. As before, Nourse has emphasized contrasts: light against dark, facial expressions of youth and age, the child's tender skin and the mother's weathered hands.

In a *Boston Evening Transcript* article, Anna Schmidt noted the reactions of dealers to such direct and uncompromising paintings.[147] One wrote to the artist: "Paint us a child blowing soap bubbles, dressed in white or a dainty baby playing with a rabbit or something fancy that will sell." A dealer in Chicago expressed almost the same opinion: "she may ask any price she pleases if only they are pretty. A number of our wealthy patrons desire to own her works who do not care for her ugly peasants." Schmidt said that Nourse's only response to this was, "How can I paint what does not appeal to me?"[148]

After their brief stay in Normandy, Elizabeth and Louise returned to Paris and took an express train to Quimper in western Brittany, a journey of fourteen hours.[149] They stopped first at Pont l'Abbé, where Elizabeth was delighted with the Bigoudine people and their colorful costumes. But it was too large a town, they decided, and went on to the Pointe de Penmarc'h, which they preferred because there was no hotel and therefore no tourists. As usual, they boarded at a local convent, the Filles de la Sagesse, and their association with the nuns gave them access to the villagers.

The artist was so pleased with the subjects and models around Penmarc'h that she returned there to paint for three consecutive years.[150] The coastal village was in the département of Finistère, not far from the art colonies of Concarneau and Pont Aven, to which both American and French painters had been attracted for some thirty-five years. Characteristically Nourse chose to work alone in an isolated spot. She had Louise, however, as a constant companion and assistant who accompanied her on all of her painting expeditions, amused the young children who posed for her, and served as interpreter to her peasant models.[151] Louise was the linguist of the two

Fig. 48 *Normandy Peasant Woman and Child*, 1900, cat. no. A–47.

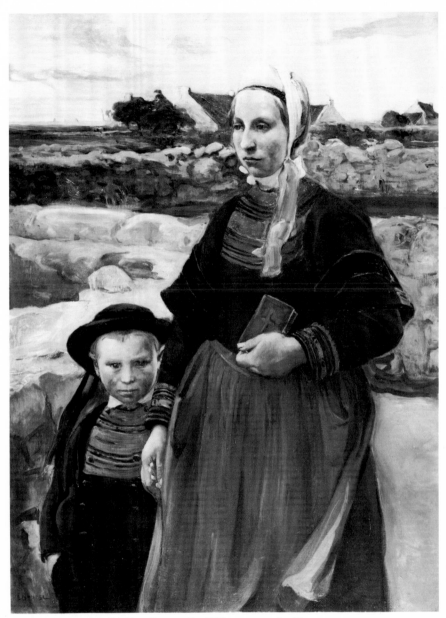

Fig. 49 *Rentrant de l'église, Penmarc'h*, 1900, cat. no. A–48.

sisters. She had previously studied Italian and Dutch and soon
learned enough Breton to communicate with the local people.

Rentrant de l'église (fig. 49) was painted during the first year at
Penmarc'h. The figures form a distinctive pattern against the hori-
zontal bands of the landscape, perhaps a deliberate experiment on
Nourse's part or perhaps an effect created when the artist moved the
canvas indoors to finish the figures in her studio. The Bigoudine
subjects, an ancient Celtic people who had somewhat flat, oriental
features and wore elaborate, heavy costumes, must have appealed to
Nourse's decorative talents.

The Bigoudine facial characteristics and costumes may be seen
again in *Enfants de Penmarc'h* (fig. 50), a charming double portrait of
two little girls whose vivid, plump features are a tribute to the light-
ness and freedom of Nourse's modeling. In contrast she used thick

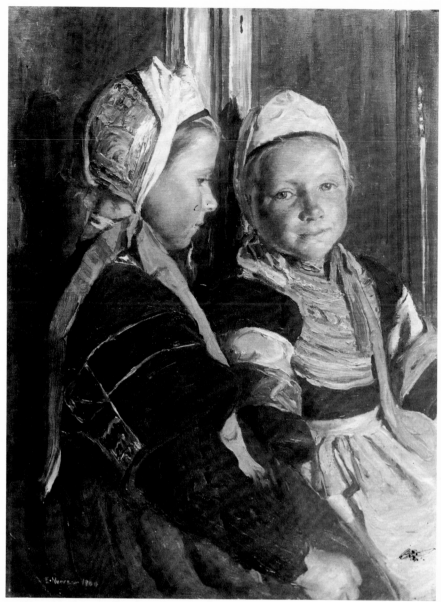

Fig. 50 *Enfants de Penmarc'h,* 1900, cat. no. C–119.

impasto for the heavy silk embroidery on the bodices and the fine lacework of the traditional coiffe. Colorful ribbons were added to the latter for festive occasions. A small panel portrait of 1900 (cat. no. C–118) shows one of these little Bretons in her ordinary dress, still wearing the distinctive headdress but without the lace and ribbons.

Nourse showed four oils and four works on paper in the 1901 New Salon, at which exhibition Carolus-Duran, the incumbent president, announced that she had been elected a *sociétaire* in the category of drawing, pastel, and watercolor.[152] She was said to be the first American woman, and only the second female, to be so honored.[153] Nourse was elated by the news and was deluged with letters, flowers, fruits, and even a case of champagne from her Parisian friends. This recognition not only added to her reputation in the eyes of the

Fig. 51 *View from the Rawson Villa, Menton,* 1901, cat. no. D–54.

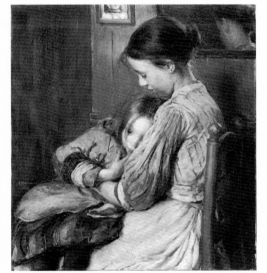

Fig. 52 *La petite soeur,* 1902, cat. no. B–82. Reproduced in color, p. 151.

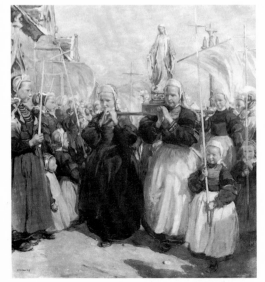

Fig. 53 *La procession de Notre Dame de la Joie, Penmarc'h,* 1903, cat. no. B–93. Reproduced in color, p. 152.

public but permitted her to have works on paper hung without examination by the jury, and to serve on the jury itself for this category. By 1904 she was elected *sociétaire* in oil painting as well, which meant that she could enter six oils and six works on paper without submitting them to the jury.[154]

A minute landscape (fig. 51), rapidly sketched at Menton and then given to Helen Rawson, shows the drawing facility that won Nourse her first *sociétaire*. With firm, sure strokes the artist captures the freshness and sweep of the Côte d'Azur, giving the tiny work a Rembrandt-like breadth. The view was taken from the villa occupied by Helen and Mary Rawson, old Cincinnati friends of the Nourses whom they visited at Menton in April 1901. It is interesting that three pairs of Cincinnati sisters, the Nourses, Rawsons, and Wachmans, all became expatriates, that one of each pair was artistic—Mary Rawson, Henriette Wachman, and Elizabeth Nourse—and that all had studied at McMicken together. The Wachmans and the Rawsons lived abroad because they found that their incomes afforded them a higher standard of living in Europe. Then, too, as single women they enjoyed more freedom there than they could have had in Cincinnati. They all remained fast friends and kept in contact with each other over the years.[155]

It was on her return to Penmarc'h in the summer of 1901 that Nourse probably painted *La petite soeur* (fig. 52),[156] a beautifully composed variation on the mother and child theme. It is instructive to compare this work to her first Salon painting, *La mère* (fig. 19), to understand the development in Nourse's style. Studio highlights and a dark, spacious background characterize the earlier example, whereas the natural light in *La petite soeur* reveals the entire shallow space into which the figures are compressed. Certain elements of both paintings remain similar, such as the triangular grouping of the figures, but the vivid contrasts of color in the later work and the oblique view of the cropped figures suggest a more experimental approach. It is obvious that Nourse brightened her palette over the years, adopted a more vigorous method of applying pigment, and redesigned her paintings to give them a less formal, more impromptu effect.

La petite soeur, Enfants de Penmarc'h, and *Dans l'ombre à Penmarc'h* (fig. 94) were shown in 1904 at the Louisiana Purchase Exposition in Saint Louis. Louise wrote proudly to Mimi Schmidt that it was a great honor—many American artists were represented by one or possibly two paintings, but those with three had to be approved by a unanimous vote of the jury.[157] Nourse received a silver medal at the exposition, but whether the award was given for the three paintings or only one is uncertain.[158]

Nourse's next major work was a Breton *pardon* titled *La procession de Notre Dame de la Joie, Penmarc'h* (fig. 53), a colorful and important religious ceremony often painted by contemporary Salon artists. A *pardon* celebrates the patron saint of a local church and is an occasion for family reunions among the peasants, who come from many surrounding parishes to join in the festivities. Nourse chose to

paint the procession that preceded the church service at the Chapel of Notre Dame de la Joie in Penmarc'h on August 15, 1903. Only religious themes appear to have aroused her interest in group scenes and this is by far the most colorful she ever painted. Strong sunlight falls across billowing banners, tall pilgrim crosses, broad young faces, and brightly decorated costumes as the procession advances toward the viewer. Nourse's brush moves freely across the surface, from richly worked shadows to high, luminous tones, to capture the effects with beguiling ease. The impression of natural light is as joyous and unrestrained as she would ever achieve again.

In the fall of 1903 Elizabeth and Louise, accompanied by Anna Schmidt, spent time in the Swiss village of Champéry, south of Montreux.[159] Although three oils and five watercolors are known to have been painted there, only two, *Le foyer, châlet suisse* (cat. no. B–90) and *Châlet suisse* (cat. no. D–58), have been located. The latter shows the chalet in which the women lived during their vacation. The titles of the unlocated paintings indicate that Nourse chose the same subjects here that she had in other rural settings—a stable, a shepherd, a spinner, and some peasant interiors.

The following year (1904) Nourse's paintings were exhibited in Paris at the New Salon, the American Woman's Art Association, and the Exposition des Orientalistes. In America they were shown in Saint Louis, Chicago, Philadelphia, and New York. But few were selling and Elizabeth became discouraged. In a letter to Mimi Schmidt, Louise wrote that since Elizabeth's work was in such demand for exhibitions, "she ought to be very happy and not in such despair all the time."[160] Louise discussed the prices of several paintings with Mimi and continued:

> *I am always happy to sell her work no matter what she receives because she then feels more appreciated and it makers her happy. I want her to enjoy her pictures—the work of her hand and heart and brain while she is alive and not have money and fame come after her death. As that rich woman in N. York told her: "Oh, Miss Nourse, you know you cannot ask very much for your work now. After you are dead, people will pay for it but not while you are alive and working," at the same time offering sister $40 for a picture for which we asked $100.[161]*

Perhaps to test the market Elizabeth also painted at least one genre scene during this period, *Intérieur français* (cat. no. A–62), which was noticeably different from her peasant subjects. Its subdued tones and genteel atmosphere—a pretty young mother in a comfortable interior reads as her children play—suggest a distinctly middle-class environment. Nourse also took pains to give the work a careful polish, as if to mollify critics of her more vigorous painting style.

If scenes such as this one and *Un jour d'été* (cat. no. A–66) lack the emotional force of her paintings of the poor, with whom Nourse's sympathies lay, they have a distinct charm of their own and may have led to a number of portrait commissions that she un-

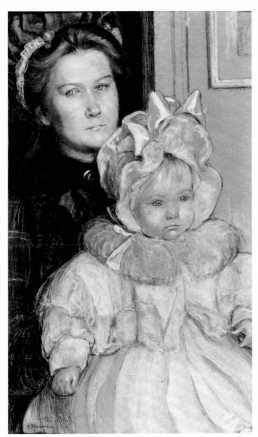

Fig. 55 *Nourrice et bébé*, 1903, cat. no. A–61.

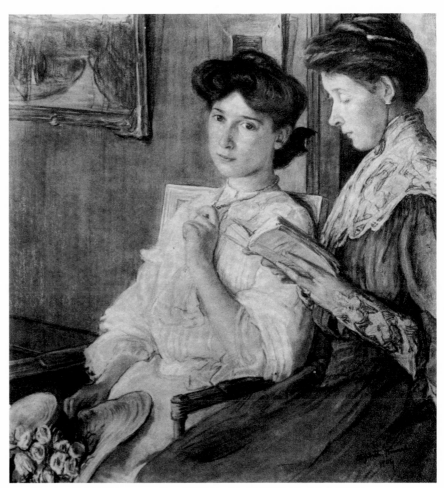

Fig. 54 *Portrait de Mme. de C. et sa fille*, 1904, cat. no. C–131.

dertook between the years 1904 and 1910. These were usually executed in pastel to capture poses and expressions as quickly as possible. One of the first is a Degas-like double portrait of Madame de Cresantignes and her daughter (fig. 54), in which Nourse explores the contrasting attitudes between the prim and fashionable mother, absorbed in her book, and her more relaxed and contemplative daughter. Beyond the daughter the room trails off at an oblique angle and all sides of the composition have been cropped for a candid effect. For her *Portrait of Mrs. James W. Bullock and her daughter Marguerite* (cat. no. C–138), commissioned by two Cincinnatians who came to Paris, the artist chose a similar format. This time, however, Nourse used light coming from a rear window to accent softly the features and white dress of the young girl. Another variation of the double portrait, *Nourrice et bébé* (fig. 55), was one of six works on paper that the artist generously donated to a benefit for the Woman's Art Club of Cincinnati in 1906.[162]

Although Nourse never publicly discussed her artistic preferences, in 1902 she expressed some of her views on contemporary painting to Anna Schmidt.[163] Schmidt, who wrote that the French gospel of modern art at that time was "to paint what you see and as

you see it," quoted Nourse's comments: "While I admire Monet, Raffaeli, and the pronounced realistic paintings, I see more with the eyes of Cazin and of Dagnan." Art history has taught us to think of Impressionists like Monet as completely at odds with the Realists who showed at the Salon, but Nourse and her contemporaries viewed them, we have begun to realize, more as a part of the same movement. She allied herself with Cazin and Dagnan-Bouveret because they were more interested in rural themes and worked in a variety of styles between the poles of Impressionism and traditional academic painting. Nourse obviously considered the Impressionists' scientific rendering of light and color as too experimental for her subject matter, but she was just as anxious to avoid the sleek classicism of Alexandre Cabanel and Bouguereau, which would have been equally unsuited to her interests.

In a further attempt to sell her work, Nourse entered an increasing number of exhibitions from 1903 to 1908. She sent paintings to Liverpool again and, for the first time, to Antwerp, Rouen, Nantes, and Liège and to the annual Philadelphia Watercolor Exhibition. She was invited to enter the newly inaugurated exhibitions of American painting at the Corcoran Gallery of Art in Washington, D.C., and several women's groups, such as the Lodge Art League in Paris, provided other opportunities for her to show her work. She served during the 1906–7 term as the first president of the Lodge Art League, a group of English-speaking artists.[164] She also exhibited in "la quatorzième exposition annuelle des Femmes artistes" with the Union de Femmes peintres et sculpteurs, who exhibited annually at Galerie Georges Petit, and received high marks for her entries from at least four Paris critics.[165] In addition she began to exhibit at the International Art Union of Paris in 1909, an annual art exhibition solely for women initiated by the International Young Women's Christian Association.[166]

Through these years Elizabeth and Louise continued their travels, seeking new sights and a fresh selection of artistic material. In February 1906 they set out for Spain via a medieval pilgrimage route through southern France.[167] According to Elizabeth's sketchbook they stopped, among other places, in Saint Jean Pied-de-Port (cat. no. D–68) and continued to Toledo after having spent Easter in Burgos. She finished at least five watercolors during this trip, including *Intérieur Basque, Pyrénées* (cat. no. B–102), which evidences her sure rendering of architectural detail in this medium and her usual preoccupation with light.

Watercolors painted later that year in northern Brittany show a greater sense of economy. She selected the simplest possible scenes— *Le paysage à Loguivy* (fig. 56) shows a rocky coastline relieved only by trees misshapen by the strong sea winds and several small cottages. The subject of another watercolor, possibly painted earlier in Spain or southern France, is a bird's-eye view of a building seen through bare branches (*Landscape,* cat. no. D–64), but the delicacy of the colors—fawn and rose and spring green—and the freshness of the light make it one of her most beautiful works in this medium. Even

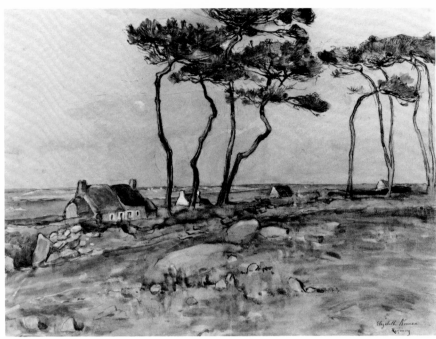

Fig. 56 *Le paysage à Loguivy,* ca. 1906, cat. no. D–72.

Fig. 57 *Le vieux calvaire, Loguivy,* ca. 1906, cat. no. D–74.

Le vieux calvaire, Loguivy (fig. 57), a village scene in which a shrine, surrounded by simple stone cottages, casts a shadow on the wall behind it, is reduced to a series of bold planes and broad washes. The standing figure with its strong shadow probably appealed to Nourse as reminiscent of traditional crucifixion scenes in which the figures of Saint John and the Virgin appear on either side of the cross.

In the fall of 1907 Anna Schmidt joined the Nourse sisters and the three explored a different area of Brittany.[168] For six weeks they stayed in a convent in Plougastel-Daoulas, a small village just south of Brest, where Anna occupied herself with her writing and Elizabeth and Louise went on painting expeditions in the surrounding countryside. Pleased with the subjects she found there, Elizabeth completed at least four oils and about a dozen watercolors. She also filled her sketchbooks with landscapes done mostly during excursions by carriage through the countryside. These excursions, or "treats," as Louise referred to them, were financed by Anna through gifts from Cincinnati friends identified by Louise as Nannie Wilson, Lottie (probably Charlotte) Miller, and Kate Reno Miller. As a result the Nourses were able to go as far as Camaret to the south and the Ile d'Ouessant and Folgoët to the north.

Nourse soon had opportunities to exhibit the watercolors that had become her great interest. She was invited by Gaston La Touche, president of the Société Internationale de la Peinture à l'Eau, to exhibit with this group in 1908.[169] The eight watercolors and two drawings she submitted were hung beside works by Albert Besnard, Frank Brangwyn, Walter Gay, Lucien Simon, and John Singer Sargent. Most of these watercolors were also sent by Nourse to the annual exhibition of American painting at the Cincinnati Art Museum

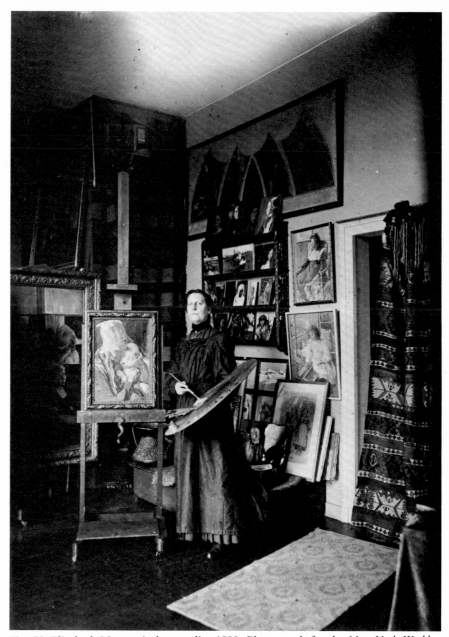

Fig. 58 Elizabeth Nourse in her studio, 1909. Photograph for the *New York World,* April 18, 1909, from Louise Nourse's Scrapbook 1, p. 93.

in 1910 and seven were included in the annual Philadelphia Watercolor Exhibition the same year.[170]

For the Cincinnati exhibition Louise priced the watercolors containing figures at $250 (or 1,000 francs) and the landscapes at $150 (or 620 francs).[171] *La vieille boutique, Finistère* (cat. no. B–115), a Breton shop interior filled with rows of glass bottles and jars through which the sun shines, was featured at this exhibition. Delightful as the work is, it lacks the strong, spare quality of the watercolors Nourse painted in 1906.

Curiously, Louise priced the three small oils shown at the 1910 Cincinnati exhibition at $200 to $250—the same as for the watercolors.[172] Two of these were sold, *Intérieur breton, Loguivy* (cat. no.

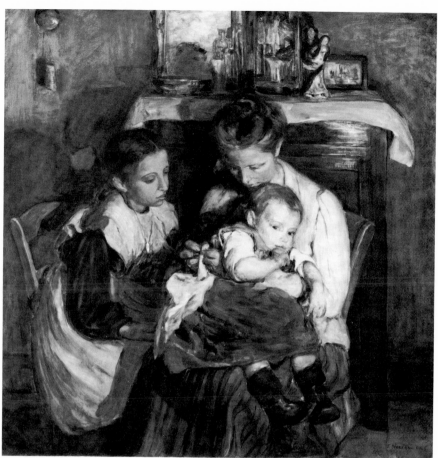

Fig. 59 *Les jours heureux,* 1905, cat. no. A–64.

B–104) and *Tendresse* (cat. no. A–87), an intimate study of a mother and child that can be seen on the studio easel in a photograph taken in 1909 of a rather stern Elizabeth posed self-consciously for a newspaper photographer (fig. 58). If the contrast between the artist and the subject of the adjacent painting is disconcerting, it is also revealing. Beneath Nourse's disciplined exterior was a range of emotions that doubtless found outlets in these subjects, as well as in the deep and lasting friendships she formed during the course of her career.

Elizabeth was particularly gratified in May 1909 when *Les jours heureux* (fig. 59), an affectionate scene of family life, was awarded first prize by Charles Cottet, Gaston La Touche, Walter Gay, and William Dannat, jurors at the first exhibition of the International Art Union in Paris,[173] and was purchased under its English title, *Happy Days,* for the Detroit Institute of Arts. Funds were provided by Mrs. Grace Whitney-Hoff, a native of Detroit and honorary president of the International Art Union, who had established an endowment that was to be used each year to purchase for an American art museum a painting shown in a Paris exhibition.[174] Despite difficulties in selling her paintings, Nourse could look back on numerous accomplishments during this period of her life. She had achieved the goal of all Salon painters, particularly expatriates, by her election to full mem-

bership in the New Salon in both categories in which she competed. Further, her work was in great demand at all of the important international exhibitions, additional evidence that the art world recognized her talent. All that remained for her fulfillment was the public acclaim she was to receive in the next few years.

VI *The Final Accolade, 1910–38*

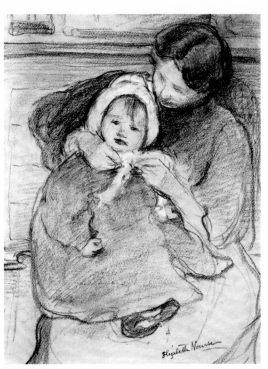

Fig. 60 *Mother Dressing a Child,* ca. 1909, cat. no. A–86. Reproduced in color, p. 153.

In the fall of 1909 the Nourses spent five weeks in Alsace at the Château de Trücksess, the summer home of the Marquise de Roy. As usual the change of scene stimulated Elizabeth's imagination.[175] She filled a sketchbook with views of the area and more studies of women and children, such as *Mother Dressing a Child* (fig. 60), a boldly designed work of flat forms and strong curving contours. During her visit she also worked on three landscapes and two genre paintings. One of the latter, *Intérieur dans les Vosges* (cat. no. A–83), is a domestic scene into which light streams through an open garden window. The other, *Les volets clos* (fig. 61), became the most important work of her career when it was purchased at the 1910 New Salon by the French Ministry of Fine Arts for the state's contemporary art collection in the Musée du Luxembourg. Following this official recognition, numerous French critics wrote favorably about the painting and much publicity was generated in the United States as well as in France.[176] Inclusion in the Luxembourg collection placed Nourse among some of her most prominent American contemporaries: Alexander Harrison, Winslow Homer, Gari Melchers, John Singer Sargent, J. Alden Weir, and James A. M. Whistler.

Les volets clos shows a contemplative Louise standing before a bureau in an interior of carefully graded tonal harmonies.[177] As one critic described the atmosphere,

> *The sunlight enters in vivid gold bars through green wooden shutters. The yellow of the sun and the green of the shutters borrow something from each other and give the color scheme for the entire picture. The mirror on the dresser reflects the rest of the room where the yellow and green still dominate.*[178]

Buoyed by this success Nourse experimented more boldly with a similar formula in her 1911 Salon entry, *La rêverie* (fig. 62).[179] Sharp angles, planes of light, and patterns of color are arranged with superb effect. Interior and exterior spaces merge and divide while at the center of the composition a woman stands before an open window and contemplates yet another illusion, goldfish swimming through the translucent water of a crystal bowl. The subject's dress, composed of vivid shades of blue, green, and violet, and the broad strokes of foliage behind her are further indications of the degree to which Nourse had been influenced by Impressionism (and even Post-Impressionism) during these years.

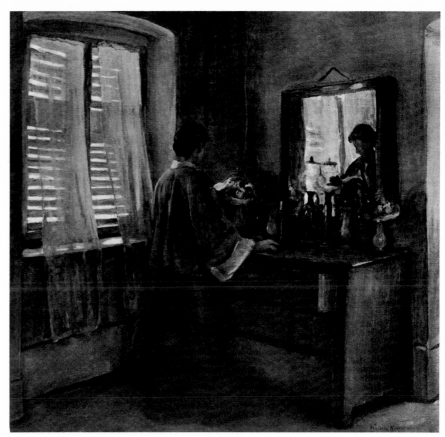

Fig. 61 *Les volets clos*, 1910, cat. no. B–120.

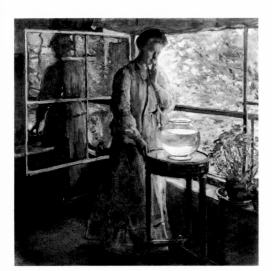

Fig. 62 *La rêverie*, ca. 1910, cat. no. B–119. Reproduced in color, p. 154.

The artist prepared carefully for this painting. She produced two nearly identical studies of the still-life elements, *Etude, Fleurs* (cat. no. E–76) and *Le poisson doré* (cat. no. E–78), both of which represent her most determined efforts thus far to depict the complex reflecting properties of glass and water.

A la tombée du jour (cat. no. A–95),[180] also shown in the 1911 Salon, was an experiment of a different sort. Nourse attempted a subdued blend of natural and artificial light to suggest the evening shadows that surround a mother preparing a young child for bed. "The hard problem to solve," Louise reported, "was how to get the effect of twilight and still have enough light to work by."[181]

In the 1912 Salon, Nourse exhibited a firelight scene, *Les heures du soir* (cat. no. A–98), a variation on her painting *Les jours heureux* of 1905 (fig. 59). A comparison of the two paintings indicates the change in her technique over the intervening years—in *Les heures du soir* the brushwork is looser and the emphasis has shifted from the figures to the subtle play of light itself. In a watercolor of 1912, *Le village de Saint Léger* (fig. 63), she shows a similar interest in the ephemeral play of light, most noticeably in the broadly painted reflections on the water and the liquid washes in the sky. A strong sense of pattern takes over the landscape, and the artist retreats from her former preoccupation with solid forms.

71

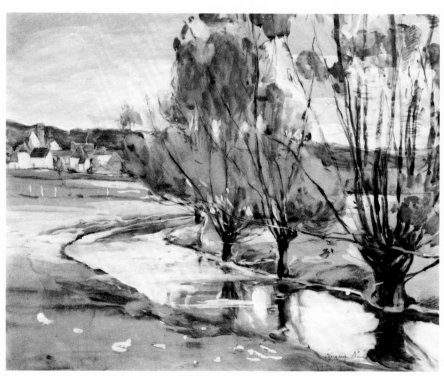

Fig. 63 *Le village de Saint Léger*, 1912, cat. no. D–86. Reproduced in color, p. 155.

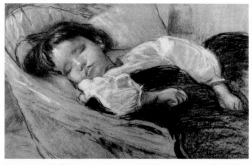

Fig. 64 *Bébé Besnard*, ca. 1913, cat. no. C–159. Reproduced in color, p. 156.

Nourse was at the peak of her career in these years just prior to World War I. Her scrapbook is filled with favorable reviews of her work in exhibitions from Paris to San Francisco, where *L'été* (cat. no. B–123) was awarded a gold medal at the Panama-Pacific Exposition.[182] She worked prodigiously to take advantage of all requests to exhibit her paintings. In 1913, for example, she prepared six oils and six works on paper for the New Salon, two oils and four watercolors for the Anglo-American Exposition in London, as well as numerous canvases for other major exhibitions.[183] One of her Salon entries was the beautifully drawn pastel *Bébé Besnard* (fig. 64), probably a portrait of the grandchild of her friend Albert Besnard, the French artist.

As a result of all this exposure, Nourse began to repeat familiar themes. Virtually the same pictorial setting that she had used in 1910 for *La rêverie* (fig. 62), painted in front of her studio window, reappears in three other major oils at this time: *L'été* (cat. no. B–123), *La fenêtre ouverte* (cat. no. B–124), and *Les petites filles en blanc* (cat. no. B–125). Only the arrangement of figures and seasonal variations in light, which continued to hold the artist's attention, create different moods in the paintings.

The year 1914 began auspiciously. Elizabeth was made an honorary member of both the Association of Women Painters and Sculptors of New York[184] and the MacDowell Society in Cincinnati for her "distinguished achievements."[185] She was also elected a member of the Philadelphia Water Color Club.[186] In July, however, the German army invaded Belgium. World War I had begun, marking the end of the art world that Nourse had known.

During the first months of the war Elizabeth kept a diary of her activities, which Anna Schmidt published in December 1914.[187] She described the preparation of Paris for siege as the French and English armies were swiftly overrun. Those who were not French citizens were advised to leave and most of the American expatriates did, but the Nourses decided to remain. "We shall stick it out and retire to the cellar," Elizabeth wrote. "It is a pretty nice cellar and not too dirty or damp."[188] Louise expressed the same sentiments to her niece: "All the Americans are going . . . but we will stay right here. I should feel like an ungrateful wretch to run away—as though I fled from some hospitable roof when smallpox breaks out."[189]

Elizabeth wrote of her dismay at the sight of artillery fire over the Luxembourg Gardens, which she could see from her studio window, yet viewed the beleaguered city with a painter's eye:

> *Paris is too beautiful now, so quiet, so exquisite in the pale autumn sunshine. And the nights! Nights of beauty—with the most wonderful effect of light and shade—because there are so few street lamps, and the great masses of shadow—the moon beams like silver—all like a wonderful painting—painted by God.*[190]

The Nourse sisters worked tirelessly to care for the refugees who flooded into Paris. Elizabeth enlisted the help of many French and American friends in collecting food, clothing, and coal for the homeless and the poor. "The bell rings every other minute," she reported, "so many poor coming and so many nice ladies with bundles to distribute."[191] She solicited donations from friends in the United States and Canada, and Anna Schmidt was particularly active in raising funds for her in Cincinnati, Boston, and Gloucester.[192] Elizabeth was especially concerned with aid to artists whose lives had been disrupted by the war. In 1919 the board of the New Salon presented her with a silver plaque in recognition of her charitable work on behalf of indigent artists and their families.[193]

Besides their work with refugees the Nourses kept in touch with Elizabeth's former models, whose husbands and sons were at the front, and gave them comfort—or funds—if they were needed.[194] Elizabeth also donated money and paintings to many benefits held in Paris for war victims.[195] She sold dolls she had fashioned from wire and plaster and dressed in Breton costumes (cat. no. F–29) to raise funds for her charities, and exhibited several in the Exposition des Jouets Français held in Paris in 1915, 1916, and 1917.[196]

Anna Schmidt frequently published letters from Nourse in American newspapers. In a letter printed in the *Boston Evening Post* in September 1916,[197] the artist described the effects of the war on the village of Penmarc'h, where she and Louise had recently spent several weeks. More than sixty village women had been widowed by the war and the remaining able-bodied men had been conscripted, leaving the women all the farm work as well as the care of their homes and children. Although neither of the Nourses was young— Elizabeth was fifty-seven and Louise was sixty-four—they helped out, apparently ignoring the advice of their doctor who had ordered

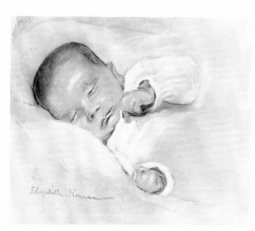

Fig. 65 *Baby Asleep*, ca. 1916, cat. no. C–165. Reproduced in color, p. 157.

them out of Paris for a rest. "It is quite a sight to see us bringing in the cows and tossing hay, besides feeding ducks, chickens, and picking off cabbage and beet leaves for the cattle," Elizabeth wrote. She and Louise probably also helped care for the children, for Elizabeth painted at least three watercolors of Breton babies at this time as well as the carefully modeled pastel *Baby Asleep* (fig. 65).

In May 1918, in spite of the fact that the Germans were on the offensive in Amiens, within sixty-five kilometers of Paris, there was a Salon exhibition for the first time in three years. Nourse had devoted so little time to painting since the war began that she showed only a single watercolor, *Chez le photographe à Penmarc'h* (cat. no. A–120), painted in 1917, of a Breton mother and child executed in tones of vivid pink and green and sky blue. By November, however, she was able to exult: "Victory! Victory! . . . everyone is singing on the Place de l'Opéra. I made my debut there, too, singing with a million others, while the avions whirled and shimmered over our heads."[198]

After the armistice it appeared that the artistic life of Paris would simply continue much as it had before the war. In 1919 Nourse showed paintings and her Breton dolls at four exhibitions[199] and sold a watercolor, *Le Lavoir dans les champs, Penmarc'h* (cat. no. B–135), at the New Salon.[200] She had painted similar scenes as early as 1888 (fig. 20) and the subject continued to hold her interest over the years. One late but undated version is a watercolor (fig. 66), painted in serene blues and greens, that depicts Plougastel women kneeling in their wooden troughs by a pond as they scrub their clothes on flat stones.

Despite Elizabeth's robust activities during the war and after, she appears to have been suffering as early as 1915 from an undiagnosed illness. She consulted several doctors during the next few years[201] but not until early 1920 was it discovered that she had cancer of the breast. A mastectomy was performed in March of that year. As a result of the operation she was unable to paint at her easel for some time, but while she was convalescing she amused herself by sketching watercolor views of the Luxembourg Gardens as they appeared by day and by night from her studio window. One exceptionally free rendering of this scene (fig. 67), inscribed "For my darling Louise Hayden Addis," was probably a wedding gift for her American friend, whose portrait she had painted in 1910.[202] A night version of the Gardens (cat. no. D–99) was brushed even more broadly, with Nourse using a Fauve-like palette—royal blue tree trunks contrast with the brilliant yellow light, and the buildings in the distance, such as Saint Sulpice, are a bright pink.

Nourse participated in her last Salon in 1921 with one oil and two pastels. The oil, *Consolation* (cat. no. A–113), had been painted in 1914 and at least one of the pastels, *Le tablier bleu* (cat. no. A–117), was probably drawn then as well.[203] An oil version of the latter (fig. 68) was left in her estate and her scrapbook contains a photograph dated 1914 showing the models posing for it.[204] Painted in warm colors of russet, blue, and orange, the oil must have seemed

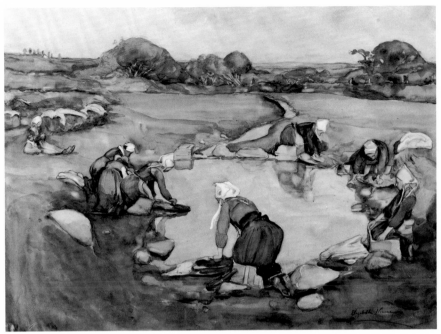

Fig. 66 *Le lavoir dans les champs, Finistère*, ca. 1908, cat. no. B–114.

Fig. 67 *Jardin du Luxembourg*, 1921, cat. no. D–97.

distinctly old-fashioned to the postwar public, which by then had seen a rapid succession of modern styles.

Realist subject matter, at least the type that had been presented at Paris Salons for so many years, appeared to have little future. Nourse must have recognized this because in 1924 she ceased to exhibit and continued to paint only for her own pleasure. She was then sixty-five years old and unwilling to accept recent trends in the art world that seemed to negate the importance of recognizable subject matter. Six years later, in 1930, she wrote:

> . . . there is little in art since the War to make one enthusiastic. I do not hold at all with the latest "fads," the cubistes—the fauves—as they are called. Do you know Camille Mauclair's "La Farce de l'Art Vivant"? He expresses my opinion very clearly.[205]

In 1921 Nourse received one last public honor that evoked much publicity in the French and American presses.[206] The University of Notre Dame in South Bend, Indiana, awarded her the Laetare Medal, given annually to a Catholic layperson for distinguished service to humanity. For this occasion Elizabeth overcame her customary shyness and addressed a crowd of more than two-hundred people assembled to honor her. The Paris edition of the *New York Herald* described the ceremony, which was presided over by the Papal Nuncio in Paris, and called Nourse "the dean of American woman painters in France and one of the most eminent contemporary artists of her sex."[207] The *Chicago Tribune,* unwilling to quibble over such distinctions, had simply referred to her as "the first woman painter of America."[208] Elizabeth may not, however, have been completely

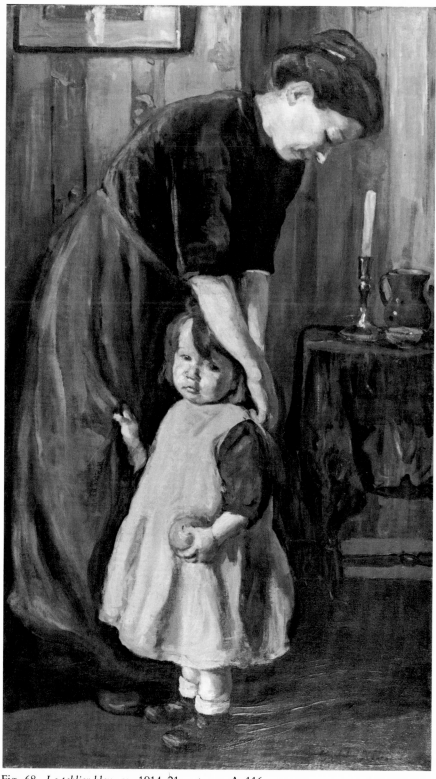

Fig. 68 *Le tablier bleu*, ca. 1914–21, cat. no. A–116.

happy with such tributes. She once told her friend Anna Schmidt that she wanted to be judged as an artist, not as a woman.[209]

During the remainder of the 1920s the Nourses saw many relatives and friends who were visiting Paris.[210] Their niece, Mary

Nourse, was there for a year to take courses in metal and leather work, and so many Cincinnatians came to the studio that Louise remarked, "Little by little we see the whole town."[211] Young Americans who met the Nourse sisters for the first time found them very French in appearance and dressed all in black. They described Elizabeth as pale and reserved, but the rosy-cheeked Louise with her bright blue eyes as vivacious and kind.[212] In retirement Elizabeth apparently reverted to the role of a dependent younger sister and left the direction of her life to Louise.

Louise died in January 1937 at the age of eighty-four. Almost immediately, Elizabeth became ill and was hospitalized.[213] A friend reported to Elizabeth's niece, Melrose Pitman of Cincinnati, that because Elizabeth had lost all interest in the world around her, refusing even to have letters read to her, she had been sent home with a nurse to care for her. She spent her days looking out over the Luxembourg Gardens and by the fall of 1938 had begun to speak of "going with Louise." She died on October 8, 1939, shortly before her seventy-ninth birthday. At her request she was buried beside her sister in Saint Léger "in the habit of the Third Order of Saint Francis of Assisi and with no flowers or wreaths as becomes a member of the Order of Penitence."[214]

Nourse left an estate of some $50,000 in bonds and real estate investments to her four nieces. She made small bequests to Elizabeth Schmidt and Dorothy Schmidt Bunker and left all of her remaining art, some seventy-four works, to their brother, her executor Walter S. Schmidt of Cincinnati, who had managed her affairs since his father's death.[215] She directed that he give what he could to museums and distribute the remainder, many of them studies for exhibited works. Since there was little demand elsewhere, most of them were given to relatives. The thirty-four works that remained were bequeathed by Schmidt in 1959 to the College-Conservatory of Music at the University of Cincinnati.

Nourse appears to have retired rather early, considering that she lived another seventeen years after she stopped exhibiting at the Salon in 1921. It must be remembered, however, that her professional career had spanned fifty-five years.

Elizabeth Nourse did not wish to be typed as a woman painter, although invariably she was. Born with great natural ability, she achieved international prominence at a time when few women artists were taken seriously. She brought to her work a spiritual dimension that enabled her to express deep personal convictions about beauty and about the importance of the daily life and work of ordinary women, whom she portrayed with sympathy and respect. Her own life attests to the fact that her dedication to this unique vision was an inspiration to the many women who supported her, publicized her, and admired and purchased her art.

1. Elizabeth Nourse (hereafter abbreviated EN) gave painting lessons to Alice Pike Barney in Cincinnati and taught watercolor technique to Albert Dubuisson in Paris briefly in 1910, but there is no record of her having held art classes as such.

2. This and the following biographical information about the Nourse family are from Conteur, "An Interesting Letter Concerning Ancestry of the Nourse Family of Cincinnati," *Cincinnati Enquirer Sunday Magazine,* February 1, 1925.

3. In a letter of 1919 to her niece Nellie Nourse Reeves of Seattle, Louise explained the origin of the family name. She said that their forebears' name was de Nourse ("of Normandy") at the time that they were driven out of France to England in the sixteenth century. Emigrating from England to America as Puritans in the seventeenth century, they built a family home in Danvers, Mass., in 1636. At that time the name was spelled either "Nurse" or "Nourse." The first Rogers ancestor to come to America was Lt. Charles Rogers in 1650. He was given a grant of land in New Hampshire after he fought in the Indian Wars.

4. E. H. Austerlitz, *Cincinnati From 1800 to 1875,* p. 105.

5. Louise Nourse (hereafter abbreviated LN) in Paris to her niece Melrose Pitman in Cincinnati, March 26, 1933. Unless otherwise indicated, all EN and LN correspondence is from the Elizabeth Nourse Papers in the Cincinnati Historical Society (hereafter cited as Elizabeth Nourse Papers).

6. C. C. Williams, comp., *Williams' Cincinnati City Directory, 1856–78.*

7. Unless otherwise indicated, all information about EN's work at the School of Design is from the catalogues of the school's annual exhibitions from 1875 through 1885. The school's name seems to have been officially changed to the School of Design of the University of Cincinnati after it came under the university's control between 1871 and 1873, and to the Cincinnati Museum Association Art School in 1884, after it became affiliated with the Cincinnati Art Museum, founded in 1881 but not opened until 1887. After the museum opened, the school became the Art Academy of Cincinnati. Up to (and even after) 1887, the school continued to be popularly and widely referred to by its original name, the McMicken School of Design, which is the designation most familiar to contemporary students and historians of art. For this reason, the original name is generally used throughout this catalogue.

8. This and the following information are from "A Review of Cincinnati's Past in the Field of Art," *Cincinnati Enquirer,* May 9, 1915.

9. Unless otherwise noted, all biographical material for Thomas S. Noble is from an article written by his granddaughter, Mary Noble Welleck Garretson, "Thomas S. Noble and His Paintings," *New-York Historical Society Quarterly Bulletin* 24, no. 4 (October 1940): 113–24.

10. Marchal E. Landgren, *American Pupils of Thomas Couture* (College Park, Md.: University of Maryland Art Gallery, 1970), p. 16.

11. *The Slave Market* represents the last sale of slaves in the United States, which Noble himself witnessed in Saint Louis. The painting was purchased for $2,000 and presented to the Chicago Public Library, where it was destroyed in the Chicago Fire of 1871. Incorporating the portraits of prominent Cincinnatians, Noble painted a replica of this work that is now in the Saint Louis Historical Society.

12. University of Cincinnati, *Catalogue of the School of Design of the University of Cincinnati* (Cincinnati, ca. 1876).

13. This and the following information are from "A Review of Cincinnati's Past in the Field of Art."

14. Charles F. Goss, *Cincinnati: The Queen City, 1788–1912,* 2: 391.

15. Louise Nourse maintained two scrapbooks, one dated 1880–1911 (now in the Nourse Family Collection, Cincinnati) and the other dated 1911–32 (now in a private collection in Cincinnati). Both contain newspaper clippings, photographs of paintings, and notes on the exhibition and sales of

her sister's work. These scrapbooks are hereafter cited as Scrapbook 1 and Scrapbook 2. The biographical material on Benn Pitman in this section is from a clipping from the *Cincinnati Sunday Commercial Tribune,* ca. 1905 in Scrapbook 1, p. 125.

16. Ibid.

17. Benn Pitman, *A Plea for an American Decorative Art, with Illustrations and Designs* (1895), p. 14.

18. University of Cincinnati, *Catalogue of the Works of Art Belonging to the School of Design of the University of Cincinnati and of the Eighth Annual Exhibition* (Cincinnati, 1876), pp. 24–27.

19. Cincinnati Art Museum, *The Ladies, God Bless 'Em: The Woman's Art Movement in Cincinnati in the Nineteenth Century* (Cincinnati, 1979), p. 15.

20. *Bulletin of the American Ceramic Society* 19, no. 9, p. 348.

21. Emma Mendenhall Anderson, *Elizabeth Nourse: A Sketch,* p. 6. This booklet was privately printed by Emma Anderson to raise money for EN's work with war victims. She had been a classmate of EN's at McMicken.

22. Cincinnati Art Museum, *The Golden Age: Cincinnati Painters of the Nineteenth Century Represented in the Cincinnati Art Museum* (Cincinnati, 1979), pp. 24–25. This catalogue, which includes biographies of 48 Cincinnati artists and 311 examples of their work, is an excellent resource for the period.

23. Ibid., p. 25.

24. Ibid.

25. Clipping from *Cincinnati Commercial Gazette,* December 17, 1877, in Scrapbook of the Woman's Art Museum Association Collection, Cincinnati Historical Society.

26. George Elliston, "Artist Niece of Famed Woman Urged to Write Her Biography," *Cincinnati Times-Star,* November 25, 1938. George Elliston was the pseudonym for a female feature writer for the *Times-Star.* A poet, Ms. Elliston was one of a number of women who promoted Nourse's work through her articles.

27. City of Cincinnati, *Official Illustrated Catalogue of the Art Department of the Cincinnati Industrial Exhibition* (Cincinnati, 1879).

28. The certificate of this membership is in Scrapbook 1, p. 74.

29. Clipping from unidentified Cincinnati newspaper, ca. 1882, in Scrapbook 1, p. 11.

30. Anna S[eaton] Schmidt, "The Paintings of Elizabeth Nourse," *International Studio* (January 1906): 247.

31. Mary L. Alexander, "Earliest and Latest Work of Meakin Shown in this Exhibit," clipping from unidentified Cincinnati newspaper, in Archives of the Cincinnati Museum Association.

32. Benn Pitman Papers, in Cincinnati Historical Society. It is not known whether Benn and Adelaide married before or immediately after her mother's death. The quiet wedding in Sandusky may imply parental disapproval of the union because of differences in age and/or religion (Pitman was a Swedenborgian).

33. EN Sketchbook 4. Eighteen of EN's sketchbooks are extant. Sketchbooks 1 and 4 through 18 are in a private collection in Cincinnati. Sketchbooks 2 and 3 are in the Cincinnati Historical Society.

34. John Henry Hudson Biographical File, Upper Sandusky (Ohio) Historical Society. Hudson owned a grain and sale business and was twice elected a state senator for Ohio. After his death in 1893 his widow was left in reduced financial circumstance and had to give painting lessons in her home.

35. Clipping, *Chicago Connoisseur,* ca. 1897, in Scrapbook 1, p. 43.

36. This and the following information are from a letter from EN in New York City to her sisters in Cincinnati, 1882. In Nourse Family Collection, Houston, Texas.

37. This and the following information are from "Art in Decoration: A Cincinnati Lady's Description of the New York Union League Club Rooms," unidentified Cincinnati newspaper, 1882, in Scrapbook 1, p. 11.

38. LN in Paris to "Dearest," November 22, 1910.

39. "Benn Pitman," *Cincinnati Sunday Commercial Tribune,* ca. 1905, in Scrapbook 1, pp. 125–26.

40. This and the following biographical information about Alice Pike Barney are from [Jean L. Lewton], *Barney Studio House* (Washington, D.C.: National Museum of American Art, 1981).

41. Interview by the author with Jean L. Lewton, curator, Barney Studio House, National Museum of American Art, 1982.

42. EN Sketchbooks 4 and 5.

43. Elliston, "Noted Artist Lived in Paris But Never Forgot Cincinnati," *Cincinnati Times-Star,* November 3, 1938.

44. This and the following information about the Schmidt family are from numerous letters written by LN and EN to various members of the family. See also Scrapbook 2, pp. 108–10, obituaries for Mr. and Mrs. Frederick Schmidt and for Anna Seaton Schmidt.

45. This and the following information are from Schmidt, "The Paintings of Elizabeth Nourse," p. 247, and Anderson, *Elizabeth Nourse: A Sketch,* p. 5.

46. EN Notebook for 1887, in Elizabeth Nourse Papers. This small notebook, which EN maintained during her trip, contains her thoughts and comments on sights she saw as well as poetry and addresses.

47. Ibid.

48. Ibid.

49. Albert Boime, *Thomas Couture and the Eclectic Vision,* p. 587.

50. EN Notebook for 1887.

51. This and the following information are from Lucy H. Hooper, "Art Schools in Paris," *Cosmopolitan* (November 1892):60.

52. EN Sketchbook 6.

53. This and the following information are from "Letter from Paris: Art Student Life in Paris," extracts from a letter from EN in Paris to Adelaide Pitman in Cincinnati, date unknown, printed in an unidentified Cincinnati newspaper, 1887. In Scrapbook 1, p. 11.

54. Schmidt, "The Paintings of Elizabeth Nourse," p. 27.

55. Clara T. MacChesney, "An American Artist in Paris: Elizabeth C. Nourse," *Monthly Illustrator* 13, no. 1 (August 1896): 4. In the Salon *livret* for 1889 Nourse is listed as the pupil of Henner and Carolus-Duran and her entry, *Entre voisines* (cat. no. B–16), was also hung on the line. MacChesney (whose name was misspelled "McChesney" in the *Monthly Illustrator*) wrote that this painting was considered deserving of an honorable mention but because Nourse had left the Académie Julian she failed to receive the award. M. Julian employed so many of the leading painters who served on the jury for the salons of the Société Nationale des Artistes Français that awards tended to go to his students.

56. Clipping from the exhibition catalogue of the Continental Gallery (London, 1891), in Scrapbook 1, p. 19.

57. Cincinnati Art Museum, *Catalogue of the Work of Elizabeth Nourse* (Cincinnati, 1893).

58. Also see Scrapbook 1, p. 19, note by LN.

59. W. G. McAdoo, "The Kind of Man Woodrow Wilson Is," *Century* (March 1913): 747.

60. EN gave *Lavoir, Paris* to Henriette Wachman, who had trained at McMicken as a carver and painter, continued her studies in Munich with Franz-Seraph von Lenbach, and then moved to Paris where she and her sister Laura resumed their friendship with the Nourse sisters. The four vacationed together in Volendam, Holland, in 1892 and in 1897 EN and LN visited Henriette and Laura in Tunis, where the latter taught for several years. (Information is from an interview by the author with John D. Wachman, nephew of Henriette and Laura Wachman, Cincinnati, 1979.)

61. EN Sketchbook 7.

62. In a letter from Mrs. G. H. Jones in Chicago to EN and LN in Paris, May 25, 1925, Mrs. Jones thanks the Nourse sisters for the gift of this cloak. LN noted on the page of the scrapbook containing the letter that the spinning wheel was given to Frederick Clasgens, a Cincinnati artist who lived in Paris. In Scrapbook 2, p. 98.

63. EN's estate contained several of these gifts, including a book, *Le Paysan dans l'oeuvre de J. F. Millet,* inscribed as a Christmas gift from "Florence" (probably Florence Este, an American artist in Paris) in 1897; a reproduction of a Millet marked "from Trottie, Xmas '89"; a copy of Millet's self-portrait, a gift from the artist's son Jean-François, who was one of EN's neighbors in Paris.

64. This and the following information are from "Artist Life in Fontainebleau," extracts from a letter written by LN in Barbizon to Adelaide Pitman in Cincinnati, June 8, 1888, printed in an unidentified Cincinnati newspaper, 1888. In Scrapbook 1, pp. 18–20.

65. This and the following information are from "Letter from Paris: Art Student in Russian Poland," extracts from a letter written by EN in Alexandria [en route to Ukraine] to Adelaide Pitman in Cincinnati, printed in an unidentified Cincinnati newspaper, 1889. In Scrapbook 1, p. 22.

66. Letter from LN in Paris to Sister Monica, O.S.U., location unknown, ca. 1932. LN acted as secretary for EN as the artist described how she painted *Les fileuses russes* (cat. no. B–57), *Dans l'ombre à Penmarc'h* (cat. no. A–53), and *Endimanché, Brittany* (cat. no. A–79).

67. Anna Seaton Schmidt to William H. Holmes, curator of the National Gallery of Art, Washington, D.C., 1915, no. 58041, in Registrar's File, National Museum of American Art, Washington, D.C. The Smithsonian Institution's National Museum of American Art received its present name in 1980. From 1937 until the recent redesignation it was the National Collection of Fine Arts, and before 1937 the National Gallery of Art.

68. The biographical information for Anna Seaton Schmidt is from "Noted Critic of Art Dies at Home in D.C.," unidentified Washington, D.C., newspaper, January 9, 1924, in Scrapbook 2, p. 110.

69. Anna Seaton Schmidt to William H. Holmes in Washington, D.C., 1915, in Registrar's File, National Museum of American Art, Washington, D.C.

70. EN Sketchbooks 9 and 10.

71. Biographical File for Mary C. Wheeler, in Montana Historical Society, Helena.

72. Alfred Vance Churchill, Smith College Art Department, Northampton, Mass., to EN in Paris, November 14, 1912, in Scrapbook 2, p. 12. The Smith College Art Gallery acquired *La becquée* (cat. no. A–71) and *Les heures du soir* (cat. no. A–98).

73. EN Sketchbook 9.

74. Schmidt, "Elizabeth Nourse: Great Honor Paid an American by France" [*Boston Transcript,* May 11, 1910], in Scrapbook 1, p. 106.

75. Vance Thompson, "American Artists in Paris," *Cosmopolitan* (May 1900): 26.

76. EN's scrapbooks contain letters from Besnard and Dagnan-Bouveret, and the Elizabeth Nourse Papers in the Cincinnati Historical Society include correspondence referring to them and the Cazins, together with photographs of Rodin and Dagnan-Bouveret inscribed to Nourse.

77. Société des Artistes Français, *Explication des Ouvrages de Peinture, Sculpture, Architecture, Gravure et Lithographie des Artistes Vivants exposés au Palais de Champs-Elysée le 1 mai 1889* (Paris, 1889).

78. EN in Florence to Adelaide Pitman in Cincinnati, May 16, 1890.

79. EN Sketchbook 10.

80. EN in Assisi to Adelaide Pitman in Cincinnati, November 9, 1890.

81. Schmidt, "Elizabeth Nourse: An American Artist," *Donohoe's* (Easter 1902): 332.

82. Ibid., pp. 332–34. The acts of personal charity that EN and LN per-

formed over the years are mentioned in so much of their correspondence that it is impossible to list all of the letters.

83. EN in Assisi to Adelaide Pitman in Cincinnati, November 9, 1890.

84. EN Sketchbook 10. Because of EN's method of signing and drawing outlines around the sketches she used as the bases for paintings, it is possible to know what some of her unlocated works look like.

85. Ibid.

86. Société Nationale des Beaux-Arts, *Catalogue Illustré des Ouvrages de Peinture, Sculpture et Gravure exposés au Champ-de-Mars le 15 mai 1891* (Paris, 1891).

87. Unidentified French caricature in Scrapbook 1, p. 23.

88. EN Sketchbook 10.

89. Schmidt, "Elizabeth Nourse: An American Artist," p. 341.

90. In her autobiography *Background with Figures* (p. 169), Cecilia Beaux, who did not live as economically as the Nourses, described a six-week trip to Italy and the Midi that cost her exactly $107 and stated that she had no sense of being penurious.

91. In several letters EN and LN wrote about EN's making their clothes and hats, and EN often described and sketched peasant costumes in her letters.

92. Donation Blotter 1, May 21, 1892, p. 107, in Archives of the Cincinnati Museum Association.

93. This and the following information are from Cincinnati Art Museum, *Art Palace of the West: A Centennial Tribute, 1881–1981* (Cincinnati, 1981). This catalogue gives an excellent history and chronology of the Cincinnati Art Museum from its inception.

94. EN Sketchbook 10.

95. "A Great American Artist's Work," *New York Herald* (Paris), February 9, 1910, in Scrapbook 1, p. 99.

96. EN's passport for Russia, 1889, in Elizabeth Nourse Papers.

97. This and the following information are from EN in Volendam to Adelaide Pitman in Cincinnati, July 1, 1892.

98. Clara T. MacChesney, "An American Artist in Paris." Clara Taggart MacChesney (1861–1928) studied in San Francisco, New York, and Paris. She exhibited at the New Salon and at the Woman's Art Club of New York City.

99. Ibid., p. 7.

100. C.G.M., "Lizzie Nourse and Her Success in Paris," *Cincinnati Post*, ca. 1892, in Scrapbook 1, p. 32. "C.G.M." was probably Charlotte Gibson Miller.

101. EN Sketchbook 11.

102. This and the following information are from a clipping in an unidentified Cincinnati newspaper, 1893, in Scrapbook 1, p. 33.

103. This and the following information are from "Exhibit in the Cincinnati Room," in *Catalogue of the Chicago Columbian Exposition: 1492–1892* (Cincinnati, ca. 1892).

104. The American Woman's Art Association was founded in 1891 by a group of American women artists resident in Paris and for many years maintained club rooms at the American Art Students' Club at 4, rue de Chevreuse in the Latin Quarter. The group held annual exhibitions of their work in the club, and it served as a center of information about opportunities for exhibiting in Europe and the United States. American male artists in Paris were so numerous that they grouped into several clubs—the American Art Association of Paris, the Paris Society of American Painters, and the older Society of American Painters.

105. John D. Kysela, S. J., "Sara Hallowell Brings 'Modern Art' to the Midwest," *Art Quarterly* 27, no. 2 (1964): 150.

106. Kysela, "Mary Cassatt's Mystery Mural and the World's Fair of 1893," *Art Quarterly* (1966): 145.

107. Cincinnati Art Museum, *Catalogue of the Work of Elizabeth Nourse.*

108. This and the following information are from "Mrs. Benn Pitman's Cremation," unidentified Cincinnati newspaper, 1893, in Scrapbook 1, p. 41.

109. Anderson, *Elizabeth Nourse: A Sketch,* pp. 3–4. Mrs. Anderson, a Cincinnati friend of Elizabeth's, wrote of the special closeness of the twins and said that "the sympathy between them was most touching."

110. Elliston, "Noted Artist Lived in Paris But Never Forgot Cincinnati."

111. Letters from LN in Cincinnati to J. H. Gest in Cincinnati, October 23 and November 3, 1893, Archives of the Cincinnati Museum Association.

112. "Art Museum Reception," unidentified Cincinnati newspaper, 1893, in Scrapbook 1, p. 41. In addition to describing the reception, the author of this review discusses EN's work in the exhibition.

113. Cincinnati Art Museum, Annotated copy of *Catalogue of the Work of Elizabeth Nourse,* in Elizabeth Nourse File, Cincinnati Art Museum Library. This copy has been inscribed in ink with the prices asked for the paintings and the works sold (handprinted) and the names of the buyers (handwritten).

114. LN in Penmarc'h to Mimi Schmidt in Cincinnati, October 14, 1900. LN wrote that she had sold photographs of Elizabeth's paintings to two Cincinnati women who visited the Nourses in Paris and that they had been glad to know that similar photographs could be purchased from Mimi Schmidt in Cincinnati. EN also frequently gave photographs of her works to friends and relatives.

115. V. G. Fischer Art Gallery, Annotated copy of *Catalogue of the Work of Elizabeth Nourse* (Washington, D.C.: 1894), in Elizabeth Nourse File, Cincinnati Art Museum Library. This copy has been inscribed in ink with handwritten prices for the paintings and notations of "sold" for those purchased.

116. This and the following information are from a letter written by LN in Washington, D.C., to Henry Clay Meader in Cincinnati, February 25, 1894. In the Meader Family Collection, Fort Wright, Ky.

117. Ibid.

118. This and the following information are from a letter written by LN in Paris to Mimi Schmidt in Cincinnati, January 12, 1904.

119. Ibid.

120. LN in Paris to Melrose Pitman in Cincinnati, ca. 1902.

121. LN in Saint Gildas-de-Rhuys to Henry Clay Meader in Cincinnati, June 18, 1894. In the Meader Family Collection, Fort Wright, Ky.

122. Ibid., this and the following information.

123. EN in Saint Gildas-de-Rhuys to Mary Nourse in Covington, Ky., October 6, 1894.

124. LN in Saint Gildas-de-Rhuys to Henry Clay Meader in Cincinnati, June 18, 1894. In the Meader Family Collection, Fort Wright, Ky.

125. This and the following information are from Julia C. Walsh, "Elizabeth Nourse: A Reminiscence," *Ave Maria* 49, no. 18 (May 6, 1939): 560–62.

126. EN Sketchbook 12.

127. This and the following information are from *Retrospective Exhibition of Sculpture by Clement J. Barnhorn* (Cincinnati Art Museum, 1934).

128. Interview by the author with Agnes Fay, Cincinnati artist, July 9, 1979. Nourse gave Barnhorn at least five paintings as gifts and he was frequently mentioned by the Nourse sisters in their correspondence.

129. Société Nationale des Beaux-Arts, *Catalogue des Ouvrages de Peinture, Sculpture, Dessins, Gravure, Architecture et Objects d'Art exposés au Champ-de-Mars le 25 avril 1895* (Paris, 1895). In the previous year the Salon had added two new categories, one for decorative arts and the other for architecture. These additions must have pleased EN, who continued to have a strong interest in the arts and crafts movement.

130. EN Sketchbooks 12, 13, 14, and 18.

131. All information about the visit in Tunis is from letters written by EN in Tunis to her niece Mary Nourse in Covington, Ky., February 1 and 10, 1898. In Nourse Family Collection, Fort Thomas, Ky.

132. Scrapbook 1, p. 75, note by LN, 1904, and "La vie artistique," review from unidentified French newspaper, 1905, p. 78.

133. EN Sketchbook 12.

134. Review of Exposition des Orientalistes from unidentified French newspaper, 1905, in Scrapbook 1, p. 75.

135. This and the following information are from the author's correspondence with Isabelle Decroisette (granddaughter of Marie Saget-Léthias) in Vanves, January 9, February 11, and May 19, 1980, in the possession of the author, and from a letter from Daniel Saget-Léthias in Soissons to his niece Isabelle Decroisette in Vanves, January 5, 1980. M. Léthias described the Nourses' bringing him to Paris in April 1908 for ten days to have some dental work done. They paid for this and took him around the city to see museums, public buildings, and churches. He recalled that the Nourses used to spend about a month annually at Saint Léger and remembered with gratitude their concern for him during World War I. They continued to make short visits to Saint Léger until Louise's death in 1937.

136. EN Sketchbook 13.

137. Ibid.

138. This and the following information are from Florence N. Levy, ed., *American Art Annual* (Boston: Noyes, Plat, 1900).

139. This pastel, left in EN's estate, is now in a private collection in Cincinnati. It is reproduced as catalogue number 323 in Adelyn D. Breeskin, *Mary Cassatt: A Catalogue Raisonné of Oils, Pastels, and Drawings* (Washington, D.C.: Smithsonian Institution Press, 1970).

140. EN Sketchbook 9.

141. Vance Thompson, "American Artists in Paris," pp. 17–18.

142. LN in Penmarc'h to Mimi Schmidt in Cincinnati, October 14, 1900; EN to "Lizzie," July 16, 1900; EN in Paris to Mimi Schmidt in Cincinnati, July 17, 1900.

143. LN in Paris to unknown correspondent, July 1900.

144. LN in Penmarc'h to Mimi Schmidt in Cincinnati, July 17, 1900.

145. Scrapbook 1, p. 62, note by LN.

146. LN in Penmarc'h to Mimi Schmidt in Cincinnati, October 14, 1900.

147. This and the following information are from Schmidt, "Elizabeth Nourse: The Work of an Eminent Artist in France," *Boston Evening Transcript* [July 12, 1902], in Scrapbook 1, p. 49.

148. Ibid. The Cincinnati friends who bought *Normandy Peasant Woman and Child* (cat. no. A–47) obviously did not share this bias but valued the sincerity of Nourse's expression.

149. LN in Penmarc'h to unknown correspondent, September 24, 1900.

150. EN Sketchbook 14.

151. In many letters over the years EN and LN speak of Louise's accompanying Elizabeth on her painting expeditions, amusing the child models, and learning languages.

152. Clipping from unidentified French newspaper, 1901, listing the newly elected *sociétaires* and *associés* at the Salon, in Scrapbook 1, p. 55.

153. This and the following information are from "Sociétaire for Miss Nourse," clipping from unidentified American newspaper, in Scrapbook 1, p. 66. The article was probably written by Anna Seaton Schmidt. EN was not, however, the first woman or American to become a member of the New Salon; Lucy Lee-Robbins had been an *associé* since the group was founded in 1890.

154. Société Nationale des Beaux-Arts, *Catalogue Illustré du Salon de 1904* (Paris, 1904) and *Catalogue Illustré du Salon de 1905* (Paris, 1905). The catalogue for 1905 contains the rules governing entries for *sociétaires* and *associés*.

155. The Wachmans and the Rawsons are often mentioned in both EN's and LN's correspondence. When Helen Rawson died in 1933 she bequeathed $5,000 to EN and LN.

156. The work was completed in her studio in 1902, when she signed and dated it.

157. LN in Paris to Mimi Schmidt in Cincinnati, January 12, 1904.

158. Scrapbook 1, p. 75, facsimile of silver medal awarded at the Saint Louis Exposition, 1904, and note by LN.

159. LN in Paris to Anna Seaton Schmidt, February 14, 1904.

160. LN in Paris to Mimi Schmidt in Cincinnati, January 12, 1904.

161. Ibid.

162. Woman's Art Club of Cincinnati, *Catalogue of the Cincinnati Woman's Art Club* (Cincinnati, 1906).

163. This and the following information are from Schmidt, "Elizabeth Nourse: The Work of An Eminent Artist in France."

164. Review of the Lodge Art League exhibition from unidentified newspaper, 1907, in Scrapbook 1, p. 81.

165. Reviews of "la quatorziéme exposition annuelle des Femmes artistes," Galerie Georges Petit, Paris, January 1905, from *Echo, Epoque, Journal des Débats,* and *La Presse,* in Scrapbook 1, p. 78.

166. Robert Dell, "Paris Letter," *American Art News* (May 10, 1913).

167. EN Sketchbook 15.

168. This and the following information are from LN in Plougastel-Daoulas to Mimi Schmidt in Cincinnati, October 1, 1907.

169. Invitation to the opening of the Société Internationale de la Peinture à l'Eau, February 6, 1908, in Scrapbook 1, p. 86.

170. Cincinnati Art Museum, *Annual Exhibition of American Art* (Cincinnati, 1910) and Pennsylvania Academy of The Fine Arts, *Eighth Annual Philadelphia Watercolor Exhibition* (Philadelphia, 1910).

171. LN in Paris to J. H. Gest in Cincinnati, April 24, 1910, and December 13, 1910, in Archives of the Cincinnati Museum Association.

172. LN in Paris to J. H. Gest in Cincinnati, March 1, 1910, in Archives of the Cincinnati Museum Association.

173. "Elizabeth Nourse," *Philadelphia Item,* June 14, 1909.

174. "Recent Acquisitions: 'Happy Days' by Elizabeth Nourse Arrives From Paris," *Bulletin of the Detroit Institute of Arts* 3, no. 4 (October 1909): 46.

175. LN at the Château de Trücksess, Obermorschweier, Haute Alsace, to "Lizzie" in Cincinnati, September 17, 1909.

176. Reviews of 1910 Salon, in Scrapbook 1, pp. 103–14.

177. Schmidt, "Elizabeth Nourse: Great Honor Paid an American by France," p. 106.

178. Jean Claude, "Le Salon de la Société Nationale des Beaux-Arts," review from unidentified French newspaper, 1910, in Elizabeth Nourse Papers.

179. Musée du Luxembourg, *Catalogue de l'Exposition d'Artistes de l'Ecole Américaine au Luxembourg* (Paris, 1919). The director of the Musée du Luxembourg, Léonce Bénédite, included *La rêverie* (cat. no. B–119) in an exhibition of American art at his museum in 1919 in gratitude for American assistance in storing and exhibiting a number of paintings from the collection in the United States during World War I.

180. This painting was purchased for the Toledo (Ohio) Art Museum to show at the inaugural exhibition of the museum's new building in 1912 (EN in Paris to Mrs. Stevens, wife of the director of the Toledo Art Museum, January 4, 1912).

181. LN in Paris to J. H. Gest in Cincinnati, December 8, 1911, in Archives of the Cincinnati Museum Association.

182. Scrapbook 2, p. 49, note by LN.

183. Scrapbook 2, pp. 40–52, notes by LN.

184. Scrapbook 2, p. 56, Letter from Association of Women Painters and Sculptors of New York to EN in Paris, April 11, 1914.

185. Scrapbook 2, p. 42, letter from Cincinnati MacDowell Society to EN in Paris, February 14, 1914.

186. Scrapbook 2, p. 56, letter from Philadelphia Water Color Club to EN in Paris, February 27, 1914.

187. "Extracts from the Diary of an American Artist in Paris, August and September, 1914," *Art and Progress* 6, no. 2 (December 1914): 41–48.

188. Ibid., p. 44, entry for August 24, 1914.

189. LN in Paris to Melrose Pitman in Cincinnati, August 22, 1914.

190. "Extracts from the Diary of an American Artist in Paris," p. 46.

191. "Extracts from the Diary of an American Artist in Paris," *Cincinnati Enquirer,* January 3, 1915, entry for November 22, 1914.

192. Anna Seaton Schmidt published EN's letters in Cincinnati and Boston newspapers and in *Art and Progress*.

193. Letter from the Board of the Société Nationale des Beaux-Arts in Paris to EN in Paris, May 24, 1919, in Scrapbook 2, p. 81.

194. "Extracts from the Diary of an American Artist in Paris," *Cincinnati Enquirer,* entries for August 25, September 25, October 10, October 12, and October 28, 1914, and January 3, 1915.

195. Scrapbook 2, pp. 68, 70, 72.

196. Ibid., pp. 70, 71, 73.

197. This and the following information are from Schmidt, "A Letter from Elizabeth Nourse," *Boston Evening Post,* September 2, 1916.

198. Anderson, *Elizabeth Nourse: A Sketch,* p. 21.

199. Scrapbook 2, p. 76, note by LN listing 1919 entries.

200. Ibid., note by LN.

201. LN in Paris to her cousin, Mrs. Thomas Graddy Kennedy in Cincinnati, May 23, 1920, in Kennedy Family Collection, Malvern, Pa.

202. Louise Hayden, a pianist, attended the music conservatory in Seattle with Alice B. Toklas in 1893 and met Toklas again in 1907 at the apartment of Gertrude and Leo Stein in Paris. Hayden first married an American, Col. Emmet Addis, and after his death married a British army officer, Col. Redvers Taylor. At the time she married Col. Addis all of the Americans named lived within a few blocks of one another. (See Linda Simon, *The Biography of Alice B. Toklas* [1977], p. 69.) It seems likely that the Nourses and Steins were acquainted, although their lives were so different that they would probably not have developed a mutual friendship. They did, however, have friends such as Louise Hayden in common.

203. *Consolation* (cat. no. A–113) is illustrated in an article by MacChesney, "American Artists in Paris," *International Studio* (November 1914): xxv.

204. Scrapbook 2, p. 60. There is evidence that Nourse used photographs as compositional aids as early as 1900. In Scrapbook 1, p. 68, there is a photograph of the models for *The Baby's Supper* (cat. nos. A–44, A–45, A–46), and on p. 72 there are two photographs of watercolors marked *Paysannes de Penmarc'h* (cat. nos. C–123 and C–128).

205. EN in Paris to Clarissa Buckley, Lincoln, Neb., February 14, 1930, in Lincoln Registrar's File, Sheldon Memorial Art Gallery, University of Nebraska.

206. Newspaper clippings, 1921, in Scrapbook 2, pp. 87–92.

207. Marcus Selden Goldman, "In the World of Art," *New York Herald* (Paris) October 1, 1921.

208. "Miss Elizabeth Nourse Given Laetare Medal," *Chicago Sunday Tribune,* March 6, 1921.

209. Schmidt, "Elizabeth Nourse: Great Honor Paid an American Artist by France," p. 106.

210. LN correspondence, Elizabeth Nourse Papers.

211. LN in Paris to Mary Nourse in Covington, Ky., June 13, 1926.

212. Interview by the author, August 16, 1980, with Mary Louise Stacey Settle, EN's great-niece, who visited her aunts in Paris in 1929. Interview by the author with Agnes Fay, Cincinnati artist, who with her husband William Fay, a pupil of Duveneck's, visited the Nourses in Paris in 1925.

213. This and the following information are from a letter written by May Merriweather in Paris to Melrose Pitman in Cincinnati, October 8, 1938.

214. "Art Museum to Receive Paintings from Estate of Elizabeth Nourse, Artist," clipping from unidentified Cincinnati newspaper, 1938, in Elizabeth Nourse Papers.

215. Inventory of the Estate of Elizabeth Nourse, 1938, in Elizabeth Nourse Papers.

Elizabeth Nourse: Painting the Motif of Humanity

Lois Marie Fink
Curator for Research,
National Museum of American Art

What specific advantages did Elizabeth Nourse and other American artists find in Paris? Would her career and her paintings have been significantly altered if she had returned to resume her life in Cincinnati?

Americans artists had, of course, gone abroad since colonial days to study in European art centers; some never returned to their native land. Nourse and her contemporaries differed, however, from their predecessors in important respects, one being that they did not have to go abroad to get a thorough academic training. She had become a skillful painter through years of study at the McMicken School of Design in Cincinnati and one term at the Art Students League in New York, where competent instructors such as Thomas S. Noble and William Sartain taught the systematic principles they had learned in Paris and Munich. Excellent educational opportunities for art students in the United States opened in the 1870s and 1880s, when art schools were established in most major cities. This did not, however, diminish the attraction of Europe; if anything, well-trained young American artists found the need to go abroad, especially to go to Paris, even more essential. Paris was the source of the critical language that dominated contemporary art, the creator of its varied imagery, and the marketplace for its products. Not even in a practical sense could a seriously ambitious painter or sculptor launch a successful career without an exposure to this international center, for another way in which Nourse's generation differed from the older artists was that they did not enjoy the protected status of painting for an American public that knew only home-produced works of art. By the 1880s journals of art, popular magazines, and even newspapers kept their potential patrons constantly informed about the Parisian art scene. Through reproductions in these publications, numerous exhibitions, and access to private and public collections, works of contemporary French painting were known across the country, the yardstick against which other works were measured. For these reasons it was essential to go to the fountainhead and to immerse oneself in it, at least for a time. Elizabeth Nourse was one of those who was so transformed by the experience that she could never return home again.

Entering a New World of Art in Paris

As far as can be measured by Salon participation, Americans were the largest single group of foreign artists in the French capital in the late 1880s, having increased from being one of the smallest during the preceding two decades. Only sixteen Americans had shown at the Salon of 1868; in 1878, sixty-two American artists were represented. At the Salon of 1888, when Elizabeth Nourse first exhibited, 140 American artists were included; the next year there were 160.[1] In the art schools of Paris the American presence among the various nationalities was clearly visible—distressingly so, according to some of the French students, who bitterly resented being jostled from their places at the Ecole des Beaux-Arts and having honors at the Salons go to these interlopers from across the ocean. A diatribe against foreign students at the Ecole, which singled out Americans in particular, was published in Paris in 1886.[2]

There was no question of Nourse's taking a Frenchman's place at the Ecole des Beaux-Arts, for as a woman she was not permitted to enroll there. With an almost legendary reputation as the finest school of art in Paris, if not in the Western world, the Ecole offered a broad curriculum of study in the history of art, aesthetics, archaeology, anatomy, and applied science in addition to studio courses. Supported by the French government, it was entirely free to students, whether French or foreign. A rigorous examination for entry assured a serious level of intent and ability in those who matriculated. This was the first of many examinations and competitions in the Ecole program, which, by pitting young artists against each other, provided an excellent preparation for the extremely competitive business of art in Paris. Through their connections with the French Institute and other prestigious organizations, the Ecole instructors became important professional associates for the younger generation, mentors who could make a significant difference in the formative stages of a career.

"It is enough to make one cry with rage. Why can not I go and study there? Where can I get instructions as complete as there? . . . If ever I am rich, I will found an art school for women," wrote the gifted young Russian painter Marie Bashkirtseff in her journal in 1878, after a visit to the Ecole.[3] A standard answer to her angry question was that because women did not have serious professional ambitions, their presence would diminish the quality of teaching. In addition, protested the authorities, it would be improper for both sexes to attend life-drawing classes together. The very idea of coeducation prompted levity, such as the response of Léon Gérôme, a teacher of painting for many years at the Ecole, "Ça sera bon pour . . . la repopulation."[4] It is more likely that efforts to exclude women were motivated by the same reasons as the protests against foreigners. Women represented additional competition and their numbers were threatening: in the 1880s they accounted for about 20 percent of the exhibitors at the Salons.[5] But times were changing and even as Nourse began her studies in Paris, the Union des Femmes

peintres et sculpteurs, founded in 1881, was actively engaged in promoting the interests of women artists. Largely through their efforts, the Ecole des Beaux-Arts was to open officially to women in 1896, although the first female students did not enter until several years later.[6]

Possibilities for study that existed for Nourse in 1887 included the Académie Julian, the Académie Colarossi, and the Académie des Champs-Elysées, each with separate studios for men and women and a faculty of prominent artists who criticized the students' work. In addition many Parisian masters maintained teaching studios in which they accepted students. Some of these provided separate classes for women; Carolus-Duran's and Benjamin Constant's were among the most popular. Other artists, including the Belgian painter Alfred Stevens and the French artist Edouard Krüg, taught women only. The American painter Henry Mosler taught a class of both men and women, who sketched from a draped model.[7] Nourse enrolled at the Académie Julian, the largest art school in Paris after the Ecole des Beaux-Arts, and the most popular private school among Americans of both sexes.[8]

Rodolphe Julian, the founder and administrator of the Académie Julian, was a painter and illustrator who had studied at the Ecole des Beaux-Arts. With some success as a Salon exhibitor but without a promising career in sight, he had opened his first teaching studio in 1868 and, as enrollment increased throughout the 1870s and 1880s, opened additional studios. By 1889 the Académie Julian included a chain of studios, of which three were for women only, and counted about six-hundred students.[9] In the United States, art students sometimes confused this entrepreneur with another French artist, Bernard-Romain Julien, who published several series of lithographic studies for use as copy work for beginners.[10] In his late forties at the time Nourse entered the academy, Julian was committed to conservative principles of art in teaching. Emphasizing the importance of details, he encouraged his novices to make separate studies of parts of the body, asserting that in modern teaching the *ensemble* was stressed to the detriment of the ability to render details.[11] Over the entrance to his studios he placed Ingres's dictum about the basic importance of drawing, "le dessin est la probité de l'art."[12] Although Julian personally worked with his students, most of the instruction was done by well-known Parisian painters and sculptors who taught by moving through the studio and critcizing each pupil's work as the entire class listened. During Nourse's stay at Julian's, the painters Adolphe Bouguereau, Gustave Boulanger, Benjamin Constant, Jules Lefebvre, and Tony Robert-Fleury were regular instructors in the women's studios. Of these Lefebvre became the most directly involved with her work.

Although Elizabeth Nourse spent only a few months at Julian's, it is important to try to assess the value of that experience for her career. She wrote home of painting there daily and reported that Lefebvre had praised her work as being "better and better," telling her that in time she "could do great things."[13] Jules Lefebvre was a painter who specialized in portraits and the female figure. A product

of the Ecole des Beaux-Arts, he had attained every possible honor: the Prix de Rome, Salon medals, membership in the French Institute. Well known among American collectors, his works were represented in a number of exhibitions and collections in the United States. Lefebvre had a reputation as a painting master who rarely praised. A word of approval from him was bound to inspire greater confidence in the novice from Cincinnati. More particularly, by suggesting to Nourse that her continual improvement promised hope for greatness in the future, he encouraged her to proceed within the same basic style and methods she was already using.

Nourse must have shared in the benefits of study at Julian's reported by other students, mainly in the opportunity to practice figure drawing and painting under professional guidance based upon general principles, and in the availability of criticism from several different teachers rather than exposure to whatever advantages or disadvantages devolved from a strong allegiance to one master. "What one got was chiefly practice," recalled Cecilia Beaux, who studied at Julian's only a few months after Nourse.

> My persistence at the Julien [sic] cours during my second winter in Paris was owing to its general, non-specific nature. I might have delivered myself, of course, to an individual master. There were several of high repute who admitted disciples. By an instinct I could not resist, I shrank from the committal, although there would have been contacts resulting from it of high value and interest. . . . At Julien's one had not to think of adherence. . . .[14]

Along with others, Beaux stressed that the students' work was not criticized at Julian's on the basis of the instructors' personal style but in accordance with general principles that they imparted, particularly their admonishment to "faire large et simple" (just the thing that Julian himself had misgivings about).

Although their experience at the Académie Julian helped Cecilia Beaux, Elizabeth Nourse, and many other Julian students to mature in academic painting, the hundreds of students who drew there daily ran the gamut from conservative to radical. This variability gave the Académie Julian the reputation of fostering nonacademic approaches to art, which it did not, even though certain radical groups (including the Nabis painters) first met there.[15] Nevertheless, the relative flexibility of the regime within the discipline of professional criticism allowed for different kinds of development. There was a freedom from the expectations imposed upon students at the prestigious Ecole and a greater range of possibility for style and imagery than that usually afforded a student working under one master. At Julian's the students could have exposure to academic principles and discipline as well as the opportunity to meet other young artists and hear the latest professional gossip; it was an excellent entree into the art world of Paris. Many Americans attested to the importance of their training there and through them, the Académie Julian had an impact upon American painting through the first three decades of the twentieth century.[16]

After spending about three months at Julian's, Nourse studied for a time with Carolus-Duran and Jean-Jacques Henner. Although their criticism cannot be related to her work in specific ways, this contact was to be very important to her in a few years when a new society of artists, in which Carolus-Duran was active, originated a second annual Salon exhibition.

Even though the program in the women's studios at the Académie Julian was basically the same as that in the men's, there were distinct differences that made the facilities for the sexes separate but not equal. Rodolphe Julian followed the practice customary in Parisian art schools—with the exception of the Académie des Champs-Elysées—of arranging for instructors to visit the women's classes once a week, whereas in the men's studios they came twice weekly. Another difference was expressed in very tangible terms: money. Fees for women were exactly double those for men. Registration at Julian's for one month was 50 francs for men, 100 for women (or, at the then prevailing rate, about $20); six months of instruction cost 200 francs for men, 400 for women; and one year cost 300 francs for men and 700 for women.[17] Women were thus charged at least twice as much but received only half the instruction provided for the men. Such an unjust arrangement required an explanation and a nicely varied range of justifications were advanced. "The reason [is] that many of the students are not studying professionally, and consequently instruction as a luxury is put at a higher price," rationalized an 1887 report on art facilities in Paris.[18] "Their wants are attended to better by the concierge, and generally their places of work are more comfortably furnished," asserted Geraldine Rowland in an article in *Harper's Bazar*.[19] Most offensive was the explanation given by Marie Adelaide Belloc in an 1890 article, "L'Ecole des Beaux-Arts offers gratuitous instruction to any who care to avail themselves of it, so that the fees for men must be low to tempt them away from the Government schools."[20] With such inequities in the Parisian art scene taken for granted, it is no wonder that when Mary Fairchild Mac-Monnies and Mary Cassatt in Paris received their contracts to paint murals for the World's Columbian Exposition and found very objectionable provisions, Cassatt "suspected that the women were being treated differently from the men."[21]

More serious than the added expense or abbreviated instruction were the qualitative differences. Arguments about racial desegregation in American schools familiar to our own generation can be readily fitted to this late nineteenth-century situation: segregated programs in the Parisian art schools could not provide the same opportunities for women because their separation from the men was based on their assumed inferiority as artists. At a crucial time in their education women were thus denied the competition of males, against whom they would have to compete throughout their careers, and they were denied being pushed to excellence by their instructors, who give every impression of having been easily satisfied with the efforts of female students. In the preceding essay Mary Alice Heekin Burke reports that after a few months of drawing at Julian's, Eliza-

beth Nourse was told that she was so competent she had no further need of continuing at the Académie, yet an extant drawing of a model she did there (fig. 18) is far from a masterly rendering of the figure. Gifted and skilled she was, but surely she could have used more critical guidance at that point in her career. In an article on the women pupils of Boston artist William Morris Hunt, Martha J. Hoppin notes that Hunt "was ridiculed for teaching women," and that one of his pupils reported—as though Hunt's methods were exceptional—that women in his classes "were criticized as roughly, made to work as strenuously, praised as frankly, as men."[22] Whereas Mary Cassatt had the good fortune to have her work criticized by Edgar Degas, one of the greatest of modern masters, Elizabeth Nourse probably received the uncritical praise more conventionally directed to gifted women.

The belief that women lacked creative ability was widespread and, in this post-Darwinian era, was often accepted as a matter of evolutionary fact. In a typical pronouncement, the author of an article about the "artistic impulse"—what would be called "creativity" today—presented his points as scientific truth. "Since woman is by nature or cultivation passive, she possesses to a less degree than man the creative art. . . . Early in the development of species, Nature established two sexes in separate organisms; and these differentiations were to the advantage not alone of the individual, but of the artistic and intellectual impulse."[23] Darwin himself suggested a scientific basis for the notion that women innately tended to be more imitative and that they possessed qualities belonging to a more primitive level of being. "It is generally admitted," he wrote, "that with women the power of intuition, of rapid perception, and perhaps of imitation, are more strongly marked than in man; but some, at least, of these faculties are characteristic of the lower races, and therefore of a past and lower state of civilization."[24] In art criticism, praise directed to the work of women usually implied excellence only insofar as this work was indistinguishable from that of men. The following phrases are typical: "do not suggest a woman's touch"; "the execution is downright and virile"; "without any of those qualities which generally betray the sex of the fair painter"; "painted with a vigor that one seldom sees in a woman's work." Women students realized that segregated classes were a severe handicap to their development. A dramatic demonstration of their frustration took place in 1896, when a group invaded the men's studio at the Académie Colarossi. Thereafter at Colarossi's, classes were integrated without further problems.[25] If Elizabeth Nourse had personal feelings about the inequities in opportunities for women artists in Paris, she left no record of them. Like most women artists of her time she made use of the opportunities available to her that best suited her needs.

One very important institution in the Parisian art world, the Salon's annual exhibitions of contemporary art held each spring in the Palais des Champs-Elysées, was open to women as well as to men. Officially titled "exhibitions of living artists," the Salons derived their popular name from having been held in the Salon Carée at the

Louvre when they originated in the seventeenth century. As regular exhibitions of works by French artists, the Salons had helped to establish a sense of tradition and continuity in French art, and promoted good critical writing based on contemporary works. During the Second Empire the Salons became international showplaces—above all, showplaces for French art before the rest of the world—and artists of many nations were represented there. Sponsored by a department of the government for most of their history, after 1881 the Salons were organized and supported by an organization of French artists, the Société Nationale des Artistes Français.

The Salons were eagerly anticipated each year, not just by elite circles of the art world, but by throngs of people from every social class, who crowded into the long galleries of the Palais to admire or to hoot. Mainly, they came to enjoy the vast variety of images among the thousands of paintings, drawings, and prints on display and then to rest their feet while sitting on benches in the sculpture gallery. A special room was provided where reviews of the exhibitions were available, along with pads of paper and pencils so that visitors could make notes about their own favorites. For artists, exposure at these events meant the opportunity to be noticed by important people—art critics, dealers, collectors, fellow artists—and the crucial experience of being compared, or so they believed, with the best of contemporary artists in the Western world.

When Elizabeth Nourse began to exhibit at the Salons in the late 1880s their singular importance had begun to erode and innovative artists no longer looked upon them as a testing ground for new ideas. But this loss of primacy, which seems so obvious from our own time, was not nearly as evident in the late nineteenth century, and to American artists, whether in France or the United States, the Salons still signified sacred ground. Works that appeared in them were virtually assured of better prospects in the American market.

Instructors and directors of the academies and the Ecole des Beaux-Arts considered it a point of honor to have their students accepted at the Salons, and they vied with each other for numbers of acceptances and awards won by their pupils. Julian encouraged his students to enter these competitions as soon as possible and because he had been associated with so many artists through the years, a number of whom became powerful in professional circles, it was claimed that he could get special favors from the Salon juries. "Indeed," writes Jacques Lethève, "by the end of the century the Académie Julian was accused of promoting a sort of Mafia: the teachers and some of their students would back each other in the elections to the jury of the Salon and in the distribution of prizes."[26] Even two decades earlier, special connections were working for Julian students. In the late 1870s when Marie Bashkirtseff was attending the academy, she confided to her journal that her instructor at Julian's, Tony Robert-Fleury, encouraged her to enter the Salon, adding, "You have in your favor that your picture is striking, and is of a generally agreeable tone. And then, too, Lefebvre, Laurens, and Bonnat [the jurors for that year] are great friends of mine."[27] It is not hard to

believe that politics played a part in the selection of Salon works. Faced with the onerous task of examining seven- to eight-thousand paintings, sculptures, drawings, and prints, of which many were very similar in subject matter, technique, and quality, and more than half of which had to be rejected, the jurors may have welcomed a list of names for special consideration simply from the standpoint of having their task eased, not to mention expediting the intricacies of returning favors for others received or anticipated.

Nourse's first entry to the Salons was for the 1888 exhibition, held about seven months after she came to Paris. Her painting *La mère* (fig. 19) was accepted, and she was thus established in the Parisian art world as a young artist of promise. The Salon of 1888 was a stellar event for American painters, six of whom—Walter Gay, William Henry Howe, Daniel Ridgway Knight, Gari Melchers, Henry Mosler, and Eugene Vail—received third-class medals, and two of whom—Theodore Earl Butler and Willard Metcalf—received honorable mention. As Burke points out in her note 55, a friend of Nourse's claimed that Nourse was denied an honorable mention because she had left Julian's studio. Although this assertion cannot be verified, the usual practice in the art world was for teachers and pupils to remain loyal to each other even after their association was ended. An artist was always considered as having been a student of a certain academy or master no matter how long after the period of study, and honors to the student reflected upon the master and consequently upon the academy. The evidence suggests that Nourse was not entirely pleased with her experience at Julian's, for although she was listed in the Salon catalogue for 1888 as a pupil of Lefebvre and Boulanger, who had been her instructors there, they were not mentioned in the 1889 catalogue, which named only Carolus-Duran and Henner as her masters.

It was a general practice at the Salons that women were not honored in proportion to their representation, for although they comprised about 20 percent of the exhibitors they regularly accounted for less than 10 percent of the award winners. Of the *hors concours,* those most honored exhibitors who in past Salons had received all possible honors and were thus no longer competing for awards, only about 4 percent were women. At the Salon of 1878, in which 25 percent of the exhibitors were women, 8 percent of the recompenses were awarded their group, and at the Salon of 1886, in which 17 percent were women, the percentage of award winners was the same.[28]

Political struggles and controversies within the Société Nationale des Artistes Français began to erupt beyond the Salon juries and in 1890 irreconcilable differences resulted in a group of artists seceding to form a separate organization, the Société Nationale des Beaux-Arts, for the purpose of holding its own Salons. As their respective titles suggest, the older organization was more nationalistic and membership was open to French artists only, those who had been admitted by jury at least once to a Salon, or to the exhibitions at the universal expositions in Paris. Jury members were elected by the en-

tire membership, according to divisions of painters, sculptors, architects, and printmakers. In the new organization none but French artists were permitted to be founders (*fondateurs*) but foreigners could join the ranks as *sociétaires,* a class of members who were invited to membership by the founding members, or as *associés,* artists whose works had been admitted to the exhibitions and whose membership was voted upon by the *sociétaires. Fondateurs* and *sociétaires* had the right to enter their works in the annual exhibitions without submitting them to the jury, and *associés* could designate one work to be free from examination while submitting the others to the scrutiny of the jury. The *sociétaires* served in turn as jury members.[29]

The organization of these artists' societies with their divisions into sections and levels of memberships, their presentation of the annual exhibitions, and their recording of statistics of these annual events year after year were marvels of French efficiency and a testament to the national passion for art. There was nothing like the French system in the English-speaking world and certainly nothing to approach the excitement generated by these exhibitions or the range of response they produced from government officials, critics, and the public. Artists from the United States, in which contemporary art was not high on anyone's list of priorities, were understandably impressed.

Nourse deserted the older Salon for the new venture and was invited to submit works to its first exhibition, probably through her association with Carolus-Duran, a *fondateur* of the Société Nationale des Beaux-Arts. Other founders of the society whose works she admired included Jean-Charles Cazin and Pascal Dagnan-Bouveret. Although these painters, with Ernest Meissonier and Puvis de Chavannes, president and vice-president of the group, were all conservative artists in imagery and technique, they represented distinctive personal approaches. To many artists and critics of the time these instigators of the "New Salon" were seen as searching for "une interpretation plus fraiche, plus directe de la nature," as Leopold Mabilleau expressed it in his review of the 1890 exhibition.[30] The only artist among the *fondateurs* who radically departed from traditional imagery was Auguste Rodin.[31]

Americans were active in the new society from its inception. Edward May, a painter from Philadelphia who had lived in Paris since 1851, was designated an honorary member, and *sociétaires* named in 1890 at the founding were painters William T. Dannat, Alexander Harrison, and John Singer Sargent, all of whom in recent years had received awards and outstanding critical reviews at the "Old Salon" sponsored by the Société Nationale des Artistes Français. *Associés* of the New Salon were sculptor Paul Wayland Bartlett, also an award winner at the Old Salons, and painter Lucy Lee-Robbins, a pupil and close friend of Carolus-Duran's.[32]

The participation of foreign artists at the Old Salon had remained fairly constant at 15 to 16 percent through the 1880s and 1890s. One wonders if such consistency were not based on a quota system. But the New Salon began with an extraordinary percentage

of foreign exhibitors (33 percent in the initial event) and thereafter their numbers varied widely, dropping to 21 percent in 1899 and up again to 29 percent in 1910. The participation of Americans varied, too. At the 1890 Salon they comprised 25 percent of the foreign group and by the end of the decade, in 1899, they accounted for 42 percent of the non-French exhibitors. By 1910 American participation dropped considerably, and at that Salon they constituted only 14 percent of the foreign artists. The average percentage of women exhibitors remained the same at both Salons, about 20 percent—another one of those astonishingly consistent statistics.

Elizabeth Nourse exhibited regularly at the New Salon of the Société Nationale des Beaux-Arts from 1890 through 1914, with the exception of 1893, when she was in the United States. No Paris Salons were held during the war years 1915 through 1917. Afterward Nourse's name appears in the New Salon catalogues for 1918 and 1920, and, for the last time, 1921. At most Salons she showed a group of works: two to four oil paintings and several drawings and watercolors or pastels. One of the advantages of the New Salon was that its smaller size with fewer exhibitors allowed painters to show more than the two works to which they were usually restricted at the Old Salon. One or two of her paintings were usually included in the illustrated catalogues of the New Salon's annual exhibitions. Nourse's works related well to the general appearance of these exhibitions, which included in the painting division a great variety of subject matter and many representations of everyday life in rural France and Holland, similar to her own subject matter. Although she was sometimes mentioned in reviews, she was not selected for particular discussion; for example, at the Salon of 1890 her painting *La dernière bouchée* (cat. no. A–5) was mentioned as "representing a poor mother and her two children . . . a strong, realistic sketch."[33]

The sponsoring organizations of both the Old and the New Salon had been founded by artists primarily for the purpose of holding exhibitions of contemporary art, and in Paris, exhibitions, like artists, were continually on the increase.[34] The former practice of holding one gigantic exhibition each year was woefully inadequate, but not only because of greater numbers of artists. New techniques and new imagery, without precedence in Western art, made the judging of contemporary art extraordinarily difficult. Seeking a receptive audience, artists who were involved with innovative painting and sculpture followed the example of the Impressionists, who had organized independent exhibitions in the 1870s and 1880s and established their own salons. Most significant of these new annual exhibitions were those of the Salon des Indépendants, which held its first show in 1884, and the Salon d'Automne, initiated in 1903. These shows were open to foreign as well as French artists.

American artists in Paris also founded their own organizations for the purpose of holding exhibitions. A men's group, the American Art Association of Paris, founded in 1890, promoted conservative art and included as honorary members many of the French artists who taught at the Ecole des Beaux-Arts and the Académie

Julian. Several small shows restricted to members were held by this group each year, but the large annual exhibition was also open to women and offered prizes donated by Senator W. A. Clark of Montana and John Wanamaker.

The Paris Society of American Painters, another men's group, was dedicated to promoting the careers of its members. Often showing together as a group, the society entered exhibits throughout Europe. The founders were American artists who had lived abroad for years, Henry S. Bisbing, Frederick A. Bridgman, Dannat, Gay, Harrison, Walter MacEwen, Melchers, Charles Sprague Pearce, Julius L. Stewart, Julian Story, and Edwin Lord Weeks.[35]

Founded in the early 1890s, the American Woman's Art Association sponsored annual exhibitions in which Elizabeth Nourse participated. She was president of the group in 1899–1900, a position held afterwards by Mary Fairchild MacMonnies, Florence Esté, and Anne Goldthwaite. Coexisting with the American Art Students' Club at 4, rue de Chevreuse from about 1910, the American Woman's Art Association appears to have merged with the former organization after 1914. "The purpose of the Association," noted the *American Art Annual* in 1900, "is to bring before the public the work of American women resident temporarily or permanently in Paris." Through the support of Mrs. Whitelaw Reid, benefactor of the association, a residence for women students in Paris was provided at 4, rue de Chevreuse. Today it is owned and operated by Columbia University. The annual exhibition was restricted to American women. At the 1900 exhibition, when Nourse was president, jurors for the annual show were American artists John White Alexander, Edward Frederick Ertz, Alexander Harrison, and Augustus Saint-Gaudens.[36]

The American Women's Club in Paris, in which Nourse participated, also organized exhibitions, but these were not exclusively for women, or even for Americans.

The organization whose efforts got women admitted to the Ecole des Beaux-Arts, the Union des Femmes peintres et sculpteurs, continued to have annual exhibitions in which Nourse was sometimes included. A review of the 1906 event described the works there as good, competent, and conservative, but without originality or revelations of new talent—an apt characterization, perhaps, of artists who had at last succeeded in getting into the Ecole.

> La quatorzième exposition annuelle des Femmes artistes, qui vient de s'ouvrir à la galerie Georges Petit, ne surprendra point par l'orginalité ni par le nouveau et si elle offre plus d'une oeuvre intéressante, elle n'en contient point d'inattendue ni non plus de révelatrice d'un talent ignore. Elle est d'une bonne moyenne.

The reviewer added that one of the best paintings was Nourse's *Dans l'ombre à Penmarc'h* (fig. 94).[37]

Like other practices relating to women in the world of art, that of holding exhibitions exclusively of women's work was controversial. Anna Lea Merrit, an American-born artist who lived in England much of her life, felt that such a practice threatened the acceptance of

female artists on the same level as males and in 1900 wrote:

Recent attempts to make separate exhibitions of women's work were in opposition to the views of the artists concerned, who knew that it would lower their standard and risk the place they had already occupied. What we so strongly desire is a place in the large field: the kind ladies who wish to distinguish us as women would unthinkingly work us harm.[38]

Another voice from England was contemptuous not only of societies for women artists but for women's art as well:

Why then a specifically woman's society? There would be equal reason for a painters' society of men with red hair or blue eyes. And when we recognize that the best members really reproduce the ideas of popular painters of the other sex, a little defaced, deformed, or emptied out, what room is there in the world for those who are not so good.[39]

Obviously Elizabeth Nourse did not share these views, for she supported these organizations by participating in their exhibitions and by active involvement as a member.

Nourse exhibited in a variety of international exhibitions. In Tunis, in 1897, at the Institute de Carthage, she won a third-class medal; at Liège in Belgium in 1909, together with Mary Cassatt, she exhibited with the Salon de l'Association pour l'encouragement des Beaux-Arts. She was represented in 1910 at the exhibition in Vienna, and in 1914 at the Anglo-American exhibition in London. In Paris in 1904, at the invitation of the Société des Orientalistes, she exhibited at the Exposition des Orientalistes, which featured paintings of scenes from the Middle East, India, Spain, Russia, Venice, and Sicily. Also in Paris she showed with the Société Internationale de la Peinture à l'Eau in 1908 and 1910, and at a special exhibit organized in 1910 by the Société Nationale des Beaux-Arts, "Les enfants, leurs portraits, leurs jouets," in which Cassatt was also represented. Elsewhere in France, Nourse exhibited at the Salon in Nice in 1910, and in Picardy in 1913, at an exhibition organized by the Société Artistique de Picardie. In the United States she was represented at the World's Columbian Exposition of 1893 in Chicago, at the National Academy of Design in 1894 in New York, and in exhibitions in Cincinnati, Washington, D.C., and Saint Louis. Such a wide range of activity was certainly the result of her experiences in the Parisian Salons and her associations with artists in Paris.

In spite of policies that discriminated against women, the Parisian art community had no equals as an environment in which women—as well as men—could most fully develop their careers as professional artists. Like other Americans, Elizabeth Nourse was encouraged by the support given to artists and art organizations by the French, and it was largely through the visibility she first gained by exhibiting at the Paris Salons that she attained a stature in the international art community that would not have been possible for her as an artist living in the United States.

Finding Significance in the Commonplace

Participation in the Parisian art world not only brought Elizabeth Nourse international recognition but also largely determined the imagery of her painting. At least three-quarters of her Salon paintings were of European peasant women—mothers with their children, women working in the fields or in the home, women at worship—subjects that were intimately related to her outlook on life. Like other female artists of her time, she concentrated her creative efforts on depicting universal experiences of women. Not too long ago this kind of subject matter, when painted by women, was considered to be an indication of their limitations as artists. Mary Cassatt, in particular, was dismissed from consideration as an important painter because of the predominance of the mother and child theme in her oeuvre; more recently, the issue of women painting women in their maternal and domestic roles has been a point for scholarly reflection. In an article dealing with controversies about distinctive qualities in paintings by women artists, Linda Nochlin addressed herself to their interpretation of female imagery and stressed the importance of historical and local factors in such works.[40] Certainly the choice of such subjects by Nourse, as by Cassatt, is directly within the mainstream of painting in the late nineteenth and early twentieth centuries, when the female figure was ubiquitous in Western art. Woman as mother or as participant in quiet domestic activities was a favorite subject of many male painters, in particular American male painters, and to walk through a gallery of American painting of the late nineteenth century (as in the National Museum of American Art or the Corcoran Gallery of Art) is to be surrounded by such images. "The idealization of woman was so popular a theme in our art in the nineties that it struck foreign observers as peculiarly American," noted E. P. Richardson.[41] The significance of this deluge of female imagery and the way in which it relates to the most profound aspirations of the time has recently attracted considerable scholarly interest.[42] At one extreme females represented an intimate involvement with the primitive origins of life, for the race as for the individual, and at the other they were associated with the highest attainments of human civilization. In the guise of Civilization, Poetry, Liberty, and the like their images were prominently placed on the walls of the Library of Congress and state capital buildings—and, on a more prosaic level, adorned billboards, magazine advertisements, and theaters.

Not only was this overwhelming presence of the female an innovation in American paintings, but figure painting itself was a radical change for native artists. Nourse and her generation were the first to be primarily concerned with the human figure as subject matter, for in the preceding decades, from the 1830s to the 1870s, landscape had prevailed over all other kinds of painting in the United States, and before that, portraits had dominated the art scene. Extensive contact with European artists, especially the French, was a major factor in bringing about this change. In the paintings exhibited by Americans at the Paris Salons from 1870 to 1900, 45 percent were

figure pieces as compared with the 25 percent of landscapes and sea views and the 21 percent of portraits.[43] Few Americans, however, approached the mastery of the French in depicting one popular Salon subject, the female nude, an image that Elizabeth Nourse obviously shunned. One of the few surviving sketches of her nude studies—of which she must have done many as a student—is of a model at the Académie Julian (fig. 18), rigorously modest in pose; one suspects from her art as from aspects of her life that she was staunchly puritanical. But this quality, too, relates to American art in a general sense, for paintings of nudes by late nineteenth-century American artists tend to be chaste and are readily distinguishable from their French counterparts. There are, of course, interesting exceptions, some of which were created by another American woman, Lucy Lee-Robbins, who exhibited in the Paris Salons at the same time Nourse was there and whose character, so Mrs. Potter Palmer of Chicago had heard, "was not above reproach."[44]

The European peasants painted by Nourse were poor, hardworking people whose repetitive chores of daily life inspired some of the most memorable images of nineteenth-century art. At the time Nourse became part of the Parisian art world in the late 1880s, the theme of the peasant in Salon art was at its zenith and was to remain popular for the next quarter-century, a period spanning the greater part of her career.

An enormous popular interest in the European peasant was sustained during these years by a plethora of books and articles on the subject.[45] There was a curiosity about these rural people—how they lived, what they thought, the meaning of their customs. Emile Zola's novel *La Terre*, first published in 1886, was based on the everyday lives of peasants without romantic characterizations, and *La Vie d'un Simple*, written by Emile Guillaumin, who was himself a *métayer*, became something of a literary sensation. Based on the life of the author's father and told in the first person, the book received an award from the French Academy and went through several editions after its initial publication in 1904. Regional studies analyzing the language of peasant folk, recording their distinctive costumes, and documenting their religious customs, were made in France and other European countries. Art critic Jules Champfleury took a serious interest in folk culture, gathered a large collection of ceramics made by peasants, and wrote important books on peasant faience and popular imagery.[46] In a very real sense urbanized Europeans in the nineteenth century rediscovered their peasant populations, a class of people in their own midst of whom most city dwellers were completely ignorant: "Un peuple inconnu, étranger parce qu'étrange, qui est d'abord perçu comme irréductiblement singulier," observes Sylvie Forestier in an essay that examines various concepts the French held about their peasantry.[47]

Americans shared this fascination with the European peasant, whose image became reassuringly familiar throughout the land in all sorts of places, ensconced on velvet-lined walls of mansions or tacked up above kitchen tables. Two examples from American col-

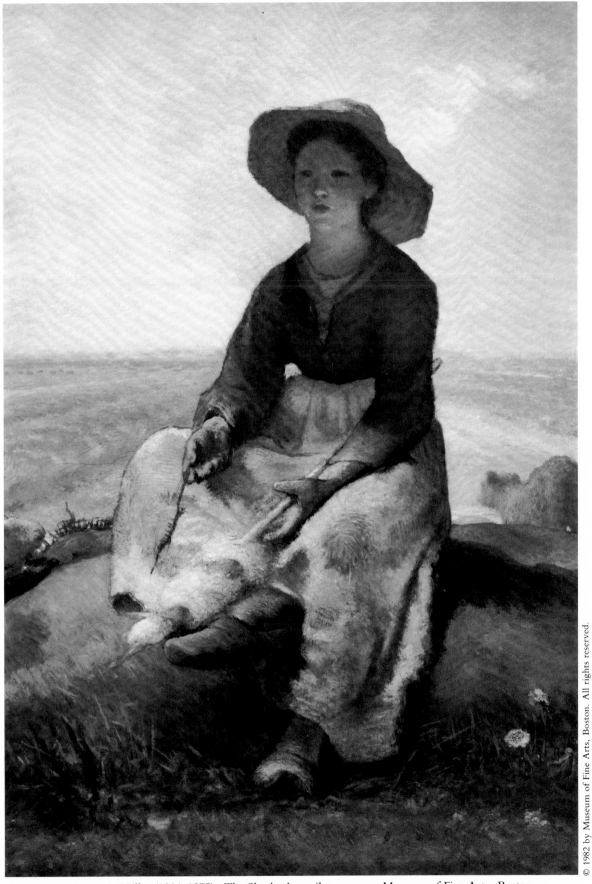

Fig. 69 Jean-François Millet (1814–1875), *The Shepherdess*, oil on canvas. Museum of Fine Arts, Boston, Massachusetts; Gift of Samuel Dennis Warren.

103

Fig. 70 Jules Breton (1827–1906), *The Song of the Lark*, 1884, oil on canvas. The Art Institute of Chicago, Illinois; Henry Field Memorial Collection.

lections are *The Shepherdess* by Jean-François Millet (fig. 69) and *The Song of the Lark* by Jules Breton (fig. 70). Never threatened by the peasant classes as potential revolutionaries, collectors on this side of the ocean could easily maintain an aesthetic distance to paintings of the downtrodden of Europe and were among the first purchasers of Millet's paintings.[48] Albert Boime has suggested that wealthy industrialists who collected these works in the 1880s, when prices had multiplied by hundreds of dollars, were attracted to the "fatalistic character" in Millet's imagery that expressed their own ideal of "workers bound eternally to the soil."[49]

Obviously, the theme must have been profoundly satisfying—if in different ways—to a wide public of viewers and readers to have received such persistent attention over several decades. Obviously, too, the imagery had lost some of its potency since the late 1840s and 1850s when Millet's seminal works at the Salons had produced

104

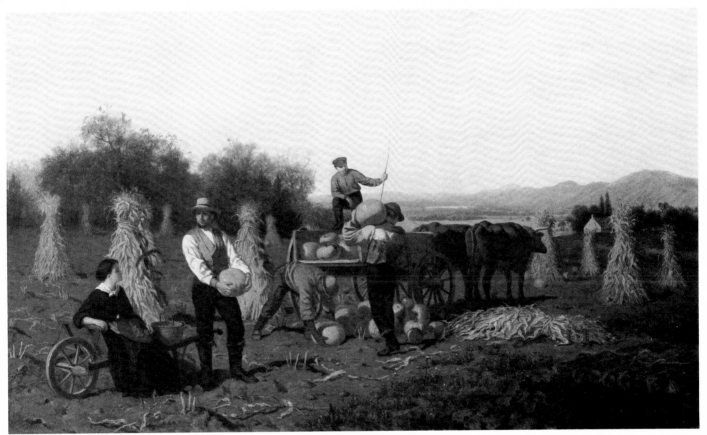

Fig. 71 John Whetton Ehninger (1827–1889), *October*, 1867, oil on canvas. National Museum of American Art, Washington, D.C.; Museum Purchase.

critical disgust and political fears. It was not until after his death in 1875, and the death in 1877 of the other most innovative master of the genre, Gustave Courbet, that the subject of peasants attained its height of popularity.

As Burke points out, Elizabeth Nourse was involved with this type of subject matter before she moved to Paris in that some of her earliest works depict rural and farm people, often blacks, from the Midwest region where she lived. Her *Tennessee Woman* (fig. 2) and *Head of a Negro Girl* (fig. 6) are examples. Americans such as these corresponded in certain ways to the peasant folk of Europe, for like the peasants, rural people and farmers were tillers of the soil and blacks were poor people with a style of life distinctively different from that of most Americans, even as French peasants represented a foreign, almost exotic way of life to Parisians. But nationalistic concepts about rural life in America and about blacks affected the imagery of these groups in American art, producing significant differences from the imagery of European peasants.

In paintings where fields extending without barriers as far as the eye can see provide an expansive setting for ploughmen and harvesters who reap the rewards of their own labor, American rural life typically was portrayed in a very positive manner. John Whetton Ehninger celebrated national attributes of productiveness and prosperity in his painting of 1867, *October* (fig. 71), which depicts the

105

Fig. 72 William Sidney Mount (1807–1868), *Farmer Whetting His Scythe*, 1848, oil on canvas. The Museums at Stony Brook, New York; Gift of Mr. and Mrs. Ward Melville, 1955.

American farmer as landowner proudly posing in the fields with his wife and hired hands. Even in scenes of poorly furnished rural homes, family members are shown as happy and healthy, unafflicted by the specter of privation or the debilitating effects of manual labor.[50] In one of the many depictions of farmers by William Sidney Mount, *Farmer Whetting His Scythe* (fig. 72), the artist presented an image of American progress and efficiency. Until mechanical reapers became common, scythes were the most efficient cutting tools for harvesting and throughout the nineteenth century were constantly improved by the ingenuity of American patents. In contrast the favored cutting tool of the French peasant was the sickle, a much smaller and lighter crescent-shaped tool preferred because it could be held in one hand and operated by a woman, whereas the scythe had to be worked with a swinging motion of both arms and required the strength of a man. Much less efficient than the scythe, the sickle left more unharvested grain, which in rural France, where landowners were required by law to permit the very poor to glean in the fields, was favorably regarded as a practical form of humanitarianism.[51] As typically portrayed in American paintings, the American farmer is male and is decidedly in control of his own fate. In paintings of French peasants, the image is usually female and the energies of the workers seem to be either passively unfocused or else completely given over to a struggle that is entirely physical, without consideration for human thought or feeling.

Changes in technology and scientific approaches to farming were taking place in France as in the United States, but in the European country they intruded upon long-established patterns of life and

Fig. 73 William Morris Hunt (1824–1879), *The Belated Kid*, 1857, oil on canvas.
Museum of Fine Arts, Boston, Massachusetts; Bequest of Elizabeth Howes.

caused great hardship, especially among the poor peasants. In an in-
terpretive essay on the rural image in French painting, Robert L.
Herbert points out that Millet was painfully aware of the adverse ef-
fect of technological changes upon the lives of peasants and pur-
posely depicted outdated implements and methods in his paintings.[52]
That kind of social concern seems almost inconceivable for American
artists, who in their works did not suggest the existence of problems
or of poverty in rural America. Although they, too, sometimes de-
picted an outmoded way of life, they did so mainly out of nostalgia
for an idealized past. William Morris Hunt's *The Belated Kid* (fig.
73), for example, does not refer to a specific time in the past, or
even to an American past. Placing the slight figure of the youthful
shepherd in an ambiguous time and place, Hunt in this work ap-

Fig. 74 Eastman Johnson (1824–1906), *The Lord is My Shepherd*, ca. 1863, oil on wood. National Museum of American Art, Washington, D.C.; Transfer from National Museum of History and Technology, Gift of Mrs. Francis P. Garvan.

proached the poetic imagery of Millet, his master, in an allusion to Biblical parable.[53]

In many ways the lives of American blacks were closer to the lives of French peasants than to those of white American farmers and rural folk. Like the peasants, the blacks were poor and were depicted in paintings as being poor. Because the blacks and the peasants were without influence or power, their images were more easily manipulated to suit the expectations of patrons of art. Represented in a favored type of subject matter, the devotional image, they were frequently sentimentalized in quiet scenes inside a sparsely furnished home, where one person or a group is shown engaged in prayer or in reading the Bible, as in Eastman Johnson's *The Lord is My Shepherd* (fig. 74) and Richard Norris Brooke's *A Pastoral Visit, Virginia* (fig. 75). In these works poverty is associated with the virtue of piety, a connection frequently found in paintings of European peas-

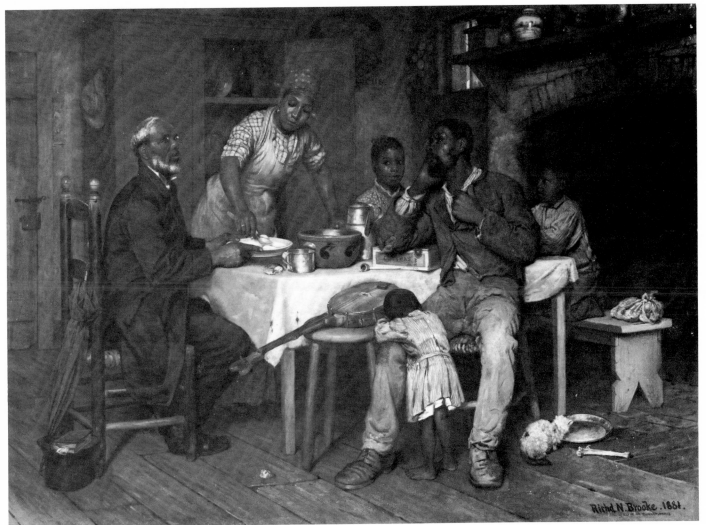

Fig. 75 Richard Norris Brooke (1847–1920), *A Pastoral Visit, Virginia*, 1881, oil on canvas. Corcoran Gallery of Art, Washington, D.C.; Purchase, Gallery Fund.

ants. Also similar to the latter is a passivity in scenes of black people at work, a suggestion of a lack of control over their lives that is in contrast to the portrayals of American farmers consciously directing their action toward an end. Like the images of French peasants, nineteenth-century paintings of American blacks tend to be feminine in character, not necessarily in the representation of female persons but in the expression of what was perceived as feminine qualities: intuitive goodness and passiveness. In a world of flux and progress, the imagery of blacks, somewhat like the imagery of peasants, provided for Americans stable reference points of what was believed to be predictable, unchanging patterns of static lives.

These qualities in American rural and black imagery appealed to American artists and their patrons. Certain aspects also appealed strongly to Elizabeth Nourse as she sought congenial subjects while a student in Cincinnati, and subsequently as she began to develop the imagery of her mature works within the context of French painting.

In Nourse's first Salon painting, *La mère* of 1888 (fig. 19), a young mother gazes intently at the child asleep in her lap. A close physical and emotional bond is expressed by the pose of the mother,

Fig. 76 *Mère et bébé*, 1892, cat. no. A–17.

who inclines her head toward the child held in her arms, and by the concentration of light in the center of the picture on the face and hands of the mother and on the child, with darkness beyond the two figures. In a later version of this theme, *Mère et bébé* (fig. 76), the subject has assumed a definite European appearance. She wears a close fitting cap that identifies her as a peasant woman and her infant suckles her breast—not an unprecedented act in American painting, but one more common in portrayals of mothers who are obviously European. Traces of brushstrokes painted more freely than in the initial Salon entry are visible in this picture, and the shapes of light and dark values that define the planes of the mother's face and the child's body are flatter and simpler. But in both of these paintings Nourse persisted in using the same basic type of composition, placing the figure of the mother parallel with the picture plane and the child in opposition to it, with movement and emotional feeling concentrated in the center of the picture. This classic means of organizing forms in space by balancing their positions and movements was probably taught at the McMicken School of Design in Cincinnati; it was to characterize most of Nourse's work. Two other paintings of nursing mothers, both titled *Maternité,* one dated 1897 (fig. 77) and the other 1898 (p. 150), are unmistakably of peasant women, distinguished as such by the garb of the mother (the same woman is shown in both paintings) and by the swaddling clothes that immobilize the child. (The custom of swaddling had persisted in Brittany.) Among the Bretons, breast feeding was the sole sanctioned method of nurturing infants and a woman felt disgraced if she were unable to nurse her baby.[54]

In these paintings, as throughout her career, Nourse worked directly from the observation of models. As Burke points out, Nourse was often in villages with no inns or accommodations and lived either with members of a religious community or with the peasants. Perhaps her own Breton ancestry, on her mother's side, contributed to an innate sympathy with women and children of the peasantry and enabled her to gain their confidence and observe them closely while living among them. Cecilia Beaux had quite a different experience in Brittany. Writing about her unsuccessful efforts to get a Breton woman to pose for her she observed, "We found that the people, especially the country folk, did not really like *les artistes*."[55]

Beaux and other Americans spoke of Brittany and Holland and their inhabitants as if they were works of art rather than real places with real people, as if they constituted a fund of picturesque materials waiting for the artist to pick and choose. "Brittany is perfect in style," wrote Cecilia Beaux. "The reserve, almost the solemnity, of the landscape may be found in the lines of the dark costume, and the white *coiffe* mingles with tints of sunlit cloud. Figures battling with the wind in full heavy cloth have their base in the strong lines of the sabot, and its making visible strong tones of ochre."[56] Americans were not, however, alone in this attitude; *sauvage Bretagne* harbored a strange beauty even for the French, and painters of every aesthetic persuasion, from Jules Breton to Paul Gauguin, found their own spe-

Fig. 77 *Maternité*, 1897, cat. no. A–31.

cial inspiration there.

When questioned about choosing workers and peasants, even unattractive people, for her paintings, Nourse explained, "To me, these people are not ugly, their faces, their toil-stained hands tell the story of their lives. I cannot paint 'pretty' people; they do not appeal to me."[57]

Even when she did paint middle-class subjects, the thrust of Nourse's work is noticeably different from similar subjects composed and painted by Mary Cassatt. In both Nourse's *Les jours heureux* of 1905 (fig. 78) and Cassatt's *The Caress* of 1902 (fig. 79), for example, the mother holds a small child on her lap while an older girl looks on from the left. In Nourse's composition the three figures are contained within an elliptical shape beginning at the back of the

Fig. 78 *Les jours heureux*, 1905, cat. no. A–64.

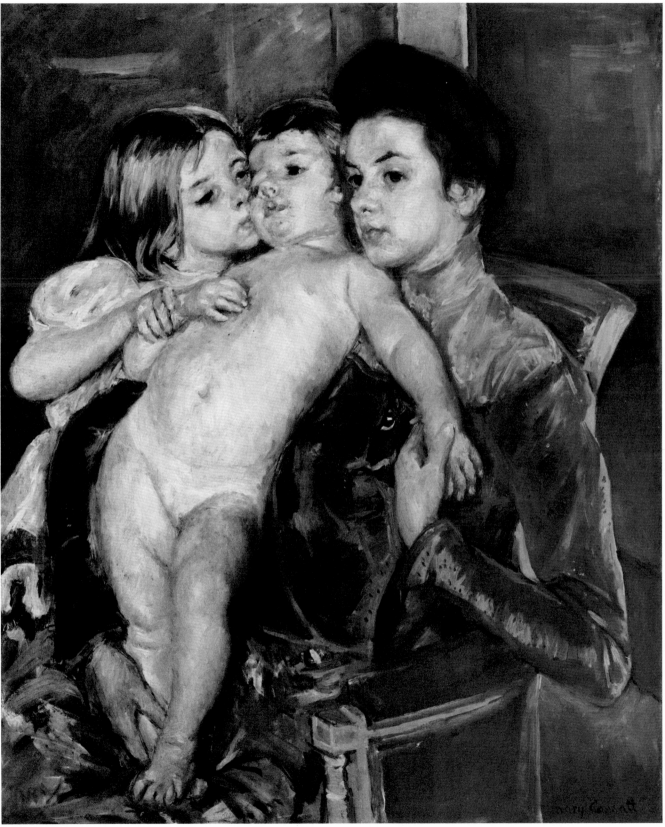

Fig. 79 Mary Cassatt, (1840–1926), *The Caress*, 1902, oil on canvas. National Museum of American Art, Washington, D.C.; Gift of William T. Evans.

girl's head and arm, coming around to the skirt of the child, passing up to the mother's arm and shoulder and through her head, and returning to the head of the girl. All forms of the three figures are soft, rounded shapes that create a harmonious visual pattern. The chest behind them—with a Madonna image on top—stabilizes the group with the strong horizontal movement of a white scarf parallel with the picture plane.

Cassatt's composition is relatively open, with movement going from the center of the picture out to the edges, as in the position of the little girl's legs and her left arm. The abrupt angular form of the mother's elbow introduces a dissonance and keeps the shapes of the three figures from resolving into a rhythmic pattern. This lack of pictorial harmony, typical in Cassatt's paintings, relates her imagery, with its lack of pattern, occasional awkwardness, and unexpected contrasts, to life itself. Cassatt's technique of applying pigment to canvas also asserts a lively movement on the surface of the canvas by separating the brushstrokes and by frequently opposing their direction to the contour of a particular shape. Nourse's brushstrokes are relatively calm and tend to repeat the contour line of shapes, a technique better suited to the balanced, closed stability of her composition. Because of Cassatt's concern to depict figures as if seen at a particular moment, she was able to capture the most distinctive quality of a child: unpredictability. In figure 79, for example, it is not possible to project the physical movement of the squirming child. The artist has thus introduced tension into the design and in a sense puts the viewer psychologically on the alert, even as one must be in the presence of a small child. In Nourse's painting, the baby seems posed, less likely to change position, although the child's glance out of the picture sets up a lively contact with the viewer. Another relevant point is that distinct methods in childrearing may be represented here; perhaps after being trussed up for the first ten or eleven months of their lives, Breton babies (if this is one) tended to be passive. In this painting and in *Mère et bébé* of 1897 (fig. 80), Nourse shows each mother engaged in sewing with a small child tucked under her arm—a combination of activities that would seem rather imprudent.

Nourse's compositions, with their balanced movement around a central axis and the studied relationship of forms to the picture plane, look to the past, to traditional painting. Although fourteen years older, Mary Cassatt was more modern in every aspect of her work. Her early exposure to art in Europe and her association with Edgar Degas, so crucial to her development, made her receptive to the new concepts and methods of Impressionism and Japanese art.

Cassatt's painting *The Caress* celebrates a moment in time as the very essence of life, whereas for Elizabeth Nourse the mother and child relationship represented an important truth of life. Nourse's membership in the Third Order of Saint Francis, an ancient lay order of the Franciscans, was an important commitment, as Burke points out, to the expression of love through sharing with others. In her paintings the mother and child theme become a paradigm of giving

Fig. 80 *Mère et bébé*, 1897, cat. no. A–33.

Fig. 81 *La toilette du matin*, 1891, cat. no. A–13.

Fig. 82 *The Morning Bath*, 1901, cat. no. A–55.

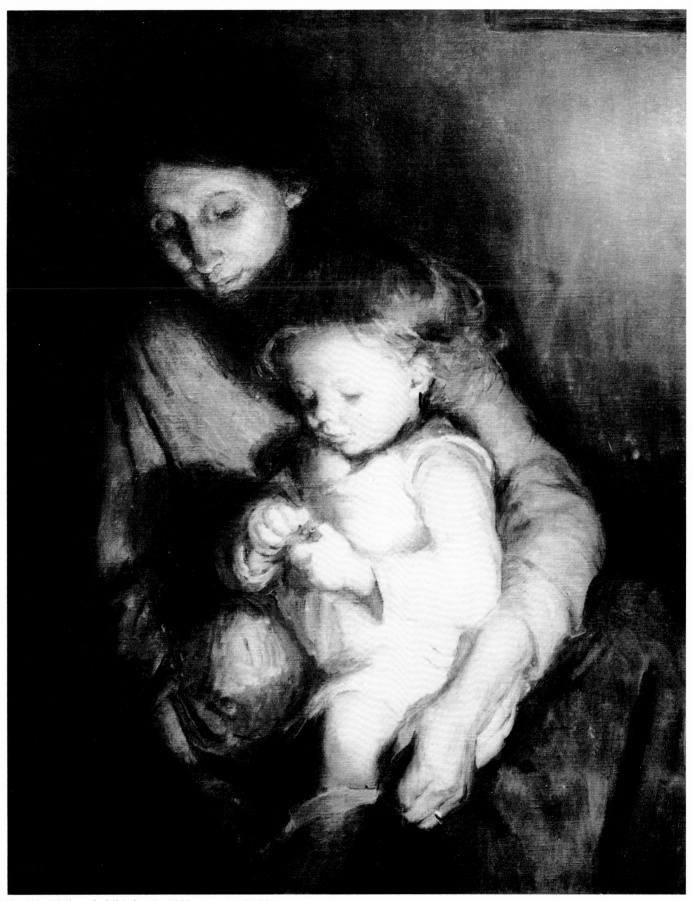

Fig. 83 *Toilette du bébé, le soir*, 1900, cat. no. A–51.

and of receiving in the ideal of Christian charity: of giving, to the utterly helpless, and of receiving, with complete trust and faith in the giver. She portrayed mothers intently involved in the essential duties of child care, feeding and washing, as in *La toilette du matin* (fig. 81) and *The Morning Bath* (fig. 82), as if they were enacting solemn rituals of sustenance and purification. Although her works are not overtly religious in content or symbolic in meaning, through the solemnity and intentness of her subjects she suggests the sanctity of the simple maternal acts and of the dependent relationship between mother and child. These quiet intimate moments often take place by lamplight, as in *Le goûter* (fig. 32), in which a mother holding a spoon feeds the child cradled in her arms while an older child standing beside her drinks from a cup. In *Toilette du bébé, le soir* (fig. 83), harsh light creates dark shadows beyond the mother and reinforces the protective, enfolding movement of her arms around the fragile form of the child.

In addition to Nourse and Mary Cassatt a number of other American artists dealt with the theme of mother and child. The familiar imagery enjoyed a tremendous vogue at the turn of the century by conveying the memory of universal origins and protective love at a time when life—and art—was becoming increasingly fragmented and depersonalized. With its obvious relationship to the tradition of the Madonna in Christian iconography, together with complex new meanings ascribed to the images of women, this imagery lent itself to a variety of interpretations. William Sergeant Kendall's painting *An Interlude* (fig. 84) portrays a contemporary mother and child caught in an affectionate moment. Stabilized by the geometric basis of their pose—their figures are contained within an approximate equilateral triangle, with the open book and the mother's left forearm as the base line—they become an enduring image. The simple geometric structure of the composition is also apparent in the background, where uncluttered wall panels divide the square picture directly in half. Because of this abstraction of the background, the square format of the picture, and the predominance of light hues, Kendall's painting has a modern appearance. Like Cassatt, Kendall was interested in the casual momentary pose, although his approach to the figures is still based on academic painting. George de Forest Brush's dignified *Mother and Child* (fig. 85) self-consciously recalls Italian Renaissance paintings of an elegant, richly attired Virgin proudly displaying her Child to the viewer. The modernity of Brush's painting is in the specific quality of the figures, who are obviously closely observed individuals (in this case Brush's wife and child). Although there is no intention of a religious content, the suggestion of the traditional Madonna image is an important aspect of Brush's conception.

The practice of adapting religious imagery to secular subjects was common in the painting of Nourse's time. In a dissertation on the painting of Mary Cassatt, Nancy Mowell Mathews discusses the prevalence and significance of the Madonna image within the mother and child theme in late nineteenth-century art.[58] George Hitchcock,

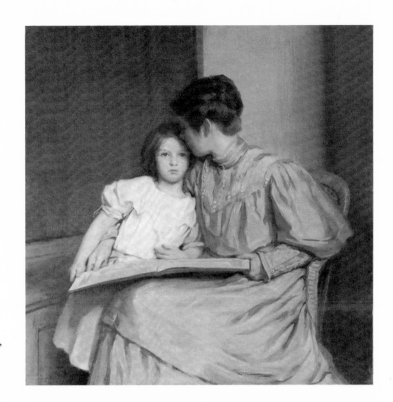

Fig. 84 William Sergeant Kendall (1869–1938), *An Interlude*, 1907, oil on canvas. National Museum of American Art, Washington, D.C.; Gift of William T. Evans.

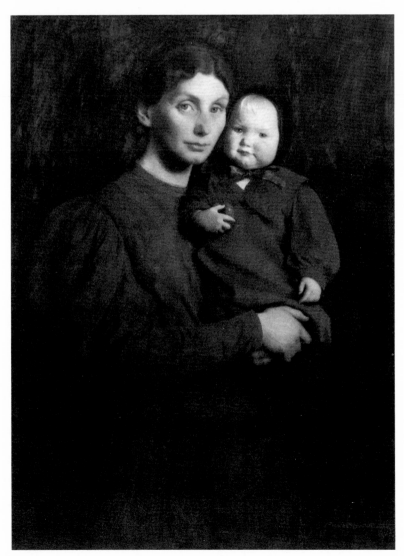

Fig. 85 George de Forest Brush (1855–1941), *Mother and Child*, 1902, oil on canvas. Corcoran Gallery of Art, Washington, D.C.; Purchase, Gallery Fund.

119

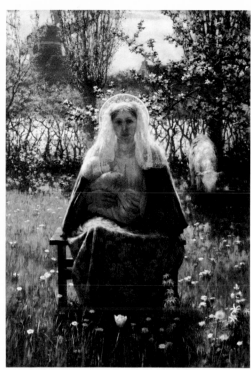

Fig. 86 George Hitchcock (1850–1913), *Blessed Mother*, 1892, oil on canvas. Cleveland Museum of Art, Ohio; Gift of Mr. and Mrs. J. H. Wade.

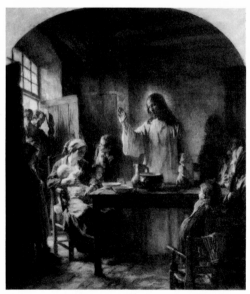

Fig. 87 Léon Augustin Lhermitte (1844–1925), *Christ Visiting the Poor*, 1905, oil on canvas. The Metropolitan Museum of Art, New York City; Purchase, 1905, Wolfe Fund.

an American who worked in Holland for many years, delighted in painting images that seem to flit between the material and spiritual worlds. His *Blessed Mother* (fig. 86), shown at the Salon of 1888, which depicts a young Dutch mother and her child sitting in a field of tulips, suggests the presence of the Virgin in an other-worldly context. In a major study of this type of imagery in American painting, Charles C. Eldredge relates such works by Hitchcock and his contemporaries to the Symbolist movement in France and to similar trends in painting elsewhere in Europe.[59]

This blurring of a distinction between sacred and secular themes occurred also in French art and was, in part, a development of the humanization of religious painting that began during the Second Empire. Among the most popular subjects of that period were the Holy Family and the Virgin and Child, the most universally understood images in Christian iconography, who were often depicted in terms of everyday life. In Eugène Delacroix's *Education of the Virgin,* for example, the artist used as his models a housekeeper and her niece dressed in their everyday clothing.[60] In addition to the Virgin and Madonna themes in late nineteenth-century painting, the merging of the sacred and the secular in Salon subject matter was expressed in scenes of peasants gathered around a table, which recalled the Last Supper, or Christ and the Pilgrims at Emmaus, or scenes that actually introduce the figure of Christ as The Unexpected Visitor. Léon Lhermitte's *Christ Visiting the Poor* (fig. 87) depicts a contemporary peasant family receiving Christ into their home and thus dramatizing the traditional association of the poor with goodness and piety. The German Fritz von Uhde and the Dutch Jozef Israels were among the Salon artists who often painted this theme.

Nourse never implies that the image of the Madonna and Child can be seen in her peasant mothers with their children, nor in her portrayals of peasants around the family table, another favorite subject, does she depict the anachronistic presence of Biblical figures among contemporary people. Her works convey the sense of an essential presence of the sacred implicit in the most common of human relationships. One of her best-known paintings, *Le repas en famille* (fig. 29, shown in Chicago at the World's Columbian Exposition in 1893 as *The Family Meal*), is an interior scene of a family seated around a table. Sharp contrasts of light and shadow are created by daylight coming through the windows in the background. The family group is dominated by the mother, who has her hands clasped in an attitude of prayer and her head turned toward her swaddled infant. As if expectantly awaiting the signal to begin, the little girl looks toward her mother, an image of tenderness and patience. (The father has already turned over his soup plate.) A later version of the subject, *Humble ménage* of ca. 1897 (fig. 41), also exploits contrasts of light and shadow through placing the table around which the family is gathered beneath a window. Again it is the mother who is the center of attention as she prepares the meal under the watchful eyes of her child and husband. Above the husband's head a mirror reflects his wife's image, which may be seen as a sacred icon upon the wall.

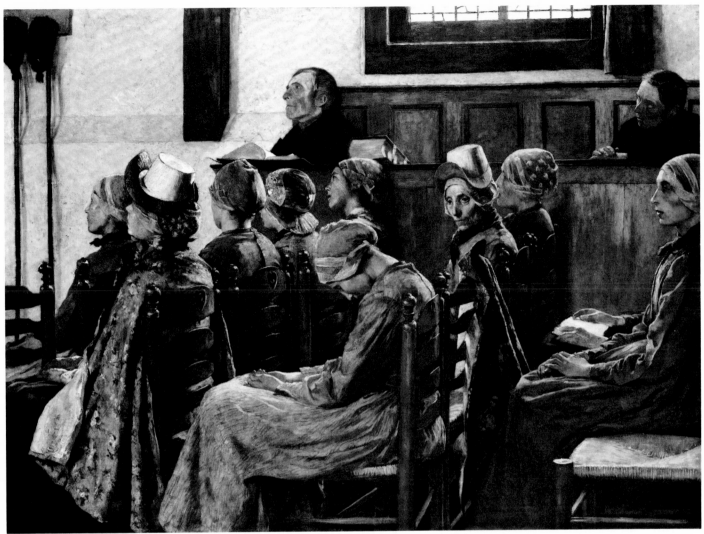

Fig. 88 Gari Melchers (1860–1932), *The Sermon*, 1886, oil on canvas. National Museum of American Art, Washington, D.C.; Bequest of Henry Ward Ranger.

Like other artists who resided in Paris and traveled throughout Europe, Nourse had access to many public and private galleries and must have had a firsthand acquaintance with many works of art. Her scenes of peasant homes suggest sources in seventeenth-century paintings by Jan Vermeer, Pieter de Hooch, and other Dutch masters, in which simple household tasks are performed in the quiet serenity of rooms bathed in light, and in the paintings of the seventeenth-century French master Louis Le Nain, in which solemn peasants at suppers and other gatherings attain a dignity that borders on the sacred. While not copying any specific source from art of the past, Nourse's works suggest a special affinity for these great artists of the seventeenth century, a period of masterful painting that was much admired and emulated by her contemporaries.

Her most overtly religious paintings portray church scenes, preparations for communion, and feast-day processions, all of which were popular subjects for Salon paintings. Involving complex arrangements of figures, these subjects are among her most impressive

works. *Vendredi Saint* (*Good Friday*) of 1891 (fig. 26) is based on a scene she observed in Rome and shows a group of women, dressed in regional costumes, absorbed in meditation and prayer. Kneeling or standing, the five most prominent figures form two diagonal movements that are the basic compositional devices in the painting. One diagonal ascends from the kneeling girl at the center through the covered heads of the two women who stand beside her, and the other descends from that point through the woman with a dark shawl over her head and on through the kneeling woman kissing the crucifix—the climax of the movement. Their unawareness of an observer together with their monumentality as fully visible figures filling most of the pictorial space enhance the singularity of their emotional mood. The kneeling form of the young girl in the foreground suggests similar figures in paintings by Caravaggio, the late sixteenth-century Italian master whose sacred subjects stressed the piety of poor people, while the downward rhythm of the women who kneel before the crucifix recall the dramatic descending movement of gestures in his *Deposition,* formerly in Santa Maria Aracelli, Rome, and now in the Vatican.

In Nourse's *Peasant Women of Borst* of 1891 (fig. 28), life-size figures, intensely absorbed in their devotional prayers, fill the frame. These stalwart Austrian peasants seem to be latter-day representatives of Albrecht Dürer's *Four Apostles,* who read and discuss scriptures with concentrated fervor, pressing their expansive figures against the edges of their panels with the compressed energy of their devotion. Nourse dramatized the impact of her composition by the forward movement of the women, who even while advancing toward the viewer seem to be unaware of being observed. Each woman is rendered as an individual whose pose and expression is a distinct reflection of her state of mind.

The subject of young girls at their first communion was enormously popular at the turn of the century; the possibility of depicting the communicants as images of innocence and purity on the threshold of adulthood, participants in a civilized rite de passage, inspired a varied range of interpretations. In some works the theme was portrayed with sentimental religiosity, showing the girls with eyes closed and heads upturned as they receive the wafer from the priest. In others the scene becomes an appropriate motif for an impressionistic rendition, with the young communicants reflecting sunlight and shadow as they walk to church. In Nourse's painting *La première communion* of 1895 (fig. 38) two girls and a nun prepare for the church ceremony. It is the priest who will give the girls a blessing, but Nourse portrays the dedicated woman of the church, the nun, whose hands on the head of the girl—ostensibly to arrange her veil—seem to impart their own blessing. The bold abstract pattern formed by the white dresses and veils of the girls and the black and white garb of the nun makes this one of the artist's most modern compositions.

Gari Melchers, one of the Americans who was named an *associé* of the Société Nationale des Beaux-Arts at its founding, virtually

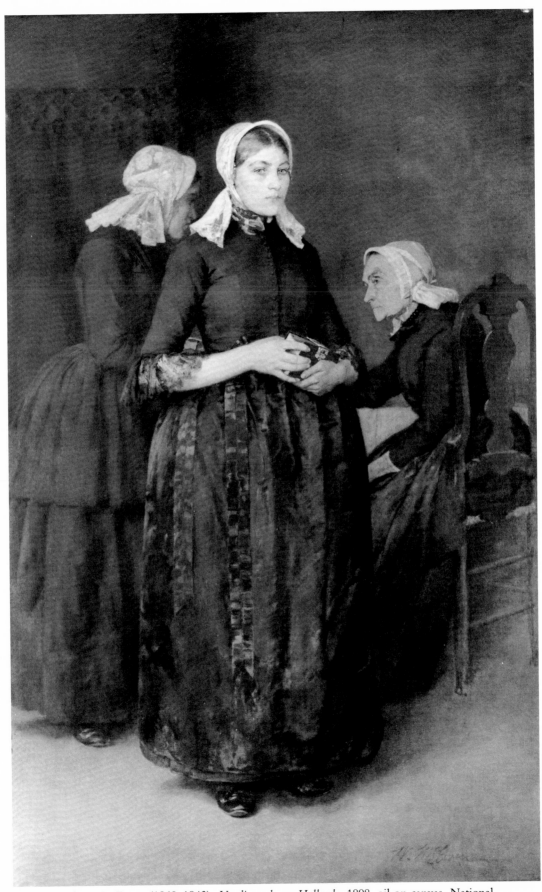

Fig. 89 Walter MacEwen (1860–1943), *Un dimanche en Hollande*, 1898, oil on canvas. National Museums of France.

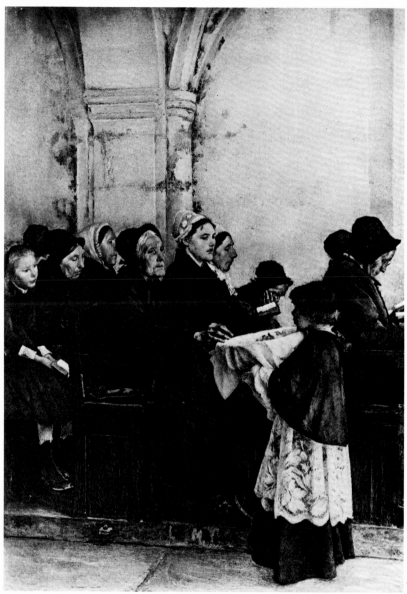

Fig. 90 Pascal Dagnan-Bouveret (1852–1929), *Le pain bénit*, 1886. Reproduced from Georges Olmer et Saint-Juirs, *Salon de 1886* (Paris: Goupil & Cie, 1886).

made a specialty of painting Dutch peasants at religious ceremonies, church services, baptisms, weddings, and communions. One of his finest compositions in this genre is *The Sermon* (fig. 88), a painting similar to Nourse's *Dans l'église à Volendam* (cat. no. B–43), which received an honorable mention at the Salon of 1886 and was later shown at the World's Columbian Exposition. Like Nourse, Melchers tried to capture the responses of the various participants in these events—the response in this case to the sermon of the unseen preacher. His approach differs from hers, however, in that he concentrates less on the devotional content than on the anecdotal detail of the young woman who has fallen asleep in church, which steals the scene. The costumes of the women, their close-fitting bonnets and little hats with high crowns, identify the scene as north Holland. The rather complex organization of the figures in the picture is based

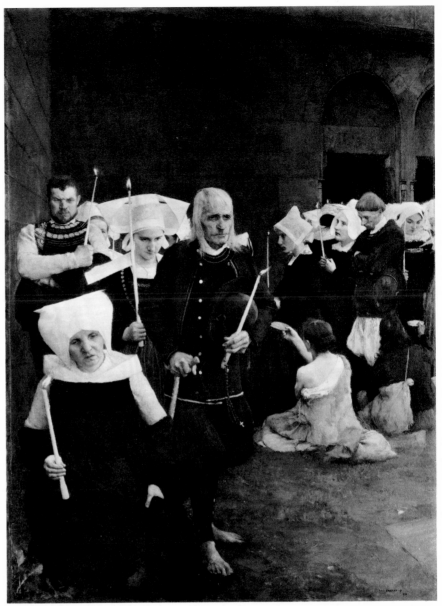

Fig. 91 Pascal Dagnan-Bouveret (1852–1929), *The Pardon in Brittany*, 1886, oil on canvas. The Metropolitan Museum of Art, New York City; Gift of George F. Baker, 1931.

on a geometric scheme formed by the poles of the collection bags hanging on the wall at the left, the vertical lines of which are repeated by the single wooden beam. The wall area is divided from poles to beam and from beam to window into an equal measure, corresponding to half the width of the window, and the exact center of the picture is just below the heedless ear of the errant parishioner. *The Sermon,* like the greater part of Melcher's work, is mainly about women. The men are of considerably less importance; they are neither as carefully observed nor portrayed with the same degree of psychological insight.

This focus upon women as individual persons is apparent in Walter MacEwen's painting *Un dimanche en Hollande* (fig. 89), a simple, effective composition of three women in long black dresses whose costumes and demeanor suggest the uncompromising auster-

ity of a Calvinist Sabbath. MacEwen, another American painter who worked in Holland while keeping in touch with the Parisian art world, expresses a sensitive psychological curiosity in these venerable upright women. Each is characterized as a distinct personality, with faces and hands that record their experiences. As Nourse said of her own peasant models, "their faces, their toil-stained hands tell the story of their lives." Such a penchant for depicting ordinary people of no distinction whatever as individuals with personal histories and thoughts and feelings is one of the hallmarks of the art and literature of this period and is basic to Nourse's oeuvre. To MacEwen old people were of special interest because they bore the physical evidence of years of toil, of hope, and of sorrow—of life itself.

Le pain bénit (fig. 90) represents the female section of a seated congregation in which the worshipers range in age from a bareheaded young girl whose feet do not touch the floor to an old woman who stretches a bony hand toward the communion bread offered by the acolyte. In this work Pascal Dagnan-Bouveret, the French painter who was one of the founders of the New Salon, has, in an astonishingly complete way, represented each person as an individual with private thoughts and emotions and a personal history. His means are undramatic—subtle differences in pose and gesture, faces that seem as if they were formed through the experience of living. As in Melchers's scene of the Dutch parishioners, there is no excitement in this scene of people who sit in church and yet they hold the viewer's attention. In the French painter's version, the act of partaking of the Eucharist provides the experience that unifies the women's varied responses.

In most late nineteenth-century representations of church scenes and ceremonies, the devout are represented as peasants, identifiable by their costumes as the folk of Brittany or other regions in France, or of localities in Holland, Italy, or Spain. The peasantry was believed to be more pious, closer to the unquestioning faith of an earlier time because they partook of a preindustrial way of life. Being relatively unburdened by the temptations and complexities of worldly goods, they seemed more capable of attaining the virtues of goodness and purity. These themes of religious ceremonies and processions, depicted for their own sake and not as records of historical events, first appeared in French art in the 1820s.[61] As the church in France diminished in power in subsequent decades and religious expression became more secular, this kind of subject matter in painting attracted a popular following, offering, as it were, a spectator's approach to worship. For artists of the 1880s and 1890s, this subject matter also related to an interest in the theater, in spectacles, in whatever in life seemed to have style. Like theatrical presentations, some of the church rituals were dramatic and colorful, with each locality celebrating its own particular feast days in a distinctive way. Best known of all such events in Europe were the annual processions in Brittany called *pardons* because they culminated in the granting of absolution to the participants. Major tourist attractions, the *pardons* were discussed at length in the many descriptive books about Brit-

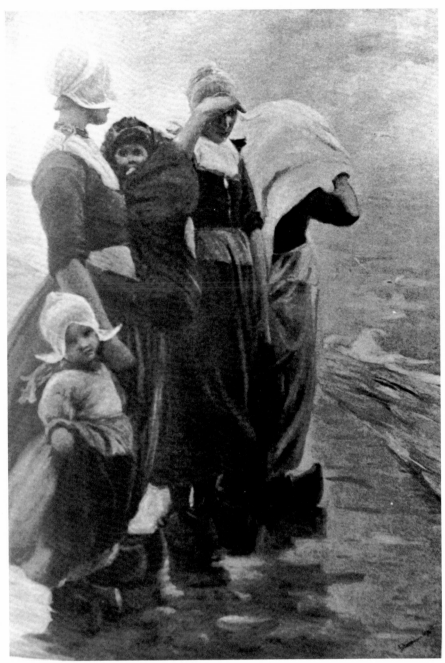

Fig. 92 *Sur la digue à Volendam*, 1892, cat. no. B–47.

tany published at the turn of the century, and at the Salons, paint-
ings of the Breton processions in themselves formed an endless
procession. *Le pardon* was one of those subjects of which neither crit-
ics nor the public seemed to tire. One of the most highly acclaimed
paintings from a long line of canvases was Pascal Dagnan-Bouveret's
Pardon in Brittany (*Le Pardon-Bretagne*) (fig. 91). In a composition that
brings the file of worshipers close to the viewer, Dagnan rendered
each figure with remarkable clarity. Compared with Nourse's paint-
ing of devout women in *Vendredi Saint* and *Peasant Women of Borst*
(figs. 26 and 28), the French painter's group of worshipers are repre-

sented more exactly in the details of anatomy and dress; each figure attracts the viewer's attention separately. Nonetheless, they do not appear as if caught up in a shared emotional mood; their poses would seem to disclose their thoughts, but like facial expressions and gestures caught by a camera, are ambiguous and subject to various interpretations. Critics of the time saw, however, "an intense faith" in each of the faces.[62] In an article that discusses photographic effects in the painting, Gabriel P. Weisberg has pointed out that the artist did indeed paint parts of his picture from photographs of models posed in his studio.[63] It was, of course, common practice for painters of the nineteenth century to make use of photographs. Nourse also based at least one of her paintings, *Le tablier bleu* (fig. 68), on a photograph. Working closely from models herself, even to the extent of posing them in adverse weather conditions or in a replica of a room constructed in her studio, Nourse quite naturally became part of the throng of admirers of Dagnan-Bouveret, marveling at his ability to represent what was before his eyes and to make striking original compositions from the ordinary events of the peasants' lives. Her painting of a procession of Breton women and children, *La procession de Notre Dame de la Joie, Penmarc'h* (fig. 53), is a well-observed scene of figures in bright sunlight with more attention to details and surface appearances than is usual in her paintings.

Nourse's paintings of figures out of doors form a distinct group in her oeuvre. In the best of these she expressed the quality that most attracted painters to the provincial folk of Brittany, Picardy, and areas of Holland, the *ensemble,* the synthesis, of form and feeling that seemed to exist between the peasants and their surroundings. Her *Fisher Girl of Picardy* of 1889 (fig. 25), painted only two years after she went to France, is a bold composition. Seen from a low point of view and silhouetted against the open sky, the young woman is firmly planted on the ground, a strong and sturdy—even craggy—figure, delineated as if her features and body were formed in resistance to the wind. Unlike the women and children in some of the interior scenes, these two do not resolve into a pattern of harmonious shapes. With a basket on her back and poles with furled nets across her shoulder creating a strong diagonal in the picture, the fisher girl has more of the awkwardness of life than the grace of art. *Sur la digue à Volendam* of 1892 (fig. 92), like *Fisher Girl,* is based on the poignant theme of women—in this instance women of Holland—looking out to sea as they wait, perhaps with hope or fear. A paradigm of life with a long tradition in art, this theme inspired a group of works by Winslow Homer in the preceding decade, paintings and prints that feature women waiting and watching by the sea. The poses of the three women in Nourse's painting emphasize the act of looking as they give undistracted attention to the sea.

In another work of 1892, *Across the Meadows (Dans les champs, Hollande)* (fig. 31), a young woman and a child are animated by the woman's looking off to the right of the picture while the child looks straight ahead. The woman's arm, placed in front of her, follows the movement of her glance toward the right while the child's hand,

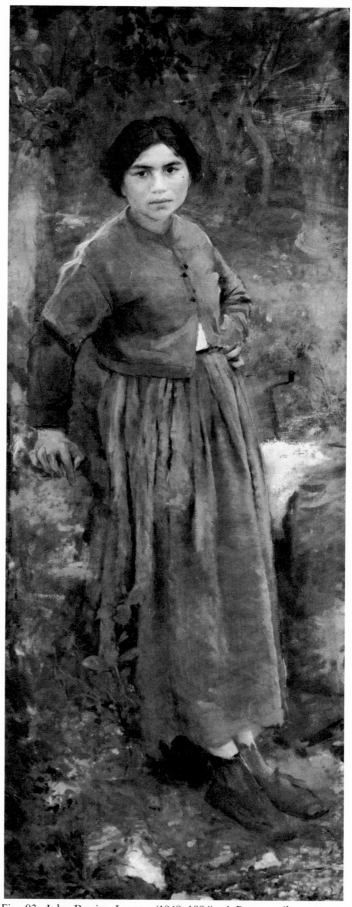

Fig. 93 Jules Bastien-Lepage (1848–1884), *A Peasant*, oil on canvas.
Museum of Art, Carnegie Institute, Pittsburgh, Pennsylvania.

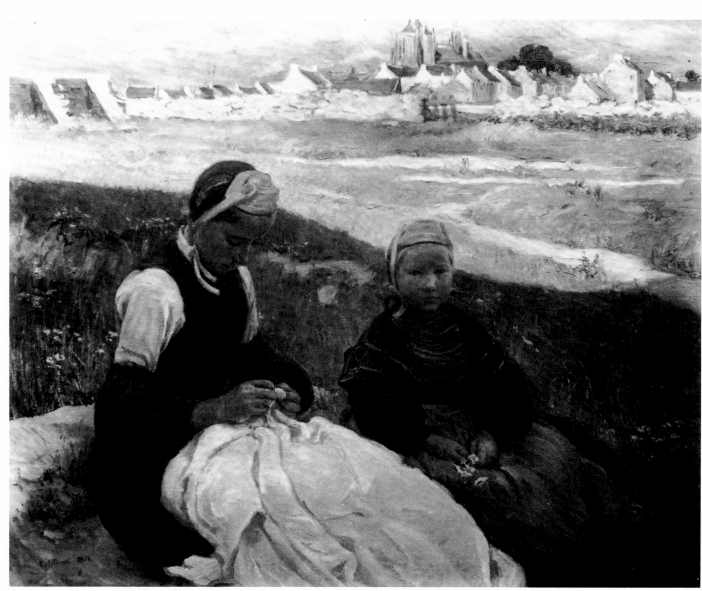

Fig. 94 *Dans l'ombre à Penmarc'h*, 1901, cat. no. A–53.

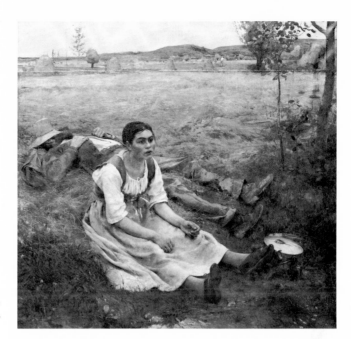

Fig. 95 Jules Bastien-Lepage (1848–1884),
Les foins, 1877, oil on canvas. The Louvre,
Paris.

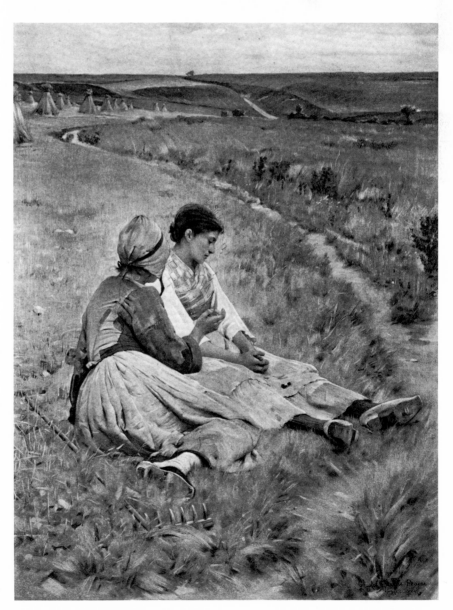

Fig. 96 Charles Sprague Pearce (1851–1914),
Peines de coeur. Reproduced from Henry Havard,
Salon de 1885 (Paris: Goupil & Cie., 1885).

placed in her pocket, reinforces her glance out of the picture. By silhouetting the figures against the fields instead of the sky, Nourse has here adapted a compositional device introduced by Jules Bastien-Lepage, the young French artist who died three years before she went to Paris. There is no convincing sense of the middle ground and background in this painting as in conventional pictorial perspective. Instead the earth and sky appear to be an integral whole, divided into horizontal bands behind the figures, who themselves seem to be inseparable from their setting. Besides stressing the relationship of the people to the land, this compositional device also serves "to heighten the spectator's sense of encounter with the figure and its surrounding space," as Kenneth McConkey points out in an article about Bastien's innovations.[64] These distinctive stylistic traits can be seen in Bastien's painting *A Peasant* (fig. 93), the background of which suggests a vertical backdrop behind the standing figure of the young woman rather than a perspective view of the trees and ground receding into the depth of the woods.

Nourse used this type of pictorial space in other paintings, as in *Les heures d'été* of 1895 (fig. 39), the background of which is formed by three distinct bands of color. At the top is the light green of the foliage of the trees; in the middle the greenish yellow of the sunlit fields; and at the bottom, a bluish green area suggesting the grass in the shade. Touches of pure pigment, violet, green, and yellow, appear on the tree trunks and in the bright middle band. Brushstrokes are bold and freely applied, although again, as in *Les jours heureux* (fig. 78), they tend to follow contours of shapes and thus enhance the sense of volume. Of special interest in this painting is the pose of the figure: the two women sit on the grass sewing, their legs stretched straight out before them in an awkward but natural position. *Dans l'ombre à Penmarc'h* (fig. 94) is similar in the position of the figures. This pose was another invention of Bastien's; it created a sensation at the 1878 Salon when he first used it in his painting *Les foins* (fig. 95). Both figures in this work appear to be a part of the field that surrounds them. The young woman has just raised herself, her expression ambiguous but self-absorbed; wholly unaware of an observer or even of herself, she slumps forward with her arms and legs, her entire figure assuming an ungainly awkwardness. Yet it is this very lack of self-awareness and grace that gives her a convincing potential for animation, for life. *Les foins* was much emulated over the next two decades. *Peines de coeur* (fig. 96), a painting by American artist Charles Sprague Pearce, is another composition that pays obvious homage to Bastien in the pose of the figures and the treatment of the pictorial space.

Bastien-Lepage was considered by some artists and critics as an intermediary between the more radical innovations of Manet and conventional academic figure painting. He was able to combine successfully two outstanding traits of art in his time that were irreconcilable for many: the ability to render with almost scientific accuracy what he observed and the ability to invest his works with his own personal expression, chiefly through his innovative poses and new

Fig. 97 Jozef Israels (1824–1911), *Quand on devient vieux*. Reproduced from Olmer et Saint-Juirs, *Salon de 1886* (Paris: Goupil & Cie., 1886).

Fig. 98 Vincent van Gogh (1853–1890), *The Potato Peeler*, oil on canvas. The Metropolitan Museum of Art, New York City; Bequest of Miss Adelaide Milton de Groot (1876–1967), 1967.

approaches to spatial perspective. Lauded for "not being concerned with the poetic or pictorial, but in the observation of data, in the rendering of what is observed, and in a concern with the psychological,"[65] Bastien was considered by some as the counterpart in art to Zola in literature. Although Elizabeth Nourse was sensitive to the importance of his innovations she adapted only those aspects that were compatible with her own aims. Her own commitment to an ethical ideal did not allow her to observe her subjects unselectively, as though they were "data," or to interpret human life as if it were determined by fate and not conditioned by human responsibility. Thus the theory and the expression of naturalism, associated with Bastien's painting as with Zola's writing, could never be the basis of her own approach to art.

Nourse was sometimes described as a Realist in reviews of her work, and because she painted what she observed that term was appropriate. But like other Americans in Europe she was quite selective about her subjects. "The perception of the lowly peasant, its hopeful, not its hopeless side, is here in a marked degree," wrote Clara T. MacChesney in 1896,[66] exactly describing the scope of Nourse's subjects. Even though Nourse was a keen observer and certainly a caring individual who performed many acts of charity, she never painted those most desperately in need, the destitute. The peasants in her pictures are poor, but they are the virtuous poor, devout and hard working and endowed with the essentials of their physical and spiritual needs. Since ancient times the poor had been associated with Christian virtue but in modern times, at least since the eighteenth century, the destitute had come to be associated with the unregenerate, the unsalvageable aspects of humanity. These unfortunates who

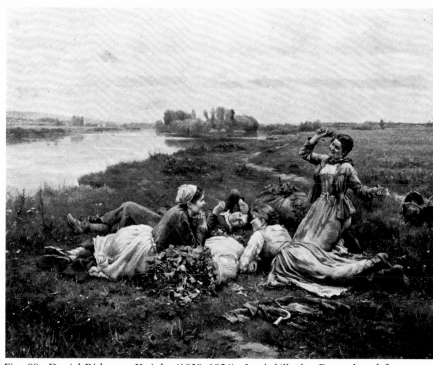

Fig. 99 Daniel Ridgway Knight (1839–1924), *Les babillardes*. Reproduced from Henry Havard, *Salon de 1885* (Paris: Goupil & Cie., 1885).

were beyond the redemptive means of society appeared persistently in nineteenth-century art.

Beginning in the 1830s with subjects of the hopeless by Octave Tassaert, paintings and prints of the destitute and the dying appeared regularly at the Salons. Jozef Israels indulged in this theme and although his *Quand on devient vieux* (fig. 97), from the Salon of 1886, is not an extreme example of the genre, it definitely does not celebrate "the hopeful side" of the human condition. Some of the most powerful images of the nether side of life among the lower classes were the paintings of Belgian and Dutch workers by Vincent van Gogh, such as *The Potato Peeler* (fig. 98) from about the same time that Melchers and Hitchcock were seeking out the more picturesque aspects of Dutch life. Nourse responded sympathetically to European peasants, not because they represented a downtrodden economic class, but because she saw them as individuals, as persons. To a greater extent than other American artists, she entered into the lives of the people she painted and her works express that sense of involvement. Early in her life abroad, she wrote home to Cincinnati that she and her sister spoke only in French, even to one another.[67] This rather extraordinary practice indicates the depth of her desire to be not just an observer but a participant.

Typically, American artists abroad remained outsiders—particularly in relation to the peasantry, who had no share in their beliefs and values—and were quite incapable of perceiving the humble rural folk in the wholeness of their humanity. Daniel Ridgway Knight

was a painter from Philadelphia who, like Nourse, worked in France during his entire career and specialized in the peasant genre. His painting *Les babillardes* (fig. 99) appeared in the Salon of 1885. In expressing his response to the French peasants he painted, he could have been a Georgia planter talking about the local darkies.

> *These peasants are as happy and contented as any similar class in the world. They all save money, and are small capitalists and investors. They enjoy life. They work hard, to be sure, but plenty of people do that. They love their native soil. In their hours of ease they have countless diversions; and the women know how to be merry even in their hours of toil.*[68]

Les babillardes (translated as "The Chatterboxes") shows four young women engaged in animated conversation. A theme Knight painted many times was Waiting for the Ferry, in which he represented attractive young women on a river bank. His concept of his peasant subjects as "happy and contented" is the basis of his imagery, which does not go beneath a superficial description.[69]

Early in her career, Elizabeth Nourse had determined the basic themes of her art: female imagery, especially the themes of mothers and children and hardworking women of the lower economic classes, and although she did not stray far from basic academic precepts she adapted innovations in late nineteenth-century painting that were consistent with her aims. If she had returned to the United States to pursue her career she would not have had the opportunities offered by the Parisian art world for international recognition that made her paintings known throughout the Western world. Further, it seems very doubtful that she would have found any subject in the United States as congenial to her as the European peasantry. The Breton peasants and the Dutch and the Picardy fisher women were not only picturesque but belonged to their land; their lives were as deeply rooted in the past as the ethical ideals that governed Nourse's life and art. In reflecting on the limited success of American authors who dealt with realistic subject matter, Henry James concluded that a distinctive problem was "the thinness of American life upon which they were obliged to draw. It was not, of course, that American life was unreal, but rather that it lacked meaningful social expression of itself; one could see how it *looked,* but the looks conveyed no significant sense."[70] Elizabeth Nourse needed a sense of the significant for her creative efforts but like other American expatriates of her time, both artists and writers, she could not find this in her native land.

Notes

1. These figures are taken from the Paris Salon catalogues and are a part of my study of American artists at the Paris salons from 1800 to 1900, a forthcoming publication of the Smithsonian Institution Press.

2. L. Verax, *De l'envahissement de l'Ecole des Beaux-Arts par les étrangers. Reclamations des élèves français* (Paris, 1886). H. Barbara Weinberg lists the names of Americans who matriculated at the Ecole des Beaux-Arts during the nineteenth century in her recent article "Nineteenth-Century American Painters at the Ecole des Beaux-Arts," *American Art Journal* (Autumn 1981): 66–84.

3. Marie Bashkirtseff, *Journal of Marie Bashkirtseff,* trans. A. D. Hall and G. B. Heckel (Chicago and New York: Rand, McNally, 1890), pp. 407–8.

4. Charles Moreau-Vauthier, *Gérôme, peintre et sculpteur, l'homme et l'artiste* (Paris: Hatchette, 1906), p. 202.

5. This fear of competition proved very real in the 1890s during efforts to win equal opportunities for women artists in Paris. J. Diane Radycki discusses the events in "The Life of Lady Art Students: Changing Art Education at the Turn of the Century," *Art Journal* (Spring 1982): 9–13.

6. The Union des Femmes peintres et sculpteurs was discussed by Wendy Slatkin in "Women Artists and the Ecole des Beaux-Arts: A Study of Institutional Change in Late Nineteenth Century France" (Paper delivered at the National Conference of the Women's Caucus for Art [held concurrently with the annual meeting of the College Art Association of America], New York City, February 25, 1982).

7. Boston Art Students' Association, *The Art Student in Paris* (Boston, 1887), pp. 31–38; lists the Parisian studios most frequented by Americans. In Archives of American Art, New York Public Library Collection, microfilm N 47.

8. In a list of Parisian studios and academies attended by American painters exhibiting at the World's Columbian Exposition in 1893, Elizabeth Broun lists the largest number, thirty-five, as having attended the Académie Julian and the next largest group, twenty-five, as having attended the Ecole des Beaux-Arts ("American Paintings and Sculpture in the Fine Arts Building of the World's Columbian Exposition, Chicago, 1893" [Ph.D. diss., University of Kansas, 1976]).

9. Jacques Lethève, *The Daily Life of French Artists in the Nineteenth Century,* trans. Hilary E. Paddon (New York: Praeger, 1972), p. 26.

10. Cecilia Beaux, for example, makes this mistake in her autobiography. "I was set to copy with Conté crayon . . . a series of lithographic drawings. . . . It was my introduction to Greek sculpture, as interpreted by 'Julien,'* and the prints were very well known as school studies. . . ." In the note to Julien's name, she adds, "Now, of course, the manager of the Paris 'Course.'" (*Background with Figures,* p. 59).

11. Marie Adelaide Belloc, "Lady Artists in Paris," *Murray's Magazine* 8, no. 45 (September 1890): 376.

12. William Rothenstein, *Men and Memories* (Columbia, Mo.: University of Missouri Press, 1981), p. 41.

13. From "Letter from Paris," an extract of a letter written by EN in Paris to Adelaide Pitman in Cincinnati, date unknown, printed in an unidentified Cincinnati newspaper, 1887. In Scrapbook 1 (p. 11), one of two scrapbooks maintained by Louise Nourse that contain newspaper clippings, photographs of Elizabeth Nourse's paintings, and notes on the exhibition and sales of Elizabeth's work. Scrapbook 1, dated 1880 to 1911, is now in the Nourse Family Collection, Cincinnati. Scrapbook 2, dated 1911 to 32, is now in a private collection in Cincinnati.

14. Beaux, *Background with Figures,* pp. 172–73.

15. Lethève, *The Daily Life of French Artists,* pp. 26–27.

16. For an informed discussion of the influence of the Académie Julian upon the art colony in Taos, New Mexico, see A. N. Jensen, "The Académie Julian and the Academic Tradition in Taos," *El Palacio* 79, no. 3 (December

1973): 37–42. I am grateful to Julie Schimmel, Smithsonian Fellow at the National Museum of American Art, for calling this article to my attention.

17. Boston Art Students' Association, *The Art Student in Paris,* p. 31.

18. Ibid., p. 28.

19. Ceraldine Rowland, "The Study of Art in Paris," *Harper's Bazar* 36 (September 1902): 759.

20. Belloc, "Lady Artists in Paris," p. 377.

21. Jeanne Madeline Weimann, *The Fair Women* (Chicago: Academy Chicago, 1981), pp. 195–96.

22. Martha J. Hoppin, "Women Artists in Boston, 1870–1900: The Pupils of William Morris Hunt," *American Art Journal* (Winter 1981): 18–19. In a review of women's art at the Salon of 1870, Zacharie Astruc commented on the restrictions of art education for women and its implications for their careers. Sharon Flescher discusses Astruc's views in an informative article, "Women Artists at the Paris Salon of 1870: An Avant-Garde View," *Arts Magazine* 52, no. 3 (November 1977): 99.

23. E. A. Randall, "The Artistic Impulse in Man and Woman," *Arena* 24 (October 1900): 415–16.

24. From Charles Darwin, *The Descent of Man, and Selection in Relation to Sex,* 2d ed. (New York, 1886), quoted in John C. Greene, *The Death of Adam: Evolution and Its Impact on Western Thought* (Ames, Iowa: Iowa State University Press, 1959), pp. 325–26.

25. Radycki describes this event in "The Life of Lady Art Students," p. 10. This academy was directed by an Italian sculptor, Filippo Colarossi.

26. Lethève, *The Daily Life of French Artists,* p. 26.

27. Bashkirtseff, *Journal of Marie Bashkirtseff,* entry for March 24, 1880, p. 473.

28. "Statistique des Beaux-Arts," in *Annuaire statistique de la France* (Paris) for 1878 (p. 296) and 1886 (p. 322).

29. Société Nationale des Beaux-Arts, "Statuts de la Société Nationale des Beaux-Arts," *Catalogue des Ouvrages de Peinture, Sculpture, Dessins, Gravure, Architecture et Objets d'Art exposés au Champ-de-Mars, le 25 avril, 1895* (Paris: 1895), pp. 299–309.

30. Leopold Mabilleau, "Le Salon du Champ de Mars," *Gazette des Beaux-Arts* 4 (July 1890): 5–6.

31. Nourse's taste remained conservative and almost twenty years later Rodin's tortured images were still beyond her comprehension. "You should see Rodin's awful things in the Salon," she wrote home in 1908. "The man has no legs and only one arm cut off at the wrist—& the lady has two legs cut off at the knees—they both have a head however" (Elizabeth Nourse in Paris to "Dearest" in Cincinnati, June 14, 1908. In Elizabeth Nourse Papers in the Cincinnati Historical Society, box 1, letter 30).

32. Société Nationale des Beaux-Arts, *Catalogue des Ouvrages de Peinture, Sculpture et Gravure exposés au Champ-de-Mars le 15 mai, 1890* (Paris, 1890).

33. "The 'Meissonier Salon,'" *Art Amateur* 23, no. 2 (July 1890): 24.

34. For a sociological analysis of the growth of all aspects of the Parisian art world and its impact upon the criticism and marketing of art, see Harrison C. White and Cynthia A. White, *Canvases and Careers: Institutional Change in the French Painting World* (New York, London, and Sydney: John Wiley & Sons, 1965).

35. The constitution of the Paris Society of American Painters is contained in the Henry Ossawa Tanner Papers, Archives of American Art, Smithsonian Institution, microfilm D 307. Information about the American Art Association and other American organizations in Paris is found in editions of the *American Art Annual* for the period.

36. For additional information see Katharine de Forest, "Art Student Life in Paris," *Harper's Bazar* 33 (July 7, 1900): 629, and Adelyn Breeskin, *Anne Goldthwaite, 1869–1944* (Montgomery, Ala.: Montgomery Museum of Fine Arts, 1977), p. 13.

37. Clipping from unidentified newspaper, in Scrapbook 1, p. 78.

38. Anna Lea Merritt, "A Letter to Artists: Especially Women Artists," *Lippincott's Magazine* 65 (March 1900): 467.

39. D. S. M., "Women Artists," *Living Age* 220 (March 18, 1899): 731.

40. Linda Nochlin, "Women Artists in the Twentieth Century: Issues, Problems, Controversies," *International Studio* 193 (May-June 1977): 170–71.

41. E. P. Richardson, *Painting in America: The Story of 450 Years* (New York: Crowell, 1956).

42. For example, see the exhibition catalogue by Patricia Hills, *Turn-of-the-Century America* (New York: Whitney Museum of American Art, 1977); Bernice K. Leader, "The Boston Lady as a Work of Art: Paintings by the Boston School at the Turn of the Century" (Ph.D. diss., Columbia University, 1980); Susan Fillin Yeh, "Mary Cassatt's Images of Women," *Art Journal* 35 (Summer 1976): 359–63; Judith Elizabeth Lyczko, "Thomas Wilmer Dewing's Sources: Women in Interiors," *Arts Magazine* 54 (November 1979): 152–57.

43. These percentages are stated and the point discussed further in my article "American Participation in The Paris Salons, 1870–1900," in *Salons, Galleries, Museums and Their Influence in the Development of Nineteenth- and Twentieth-Century Art, Acts of the Twenty-fourth International Congress of Art History* (Bologna, 1979).

44. Weimann, *The Fair Women,* p. 191.

45. Robert L. Herbert, "City vs. Country: The Rural Image in French Painting from Millet to Gauguin," *Artforum* (February 1970): 50. For a discussion of the history of peasant imagery in European painting, prints, and book illustrations, see Madeleine Fidell-Beaufort, "Peasants, Painters and Purchasers," in *The Peasant in French Nineteenth Century Art* (Dublin: Douglas Hyde Gallery, Trinity College, 1980), pp. 45–82.

46. Alain Monestier discusses these interests of Champfleury in "Champfleury: Le réalisme et l'imagerie populaire," in *Hier pour demain: Arts, traditions et patrimoine* (Paris: Grand Palais, 1980), p. 122.

47. Sylvie Forestier, "L'image du paysan au XIXe siècle," in *Hier pour demain,* p. 79.

48. For a discussion of the early collectors, see my article "French Art in the United States, 1850–1870: Three Dealers and Collectors," *Gazette des Beaux-Arts* 92, no. 6 (September 1978): 87–100.

49. Albert Boime, "America's Purchasing Power and the Evolution of European Art in the Late Nineteenth Century," in *Salons, Galleries, Museums and Their Influence in the Development of Nineteenth- and Twentieth-Century Art,* p. 137.

50. For additional discussion and illustrations of this theme, see Hermann Warner Williams, Jr., *Mirror to the American Past* (Greenwich, Conn.: New York Graphic Society, 1973) and Patricia Hills, *The Painters' America: Rural and Urban Life, 1810–1910* (New York: Whitney Museum of American Art, 1974).

51. John Horne, "The Peasant in Nineteenth Century France," *The Peasant in French Nineteenth Century Art,* p. 33.

52. Robert L. Herbert, "City vs. Country: The Rural Image in French Painting from Millet to Gauguin," p. 49.

53. For a discussion of Millet in relation to American artists, see Laura L. Meixner, *Millet, Monet, and Their North American Counterparts* (Memphis: Dixon Gallery and Gardens, 1981).

54. Yann Brekilien, *La vie quotidienne des paysans en Bretagne au XIXe siècle* (Paris: Hachette, 1966), p. 149.

55. Cecilia Beaux, *Background with Figures,* p. 147.

56. Ibid., p. 145.

57. Anna Seaton Schmidt, "Elizabeth Nourse: The Work of an Eminent Artist in France," *Boston Evening Transcript* [July 12, 1902], in Scrapbook 1, p. 49.

58. Nancy Mowell Mathews, "Mary Cassatt and the 'Modern Madonna' of the Nineteenth Century" (Ph.D. diss., New York University, 1980).

59. Charles C. Eldredge, *American Imagination and Symbolist Painting* (New York: Grey Art Gallery and Study Center, New York University, 1979).

60. Elisabeth Kashey, "Religious Art in Nineteenth Century France," in *Christian Imagery in French Nineteenth Century Art, 1789–1906* (New York: Shepherd Gallery, 1980), p. 8.

61. Ibid., p. 6.

62. Henry Havard in *Le Siècle,* quoted in Gabriel P. Weisberg in "P. A. J. Dagnan-Bouveret and the Illusion of Photographic Naturalism," *Arts Magazine* 56 (March 1982): 103.

63. Weisberg, pp. 102–3.

64. Kenneth McConkey, "'Pauvre Fauvette' or 'Petite Folle': A Study of Jules Bastien-Lepage's 'Pauvre Fauvette,'" *Arts Magazine* 55 (January 1981): 140. Recent major scholarship on Bastien-Lepage includes William Steven Feldman, "The Life and Work of Jules Bastien-Lepage (1848–1884)" (Ph.D. diss., New York University, 1974).

65. W. C. Brownell, "Bastien-Lepage: Painter and Psychologist," *Magazine of Art* (London) (May 1883): 271.

66. Clara T. MacChesney, "An American Artist in Paris: Elizabeth C. Nourse," *Monthly Illustrator* 13, no. 1 (August 1896): 8.

67. Extract of a letter from EN in Paris to Adelaide Pitman in Cincinnati, date unknown, printed in an unidentified Cincinnati newspaper. In Scrapbook 1, p. 18.

68. Daniel Ridgway Knight, quoted in G. W. Sheldon, *Recent Ideals of American Art* (New York and London, 1890), pp. 24–25.

69. For other American concepts of French peasants, see Peter Bermingham, *American Art in the Barbizon Mood* (Washington, D.C.: Smithsonian Institution Press for the National Collection of Fine Arts, 1975), pp. 79–86, and David Sellin, *Americans in Brittany and Normandy: 1860–1910* (Phoenix: Phoenix Art Museum, 1982).

70. Quoted in Lyall H. Powers, *Henry James and the Naturalist Movement* (East Lansing, Mich.: Michigan State University Press, 1971), p. 11.

Chronology

Unless otherwise noted, the artist lived and traveled with her sister, Louise Nourse, after her departure to France in 1887.

1859
Born October 26, Mount Healthy, Ohio; one of twin daughters of Caleb Elijah and Elizabeth Rogers Nourse.

1874–81
Entered School of Design of the University of Cincinnati (still generally known by original name, the McMicken School of Design), graduating June 1881. Classes included drawing and watercolor under Will H. Humphreys, oil painting under Thomas S. Noble, wood carving under Benn Pitman, china painting under Marie Eggers, sculpture (1879–81) under Louis Rebisso, and engraving under an unknown instructor.

1879
Exhibited at Cincinnati Industrial Exhibition, and again in 1881–84 and 1886.
Became honorary member of the Cincinnati Woman's Pottery Club.

1880
Earned money by making drawings of private homes, illustrating magazine articles, and executing portraits, flower drawings, and mural decorations.

1881
Graduated from McMicken in June. Declined offer to teach drawing there in order to remain a painter (listed in Cincinnati city directory as "artist").

1882
April 21: Father died in Cincinnati.
Summer: Traveled to Sandusky, Ohio, where her twin sister Adelaide married Benn Pitman in August (date unknown). Made additional trips in August with Mimi Schmidt, a close friend, to Quebec, Niagara Falls, and Washington, D.C.
August 27: Mother died in Cincinnati.
Fall: Under chaperonage of Mrs. John H. Hudson, went to New York City and studied at the Art Students League, probably beginning in September. Attended life class under William Sartain.

1883
Returned to Cincinnati from New York (probably by early spring). Lived with older sister, Louise, and began supporting herself and Louise through sales of her art work and decorative commissions.

Exhibited for first time at the American Water Color Society, New York, and thereafter in 1884, 1886, and 1911.
Exhibited at Detroit Art Loan Exhibition.

1884–86
Summers: Spent a part of each summer working in Tennessee mountains.

1885–86
Returned in 1885 and 1886 to McMicken school (as it was still called) to take first life classes offered to women; studied under Thomas S. Noble.

1887
July 20: Sailed on the *Westernland* from New York; arrived in Paris in late August. Stayed initially at Villa des Dames, Paris.
Studied three months at the Académie Julian under critical supervision of Gustave Boulanger and Jules Lefebvre.
Rented studio at 8, rue de la Grande Chaumière.
Took work to Jean-Jacques Henner and Carolus-Duran for criticism.

1888
Spring: Entered *La mère* (A–2) in the Salon of the Société Nationale des Artistes Français, Paris; painting was accepted and was hung "on the line."
Summer and early fall: Worked in Barbizon.

1889
January–February: Visited the Ukraine, near Kiev, as guest of Tolla Certowicz, a sculpture student at the Académie Julian (unaccompanied by Louise).
Exhibited two paintings at the Société Nationale des Artistes Français.
Exhibited *La mère* at the Royal Academy, London.
July: Worked in Etaples, Picardy, accompanied by Anna S. Schmidt and her sister, Elizabeth Schmidt Pilling, of Washington, D.C. (sisters-in-law of Cincinnati friend Mimi Schmidt).
Vacationed at Le Portel and Boulogne with friends from the Académie Julian, Mary Wheeler and Beulah Strong.

1890
January: Traveled south with Louise, Anna Schmidt, Beulah Strong, and Mary Wheeler to Avignon and through Provence to Marseilles; sailed to Genoa. Visited Naples, Pompeii, and Capri.
February: In Rome, received telegram inviting her to exhibit in Paris with the newly formed Société Nationale des Beaux-Arts. Sent Société two oils and two watercolors, and exhibited in its salons annually thereafter until 1914 when salons closed due to onset of World War I, and again in 1918, 1919, and 1921.
March: Visited Grotta Ferrata, Tivoli, Venice, and Florence, with side trips to Pisa and Siena from Florence.
July–November: Worked in Assisi, accompanied only by Louise.
November–June 1891: Worked in Rome; rented a studio in same building as one used by Elihu Vedder.

1891
July 1–mid-August: Worked in Borst, Austria, for six weeks.

August: Took Rhine steamer to Koblenz; visited Nuremberg and Trier, returning to Paris in September.
Exhibited in London at the Continental Gallery and at the Institute of Painters in Oil Colours, and in Philadelphia at The Art Club.

1892
Moved to new studio at 72, rue Notre Dame les Champs.
July–August: Worked in Volendam, Holland, in studio shared with friends from Cincinnati, Henriette and Laura Wachman; visited Huizen and Laaren, Holland.
Exhibited in London at the Royal Academy, the Institute of Painters in Oil Colours, the New Watercolour Society, and the Royal Society of British Artists; in Liverpool at the Walker Art Gallery; in Munich at the Kunstaustellung; and in Philadelphia at The Art Club.

1893
April 21: Sailed for New York City. Returned to Cincinnati via Washington, D.C. Stayed at the Benn Pitman home.
Visited World's Columbian Exposition in Chicago, where two of her paintings, *Peasant Women of Borst* (B–39) and *Le pardon de Saint François d'Assise* (B–32), exhibited under its English title *The Pardon at Assisi,* were on loan to the Cincinnati Room exhibition. (*Peasant Women of Borst* had been purchased for the Cincinnati Art Museum by the subscription of seventeen Cincinnati women.) Exhibited also at the Palace of Fine Arts at the World's Columbian Exposition; received medal for her work, *The Reader* (B–49), and *Vendredi Saint* (B–37) and *Le repas en famille* (B–42), shown under their English titles *Good Friday* and *The Family Meal.*
September 12: Death of her twin, Adelaide Pitman, in Cincinnati.
November 26–December 9: Had only major solo exhibition of her work at the Cincinnati Art Museum, where one hundred works were shown.

1894
January: Began six-week visit in Washington, D.C., with Elizabeth Schmidt Pilling and her husband John.
February 5–14: Exhibition of sixty-one works (previously shown at the Cincinnati Art Museum) at the V. G. Fischer Art Gallery, Washington, D.C. This gallery acted as her primary dealer in the United States until it closed in 1912.
April: Sailed for Southampton, England. Spent several weeks in England; exact locales unknown.
May: Arrived in Paris; unable to locate suitable studio. Traveled to Brittany. Visited Concarneau and Pont-Aven; decided to work in Saint Gildas-de-Rhuys because there were no tourists. Remained in Saint Gildas until October 8, boarding with the Sisters of Charity of Saint Louis.
September: Located new studio at 80, rue d'Assas, where she and Louise resided for the rest of their lives.
Exhibited for the first and only time at the National Academy of Design, New York City, showing *Dutch Interior, Volendam* (B–44) and *The Reader* (B–49).

1895
Spring: Elected *associé* of the Société Nationale des Beaux-Arts in the category of drawing.
Summer: Worked in Saint Gildas-de-Rhuys, Brittany; visited Saint Léger-en-Yvelines, a village in the forest of Rambouillet, which was to become her favorite country retreat.

Invited to exhibit for the first time at the Chicago Art Institute's Annual Exhibition of American Art; exhibited again annually (except for 1907) through 1914.

Invited to exhibit at the Pennsylvania Academy of The Fine Arts' Annual Exhibition of American Art; exhibited again in this annual fifteen times.

Exhibited in Liverpool, England, at the Walker Art Gallery.

Exhibited at the Saint Louis Exposition and at the Music Hall in Saint Louis. Exhibited at the Music Hall again in 1896.

1896–99

Summers: Rented cottage from the Léthias family in Saint Léger-en-Yvelines, near Paris, and worked there.

1897

February–April: Worked in Tunisia, with a side trip to Biskra, Algeria.

Exhibited at the Institute de Carthage, Tunis; awarded third-class medal.

Exhibited in Copenhagen at the International Exposition.

Exhibited for the first time at the Annual Exhibition of Works by American Artists at the Cincinnati Art Museum; exhibited again in this annual nine times.

Invited for the first time to exhibit at the Exhibition of International Art at the Carnegie Museum, Carnegie Institute, Pittsburgh; exhibited again in this annual seven times.

Exhibited at the Tennessee Centennial Exposition in Nashville; awarded silver medal for *La leçon de lecture* (A–24), shown under its English title *The Reading Lesson*.

Le goûter (A–18) donated to the Art Institute of Chicago under the title *Mother and Children*.

1899

Summer: Worked in Saint Léger-en-Yvelines; also modeled several works in bas-relief.

Fall: Elected president of the American Woman's Art Association of Paris for the term 1899–1900. Entered annual exhibitions of this group of women artists residing in Paris.

Plein été (A–39) given by unknown donor to the Art Gallery of South Australia under its English title, *Midsummer*.

1900

April: Exhibited *Dans l'église à Volendam* (B–43) at the Exposition Universelle in Paris; this work was awarded a silver medal.

Summer: Remained in Paris, welcoming visiting friends.

September: Worked for approximately ten days in Normandy. Then traveled in Brittany through Finistère, going via Quimper and Pont l'Abbé to Pointe de Penmarc'h, where she and Louise boarded at the convent of the Filles de la Sagesse.

1901

Elected *sociétaire* of the Société Nationale des Beaux-Arts in the category of drawing, pastel, and watercolor.

April: Visited the Côte d'Azur, staying in Menton with Mary and Helen Rawson, friends from Cincinnati.

Summer: Worked in Penmarc'h, Brittany.

1902

Summer: Worked in Penmarc'h, Brittany.

November: Exhibited in New York City at the Woman's Art Club of New York; exhibited at the club's annual again in 1904, 1911, and probably other years as well.

1903

Summer: Worked in Penmarc'h, Brittany.

Fall: Worked in Champéry, Switzerland.

Winter 1903–4: Ill and unable to paint.

1904

Elected *sociétaire* of the Société Nationale des Beaux-Arts in the category of oil painting.

Elected associate member of the Newspaper Artists' Association and Magazine and Book Illustrators' Society.

Invited to exhibit with the Société des Orientalistes at the Exposition des Orientalistes, Paris; exhibited with this group again in 1906.

Exhibited at the Louisiana Purchase Exposition in Saint Louis; awarded silver medal for *La petite soeur* (B–82), *Dans l'ombre à Penmarc'h* (A–53), and *Enfants de Penmarc'h* (C–119).

Awarded prize for best oil painting in the annual exhibition of the Woman's Art Club of New York.

1905

January: Exhibited with the Union des Femmes peintres et sculpteurs at the Galerie Georges Petit in Paris. Probably exhibited with group periodically although its records are incomplete; is known to have exhibited in 1916.

Exhibited in Nantes at the Exposition des Amis des Arts; exhibited again with this group in 1908, 1911, and 1912.

Exhibited in Antwerp, Belgium.

Exhibited in Paris suburb of Nogent-sur-Marne at the Colonial Exhibition; awarded medal for *Les toits de Tunis* (D–51).

1906

February-April: Traveled in the Pyrénées Atlantique (formerly the Basses-Pyrénées) département, going on to Saint Jean Pied-de-Port. Visited Burgos and Toledo in Spain.

July: Painted watercolors in Loguivy, northern Brittany.

Donated six works on paper to a benefit for the Woman's Art Club of Cincinnati, of which she was an honorary member.

Was elected first president (for 1906–7 term) of the Lodge Art League, a group that held annual exhibitions of English-speaking women artists under the auspices of the Episcopal Church in Paris; exhibited again with this group five times.

1907

Fall: Worked in Plougastel-Daoulas, a village near Brest in western Brittany.

Invited to enter the first annual Exhibition of Contemporary Painting at the Corcoran Gallery of Art, Washington, D.C.; exhibited again in this annual in 1910/11 and 1912/13.

Exhibited in Philadelphia at the annual Philadelphia Watercolor Exhibition at the Pennsylvania Academy of The Fine Arts; exhibited again in this annual in 1909, 1910, and 1912.

1908

Visited in Paris by Judge and Mrs. Thomas J. Burke of Seattle, who in 1932 gave their collection of ten of her paint-

ings to the University of Washington.

Exhibited in Paris with the Société Internationale de la Peinture à l'Eau; exhibited again with this group in 1910.

1909

May: Exhibited at the Château de Bagatelle exhibition of the Société Nationale des Beaux-Arts; exhibited again there in 1910 and 1913.

September: Visited the Château de Trücksess in Haute Alsace as guest of the Marquise de Roy; visited Strasbourg before returning to Paris on October 6.

Exhibited in Liège with the Salon de l'Association pour l'encouragement des Beaux-Arts.

Exhibited in Liverpool and Rouen.

Exhibited at the International Art Union, Paris; *Les jours heureux* (A–64) won Whitney-Hoff Purchase Award and was given to Detroit Institute of Arts under its English title, *Happy Days.*

1910

Exhibited in "Les enfants, leurs portraits, leur jouets," organized by the Société Nationale des Beaux-Arts, Paris.

Exhibited in Vienna Exhibition.

Exhibited in Nice.

Les volets clos (B–120) purchased by the French government for its collection of contemporary art at the Musée du Luxembourg, Paris.

1911

Exhibited in Vienna with Society of Women Artists, a newly formed international group of female artists.

Exhibited in Rome at the Exposizione Internationale.

Exhibited in Boston at the Water Color Club.

1912

Exhibited in Paris at the Exposition des Quelques with a group of twenty-seven women painters and sculptors.

Exhibited in Indianapolis at the John Herron Art Institute.

Exhibited in Nantes, Liège, Le Havre, and Bordeaux.

1913

Exhibited in Liverpool.

Exhibited in Le Torquet, Picardy, with the Société Artistique de Picardie, a group of expatriate American artists who had worked in Normandy formed by Henry Ossawa Tanner.

Shared first prize at the American Woman's Art Association exhibition in Paris (with three paintings by other artists) for *La bonne menagère* (B–112), a watercolor.

1914

Named honorary member of the Association of Women Painters and Sculptors (formerly called the Woman's Art Club) of New York City.

Named honorary member of the MacDowell Society of Cincinnati.

Elected member of the Philadelphia Water Color Club.

Exhibited two oils and three watercolors at the Anglo-American Exposition in London.

1914–18

Devoted time almost entirely to charitable work after outbreak of World War I in July, although continuing to send paintings to exhibitions.

1915

Exhibited at the Panama-Pacific Exposition in San Francisco; *L'été* (B–123), exhibited under its English title *Summer,* was awarded a gold medal.

Exhibited dolls in Paris at the Exposition des Jouets Français, and again in 1916 and 1917.

1917

Summer: Worked for several weeks in Penmarc'h, Brittany.

Exhibited in Liverpool.

1918

Spring: Exhibited in the first Salon of the Société Nationale des Beaux-Arts to be held since 1914; exhibited there twice again, in 1920 and 1921. Based on Louise's list of entries in Scrapbook 2, page 76, for the New Salon of 1919, EN may have exhibited that year as well, but her name does not appear in the Salon's exhibition catalogue.

Summer: Worked for several weeks in Penmarc'h, Brittany.

1919

Presented with silver plaque by the board of the Société Nationale des Beaux-Arts in recognition of her work on behalf of indigent artists during World War I.

Exhibited *Les volets clos* (B–120) and *La rêverie* (B–119) in L'Exposition de l'Ecole Américain au Luxembourg at the Musée du Luxembourg, Paris.

Exhibited paintings and Breton dolls at the Exposition des Peintres d'Amor at the Goupil Galerie, Paris.

Exhibited in Bordeaux.

1920

Underwent surgery for breast cancer in Paris.

Exhibited in London.

Exhibited in Paris with a group of American artists at the Galerie Manuel Frères.

1921

Awarded the Laetare Medal by Notre Dame University, South Bend, Indiana, for distinguished service to humanity.

1924

Exhibited with Les Artistes Américains de Paris at the Knoedler Galleries, Paris.

Retired and painted thereafter only for her own pleasure.

1937

January: Death of Louise Nourse in Paris.

Became ill.

1938

October 8: Died and was buried beside Louise in the church cemetery at Saint Léger-en-Yvelines.

1941

Exhibition of works left in her estate at the Closson Gallery, Cincinnati.

Color Illustrations

Cabin Interior, Millville, Indiana, 1881, cat. no. B–7.

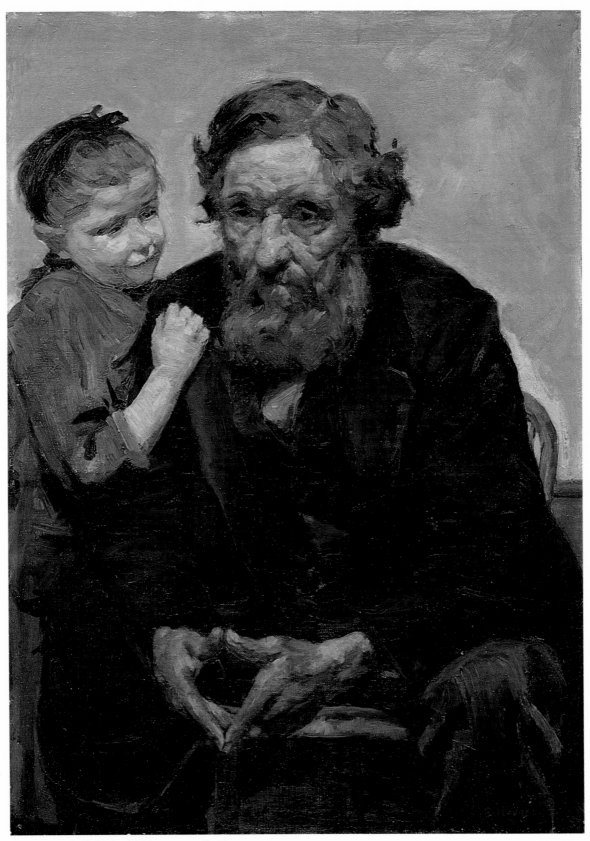

Old Man and Child, by 1887, cat. no. B–11.

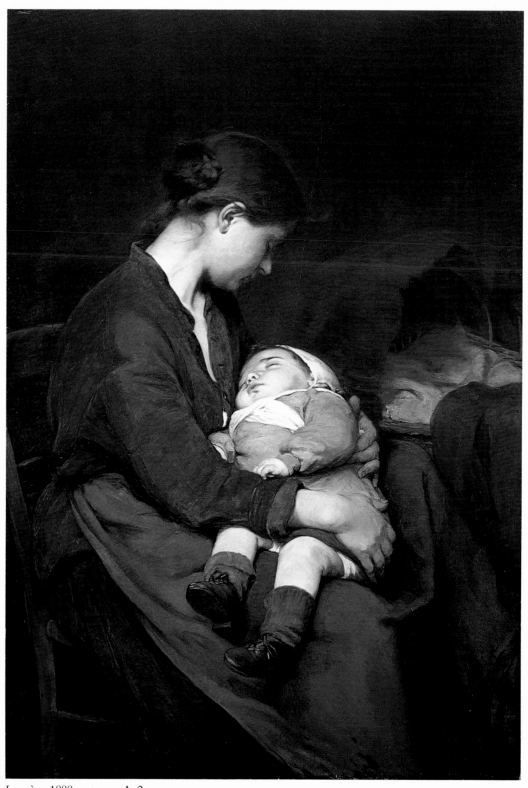

La mère, 1888, cat. no. A–2.

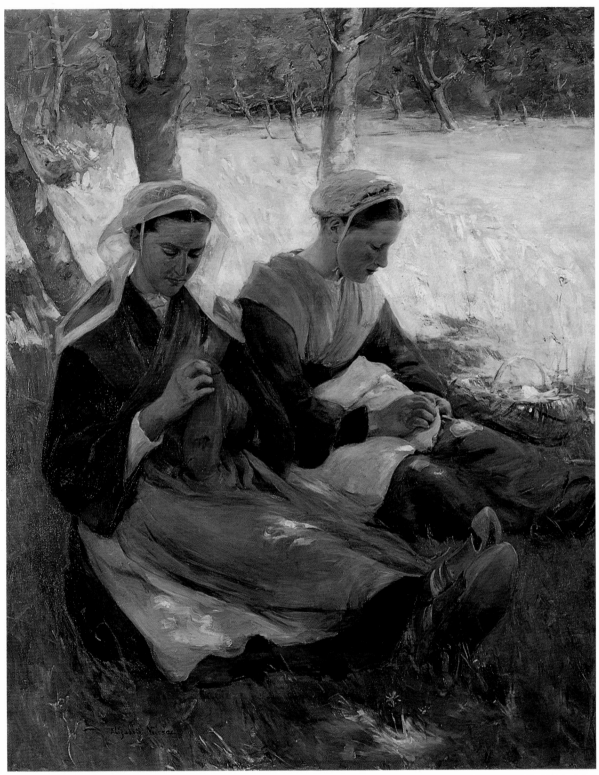

Les heures d'été, 1895, cat. no. B–59.

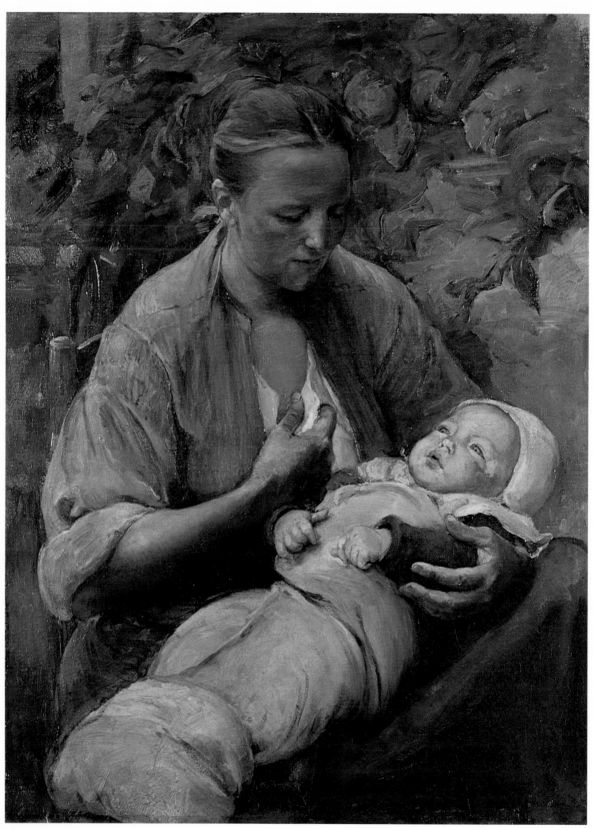

Maternité, 1898, cat. no. A–38.

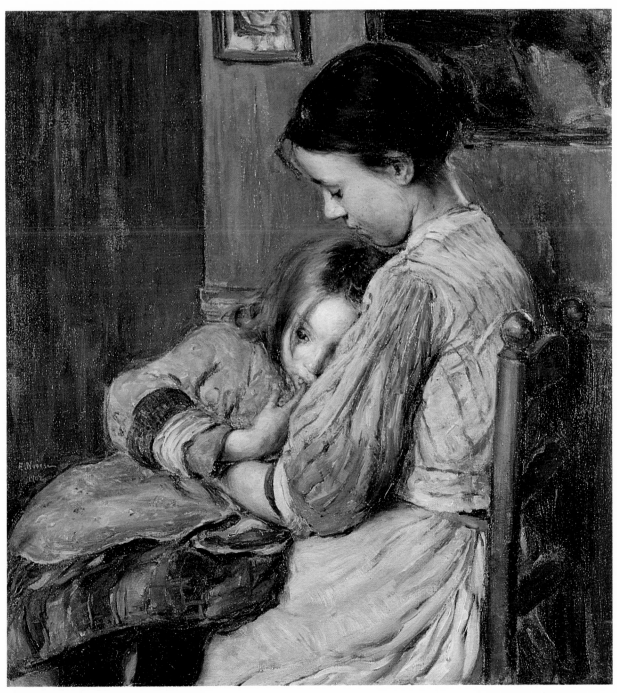

La petite soeur, 1902, cat. no. B–82.

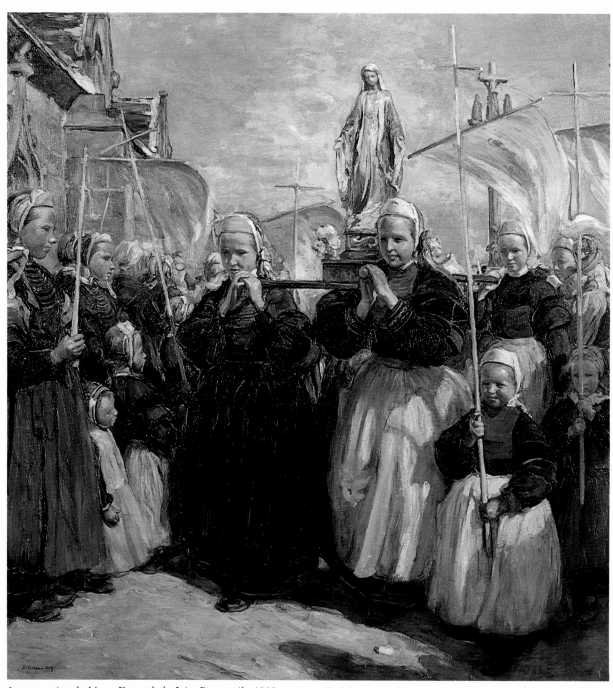

La procession de Notre Dame de la Joie, Penmarc'h, 1903, cat. no. B–93.

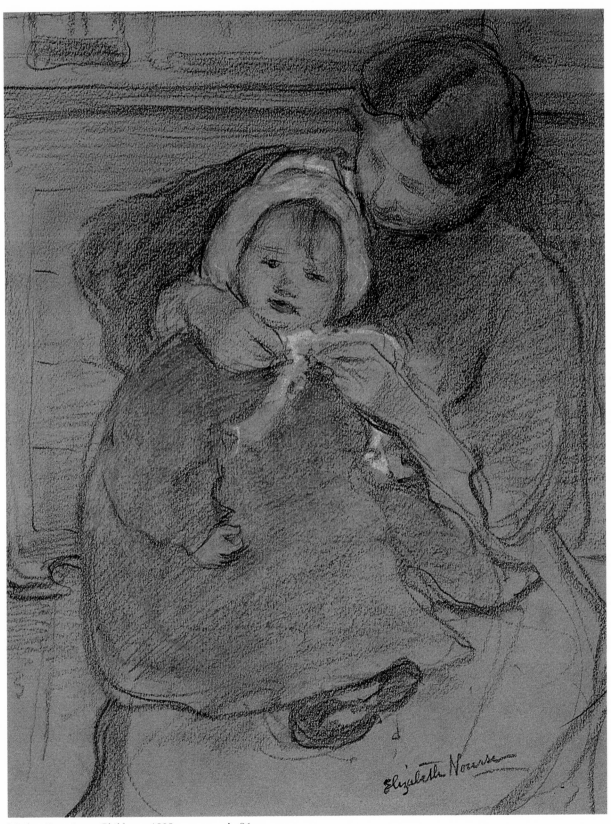

Mother Dressing a Child, ca. 1909, cat. no. A–86.

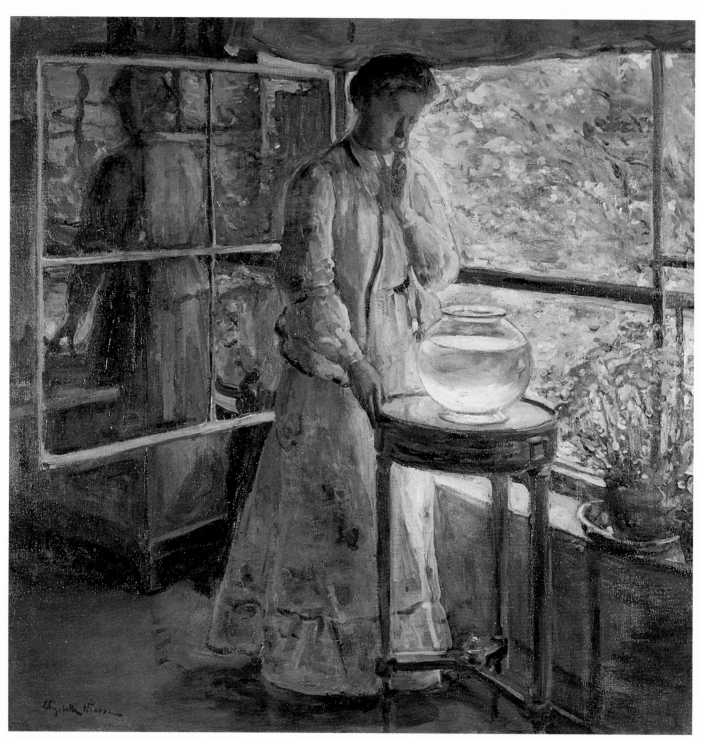

La rêverie, ca. 1910, cat. no. B–119.

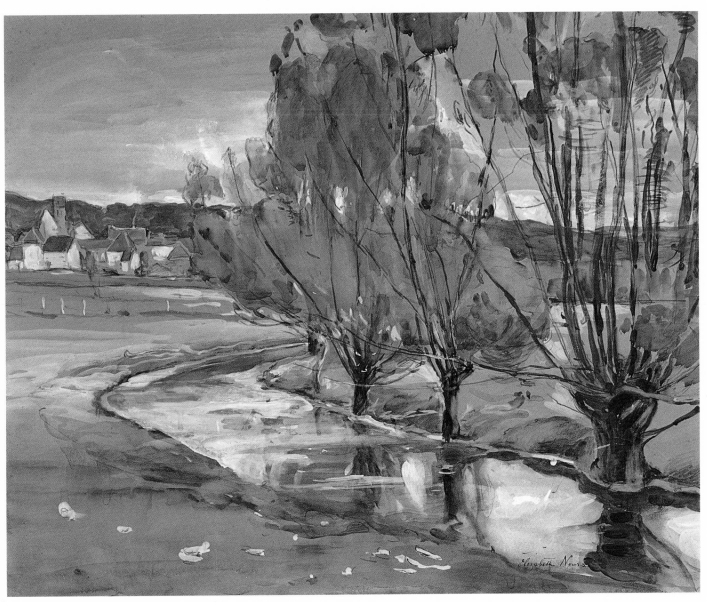

Le village de Saint Léger, 1912, cat. no. D–86.

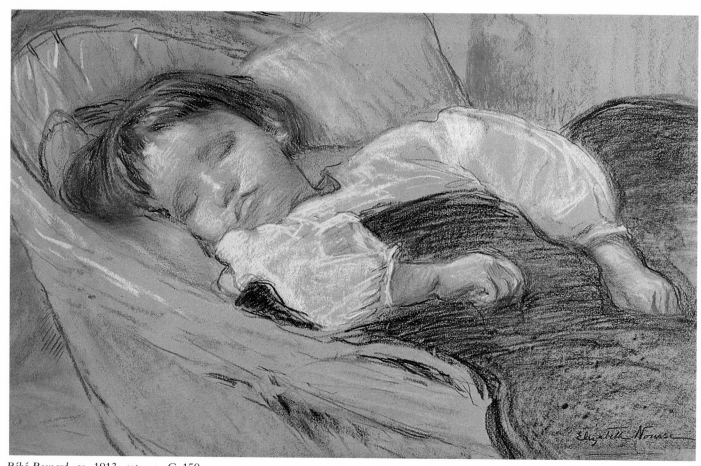

Bébé Besnard, ca. 1913, cat. no. C–159.

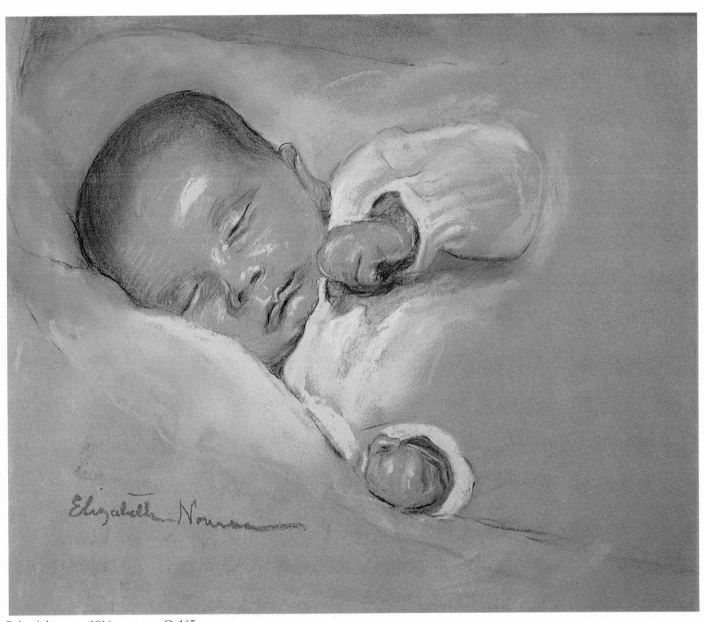

Baby Asleep, ca. 1916, cat. no. C–165.

Catalogue Raisonné

The entries describing the known works of Elizabeth Nourse are arranged chronologically by type of subject matter, as follows: A. Women and Children; B. Other Genre Scenes; C. Portraits and Figure Studies; D. Landscape and Architecture; E. Still Life, Birds, and Animals; F. Miscellaneous; G. Sculpture; H. Sketchbooks.

Illustrations Reproductions are not available for many of the paintings. Whenever possible, the entries for these are illustrated with drawings from Nourse's sketchbooks, eighteen of which are extant (see section H). Because Nourse drew an outline around (and usually initialed) the sketches that she used as the bases for finished works, her preliminary and finished work can often be correlated.

Titles Many of Nourse's paintings were given both a French and an English title. The first title listed is the one used by the artist when the work was first exhibited.

Dimensions The dimensions are in inches, followed in parentheses by centimeters. Height precedes width and depth.

Exhibition(s) A solidus (/) between two dates indicates a winter exhibition beginning in one year and extending into the next.

Reference(s) Titles of exhibition catalogues are included in the references only when the catalogue provides information supplementary to the fact that the work was exhibited. Unless otherwise indicated, all correspondence cited in the references is in the Elizabeth Nourse Papers, Cincinnati Historical Society. All newspaper clippings that are not fully referenced are from unidentified newspapers. Most of the clippings are from two scrapbooks maintained by Louise Nourse: Scrapbook 1, 1880 to 1911, and Scrapbook 2, 1911 to 1932. Many of the references are in shortened form; these are fully cited in the Bibliography.

The following abbreviations are used in the catalogue entries:

Abbreviations	Sources
AIC 18—; 1900	Annual exhibitions of American art at the Art Institute of Chicago and exhibition catalogues for 1895, 1898, 1901, 1904, 1905, 1906, 1908, 1909, 1910, 1911, 1912, 1913.
Anglo-American 1914	Anglo-American Exposition in London, 1914.
Archives	Archives of the Cincinnati Museum Association.
Bagatelle 19—	Exhibitions of the Société Nationale des Beaux-Arts at the Château de Bagatelle in 1909, 1910, 1913.
CAM 18—; 19—	Annual exhibitions of works by American artists at the Cincinnati Art Museum and exhibition catalogues for 1897, 1898, 1907, 1910, 1912, 1913, 1921, 1923, 1925, 1926.
CAM 1893 and Annotated CAM 1893	Solo exhibition, "The Work of Elizabeth Nourse" at the Cincinnati Art Museum, November 25–December 9, 1893, and exhibition catalogue. The term "Annotated CAM 1893" refers to a copy of the catalogue inscribed by hand, in ink, with prices requested for the works of art and a record of sales, in the form of names of purchasers. This copy is in the Elizabeth Nourse File, Cincinnati Art Museum Library.
Carter 1893	Carter, "The High Art Exhibit: Miss Nourse's Pictures at the Museum," *Cincinnati Times-Star*, December 8, 1893.
CGA 19—	Annual exhibitions of oil paintings by contemporary American artists at the Corcoran Gallery of Art, Washington, D.C., and exhibition catalogues for 1907, 1910/11, 1912/13.
CIE 18—	Annual exhibitions of the Department of Fine Arts, a division of the Cincinnati Industrial Exhibitions, and exhibition catalogues for 1879, 1881, 1882, 1883, 1884, 1886.
Closson 1941	Solo exhibition, "Retrospective Exhibition of Oils, Pastels, Drawings, and Water Colors by Elizabeth Nourse," at the Closson Gallery, Cincinnati, June 2–14, 1941, and exhibition catalogue.
College 1941	Solo exhibitions of twenty-one paintings by Elizabeth Nourse at the College of Music, Cincinnati, June and October 1941, and list of works exhibited. The list is in the Elizabeth Nourse Papers, Cincinnati Historical Society.
Elliston, November 1938	George Elliston, "Artist Niece of Famed Woman Urged to Write Her Biography," *Cincinnati Times-Star*. November 25, 1938.
Elliston, December 1938	George Elliston, "Famous Artist Leaves to Cincinnati Realtor Largest Private Collection of Her Paintings," *Cincinnati Times-Star*, December 27, 1938.
EN	Elizabeth Nourse.
EN Papers	Elizabeth Nourse Papers, in Cincinnati Historical Society.
Estate 1938	Estate of EN and inventory dated 1938 (in EN Papers). The inventory lists seventy-four works left in the artist's estate, many of which cannot be identified because they were given general titles, such as *Femme et enfant*, and because their media is not identified.
Fischer 1894 and Annotated Fischer 1894	Solo exhibition, "The Work of Elizabeth Nourse," V. G. Fischer Art Gallery, Washington, D.C., February 5–17, 1894, and exhibition catalogue. The term "Annotated Fischer 1894" refers to a copy of the catalogue inscribed by hand, in ink, with prices requested for the works of art and no-

tations of "sold" for those purchased. This copy of the catalogue is in the Elizabeth Nourse File, Cincinnati Art Museum Library.

Golden Age 1979/80 Exhibition, "The Golden Age: Cincinnati Painters of the Nineteenth Century Represented in the Cincinnati Art Museum," October 6, 1979–January 2, 1980, and exhibition catalogue.

Goldman 1921 Marcus Selden Goldman, "Elizabeth Nourse," *Paris Review: The Illustrated American Magazine in France* (November 20, 1921): 7–10, 31.

IAU 19— Annual exhibitions of the International Art Union of Paris (sponsored by the International YWCA) and exhibition catalogues for 1908, 1911, 1912, 1913. These exhibitions are reviewed in newspaper clippings in Scrapbook 1 and Scrapbook 2.

Indian Hill 1978 Exhibition, "The Golden Era of Art," sponsored by the Indian Hill Historical Museum Association, Cincinnati, June 1978, and exhibition catalogue.

Inventory 1932 Inventory of paintings by EN given to the University of Washington, Seattle, by Judge and Mrs. Thomas J. Burke.

LN Louise Nourse.

Lodge 19— Annual exhibitions of the Lodge Art League, organized by Holy Trinity, an American Episcopal church in Paris, for 1906, 1907, 1908, 1911, 1912, 1913. These exhibitions are reviewed in newspaper clippings in Scrapbook 1 and Scrapbook 2.

Lord 1893 Caroline Lord, "Miss Nourse's Work," review of the solo exhibition of EN's work referenced in CAM 1893. The review is from a Cincinnati newspaper and is in Scrapbook 1, p. 36.

Lord 1910 Caroline Lord, "Paintings by Elizabeth Nourse," review of an exhibition of American art at the Cincinnati Art Museum in 1910. The review is from a Cincinnati newspaper and is in the EN Papers.

MACI 18—; 19— Annual exhibitions of international art at the Museum of Art, Carnegie Institute, Pittsburgh, and exhibition catalogues for 1897/98, 1900/1901, 1901/02, 1904/05, 1908, 1909, 1914, 1923.

MacChesney 1896 Clara T. MacChesney, "An American Artist in Paris: Elizabeth C. Nourse," *Monthly Illustrator* 13, no. 1 (August 1896).

McMicken 18— Annual student exhibitions at the School of Design, University of Cincinnati (generally known as the McMicken School of Design), later the Cincinnati Art Academy, and exhibition catalogues for 1875, 1876, 1877, 1878, 1879, 1880, 1881, 1882.

Medora 1895 Medora, "Art and Artists in Paris," *Cincinnati Tribune*, July 28, 1895. A clipping of the article is in Scrapbook 1, p. 47.

New Salon 18—; 19— Annual Salons of the Société Nationale des Beaux-Arts in Paris and exhibition catalogues for 1890–1921.

Old Salon 18— Annual Salons of the Société Nationale des Artistes Français and exhibition catalogues for 1888, 1889.

Orientalistes 19— Annual exhibitions of the Société des Orientalistes, Paris, 1904, 1906. Information about these exhibitions is in Scrapbook 1, pp. 75 and 78.

PAFA 18—; 19— Annual exhibitions of American art at the Pennsylvania Academy of The Fine Arts, Philadelphia, and exhibition catalogues for 1895/96, 1896/97, 1898–1906, 1908, 1909, 1911, 1912, 1913, 1914.

PAFA Watercolor 19— Annual Philadelphia watercolor exhibitions at the Pennsylvania Academy of The Fine Arts, Philadelphia, and exhibition catalogues for 1907, 1909, 1910, 1912.

Peinture 1908	Exhibition of the Société Internationale de la Peinture à l'Eau, Paris, 1908, with a list of EN's entries prepared by LN. The list is in Scrapbook 1, p. 87.
Photo	Photographs of paintings by EN in private collections.
Quelques 1912	"Exposition des Quelques," an exhibition of work by women painters, Galerie Brunner, Paris, January 4–12, 1912, and exhibition catalogue.
Reception 1893	"Art Museum Reception," a review of the exhibition of EN's work at the Cincinnati Art Museum in 1893 from a Cincinnati newspaper. A copy of the clipping is in Scrapbook 1, p. 41.
Schmidt 1902	Anna Seaton Schmidt, "Elizabeth Nourse: An American Artist," *Donohoe's* (Easter 1902): 329–38.
Schmidt 1906	Anna S[eaton] Schmidt, "The Paintings of Elizabeth Nourse," *International Studio* (January 1906): 247–53.
Schmidt family	Owners of many works by EN. Two generations of the Schmidt family of Cincinnati were close friends of EN's and it is often impossible to determine which member owned a certain work. The family consisted of Frederick A. and Mimi Schmidt and their four children: Fr. Austin Schmidt, S.J.; Walter S. Schmidt; Elizabeth Schmidt; and Dorothy Schmidt Bunker. In addition, it numbered Frederick Schmidt's three sisters: Anna Seaton Schmidt, Charlotte Schmidt, and Elizabeth Schmidt Pilling (of Washington, D.C.).
Scrapbook 1	A scrapbook pertaining to the work of EN maintained by LN from 1880 to 1911. It contains newspaper clippings, photographs of paintings, and notes by LN about the exhibition and sales of her sister's work. The scrapbook is in the Nourse Family Collection, Cincinnati.
Scrapbook 2	A scrapbook pertaining to the work of EN maintained by LN from 1911 to 1932. Its contents are similar to those of Scrapbook 1, above. The scrapbook is in a private collection in Cincinnati.
Sketchbooks 1–18	The eighteen surviving annotated sketchbooks of EN's, dated 1874 through 1920. Sketchbooks 1 and 4 through 18 are in a private collection in Cincinnati. Sketchbooks 2 and 3 are in the Cincinnati Historical Society.
Thompson 1900	Vance Thompson, "American Artists in Paris," *Cosmopolitan* (May 1900): 17–26.
Tietjens 1910	Emma H. Tietjens, "An American Woman Painter Who Has Been Honored in Paris," *Current Literature* (February 10, 1910): 90–93.
U.C. 1974	Solo exhibition, "The Paintings of Elizabeth Nourse," at the University of Cincinnati, May 1974, and exhibition catalogue.
Walsch 1922	James J. Walsch, "An American Woman Artist: Painter of the Poor," *Extension Magazine* (August 1922).
Wheeler 1910	Mary C. Wheeler, "An American Artist Honored," clipping from a Helena, Montana, newspaper, 1910, in Scrapbook 1, p. 114.

A Women and Children

A–1
Group in the Park
1885
Unlocated
Reference: Scrapbook 1, p. 12 (photo marked *Elizabeth Nourse/ 1885 Cincinnati*).

A member of the Nourse family states that the infant is EN's nephew, Emerson Pitman, and that he is seated on the lap of the family laundress.

A–2
La mère (Pleasant Dreams)
1888
Figure 19 and page 148
Oil on canvas; 45$^{15}/_{16}$ × 32$^{1}/_{16}$ (116.6 × 81.4)
Signed lower left: *E. Nourse/ '88*
Owner: Private collection.
Previous owners: Parker Mann, Washington, D.C., in 1894; Mrs. Woodrow Wilson, Princeton, N.J., in 1913; Spiva Art Center, Joplin, Mo., 1967–81, gift of Freeman R. Johnson; Jeffery R. Brown Fine Arts gallery, North Amherst, Mass., to 1982.
Exhibitions: Old Salon, 1888, no. 1925; London, Continental Gallery, 1891, no. 4 (as *How Dear a Life Your Arms Enfold*); Liverpool, 1892; Glasgow, 1893; CAM 1893; Fischer 1894, no. 11; Woman's Art Club of New York, 1905, no. 18, loaned by Parker Mann.
References: Scrapbook 1, p. 19 (page from Continental Gallery exhibition catalogue, 1891, with entry and illustration of *La mère* pasted in scrapbook) and p. 76 (letter from Woman's Art Club of New York to EN in Paris, June 6, 1905); Schmidt 1906, p. 147; Annotated CAM 1893 (price, $300); W. G. McAdoo, "The Kind of Man Woodrow Wilson Is," *Century* (March 1913): 747; Scrapbook 2, p. 55 (Selena Armstrong Harmon, "Washington Women Worth While," Philadelphia newspaper, ca. 1914).

Parker Mann (1852–1918), the first owner, was an artist who studied at the Ecole des Beaux-Arts and was a member of the Society of Washington Artists and president of the Washington Water Color Club in Washington, D.C. He loaned this painting to the 1906 exhibition of the Woman's Art Club of New York, in which it received the prize for the best oil.

A–3 is a study for the mother's head in *La mère* and A–4 is a drawing for the work.

A–3
Madonna (Study for La mère)
1888
Oil on canvas; 16 × 12¾ (40.6 × 32.4)
Signed lower right: *E. Nourse/Paris 1888*
Owner: Private collection, Cincinnati.

This is a study for the mother's head in A–2. It is in a frame six inches wide carved in deep relief by Louise Nourse, who used the stylized floral designs taught by Benn Pitman.

A–4
Mère et bébé
ca. 1888
Drawing
Unlocated
Exhibition: New Salon 1914, no. 1569.
Reference: Scrapbook 2, p. 51 (note by LN).

LN noted in Scrapbook 2 that this was a drawing for A–2.

A–5
La dernière bouchée (The Last Mouthful)
1889
Oil on canvas
Unlocated
Previous owner: Senhor Mendonça, Washington, D.C., and Brazil, in 1894.
Exhibitions: New Salon 1890, no. 672; CAM 1893, no. 10; Fischer 1894, no. 6.
References: Annotated Fischer 1894 (price, $300); Scrapbook 1, p. 41 (E. E. Newport, "In a Private Gallery," Washington, D.C., newspaper, 1894).

Senhor Mendonça bought this painting in 1894 at an exhibition held at the V. G. Fischer Art Gallery in Washington, D.C. Mendonça was the Brazilian minister to the United States and was a collector of European and American art. He owned a *Magdalen* by Murillo, *Susannah and the Elders* by Titian, and fourteen landscape paintings by the Washington artist Max Weyl (see comment, C–110). He was said to have bought another Nourse painting at the 1894 exhibition, "an old kitchen interior," but this work cannot be identified.

A–6
Fisher Girl of Picardy
1889
Figure 25
Oil on canvas; 46¾ × 32⅜ (118.6 × 82)
Signed lower right: *E Nourse/Etaples 1889*
Owner: National Museum of American Art, Washington, D.C., gift of Elizabeth Schmidt Pilling, 1915.3.1.
References: Catalogues of the National Gallery of Art, Washington, D.C., 1916, 1922, 1926; Dayton Art Institute, *American Expatriate Painters of the Late Nineteenth Century* (1976), p. 120; letter from Anna Seaton Schmidt to William H. Holmes, Washington, D.C., 1915, in Registrar's File, National Museum of American Art, Washington, D.C.

In her 1915 letter to W. H. Holmes, curator of the National Gallery of Art, Anna Schmidt wrote: "I was with Elizabeth when she painted that girl on the Etaples Dunes—it was so cold and windy that the model used to weep, but the painter never murmured. I think the picture possesses in a striking degree that stormy atmosphere of the French coast on windy fall days. . . ." There is a sketch for this work in H–9.

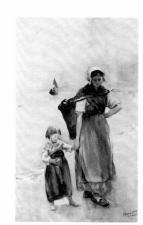

A–7
Fisher Woman and Child
1889
Watercolor on paper; 19 × 12 (48.2 × 30.5)
Signed lower right: *E. Nourse 1889/ à Etaples*
Owner: Private collection, Cincinnati.
Previous owner: Either the Ives or the Duhme family, Cincinnati.

A–8
Russian Peasants
1889
Pencil and chalk on paper; 9½ × 12½ (24.1 × 31.7)
Signed lower right: *Elizabeth Nourse*
Written verso: *Russian sketches made in the village of Konstantynowka, district of Ukraine/ government of Kief, Russia.*
Owner: Cincinnati Art Museum, gift of Melrose Pitman, 1970.168.

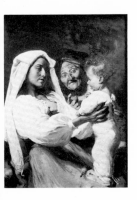

A–9
The Three Ages (Three Generations)
1890
Oil on canvas; 40 × 30 (101.6 × 76.2)
Owner: Private collection.
Previous owners: Estate 1938; Mary
Nourse, Fort Thomas, Ky., 1938–59;
Clara Nourse Thompson, Fort
Thomas, Ky., 1959–80.
Exhibitions: CAM 1893, no. 11;
Fischer 1894, no. 7.
Reference: Annotated CAM 1893
(price, $200).

There are three sketches for this work
in H–10.

A–10
Mother and Baby, Assisi
1890
Unlocated
Exhibitions: CAM 1893; no. 57;
Fischer 1894, no. 39.
Reference: Annotated CAM 1893
(price, $20; records sale).

This was subtitled *Assisi Street Scene.*

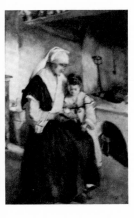

A–11
Borst Interior
1891
Watercolor; 48 × 24½ (122 × 62.3)
Owner: Private collection, Richmond,
Ky.
Previous owner: Burnam family, Cov-
ington, Ky.
Exhibitions: CAM 1893, no. 25;
Frankfurt, Kentucky Historical Soci-
ety, "Pageant of the Blue Grass,"
1977, no. 83.
Reference: Annotated CAM 1893
(price, $150; records sale).

The painting shows a Borst peasant
woman seated before her kitchen
hearth as she reads to a little girl stand-
ing beside her. There is a sketch of the
interior setting of this work, without
the figures, in H–10.

A–12
Learning to Walk
1891
Unlocated
Exhibition: CAM 1893, no. 26.
Reference: Annotated CAM (price,
$150).

A–13
La toilette du matin (The Morning
Bath)
1891
Figure 81
Oil on canvas; 30 × 39 (76.2 × 99)
Signed upper right: *E. Nourse '91*
Owner: University Club of Cincinnati.
Previous owner: Mrs. Thomas W.
Graydon, Cincinnati.
Exhibitions: New Salon 1891, no. 776;
The Art Club of Philadelphia, 1892,
no. 5.

Two rough sketches for this work in
H–10 show the figures reversed. EN
saw this scene on the Rhine river as
she was traveling back to Paris from
Borst, Austria.

A–14
Across the Meadows (Dans les champs,
Hollande)
1892
Figure 31
Oil on canvas; 38½ × 29 (97.8 ×
73.7)
Signed lower right: *E. Nourse/Volen-
dam '92*
Owner: Private collection, Cincinnati,
from 1899.
Exhibitions: London, Royal Academy,
1892; CAM 1893, no. 15; New Salon
1894, no. 824.
Reference: Annotated CAM 1893
(price, $300).

A single sketch for this work in H–11
shows that EN captured immediately
the poses and landscape elements she
utilized for this painting.

A–15
Volendam Woman and Child
1892
Pencil on paper; 10⅝ × 8½ (27 ×
21.5)
Inscribed lower center: *CtLo– Volen-
dam/ Aug. 1—*
Owner: Cincinnati Historical Society,
gift of Melrose Pitman.

There is a sketch of a Dutch boy on
the back of this drawing.

A–16
The Kiss (Mother and Child)
1892
Oil on canvas; 22⅝ × 20⅜ (56.5 × 51.2)
Signed upper right: *E. Nourse '92*
Owner: Private collection, Cincinnati, from 1980.
Previous owner: Ran Gallery, Cincinnati.
Reference: Scrapbook 1, p. 33 (clipping from *Cincinnati Commercial Gazette*, 1893).

The clipping of 1893 states that EN sold a great many pictures in Washington, D.C., when she visited there on her way from Paris to Cincinnati in the spring of 1893, and remarks that "the people went wild over" this painting of "a little child standing on tiptoe to steal a kiss from its mother's lips. . . . She could have sold it a half dozen times over."

A–17
Mère et bébé (The Young Mother)
1892
Figure 76
Oil on canvas
Signed upper left: *E. Nourse Paris 1892*
Unlocated
Previous owner: Dudley Porter, Haverhill, Mass., in 1893.
Exhibition: CAM 1893, no. 20, loaned by Dudley Porter.
References: Annotated CAM 1893; Scrapbook 1, p. 28 (photo); MacChesney 1896, p. 7 (illus.).

Dudley Porter, the owner of this work, loaned two other paintings, B–21 and B–53, to the 1893 exhibition at the Cincinnati Art Museum.

A–18
Le goûter (Evening) (Mother and Children)
1893
Figure 32
Oil on canvas; 45⅛ × 29⁹⁄₁₆ (114.5 × 75.1)
Signed lower left: *E. Nourse '93*
Owner: Valparaiso (Indiana) University Art Galleries and Collections, bequest of Percy Sloan, 1953.
Previous owner: Art Institute of Chicago, 1897–1953, gift of Mrs. Charles E. Culver.
Exhibitions: New Salon 1893, no. 799; CAM 1893, no. 3; Fischer 1894, no. 3; AIC 1895, no. 258; Art Institute of Chicago, "Half a Century of American Art," 1939/40, no. 123.

References: Annotated CAM 1893 (price, $600); the painting was called *Mother and Children* in the *Chicago Inter-Ocean*, October 23, 1895; *Chicago Tribune*, November 2, 1902; *Literary Digest* (June 12, 1926) (cover illus.).

There is a sketch for this work in H–11.

A–19
Madonna and Child
by 1983
Unlocated
Previous owner: Mrs. Walsh, Cincinnati, in 1893.
Exhibition: CAM 1893.
References: Annotated CAM 1893 (price, $150); Lord 1893.

Caroline Lord's review describes this work and that in A–20 as "two Madonnas, in one of them we find the traditional halo, the mother with sunken eyes and pallid cheeks, is pressing a chubby boy to her lips."
Caroline Lord (1859–1927) was a Cincinnati artist who studied with EN at McMicken and became an instructor at the Cincinnati Art Academy. She wrote several articles about EN and her work.

A–20
Madonna and Child
by 1893
Unlocated
Previous owner: Goldman, Cincinnati, in 1893.
Exhibition: CAM 1893, no. 31.
References: Annotated CAM 1893 (price, $100); Lord 1893.

See comments, A–19.

A–21
La leçon de couture (The Sewing Lesson)
1894
Oil on canvas
Unlocated
Previous owner: Maria Longworth Storer, Cincinnati.
References: Scrapbook 1, p. 44 (photo and note by LN); EN in Saint Gildas to Mary Nourse in Covington, Ky., October 6, 1894; Medora 1895.

This work was painted at the convent of the Sisters of Charity in Saint Gildas-de-Rhuys, Brittany. There is a single sketch for it in H–12.

A–22
Mother and Baby in Cradle (Maternité)
1894
Watercolor on paper; 20 × 15 (55.8 × 40.5)
Signed lower right: *E. Nourse 1894*
Owner: Allen I. Hunting, Grand Rapids, Mich.
Previous owner: Mr. and Mrs. Allen Ives, Cincinnati.

A–23
Saint Gildas de Rhuys
1894
Oil on paperboard; 35 × 26 (88.9 × 67.3)
Signed upper right: *E. Nourse '94*
Owner: Midwestern Galleries, Cincinnati, from 1981.
Previous owners: Laura Freeman Stearns, Cincinnati, 1912–62; Helena Stearns Bennett, Tucson, Ariz., 1962–66; Robert E. Gable, Stearns, Ky., 1967–81.
Exhibition: Closson Gallery, Cincinnati, 1912.
Reference: "Work of Cincinnati Women Artists Shown," *Cincinnati Times-Star*, May 1916.

The *Times-Star* article mentioned the four Nourse canvases for sale at the Closson Gallery that H. B. Closson brought back from Paris in the summer of 1912. This painting was praised for the fine atmospheric feeling in the room created by the smoke from the fireplace.

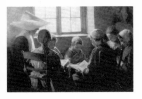

A–24
La leçon de lecture (The Reading Lesson)
ca. 1895
Oil on canvas
Unlocated
Exhibitions: New Salon 1896, no. 965; PAFA 1896/97, no. 246; Nashville, "Tennessee Centennial Exposition," 1897, no. 345 (awarded gold medal).
References: Scrapbook 1, p. 52 (photo); "Award of Prizes," *Nashville Sun*, May 26, 1897.

This must be a large painting because A–25, a study for it, contains only three of its seven figures. There is a single summary sketch for this work in H–12.

A–25
Study for La leçon de lecture
1895
Oil on canvas; 22 × 31 (55.9 × 78.7)
Signed lower left: *Elizabeth Nourse*
Owner: Mrs. William Krumer, Cincinnati, from 1978.
Previous owner: Mrs. John C. Pogue, Cincinnati.

This study for A–24 shows only part of the composition, the first three figures on the left before the sunny window.

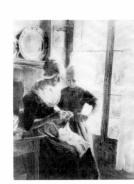

A–26
Mère et fillette hollandaise (The Sewing Lesson)
1895
Oil on canvas; 46 × 30 (116.8 × 76.3)
Signed lower left: *E. Nourse '95*
Owner: Private collection, Rochester, N.Y.
Previous owner: Mrs. Daniel B. Meacham, Cincinnati.
Exhibitions: New Salon 1896, no. 966; Woman's Art Club of Cincinnati, 1901, loaned by Mrs. Daniel B. Meacham.
Reference: Scrapbook 1, p. 50 (letter from Charlotte Gibson Miller in Cincinnati to EN in Paris, November 20, 1901).

The letter from Charlotte Gibson Miller, a fellow student of EN's at McMicken, indicates what a contemporary admired in this work: "the softness of the lace caps, the hardness of the worn hands, the background of tender green and colored bric-a-brac in the cheery window . . . the delicious light that comes through those fairy curtains."
A sketch for this work in H–12 is identical to the painting.

A–27
Mother and Child
1895
Figure 40
Oil on canvas; 22 × 19 (55.9 × 48.2)
Signed upper right: *E. Nourse 1895*
Owner: Mrs. David D. Hunting, Grand Rapids, Mich.
Previous owner: Mr. and Mrs. Allen Ives, Cincinnati.
Exhibition: Dayton Art Institute, "American Expatriate Painters of the Late Nineteenth Century," 1976 (catalogue p. 120).

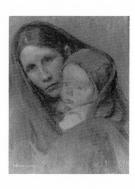

A–28
A l'abri (Mère et bébé)
ca. 1897
Oil on canvas
Signed lower left: *E. Nourse*
Unlocated
Previous owner: Mrs. Benedict, Chicago.
Exhibitions: New Salon 1898, no. 941; AIC 1898, no. 273.
Reference: Scrapbook 1, p. 59 (photo and note by LN).

A–29 is a study for this painting.

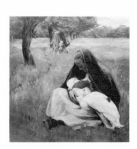

A–29
Study for A l'abri
ca. 1897
Oil on unprimed canvas; 16 × 14 (40.6 × 35.5)
Signed upper right: *"Tootie"—EN*.
Owner: Private collection, Alexandria, Va.

This study for A–28 probably once belonged to Anna Seaton Schmidt, who lived in Washington, D.C., at the time it was sold there. There are four sketches for this work in H–13. EN used the final one for the composition of this painting.

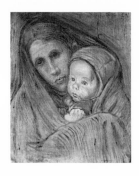

A–30
Dans le pré (In the Meadow)
1897
Oil on canvas
Owner: Private collection.
Previous owner: Nora Houston, Richmond, Va., in 1926.
Exhibitions: New Salon 1898, no. 939; PAFA 1900.
Reference: Scrapbook 1, p. 61 (French review of the 1898 New Salon).

The French critic coined the word "noursery" to describe this mother and child theme. There is a single sketch for this painting in H–13.

A–31
Maternité
1897
Figure 77
Oil on canvas; 34 × 26 (86.3 × 66)
Unlocated
Previous owner: Willoughby-Toschi Gallery, San Francisco, in 1970.
Exhibitions: New Salon 1898, no. 940; PAFA 1900, no. 213.
References: *Antiques* 97 (January 1970): 42 (illus.); Letter from Daniel Saget-Léthias, Soissons, to his niece, Mme. Isabelle Decroisette, Vanves, February 6, 1980, in possession of M. A. H. Burke.

In his letter, M. Saget-Léthias recounted that during the summer of 1897 he and his mother, Mme. Marie Saget-Léthias, served as the models for this painting in Saint Léger.

A–32 is a study for this work. See also C–137.

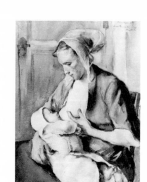

A–32
Study for Maternité
1897
Watercolor on paper; 13 × 11¼ (33 × 28.5)
Signed and inscribed upper right: *E. Nourse 1897/ Dear Henriette 1919/ Elizabeth*
Owner: Stanley Cohen, Cincinnati.
Previous owner: Henriette Wachman, Cincinnati.

EN gave this study for A–31 to her friend, Henriette Wachman, who had been her fellow student at McMicken. Henriette and her sister, Laura Wachman, were living in Rome in 1919.

A–33
Mère et bébé
1897
Figure 80
Oil on canvas
Unlocated
Previous owner: Mrs. Pearsall, Dublin, Ireland, in 1900.
Exhibitions: New Salon 1897; Nashville, "Tennessee Centennial Exposition," 1897, no. 347; PAFA 1898, no. 329; AIC 1898, no. 273; Paris Exposition, 1900 (awarded silver medal).
References: Schmidt 1902, p. 332; Scrapbook 1, p. 56 (reproduction of work and note by LN).

A–34 is a drawing of this work.

A–34
Mère et bébé
1897
Drawing
Unlocated
Previous owner: Mrs. Peck, in 1909.
Reference: Scrapbook 1, p. 56 (note by LN).

This is a drawing of A–33.

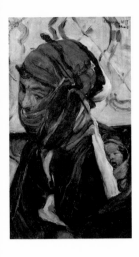

A–35
Tête bédouine
1897
Oil on wood panel; 9½ × 5½ (24 ×
14)
Signed upper right: *E. Nourse 1897/
Tunis*
Owner: M. A. Burke, Cincinnati.
Previous owner: Midwestern Galleries,
Cincinnati.
Exhibition: Orientalistes 1904.
References: Scrapbook 1, p. 75 (entries
for 1904 Orientalistes exhibition); Ar-
sène Alexandre, "Les orientalistes," *Fi-
garo*, February 22, 1904; EN in Tunis
to Mary Nourse in Covington, Ky.,
February 1897.

The sketch for this work in H–12
shows a full-length figure with a
mountain landscape in the background.
EN wrote her niece, Mary Nourse,
that she was unable to complete any
large pictures in Tunis because she
could only get her models to pose for
a short time.

The annual exhibition of the Société
des Orientalistes was organized in 1892
by Léonce Bénédite, director of the
Musée de Luxembourg. The 1904 ex-
hibition, held at the Grand Palais in
Paris, included works by EN and
twenty-three French artists. It featured
a series of studies by Léon Gérôme, an
artist EN apparently admired as her es-
tate included several of his prints.

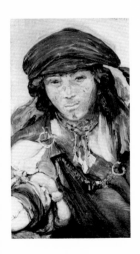

A–36
Tête bédouine
1897
Oil on wood panel; 9½ × 5½ (24 ×
14)
Signed upper right: *E. Nourse Tunis/
1897.*
Owner: Private collection, Blanchester,
Ohio, from 1979.
Exhibition: Orientalistes 1904.
Reference: Scrapbook 1, p. 75 (entries
for 1904 Orientalistes exhibition).

There is a sketch for this work in H–
12 on the same page as a sketch for A–
35. The sketch for A–36 is a bust-
length figure drawn in greater detail
than the one for A–35 to record the
elaborate costume.

A–37
Femme aux fagots
ca. 1898
Oil on canvas; 46 × 32½ (117 ×
82.6)
Signed lower left: *E. Nourse*
Owner: Portland (Oregon) Art Mu-
seum, gift of Mrs. Ineze Miller, 1969.

There are four sketches for this work
with its Millet-like theme in H–13. EN
tried and discarded a horizontal format
and also made several sketches of the
child alone.

A–38
Maternité
1898
Figure 46 and page 150
Oil on canvas; 34 × 26 (86.3 × 66)
Signed lower right: *E. Nourse '98*
Owner: Stanley Cohen, Cincinnati,
from 1980.
Previous owners: Susan Watkins, Paris;
Ran Gallery, Cincinnati, 1980.
References: Scrapbook 1, p. 61 (photo
and note by LN) and p. 76 (clipping
from *New York Herald* (Paris), June 30,
1905).

This version of A–31 and A–32 shows
the same models but the figures are re-
versed and shown in a landscape rather
than in an interior. The *Paris New York
Herald* article described the 1905 wed-
ding in Paris of Mary Greene Shepherd
and Ernest L. Blumenschein, who
were later to become artists in Taos,
N. M. Susan Watkins, the previous
owner of this work, was an American
artist in Paris who served as maid of
honor at the wedding. Among the
guests were EN, Frederick Frieseke,
and Sara Hallowell.

A–39
Plein été (Midsummer)
1898
Figure 47
Oil on canvas; 31½ × 29½ (80 ×
74.9)
Signed lower right: *E. Nourse 1898*
Owner: The Art Gallery of South
Australia, Elder Bequest, 1899.0.150.
Exhibition: New Salon 1899, no. 114.

There are thirteen sketches for this
work and several sketches of the baby
alone in H–13. This is an unusually
large number since EN ordinarily
needed only one or two quick sketches
to decide upon her composition. A–40
is an oil study for this work.

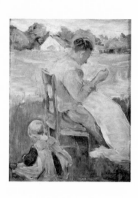

A–40
Study for Plein été
1898
Oil on paperboard; 12 × 9 (30.5 × 22.9)
Signed lower right: *E. Nourse 1898*
Owner: Marian Thompson Deininger, Houston, from 1980.
Previous owners: Estate 1938; Clara Nourse Thompson, Fort Thomas, Ky., 1938–80.
Reference: Elliston, November 1938 (illus.).

This is a study for A–39.

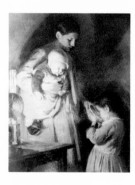

A–41
La soif (Thirst) (A boire)
1898
Oil on canvas
Signed lower left: *E. Nourse 1898*
Unlocated
Previous owner: K. M. Depeaux, Rouen, France.
Exhibition: New Salon 1898, no. 938.
References: Thompson 1900, p. 22 (illus.); Scrapbook 1, p. 60 (photo and note by LN).

There are four sketches for this work in H–13, two with the mother and baby seated and two showing the poses EN used for the painting.

A–42
La veillée
1899
Oil on canvas
Signed lower left: *E. Nourse 1899*
Unlocated
Previous owner: Mrs. Cassell, Honolulu, in 1900.
Exhibition: New Salon 1899, no. 113.
References: "American Artists' Series," *Century* (January 1900) (illus.); Schmidt 1906, p. 250; EN in Paris to "Lizzie" in Cincinnati, July 15, 1900, and Jean-Charles Cazin in Paris to EN in Paris, June 12, 1898.

EN wrote to her friend in Cincinnati, the otherwise unidentified Lizzie, that Mrs. Cassell saw Charles Baude's etching of this work in *Century* and ordered it from Paris, paying $600 for it. Jean-Charles Cazin (1841–1901), a *sociétaire* in the New Salon, wrote to praise the painting and said that it would be an excellent entry for the Paris Exposition of 1900. He also mentioned that EN had acquired thirty-two votes favoring her election to *sociétaire* in the New Salon and ended by saying: "I repeat—make use of me,"

implying that a bit of campaigning was required to achieve election.

There are four sketches for this work in H–13, and A–43 is a study for it.

A–43
Study for La veillée
1899
Watercolor
Unlocated
Previous owner: Mrs. Hammond, Evanston, Ill., in 1912.
Exhibitions: New Salon 1899, no. 1974; Chicago Watercolor Society, 1912, no. 167, loaned by Mrs. Hammond.
Reference: *Chicago Tribune*, May 11, 1912 (illus.).

This is a study for A–42.

A–44
The Baby's Supper
1900
Oil on canvas
Unlocated
Previous owner: Mrs. Louis Duhme, Cincinnati, in 1902.
Exhibition: Woman's Art Club of Cincinnati, 1902, no. 41, loaned by Mrs. Louis Duhme.
Reference: Scrapbook 1, p. 63 (photo and note by LN).

The photograph of this painting in Scrapbook 1 is too faded to reproduce, but it is identical to A–45.

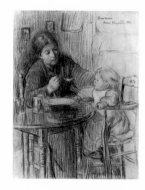

A–45
Study for The Baby's Supper (Dinner Time)
1900
Pastel on paper; 14 × 10¾ (36.5 × 27.3)
Inscribed upper right: *Dear Mimi/ from Elizabeth 1901*
Owner: Mr. and Mrs. Walter S. Bunker, Cincinnati.
Previous owner: Mrs. Frederick A. Schmidt, Cincinnati.
Exhibition: Indian Hill 1978, no. 54.
Reference: Elliston, December 1938 (illus.).

This study for A–44 was given by EN to her close friend Mimi Schmidt. There are three sketches for this work in H–14.

A–46
The Baby's Supper
1900
Oil
Unlocated
Reference: LN in Paris to unknown
person, July 1900.

In her letter LN referred to this work
as a small oil version of A–44 that a
gentleman in Paris ordered after he
saw a drawing of it (presumably A–
45).

A–47
Normandy Peasant Woman and Child
1900
Figure 48
Oil on canvas; 25¹⁄₁₆ × 18¾ (63.6 ×
47.5)
Signed lower right: *E. Nourse 1900*
Owner: Cincinnati Art Museum, gift
of Mrs. C. F. Dickson in memory of
her parents, Mr. and Mrs. James Bul-
lock, 1936.834.
Exhibition: Columbus (Ohio) Gallery
of Fine Arts, "Painters of the Past,"
March 20–April 12, 1942, no. 21.
Reference: LN in Finistère, Brittany, to
unknown person, September 24, 1900.

LN wrote that she and EN went to
Normandy from Paris on September 2,
1900, but found "Normandie was not
the place for E. . . . The farms were so
large—everyone behind locked gates
and barbed wire fences—the people so
hard to get at and get acquainted with
and so unpaintable." The sisters con-
tinued on to Penmarc'h in Brittany for
the first of many visits.

A–48
Rentrant de l'église, Penmarc'h (Com-
ing Home from Church, Brittany)
1900
Figure 49
Oil on canvas; 39½ × 30 (100.4 × 76)
Signed lower left: *E. Nourse 1900*
Owner: Private collection, Cincinnati.
Exhibitions: New Salon 1901, no. 709;
MACI 1901/2, no. 175; PAFA 1902,
no. 217.
Reference: Schmidt 1902, p. 336.

There is a single sketch, outlined with
a frame and initialed by EN, for this
work in H–14. It shows the same land-
scape background and the same figure
of the mother, but a little girl stands
on the opposite side from the Breton
boy seen in the painting.

A–49
Retour du travail, St. Léger (Return
from Work, St. Léger)
ca. 1900
Oil on canvas
Unlocated
Previous owner: Robert B. Ayers,
Cincinnati.
Exhibitions: New Salon 1901, no. 710;
AIC 1901, no. 273; PAFA 1902, no.
510.
References: EN Papers (note by Mel-
rose Pitman); Scrapbook 1, p. 67
(French review of 1901 New Salon).

The French review described this work
as a scene of a Breton woman cutting
cabbage in her cottage as her son,
lighted by a ray of sunshine, appears at
the door. The illustration for this entry
is the first of three sketches in Sketch-
book 14 (H–14) of a similar scene and
the one that best fits this description.
A–50 is probably a study for A–49.

A–50
Study for Retour du travail, St. Léger
ca. 1900
Watercolor
Unlocated
Exhibitions: New Salon 1903, no. 443;
Liège Exposition, 1909.
Reference: Scrapbook 1, p. 95 (entries
for 1909 Liège Exposition).

This is probably a study for A–49.

A–51
Toilette du bébé, le soir
1900
Figure 83
Oil on canvas; 38 × 24 (96.5 × 66)
Signed lower left: *E. Nourse/ 1900*
Owner: Private collection, Cincinnati.
Previous owner: Ran Gallery, Cincin-
nati.
Exhibitions: New Salon 1902; MACI
1900/1901, no. 177.
References: Scrapbook 1, p. 70 (Baude
etching); Schmidt 1902, p. 335 (illus.).

A–52 is a study for this painting.

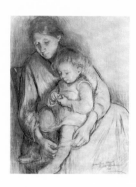

A–52
Study for Toilette du bébé, le soir
1900
Pastel on paper mounted on canvas; 23 × 19 (58.5 × 48.3)
Inscribed and signed lower right: *To dear Fred Clasgens/ Elizabeth Nourse/ 1910*
Owner: Mr. and Mrs. David Bowen, Cincinnati.
Previous owners: Frederick Clasgens, Cincinnati; John Druffel, Cincinnati.
Reference: EN Papers; Interview, Mary Alice Heekin Burke with Mrs. Robert A. Cline, cousin of Frederick Clasgens, August 1, 1979.

Frederick Clasgens was a sculptor from Cincinnati who lived in Paris for many years with his older sister, Agnes. The latter was a contemporary of the Nourses and visited them often in their studio.
 This work is a study for A–51.

A–53
Dans l'ombre à Penmarc'h
1901
Figure 94
Oil on canvas
Signed lower left: *E. Nourse 1901*
Unlocated
Previous owner: F. Van Dyke, Antwerp, in 1908.
Exhibitions: New Salon 1902; PAFA 1903, no. 210; Saint Louis Universal Exposition, 1904, no. 569 (awarded silver medal); "La quatorzième exposition annuelle des Femmes artistes," Galerie Georges Petit, Paris, 1905; Antwerp Exposition, 1908.
References: Scrapbook 1, p. 68 (photo and note by LN), p. 75 (note by LN and facsimilie of silver medal award for Saint Louis Universal Exposition), and p. 78 (reviews of "La quatorzième exposition annuelle des Femmes artistes," Galerie Georges Petit, Paris, January 1905, from *Echo, Epoque, Journal des Debats,* and *La Presse*); LN in Paris to Sister Monica, O.S.U. (location unknown), ca. 1931.

EN was awarded a silver medal for this and two of her other paintings, B–82 and C–119, at the Saint Louis exposition. In her letter to the American nun, Sister Monica, LN included EN's description of this painting as "a large canvas painted on the windy point of Penmarc'h where there were no trees to stand against the wind. The shadow cast by one of the picturesque stone houses of the country and the church

in the background is a famous one with its 'cloche à jour' and its wooden statues. The figures wear the richly embroidered orange and red costume of the Bigoudines and the local cap which is thought to have been worn by Queen Anne."

A–54
L'enfant endormi
ca. 1901
Watercolor on paper; 24 × 18 (61 × 45.8)
Signed lower right: *Elizabeth Nourse*
Owner: Stanley Cohen, Cincinnati.
Previous owner: Midwestern Galleries, Cincinnati.
Exhibition: New Salon 1901, no. 1323.

A–55
The Morning Bath
1901
Figure 82
Oil on canvas; 40 × 30 (101.6 × 76.2)
Signed lower left: *E. Nourse 1901*
Owner: Young Men's Christian Association, University of Cincinnati, in memory of Mary H. Gamble, 1930.
Reference: Mary L. Alexander, "In Memory of Mrs. David B. Gamble," *Cincinnati Enquirer,* March 8, 1930 (illus.).

This painting is similar to A–56.

A–56
Le bain (The Morning Bath)
1901
Oil on canvas
Unlocated
Previous owners: William H. and Blanche Duggan Cole, Los Angeles, in 1908.
References: "Art Notes," *Chicago Sunday Record Herald,* September 28, 1902 (illus.); Schmidt 1902; "The Morning Bath by Elizabeth Nourse," *Los Angeles Sunday Times,* May 3, 1908 (illus.).

The *Chicago Sunday Record Herald* described this work as a large painting "pleasantly suggestive of Dagnan-Bouveret," examples of whose work were then on view at the Anderson Gallery. The *Los Angeles Sunday Times* described the new studio built by William and Blanche Cole, both artists, at 1109 Magnolia Avenue. It stated that Cole was a discriminating collector, as his father had been, and remarked that *The Morning Bath* was the most striking picture among the twelve or fifteen paintings in his collection.
 This painting is similar to A–55.

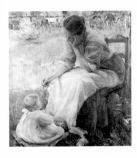

A–57
Meditation
1902
Oil on canvas; 26½ × 27½ (67.3 × 69.9)
Signed lower right: *Elizabeth Nourse/ 1902*
Owner: Sheldon Memorial Art Gallery, University of Nebraska, Lincoln, from 1978.

Some of the sketches in H–13, made for A–39, served as the basis for this composition.

A–58
Mère et bébé
ca. 1902
Distemper on paper
Unlocated
Exhibition: New Salon 1902, no. 417.

A–59
Les tricoteuses, paysannes de Penmarc'h
ca. 1902
Watercolor
Unlocated
Exhibitions: New Salon 1903, no. 444; PAFA Watercolor 1910, no. 151; Nantes Exposition 1905, no. 10; CAM 1910, no. 113.
Reference: *Nantes Populaire*, February 16, 1905.

This work is a variation of A–60.

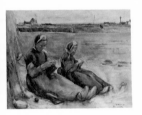

A–60
Study for Les tricoteuses, paysannes de Penmarc'h
ca. 1902
Watercolor; 14 × 18½ (35.5 × 47)
Signed lower left: *E. Nourse/ Penmarc'h*
Owner: College-Conservatory of Music, University of Cincinnati, bequest of Walter S. Schmidt, 1962.4.33.
Exhibition: U.C. 1974, no. 31.

This is one of thirty-four works left in EN's estate that were bequeathed by her executor, Walter S. Schmidt, to the College-Conservatory of Music of the University of Cincinnati. Schmidt was a civic leader who served as president of the Board of the College of Music for many years and occupied the same position after the school merged with the Conservatory of Music, when both became part of the University of Cincinnati.
This painting is a variation of A–59.

A–61
Nourrice et bébé (Mère et bébé)
1903
Figure 55
Pastel on paper; 28 × 16¾ (71.1 × 43.6)
Signed lower left: *E. Nourse/ 1903*
Owner: Private collection, Cincinnati.
Exhibitions: Lodge 1906; Woman's Art Club of Cincinnati 1906, no. 57 (exhibited as *Mère et bébé*).
Reference: Scrapbook 1, p. 81 (Paris review of 1906 Lodge exhibition).

This is one of six works on paper that EN donated to a benefit for the Woman's Art Club of Cincinnati in 1906. She was an honorary member of the club for many years.

A–62
Intérieur français
ca. 1904
Oil on canvas
Signed lower right: *Elizabeth Nourse*
Unlocated
Exhibitions: New Salon 1904, no. 962; AIC 1904, no. 319; Liège Exposition, 1909.
References: Scrapbook 1, p. 73 (photo) and p. 95 (entries for 1909 Liège Exposition).

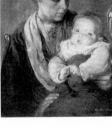

A–63
Le premier né (The First Born)
ca. 1904
Oil on canvas
Signed lower right: *Elizabeth Nourse*
Unlocated
Previous owner: Mrs. Peck, in 1909.
Exhibitions: New Salon 1904, no. 963; AIC 1904, no. 320; PAFA 1905, no. 487.
References: Scrapbook 1, p. 74 (photo and note by LN); Walsh 1922, p. 19 (illus.); EN Papers (photo).

A–64
Les jours heureux (Happy Days)
1905
Figures 59 and 78
Oil on canvas; 40 × 40 (101.6 × 101.6)
Signed lower right: *E. Nourse 1905*
Owner: The Detroit Institute of Arts, Whitney-Hoff Purchase Award, 1909.27.
Exhibitions: New Salon 1905, no. 960; AIC 1905, no. 244; PAFA 1906, no. 157; CGA 1907, no. 35; CAM 1907, no. 62; MACI 1908, no. 238; IAU 1909.

There is a sketch for this painting in H–18. A–65 is a study for the work, and A–98 is a variation on it.

A–65
Study for Les jours heureux
ca. 1905
Work on paper
Unlocated
Exhibitions: New Salon 1905, no.
1564; Woman's Art Club of Cincinnati
1906, no. 54.

This is a study for A–64. EN exhibited
both works in the New Salon of 1905.

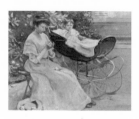

A–66
Un jour d'été
ca. 1905–7
Watercolor and gouache on paper-
board; 21½ × 28 (54.6 × 71.2)
Signed lower right: *Elizabeth Nourse*
Owner: Mr. and Mrs. Walter S.
Bunker, Cincinnati.
Previous owner: Walter S. Schmidt,
Cincinnati.

The title of this work is written on the
back of the paperboard.

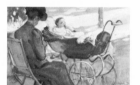

A–67
Mother with Baby in Carriage
ca. 1905–7
Pastel on paper; 15 × 23½ (38 × 57.8)
Signed lower right: *Elizabeth Nourse*
Owner: Louise Settle Talley, Stockton,
Calif., from 1950.
Previous owners: Estate 1938; Mary
Louise Stacy Settle, Stockton, Calif.,
1938–50.

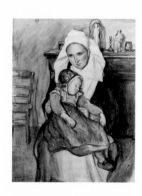

A–68
L'enfant qui dort
ca. 1906
Watercolor on paper; 24¾ × 19¼ (63
× 49)
Signed lower left: *Elizabeth Nourse*
Owner: Private collection, Middle-
town, Ohio, from 1959.
Previous owners: Walter S. Schmidt,
Cincinnati; Mrs. Henry Rattermann,
Jr., Cincinnati.

A label on the reverse of this work
states that it is the first study for A–74.

A–69
Sketch for L'enfant qui dort
ca. 1906
Charcoal and chalk on paper; 12½ ×
9½ (31.8 × 23.5)
Signed lower right: *Elizabeth Nourse*
Owner: Private collection, Alexandria,
Va.

This and A–70 are preliminary sketches
for A–68 and A–74, drawn on opposite
sides of the same piece of paper. This
sketch, which is signed, is the one EN
selected for the final composition.

174

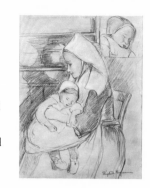

A–70
*Sketch for L'enfant qui dort with inset
head of a baby*
ca. 1906
Charcoal and chalk on paper;
12½ × 9½ (31.8 × 23.5)
Owner: Private collection, Alexandria,
Va.

This and A–69 are preliminary sketches
for A–68 and A–74. Both A–69 and A–
70 must be pages from EN's sketch-
book, which she gave to Anna Seaton
Schmidt who lived in Washington,
D.C., at the time they were sold there.

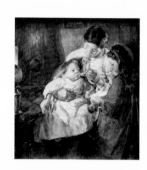

A–71
La becquée
ca. 1907
Oil on canvas
Signed lower right: *E. Nourse*
Unlocated
Previous owner: "Nantes Museum,"
France.
Exhibitions: New Salon 1907, no. 928;
Rouen Exposition 1909; Nice Exposi-
tion 1910; Nantes, "Exposition des
Amis des Arts," 1911, no. 340.
References: Scrapbook 1, p. 80 (photo
and note by LN), p. 95 (entries for
1909 Rouen Exposition), and p. 99
(entries for 1910 Nice Exposition).

This painting contains the same figures
of mother and baby as A–72, but the
figure of a little girl to the right has
been added. There is a sketch for this
work with the little girl standing be-
hind the baby on the right in H–18.

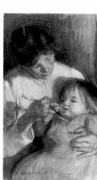
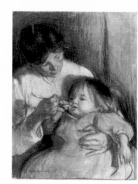

A–72
La becquée
(Mother Feeding Her Baby)
ca. 1907
Crayon and pastel on paper; 26 x 20
(66 x 50.9)
Signed lower left: *Elizabeth Nourse*
Unlocated
Previous owner: Smith College Mu-
seum of Art, Northampton, Mass.,
1911–47.
References: " 'La Becquée' by Eliza-
beth Nourse," *Springfield Sunday Re-
publican,* April 30, 1911 (illus.); Scrap-
book 2, p. 12 (letter from Alfred
Vance Churchill, Smith College, to
EN in Paris, November 14, 1912); EN
Papers (glass negative); Records of
Smith College Museum; *Kende Galler-
ies at Gimbel Brothers Sale* (New York),
January 10, 1947, no. 249; Parke-Ber-
net Galleries (New York), *Estate Sale of
Albert E. McVitty,* 1949, no. 70.

This drawing was discussed in the
Springfield Sunday Republican in 1911
when it was acquired by Smith Col-
lege. The 1912 letter from Alfred

Vance Churchill, head of the art department at the college, expressed his pleasure in acquiring it for the college museum. There is a glass negative of the drawing among the eighteen negatives left in EN's estate, which are now at the Cincinnati Historical Society. This drawing was deaccessioned by Smith College in 1947 and was then listed in the 1949 Parke-Bernet sale catalogue as *Mother and Child*, signed upper right: *Mary Cassatt*. Given its provenance and the fact that the same models for the mother and baby appear in A–71, which has the same title, it would appear that the signature on the drawing was changed between 1947 and 1949.

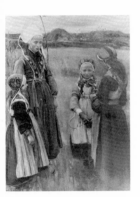

A–73
Dans les champs à Plougastel
1907
Oil on canvas
Signed lower left: *Elizabeth Nourse*
Unlocated
Reference: Scrapbook 1, p. 82 (marked photo).

There is an outline and initialed sketch for this work in H–15.

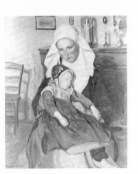

A–74
L'enfant qui dort, Plougastel
1907
Oil on canvas
Signed lower left: *Elizabeth Nourse*
Unlocated
Exhibition: New Salon 1907, no. 931.
Reference: Scrapbook 1, p. 82 (photo and note by LN).
A–68 is a watercolor study for this painting. As usual, EN made some changes in her final version. The oil is extended at the top to include a framed picture in the scene and there is less foreground than in the watercolor study. A–69 and A–70 are preliminary sketches for A–68 and A–74.

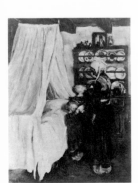

A–75
Intérieur breton, Plougastel
ca. 1907
Oil on canvas; 25¹⁵/₁₆ × 16¹³/₁₆ (73 × 59.7)
Signed lower left: *Elizabeth Nourse*
Owner: Art Museum of the Cincinnati Public Schools.
Previous owner: Withrow High School, Cincinnati.
Exhibitions: New Salon 1908, no. 898; PAFA 1909, no. 141; Woman's Art Club of New York, 1911, no. 31.
References: Lord 1910; *Art and Progress* (June 1915) (illus.).

175

A–76
La jeune mère
ca. 1907
Wood engraving
Unlocated
Reference: Scrapbook 1, p. 81 (clipping from French newspaper, 1907).

This is the first example of engraving done by EN since 1882. The French newspaper article listed it as no. 0319 in an auction held in Paris in 1907 for the benefit of widows and orphans of artists.

A–77
Mère et bébé (Mother and Child)
ca. 1907
Watercolor
Unlocated
Exhibitions: PAFA Watercolor 1907, no. 220; CAM 1907, no. 65.

A–78
Mère et bébé, Finistère
ca. 1907
Oil on canvas; 24½ × 19¾ (61.5 × 50.2)
Signed upper right: *Elizabeth Nourse*
Owner: University of Washington, Seattle, gift of Judge and Mrs. Thomas J. Burke, 1932.
Exhibitions: New Salon 1910, no. 965; AIC 1910, no. 166; PAFA 1911, no. 132; Quelques 1912, no. 105.

This canvas is dated 1907 because of its similarity to A–74. The same models, in the costumes of Plougastel-Daoulas, were used. Labels on the back of this canvas indicate that the work was exhibited in Chicago, no. 35; in Nantes, no. 182; and in Nice, but no records have been found to corroborate this.

Judge and Mrs. Burke, the previous owners, visited EN in Paris often. Their gift to the University of Washington was used to establish the Thomas J. Burke Memorial Museum, a natural-history museum with emphasis on the Pacific Rim. The Burkes gave ten Nourse paintings to the university, but seven cannot be located.

A–79
Endimanché, Brittany
ca. 1908
Oil on canvas
Signed lower left: *Elizabeth Nourse*
Unlocated
Previous owner: Société Royale des Beaux-Arts, Ghent, in 1909.
References: Scrapbook 1, p. 90 (photo and note by LN); Goldman 1921 (illus.).

There are two loose sketches for this work that have been placed in H–14.

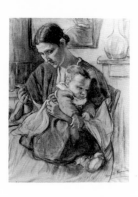

A–80
Mère et bébé, femme qui coud
ca. 1908
Pastel on paper; 32 x 25¾ (81.2 × 65.4)
Signed lower right: *Elizabeth Nourse*
Owner: Private collection.
Previous owner: Estate 1938, no. 57
Exhibitions: New Salon 1908, no. 1611; PAFA Watercolor 1912, no. 132; Quelques 1912, no. 106.

There are two sketches for this work in H–18. A–81 is also a sketch for it.

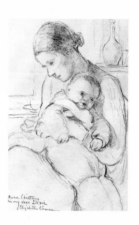

A–81
Sketch for Mère et bébé, femme qui coud
ca. 1908
Charcoal and chalk on paper; 9½ x 6 (23.5 x 15)
Inscribed and signed lower left: *Merrie Christmas/ for my dear Dixie/Elizabeth Nourse*
Owner: Cincinnati Art Museum, gift of Mrs. Mary L. Alexander, 1950.142.

This drawing was probably given by EN to Dixie Selden, a Cincinnati artist who often painted in Europe. It was donated to the museum by her friend, Mary Alexander, Cincinnati sculptor and art critic for the *Cincinnati Times-Star*. This work is a sketch for A–80.

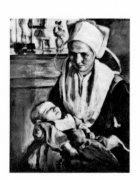

A–82
L'enfant qui dort (Mother and Child)
ca. 1909
Oil on canvas; 28½ x 23¼ (72.5 x 59)
Signed upper right: *Elizabeth Nourse*
Owner: Kenneth Lux Gallery, New York, from 1980.
Exhibitions: New Salon 1909, no. 912; AIC 1909, no. 188; New York, Kenneth Lux Gallery, "Recent Acquisitions in American Paintings," October 14–November 18, 1980, no. 2.
Reference: *Sotheby Parke Bernet & Co. Sale* (London), February 6, 1980, no. 95 (as *A Dutch Mother and Child*).

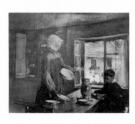

A–83
Intérieur dans les Vosges
1909
Oil on canvas; 39 x 39 (99 x 99)
Signed lower right: *E. Nourse*
Owner: Private collection, Middletown, Ohio, from 1959.
Previous owner: Mrs. Henry Rattermann, Jr., Cincinnati.
Exhibitions: New Salon 1910, no. 962; IAU 1911.
References: Scrapbook 1, p. 113 (photo and note by LN); E. M. Heitkamp, "Artist Shows the Simple Life of the

Peasants of the Vosges," *Detroit Free Press,* June 4, 1911 (illus.).

LN noted that the young boy model was René de Roy, son of the Marquise de Roy. The Nourses visited the marquise at her summer home in Haute Alsace in 1909. A–84 and A–85 are sketches for this painting.

A–84
Sketch for Intérieur dans les Vosges [with one figure]
1909
Charcoal and pastel on paper; 9 x 12 (22.2 x 30.5)
Inscribed lower left: *Haute Alsace*
Owner: Private collection, Middletown, Ohio, from 1959.
Previous owner: Mrs. Henry Rattermann, Jr., Cincinnati.

This and A–85 are sketches for A–83 and were probably taken from H–16.

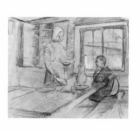

A–85
Sketch for Intérieur dans les Vosges [with two figures]
1909
Charcoal and pastel on paper; 9 x 12 (22.2 x 30.5)
Owner: Private collection, Middletown, Ohio, from 1959.
Previous owner: Mrs. Henry Rattermann, Jr., Cincinnati.

This and A–84 are sketches for A–83 and were probably taken from H–16.

A–86
Mother Dressing a Child
ca. 1909
Figure 60 and page 153
Charcoal and pastel on paper; 9½ x 7½ (24.1 x 19)
Signed lower right: *Elizabeth Nourse*
Owner: Mr. and Mrs. W. Roger Fry, Cincinnati.

This sketch is dated in relationship to the sketches in H–16, which show the same models also drawn in charcoal and pastel on gray paper.

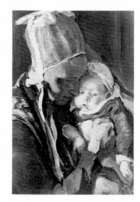

A–87
Tendresse
ca. 1909
Oil on canvas
Unlocated
Previous owner: Mrs. Cyrus E. Perkins, Grand Rapids, Mich., in 1912.
Exhibitions: New Salon 1909, no. 911; Liverpool, Walker Art Gallery, "Autumn Exhibition of Modern Art," 1909/10, no. 339; CAM 1910, no. 105; Woman's Art Club of New York, An-

nual Exhibition, 1911, no. 30.
References: Helen Moseley, "In Local Art Circles," *Grand Rapids Herald*, 1910; Goldman 1921, p. 9 (illus.); Lord 1910.

Mrs. Cyrus E. Perkins, the previous owner of this work, was the first president of the Grand Rapids Art Association in 1910, at which time she acquired her first Nourse painting, *Humble ménage* (B–71).

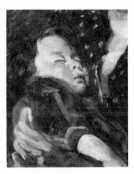

A–88
Child Asleep (Sleeping Child)
ca. 1910
Oil on paperboard; 8¼ x 6¾ (21 x 17.1)
Signed lower left: *Elizabeth Nourse*
Reference: Sale catalogue, Sotheby Parke Bernet (New York), *American Impressionist and Twentieth Century Paintings, Drawings, and Sculpture,* March 11, 1982, no. 1.

This is a study for a mother and child painting and is dated stylistically because of the models' similarity to those in A–89, A–90, and A–91.

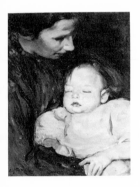

A–89
L'enfant qui dort
ca. 1910
Unlocated
Reference: Scrapbook 1, p. 102 (photo and note by LN).

A–90 is a study for the baby in this picture.

A–90
Child Asleep (Study for L'enfant qui dort)
ca. 1910
Oil on paperboard; 11 x 8½ (28 x 21.5)
Signed lower left: *E. Nourse*
Owner: Private collection, Saint Martin's, Ohio, gift of Clement J. Barnhorn.

This is a study for the figure of the baby in A–89. It was given by EN to her friend, Clement Barnhorn (see comment, B–51, and portrait, C–104).

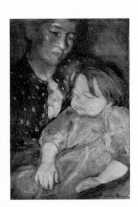

A–91
Mère et bébé
ca. 1910
Oil on canvas
Signed lower right: *Elizabeth Nourse*
Unlocated
Previous owner: Mrs. Joseph H. Meyers, Cincinnati.

This work is known only from a photograph and a note by LN listing the title and owner in an album of EN's work given to the Léthias family in Saint Léger, France. The models are identical to those in A–88.

A–92
Mother and Children
by 1910
Oil
Unlocated
Reference: Wheeler 1910.

In her 1910 newspaper article, Mary Wheeler described this painting as "a mother feeding three little ones, an oil sketch for a salon picture."

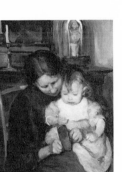

A–93
Le soulier neuf
ca. 1910
Oil on canvas; 24 x 20 (61 x 50.8)
Signed lower left: *E Nourse*
Owner: Private collection, Deerfield, Mass.
Previous owners: Edith Nourse Rogers, Lowell, Mass., 1912–60; Admiral Harold Lawrence, Saco, Maine, 1960–80.
References: Scrapbook 2, p. 39 (letter from Edith Nourse Rogers in Lowell, Mass., to EN in Paris, ca. 1912); *Estate Sale of Admiral Harold Lawrence* (Saco, Maine), 1980, no. 185.

This painting was a gift from EN to Edith Nourse Rogers, who was obviously a descendant of the same New England family as EN, with whom she became acquainted in France. Edith Nourse Rogers had been educated in Paris and made frequent trips abroad. During World War I she worked with the Red Cross in Paris and after the war served as a liaison with veterans' groups under three presidents—Harding, Coolidge, and Hoover. Mrs. Rogers served seventeen terms in Congress as the Representative from the Fifth District in Massachusetts. In addition to this painting, she also owned B–44.

A–94 is a pastel study for this painting.

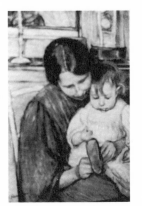

A–94
Study for Le soulier neuf
ca. 1910
Pastel on paper; 24 x 20 (61 x 50.8)
Signed lower left: *Elizabeth Nourse*
Owner: Private collection.
Previous owner: Edith Noonan Burt, Stuart, Fla.
Exhibition: New Salon 1910, no. 1620.

The previous owner was EN's niece, an artist at the Rookwood Pottery from 1904 to 1910. She married Stanley Gano Burt, who was chief chemist at the pottery from 1897 to 1929. This pastel is a study for A–93.

A–95
A la tombée du jour (Close of Day) (Twilight)
ca. 1911
Oil on canvas; 39⅜ x 39½ (100 x 100.4)
Signed lower right: *Elizabeth Nourse*
Owner: Private collection, Cincinnati.
Previous owner: The Toledo Museum of Art, 1912–73; gift of E. D. Libbey.
Exhibitions: New Salon 1911, no. 1014; AIC 1911, no. 255; John Herron Art Institute, Indianapolis, 1911/12.
References: Scrapbook 2, p. 2 (photo); Anna Seaton Schmidt, "The Paintings of Elizabeth Nourse," *Art and Progress* (October 1912): 746–47; Clara T. MacChesney, "Mothers and Children: The Inspiration of Two Famous American Women Artists," *Vogue*, November 1912, p. 39 (illus.); Archives (letter from LN in Paris to J. H. Gest in Cincinnati, December 8, 1911).

In her letter LN told J. H. Gest that this was one of the most difficult pictures EN had ever attempted because of the problem of combining the effects of lamplight and twilight. There are three sketches for this work in H–16.

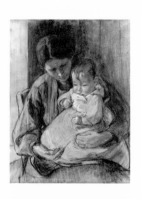

A–96
Mère et bébé
ca. 1911
Pastel on paper; 29 x 23⅞ (73.8 x 60.4)
Signed lower right: *Elizabeth Nourse*
Owner: Private collection, Cincinnati.
Previous owner: Col. P. Lincoln Mitchell, Cincinnati.
Exhibitions: New Salon 1911, no. 1634; Quelques 1912, no. 105.

There is a sketch for this work in H–16.

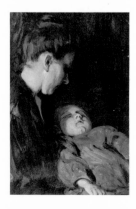

A–97
L'enfant qui dort
ca. 1912
Oil on canvas
Signed lower right: *E. Nourse*
Previous owner: J. Rosier, [Liège?]
Exhibitions: New Salon 1912, no. 1013; AIC 1912, no. 181; Liège Exposition, 1912.
Reference: Scrapbook 2, p. 20 (photo and note by LN) and p. 16 (entries for

1912 Liège Exposition and note by LN).

LN noted that this work was sold in Liège in 1912.

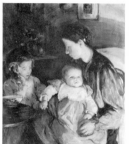

A–98
Les heures du soir (Evening Hours)
ca. 1912
Oil on canvas; 39 x 29½ (99 x 75)
Signed lower right: *Elizabeth Nourse*
Owner: The Butler Institute of American Art, Youngstown, Ohio, since 1947.
Previous owner: Smith College Museum of Art, Northampton, Mass., gift of Mrs. J. E. Lambie, 1913.
Exhibitions: New Salon 1912, no. 1015; AIC 1912, no. 180.
References: *Kende Galleries at Gimbel Brothers Sale* (New York), January 24–25, 1947, no. 269; Butler Institute of American Art, *Catalogue of the Permanent Collection* (1951), no. 84.

This painting is a variation on A–99.

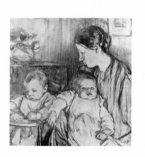

A–99
Les jumeaux (The Twins)
ca. 1912
Pastel
Signed lower right: *Elizabeth Nourse*
Unlocated
Previous owner: Mrs. Larz Anderson, Cincinnati, in 1925.
Exhibitions: New Salon 1912, no. 1662; PAFA Watercolor 1912, no. 139; CAM 1925, no. 172, loaned by Mrs. Larz Anderson.
References: *Philadelphia North American,* November 10, 1912 (illus.); *Philadelphia Public Ledger,* November 17, 1912.

Emma Mendenhall Anderson, the previous owner, studied at the McMicken School of Design with EN and wrote a book about her in 1922. This drawing is a variation on A–98, the difference being the substitution of a twin baby in a high chair in this pastel for the little girl on the left in the oil painting.

A–100
Marchande des fleurs
ca. 1912
Probably oil on canvas
Unlocated
Exhibition: Bordeaux Exposition, 1912.
Reference: Scrapbook 2, p. 16 (note by LN).

LN noted that this work was sold at the Bordeaux exposition. It is probably an oil painting of A–101.

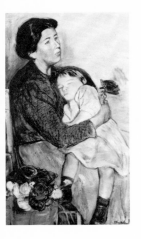

A–101
Marchande des fleurs
ca. 1912–21
"Drawing with color"
Signed lower right: *Elizabeth Nourse*
Unlocated
Previous owner: Walter S. Schmidt, Cincinnati.
Exhibitions: New Salon 1921, no. 1477; Closson 1941.
Reference: Cherry Greve Lyford, "New Gallery of Art Opening Sunday," *Cincinnati Times-Star,* October 9, 1941.

A–100 is probably an oil painting of this composition, described in the 1912 New Salon catalogue as a "drawing with color." Since A–100 was sold in 1912, this drawing may have been completed by that date or EN may have prepared it for the 1921 New Salon.

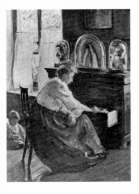

A–102
La menagère
ca. 1912
Oil on canvas
Signed lower right: *Elizabeth Nourse*
Unlocated
Previous owner: Mrs. Alex F. Weisberg, Dallas, in 1920.
Exhibitions: New Salon 1912, no. 1011; Le Touquet (Picardy), "Société Artistique de Picardie," 1913, no. 125; Anglo-American 1914; Paris, Galerie Manuel Frères, 1920.
References: Scrapbook 2, p. 19 (photo), p. 60 (note by LN), and p. 83 (entries for 1920 Galerie Manuel Frères exhibition).

This work was priced at 1,500 francs, about $300, at the Le Touquet exhibition (which was organized by the American artist Henry Ossawa Tanner), but was later sold at the Galerie Manuel Frères for 3,500 francs. EN only began to exhibit at private Paris galleries after World War I. There are two sketches for this work in H–16, one of the woman alone and one of the child.

A–103
Mère et bébé
ca. 1912
Oil on canvas
Unlocated
Exhibitions: New Salon 1912, no. 1012; AIC 1912, no. 179; Lodge 1913.
Reference: Scrapbook 2, p. 38 (Paris review of 1913 Lodge Art League exhibition).

A–104
Mother and Sleeping Child
ca. 1912
Oil on paperboard; 23¼× 15¾ (59 × 40)
Signed lower right: *E. Nourse*
Owner: College-Conservatory of Music, University of Cincinnati, bequest of Walter S. Schmidt, 1962.4.14.
Exhibitions: College 1941, no. 33; U.C. 1974, no. 1.

For information on Walter S. Schmidt's bequest to the owner, see comment, A–60.

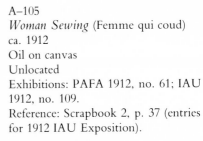

A–105
Woman Sewing (Femme qui coud)
ca. 1912
Oil on canvas
Unlocated
Exhibitions: PAFA 1912, no. 61; IAU 1912, no. 109.
Reference: Scrapbook 2, p. 37 (entries for 1912 IAU Exposition).

The illustration for this entry is a charcoal and chalk sketch with an outline drawn around it, signed *E.N.*, in H–16; the sketch may be the basis for this work.

A–106
La mère
ca. 1913
Oil on canvas
Unlocated
Exhibitions: New Salon 1913, no. 961; AIC 1913, no. 247; PAFA 1914, no. 51.

A–107 is probably a study for this subject.

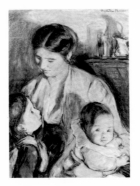

A–107
Study for La mère
ca. 1913
Pastel on paperboard; 24 × 18 (61 × 45.6)
Signed upper right: *Elizabeth Nourse*
Owner: College-Conservatory of Music, University of Cincinnati, bequest of Walter S. Schmidt, 1962.4.14.
Exhibitions: New Salon 1913, no. 1661; Le Touquet (Picardy), "Société Artistique de Picardie," 1913, no. 124; U.C. 1974, no. 20.

As an indication of what EN was able to earn from her work, the price marked on the back of this pastel is 300 francs, about $50 at the time it was drawn, although the price listed at the Le Touquet exhibition was 500 francs.

This work is probably a study for A–106 and, like A–108, is a variation on the subject.

For information on Walter S. Schmidt's bequest to the owner, see comment, A–60.

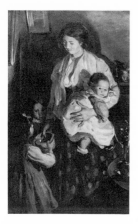

A–108
La mère
ca. 1913–21
Oil on canvas; 48 × 30½ (122 × 77.5)
Unlocated
Previous owner: Wightman Memorial Art Gallery, University of Notre Dame, South Bend, Indiana, gift of the artist, 1921.
Reference: Dom Gregory Gerrer, O.S.B., *Catalogue of the Wightman Memorial Art Gallery,* University of Notre Dame Bulletin, vol. 29, no. 3, 1934.

EN presented this painting to the University of Notre Dame when it awarded her the Laetare Medal in 1921. A–107 is a variation on this subject, for which there are six sketches in H–17. The most finished of the latter is drawn in charcoal and colored chalk and has an outline drawn around it. The sketch is signed *Elizabeth Nourse 1912.* It is not known whether EN executed the oil painting in 1912 or painted it later.

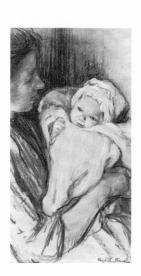

A–109
Le nouveau-né
ca. 1913
Pastel on paper; 19 × 11 (48.5 × 28)
Signed lower right: *Elizabeth Nourse*
Owner: Private collection, Cincinnati.
Previous owners: Estate 1938, no. 16; Martin G. Dumler, Cincinnati.
Exhibition: New Salon 1913, no. 1657.

A–110
Le petit nourisson
ca. 1913
Oil on canvas
Unlocated
Exhibition: New Salon 1913, no. 963.

A–111 is probably a study for this work.

A–111
Study for Le petit nourisson
ca. 1913
Work on paper
Unlocated
Exhibition: New Salon 1913, no. 1660.

This is probably a study for A–110.

A–112
L'attente (Waiting)
ca. 1914
Oil on canvas; ca. 40 × 40 (ca. 101.6 × 101.6)
Unlocated
Exhibitions: New Salon 1920; MACI 1923, no. 19.
References: Scrapbook 2, p. 83 (entries for 1920 New Salon); Archives (letter from LN in Paris to J. H. Gest in Cincinnati, April 1, 1921).

In her letter to J. H. Gest, LN gave the measurements of this painting and the following description: "In treatment it is like *L'été* [B–123]. Elizabeth painted it in 1914 in our studio—the models were a Mother and baby—posing near the big window, the background was the garden de Luxembourg en face. The mother and child refugiées—they are simply waiting—hoping—trusting—you see at once that they are in an environment not their own. It is a very beautiful painting—full of sunshine and light. . . ."

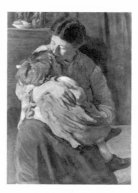
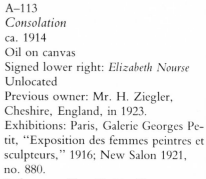

A–113
Consolation
ca. 1914
Oil on canvas
Signed lower right: *Elizabeth Nourse*
Unlocated
Previous owner: Mr. H. Ziegler, Cheshire, England, in 1923.
Exhibitions: Paris, Galerie Georges Petit, "Exposition des femmes peintres et sculpteurs," 1916; New Salon 1921, no. 880.
References: Clara T. MacChesney, "American Artists in Paris," *International Studio* (November 1914): xxiv–xxviii (illus.); Scrapbook 1, p. 85 (entries for 1921 New Salon) and p. 72 (entries for 1916 Galerie Georges Petit exhibition).

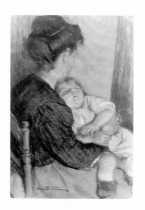

A–114
Mother and Sleeping Child
ca. 1914
Pastel on paper; 25¾ × 19¼ (65.5 × 49)
Signed left center: *Elizabeth Nourse*
Owner: Louise Settle Talley, Stockton, Calif., from 1970.
Previous owners: Charles E. Nourse, Cincinnati, to 1939; Mrs. Charles E. Nourse, Cincinnati, 1939–58; Mary Louise Stacey Settle, Stockton, Calif., 1939–70.

A–115
Petit Joseph
ca. 1914
Work on paper
Unlocated
Exhibition: New Salon 1914, no. 1570.
Reference: Scrapbook 1, p. 53 (entries
for 1914 New Salon and note by LN).

LN noted that the subject of this work
was one of EN's favorite models, the
otherwise unidentified Thérèse, and
her child.

A–116
Le tablier bleu (The Little Blue Apron)
ca. 1914–21
Figure 68
Oil on canvas; 35¾ × 20½ (90.8 ×
54)
Signed lower right: *Elizabeth Nourse*
Owner: Mr. and Mrs. Walter S.
Bunker, Cincinnati.
Exhibitions: College 1941, no. 17; In-
dian Hill 1978, no. 55.
References: Scrapbook 2, p. 85 (photo
of the posed models, 1914); Mary L.
Alexander, "Full Range of Paintings
Now on Display by Cincinnati's Most
Noted Woman Artist," *Cincinnati En-
quirer,* June 2, 1941.

In Scrapbook 2 there is a photograph
taken in 1914 of the models posing for
this painting, but A–117, a pastel study
for it, was exhibited in 1921. The exact
date of the oil's execution is, therefore,
unknown.

A–117
Study for Le tablier bleu
ca. 1914–21
Pastel
Unlocated
Exhibitions: New Salon 1921, no.
1478; College 1941, no. 16.

This is probably a study for A–116.

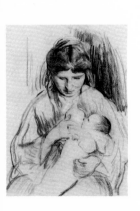

A–118
Mère et Bébé, Refugiées du Nord
ca. 1915
Pastel on paper; 12¼ × 9¼ (31.2 ×
23.5)
Signed upper right: *Elizabeth Nourse*
Owner: Mr. and Mrs. Randy Sandler,
Cincinnati.

The title is written on the reverse of
the picture.

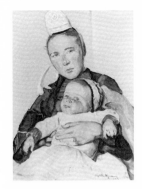

A–119
Breton Mother and Child
ca. 1917
Watercolor on paper; 25½ × 19⅛
(64.8 × 48.5)
Signed lower right: *Elizabeth Nourse/
Penmarc'h*
Owner: Private collection, Cincinnati.
Previous owner: Walter S. Schmidt,
Cincinnati.

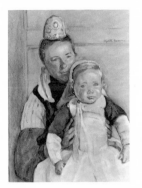

A–120
Chez le photographe à Penmarc'h
1917
Watercolor with charcoal and gouache
on paper; 33 × 26 (83.8 × 66)
Signed upper right: *Elizabeth Nourse*
Owner: Private collection, Cincinnati,
from 1947.
Previous owner: Walter S. Schmidt,
Cincinnati.
Exhibition: New Salon 1918.
Reference: Scrapbook 2, p. 73 (entries
for 1918 New Salon).

In 1918 the New and Old Salons held
a combined exhibition in Paris with
the works divided by Salon and with a
separate catalogue for each Salon.

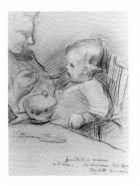

A–121
Jeannot et sa maman
1923
Pastel on paper; 12½ × 9½ (31.8 ×
24.2)
Signed and inscribed lower right: *Jean-
not et sa maman/ a 11 mois—Sa marraine
1923 Dec/ Elizabeth Nourse*
Owner: College-Conservatory of Mu-
sic, University of Cincinnati, bequest
of Walter S. Schmidt, 1962.4.26.

This was probably a sketch for a por-
trait that EN gave to the mother of her
godchild, Jeannot.
 For information on Walter S.
Schmidt's bequest to the owner, see
comment, A–60.

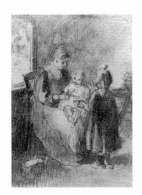

A–122
Mother, Baby, and Child
by 1923
Pastel on paper; 7 × 6 (17.5 × 15)
Signed lower left: *E. Nourse*
Owner: Private collection, Cincinnati.

This pastel is undated; there are no
sketches similar to it in the various
sketchbooks. Stylistically, however, it
might have been drawn as early as
1910.

B Other Genre Scenes

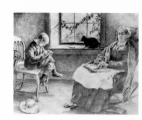

B–1
Domestic Scene
1874
Pencil on paper
Unlocated
Previous owner: Schmidt family, Cincinnati, in 1938.
Reference: Elliston, December 1938 (illus.).

When she was fifteen, EN submitted this sketch to qualify for admission to the institution known as the Mc-Micken School of Design.

B–2
Father's On the Pledge To-Night
1875
Drawing
Signed lower left: *E. Nourse*
Previous owner: Fillmore Brothers Publishers, Cincinnati.

This is an illustration for sheet music published by Fillmore Brothers, music publishers in Cincinnati.

B–3
Figure in Costume
1880
Drawing
Unlocated
Exhibition: McMicken 1880, no. 645.

B–4
Millville, Indiana, Interior
1880
Watercolor on paper; 10¼ × 14¾ (26 × 37.5)
Written on verso by Mary Nourse:
Painted by Elizabeth Nourse in Millville, Indiana 1880
Owner: Marian Thompson Deininger, Houston, from 1959.
Previous owner: Mary Nourse, Fort Thomas, Ky., to 1959.

Millville is a small town outside New Castle, Indiana, which was on the Erie Canal in 1880. B–7 is an identical scene viewed from a greater distance.

B–5
Street Boy
1880
Drawing
Unlocated
Exhibition: McMicken 1880, no. 650.

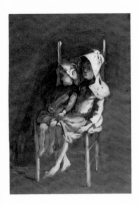

B–6
Two Children Seated
1880
Watercolor and gouache on paper; 16¾
× 11½ (42.5 × 29.3)
Written on verso by Mary Nourse:
Painted by/Elizabeth Nourse/ 1880
Owner: Private collection, Fort
Thomas, Ky.
Previous owners: Mary Nourse, Fort
Thomas, Ky., to 1959; Clara Nourse
Thompson, Fort Thomas, Ky., 1959–
79.

B–7
Cabin Interior, Millville, Indiana
1881
Figure 3 and page 146
Watercolor on paper; 11 × 14 (28 ×
35.5)
Signed lower right: *E. Nourse/ '81*
Owner: Mr. and Mrs. W. Roger Fry,
Cincinnati.

See comment, B–4.

B–8
Fruit Canning Time
ca. 1882
Watercolor
Unlocated
Exhibition: CIE 1882, no. 353.
Reference: EN in New York to her
sisters in Cincinnati, 1882, letter in
Nourse Family Collection, Houston.

B–9
Cabin Interior, Tennessee
ca. 1885
Watercolor
Unlocated
Previous owners: Mrs. Larz Anderson,
Cincinnati, to 1918; Mrs. Thomas J.
Emery, Cincinnati, in 1918.
Reference: Scrapbook 2, p. 74 (letter
from Fanny Polk Hosea in Cincinnati
to EN in Paris, May 4, 1918).

Judge and Mrs. Lewis Hosea were
hosts in 1918 for a benefit for EN's
war work, held at their home in Cin-
cinnati. Mrs. Larz Anderson donated
this watercolor to the benefit and Mrs.
Thomas J. Emery purchased it there
for $25.

B–10
Tennessee Woman Weaving
ca. 1885
Oil on canvas; 37¼ × 25½ (94.6 ×
64.8)
Owner: Mildred Cook O'Nan, Cin-
cinnati, from 1935.

There is a finished sketch for this
painting in H–4.

B–11
Old Man and Child
by 1887
Figure 8 and page 147
Oil on canvas; 22 × 16¼ (55.8 ×
41.3)
Signed lower right: *E. Nourse*
Owner: Private collection, Cincinnati,
from 1968.
Previous owners: John Dinkelaker,
Cincinnati, 1937–40; Herbert Dinke-
laker, Cincinnati, 1940–68.

B–12
Old Market Woman
by 1887
Figure 9
Watercolor on paper; 22½ × 15½
(57.2 × 39.4)
Signed lower left: *Elizabeth Nourse*
Owner: Barbara D. Gallen
Previous owners: Martin G. Dumler,
Cincinnati; Private collection, Cincin-
nati.
Reference: Scrapbook 2, p. 86 (letter
from Martin G. Dumler, Cincinnati,
to EN in Paris, January 4, 1921).

Mr. Dumler sent this watercolor to
Paris to have EN sign it and she noted
that she painted it when she lived in
Corryville, a suburb of Cincinnati
known today as Mount Auburn.

B–13
Flower Market at Saint Sulpice
ca. 1888
Unlocated
Previous owner: Mrs. W. W. Love,
Helena, Montana, before 1910.
Reference: Wheeler 1910.

B–14
Lavoir, Paris
1888
Figure 20
Watercolor on paper; 14⅝ × 21½
(37.2 × 54.5)
Signed lower right: *Lavoir Paris/ E.
Nourse 1888*
Owner: Private collection, Cincinnati.
Previous owner: Henriette Wachman,
Rome, Italy.

This was the first of several scenes EN
was to paint of the public washing
places in France.
 See A–32 for information about
Henriette Wachman.

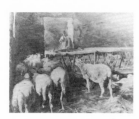

B–15
Dans la bergerie à Barbizon (In the Sheepfold)
1888
Oil on canvas
Unlocated
Exhibitions: Old Salon 1889, no. 2022; London, Royal Academy, 1892, no. 442 (as *The Call to Pasture*); CAM 1893, no. 9; Fischer 1894, no. 13.
References: Scrapbook 1, p. 20 (photo marked "sold in London"); Annotated CAM 1893 (price, $150).

B–16
Entre voisines (Among Neighbors)
1888
Figure 23
Oil on canvas; ca. 48 × 48 (ca. 122 × 122)
Unlocated
Previous owner: John Irving Pearce, Jr., Chicago, in 1912.
Exhibitions: Old Salon 1889, no. 2021; Nashville, "Tennessee Centennial Exposition," 1897, no. 242, loaned by John I. Pearce, Jr.
References: *American Art Annual* (1898), p. 136; Scrapbook 1, p. 19 (letter from John I. Pearce, Jr., in Chicago to EN in Paris, November 22, 1912).

John I. Pearce, the former owner, was the owner of the Sherman Hotel in Chicago and served on a committee for the World's Columbian Exposition in 1893. At this time he bought a second Nourse painting, B–37.

There are three sketches for *Entre voisines* in H–8, the third of which is closest to the final composition.

B–17
Wash-house at Fleury
ca. 1888
Watercolor
Unlocated
Exhibitions: CAM 1893, no. 78; Fischer 1894, no. 54.
Reference: Annotated CAM 1893 (price, $50).

The illustration for this entry is a sketch of a washhouse at Fleury (in H–7) that may be the basis for this work.

B–18
A Courtyard in Barbizon
1889
Unlocated
Previous owner: Mrs. Cassily, Cincinnati, in 1893.
Exhibition: CAM 1893, no. 39.
References: Annotated CAM (price, $25); Reception 1893.

The review states that the model for this work posed as the woman in Jean-François Millet's *The Angelus* (fig. 21); figure 22 is a sketch of her, marked "La Mère Adele," from H–7.

B–19
Street Scene, Barbizon
1889
Unlocated
Exhibition: CAM 1893, no. 23.
Reference: Annotated CAM 1893 (price, $85).

B–20
Dans la campagne (Girl with Milk Cans)
1889
Oil on canvas; 46 × 30^{15}/$_{16}$ (116.8 × 78.2)
Signed lower left: *E. Nourse/ Etaples 1889*
Owner: Dorothy M. Hawley, Trumbull, Conn.
Previous owners: H. Wood Sullivan, Washington, D.C., in 1903; E. B. Meyrowitz, New York, 1903.
Exhibitions: New Salon 1890, no. 571; CAM 1893, no. 12; Fischer 1894, no. 8.
References: Annotated Fischer 1894 (price, $250; marked "sold"); Carter 1893; H. Wood Sullivan Sale, *American Art Annual* (1903–4), p. 61.

In his review of the 1893 exhibition at the Cincinnati Art Museum, Carter used this painting to illustrate his thesis that EN's strong point was her drawing and observed that "there is actual weight upon the girl's shoulders and should she take a step you feel it would be a heavy one."

B–21
Dutch Peasant Girl Reading
1889
Oil on canvas
Unlocated
Previous owner: Dudley Porter, Haverhill, Mass., in 1903.
Exhibition: CAM 1893, no. 21, loaned by Dudley Porter.

Dudley Porter loaned two other paintings to the 1893 exhibition, A–17 and B–50.

B–22
Etaples, Brittany Coast
1889
Watercolor on paper; 11½ × 18½
(29.2 × 49)
Signed lower right: *Elizabeth Nourse/
Etaples*
Owner: College-Conservatory of Music, University of Cincinnati, bequest of Walter S. Schmidt, 1962.4.31.
Exhibition: U.C. 1974, no. 29.

For information on Walter S. Schmidt's bequest to the owner, see comment, A–60.

B–23
An Etaples Fair
1889
Unlocated
Exhibitions: CAM 1893, no. 37; Fischer 1894, no. 23.
Reference: Annotated CAM 1893 (price, $75).

B–24
Etaples Fisher-Girl
1889
Unlocated
Previous owner: David Wachman, Cincinnati, in 1893.
Exhibitions: CAM 1893, no. 29, loaned by David Wachman.

David Wachman, the former owner, was the brother of Henriette and Laura Wachman, expatriate friends of EN and LN (see comment, A–32). The illustration for this entry is a sketch in H–9 that may be the basis for this work.

B–25
Etaples Street Scene
1889
Unlocated
Exhibitions: CAM 1893, no. 48; Fischer 1894, no. 38.
Reference: Annotated CAM 1893 (price, $35).

B–26
Fisher Girl, Le Portel
1889
Watercolor
Unlocated
Previous owner: Mrs. Cassily, Cincinnati, in 1893.
Exhibition: CAM 1893, no. 80.
Reference: Annotated CAM 1893 (price, $50).

Le Portel is a seaside town about a mile from Boulogne. The Nourses and their friends, Beulah Strong, Mary

Wheeler, and Anna Schmidt, vacationed there in the summer of 1889. H–9 contains a number of sketches EN made in Le Portel.

B–27
Russian Peasant Spinning
1889–93
Unlocated
Exhibition: CAM 1893, no. 42.
Reference: Annotated CAM 1893 (price, $50; records sale).

Because EN brought sketches and costumes back from her trip to Russia in 1889 and prepared works from them as late as 1905, it is impossible to date them precisely. The illustration for this entry is a sketch in H–8 that may be the basis for this work.
B–56, B–57, and B–58 are other works with Russian themes.

B–28
La vielle cuisine fleurie
1889
Watercolor
Unlocated
Exhibition: New Salon 1890, no. 1130.

B–29
A la fontaine
1890
Figure 27
Oil on canvas
Unlocated
Previous owner: Mme. de Virel-Millier, Paris.
Exhibition: New Salon 1891, no. 706.
References: R. H. Sherard, "Clever Italian Studies by Miss Nourse," *New York Morning Journal,* March 8, 1891; Scrapbook 1, p. 23 (note by LN and Paris review of 1891 New Salon).

R. H. Sherard's article describes this picture, two girls beside a well at Assisi, as two life-size figures posed before a mass of rose leaves. There are three sketches for this work in H–10.

B–30
Assisi Interior
1890
Unlocated
Exhibitions: CAM 1893, no. 46; Fischer 1894, no. 30.
Reference: Annotated CAM 1893 (price, $35).

B–31
Assisi Street Scene
1890
Unlocated
Exhibitions: CAM 1893, no. 47;
Fischer 1894, no. 31.
Reference: Annotated CAM 1893
(price, $50).

B–32
Le pardon de Saint François d'Assise
(The Pardon at Assisi)
1890
Oil on canvas
Signed lower right: *Il Perdone/ E.
Nourse/ Assisi '90*
Unlocated

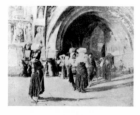

Previous owners: Mrs. A. S. Winslow,
Cincinnati, in 1893; C. R. Winslow,
Cincinnati; Mrs. W. L. Deveraux,
Portland, Oregon, in 1926.
Exhibitions: New Salon 1891, no. 707;
Chicago, "World's Columbian Exposi-
tion," 1893, Cincinnati Room, no. 18,
loaned by Mrs. A. S. Winslow; CAM
1893, no. 7, loaned by Mrs. A. S.
Winslow.
References: Scrapbook 1, p. 23 (un-
marked clipping from Cincinnati
newspaper, ca. 1891); MacChesney
1896, p. 5.

Mrs. August S. Winslow, the first
owner, was a vice-president of the
Cincinnati Woman's Art Museum As-
sociation, which was organized in 1877
to establish an art museum in the city.

In the Cincinnati newspaper article,
a letter from EN is quoted that de-
scribes this work: ". . . it represents
the fête called 'The Pardon' which
took place in August. The peasantry
come from all over carrying a tall stick
formed like a cross. They make this
pilgrimage every year, some of them
walking ten days! They carry their
food in bundles balanced on their
heads, and sleep out of doors. I wanted
to paint them just as they come into
the church singing 'Ave Maria' as they
walked, and kissing every other stone
with rapture. They seemed so sweet
and innocent—just like children.''

Figure 33 shows this painting hang-
ing in the Cincinnati Room at the
World's Columbian Exposition in Chi-
cago. There is a sketch for the work in
H–10. EN also exhibited B–39 in the
Cincinnati Room.

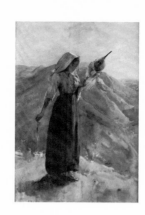

B–33
Peasant Spinning, Assisi
1890
Watercolor on paper; 21 × 14½ (63.3
× 36.9)
Signed lower left: *E. Nourse/ Assisi '90*
Owner: Private collection, Cincinnati.
Previous owner: Thornton Hinkle,
Cincinnati, in 1893.
Exhibition: CAM 1893, no. 70.
References: Reception 1893; Annotated
CAM 1893 (price, $50).

B–34
Capri Street Scene
1890
Watercolor
Unlocated
Exhibitions: CAM 1893, no. 77;
Fischer 1894, no. 53.
References: Annotated CAM (price,
$50); Reception 1893.

The 1893 Cincinnati newspaper article
described this work as showing "white
walls against a blue sky."

B–35
Fair at Grotta Ferrata
1890
Unlocated
Exhibitions: CAM 1893, no. 41;
Fischer 1894, no. 26.
Reference: Annotated CAM 1893
(price, $150).

B–36
Naples
1890
Watercolor
Unlocated
Exhibition: Sandusky, Ohio, "Work of
Former Sandusky Artists," ca. 1908.
Reference: Scrapbook 1, p. 89 ("Work
of Former Sandusky Artists," from
Sandusky, Ohio, newspaper, ca. 1908).

The review from the Sandusky news-
paper was of an exhibition that in-
cluded the work of EN and Charles C.
Curran, a fellow student of EN's at the
McMicken school and a native of San-
dusky. EN saw him in Sandusky in
1882. *Naples* was described as a scene
of two little Italian girls standing on a
windswept cliff and looking out over
the sea.

B–37
Vendredi Saint (Good Friday)
1891
Figure 26
Oil on canvas; 62 × 55 (154.9 × 139.7)
Signed upper left: *E. Nourse/ Rome 1891*
Owner: Union League Club of Chicago, Ill.
Previous owner: John Irving Pearce, Jr., Chicago, 1893–1901.
Exhibitions: New Salon 1891, no. 795; London, Continental Gallery, 1891; Munich, 1892; Chicago, "World's Columbian Exposition," 1893 (awarded medal); CAM 1893, no. 4; Nashville, "Tennessee Centennial Exposition," 1897, no. 699, loaned by John I. Pearce, Jr.

One of the largest pictures EN ever painted, this scene in the dim interior of a church represents the traditional kissing of the cross on Good Friday. There are three sketches for this work in H–10, the last of which is outlined and signed by EN and is the one most like the painting. There is an additional rough sketch of the small girl kneeling in front, a figure that does not appear in the other sketches.

John I. Pearce, Jr., the previous owner, also owned B–16 (see comment).

For this painting, B–42, and B–49, EN received a medal at the Palace of Fine Arts, World's Columbian Exposition, 1893.

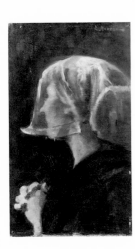

B–38
Head of a Woman Praying
ca. 1891
Oil on wood panel; 9¹⁵⁄₁₆ × 5⁹⁄₁₆ (23.7 × 14.2)
Signed upper right: *E. Nourse*
Written on verso: *A ma chère Amie Elizabeth Nourse/ Souvenir affection de Margery West*[field]
Owner: Minona Stevens Luce, Falmouth Foreside, Maine, from 1955.
Previous owners: Mrs. Edward W. Donn, Washington, D.C.; Edward W. Donn, Jr., Washington, D.C.; Minona Donn Smoot, Washington, D.C.

B–39
Peasant Women of Borst
1891
Figure 28
Oil on canvas; 38⅝ × 21⅝ (97.2 × 54.2)
Signed lower left: *E. Nourse Borst/ 1891*
Owner: Cincinnati Art Museum, gift by subscription, 1892.3.
Exhibitions: The Art Club of Philadelphia, "Third Annual Exhibition of Oil and Sculpture," 1891; Chicago, "World's Columbian Exposition," Cincinnati Room, no. 4; CAM 1893, no. 8, loaned by Cincinnati Museum Association; CAM, "Fiftieth Anniversary Exhibition of Work by Teachers and Former Students of the Art Academy of Cincinnati," 1937/38, no. 109; CAM, "Cincinnati Artists of the Past," 1942, no. 74; Golden Age 1979/80, no. 226.
References: *"Peasant Women of Brest* [sic] and *Good Friday,"* Cincinnati Commercial Tribune, March 6, 1910.

Seventeen prominent Cincinnati women made up the group of subscribers who donated this work to the Cincinnati Art Museum. Benn Pitman donated a carved frame for it. H–10 contains an outlined and initialed sketch for this work and a portrait sketch of the older woman to the right in the painting.

EN exhibited this painting and B–32 in the Cincinnati Room, World's Columbian Exposition (fig. 33).

B–40
Peasant Women Saying the Angelus
(Study for Peasant Women of Borst)
1891
Unlocated
Previous owner: Eugène Hémar, Paris.
Exhibitions: CAM 1893, no. 50; Fischer 1894, no. 34.
References: Annotated CAM 1893 (price, $75); Scrapbook 1, p. 23 (note by LN).

LN noted that this was the first study for B–39.

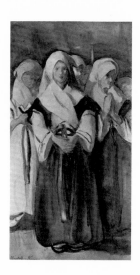

B–41
The Angelus
1891–1922
Watercolor on paper; 15¾ × 8¾ (40 × 22.3)
Signed lower left: *Elizabeth Nourse*
Inscribed on mat: *Dear Mr. Gest/ Souvenir Amical/Elizabeth Nourse*
Owner: Private collection, Cincinnati, from 1975.
Previous owners: J. H. Gest, Cincinnati, 1922–35; Henry Gest, Cincinnati, 1935–75.
Reference: Scrapbook 2, p. 94 (letter from J. H. Gest in Cincinnati to EN in Paris, October 10, 1922).

EN gave this watercolor version of A–39 and A–40 to J. H. Gest, director of the Cincinnati Art Museum, in gratitude for his many kindnesses to her. Gest organized her 1893 exhibition at the museum while he was assistant to Col. A. T. Goshorn, then director, and invited her to enter many museum exhibitions after he became director. He frequently stored paintings for her between fall and spring exhibitions in the United States to save her the expense of shipping them back to Paris.

B–42
Le repas en famille (The Family Meal)
1891
Figure 29
Oil on canvas
Unlocated
Previous owner: George W. Perkins, New York, 1893.
Exhibitions: New Salon 1892, no. 775; Chicago, "World's Columbian Exposition," 1893, no. 373 (awarded medal); CAM 1893, no. 6.
References: MacChesney 1896, p. 7; Schmidt 1906, p. 247; Scrapbook 1, p. 79 (letter from George W. Perkins in New York to EN in Paris, September 25, 1906); Tietjens 1910.

George W. Perkins was a partner in J. P. Morgan and Company when he wrote EN to tell her how much he enjoyed this painting, which he had bought at the Columbian Exposition. He added that his wife was a niece of Mrs. George Thornton of Cincinnati, who owned two floral paintings by EN. A signed sketch for this work in H–10 was done in Borst. It shows only the mother and the older child at the table.

For this painting, B–37, and B–49, EN received a medal at the Palace of Fine Arts, World's Columbian Exposition, 1893.

B–43
Dans l'église à Volendam (In the Church at Volendam)
1892
Oil on canvas; 49 × 62 (125 × 157.5)
Signed lower left: *E Nourse*
Owner: University of Washington, Seattle, gift of Judge and Mrs. Thomas J. Burke, 1932.
Exhibitions: New Salon 1893, no. 797; CAM 1893, no. 1; Fischer 1894, no. 1; Saint Louis Exposition and Music Hall Association, 1896; Copenhagen Exposition, 1897, no. 22; Paris, "Exposition Universelle," 1900, no. 243 (awarded silver medal); PAFA 1901, no. 403.
References: Annotated CAM 1893 (price, $800); MacChesney 1896, p. 8; LN in Paris to Mimi Schmidt in Cincinnati, January 12, 1904; Tietjens 1910, p. 92.

In her letter to Mimi Schmidt, LN discussed the list of prices for paintings, which she had previously sent to Schmidt in Cincinnati. LN wrote that the price for this painting was $700 although she had sold it once for $1,000; the buyer decided, however, that it was too large and took two small pictures in its place for $500 each. There is a sketch for this work in H–11.

For information on the Burkes' gift to the owner, see comment, A–78.

B–44
Dutch Interior, Volendam (Intérieur hollandais)
1892
Oil on canvas; 30 × 39½ (76.2 × 100.3)
Signed lower right: *E. Nourse '92*
Owner: Private collection, Massachusetts.
Previous owners: Edith Nourse Rogers, Lowell, Mass.; Admiral Harold Lawrence, Saco, Maine.
Exhibitions: CAM 1893, no. 17; Fischer 1894, no. 12; New York, National Academy of Design, 1894, no. 211; New Salon 1896, no. 967.
References: Annotated CAM 1893 (price, $400); *Estate Sale of Admiral Harold Lawrence* (Saco, Maine), 1980, no. 240.

The previous owner, Edith Nourse Rogers, also owned A–93.

B–45
Intérieur Holland, l'Année (Dutch Interior, l'Année)
ca. 1892
Oil on canvas; 18⅞ × 24½ (47.6 × 62.3)
Signed lower right: *Elizabeth Nourse*
Owner: College-Conservatory of Music, University of Cincinnati, bequest of Walter S. Schmidt, 1962.4.7.
Exhibitions: Closson 1941; U.C. 1974, no. 6.

The title of this painting is written on the back and there are labels reading *Amiens (May 18–July 2)* and *Chicago.*
 For information on Walter S. Schmidt's bequest to the owner, see comment, A–60.

B–46
A Maarken Interior
1892
Unlocated
Exhibitions: CAM 1893, no. 36; Fischer 1894, no. 22.
Reference: Annotated CAM 1893 (price, $100).

Maarken is a Dutch village that Nourse visited for several days during her stay in Volendam, a town on the Zuyder Zee.

B–47
Sur la digue à Volendam (On the Dyke)
1892
Figure 92
Oil on canvas
Signed lower right: *E. Nourse '92*
Unlocated
Previous owner: Richard A. Harlow, Washington, D.C.
Exhibitions: New Salon 1893, no. 798; CAM 1893, no. 2; Fischer 1894, no. 2; Saint Louis Exposition and Music Hall Association, 1895; MACI 1897/98, no. 171.
References: Annotated CAM 1893 (price, $700); MacChesney 1896, p. 4 (illus.); Schmidt 1902, p. 330; Schmidt 1906, p. 251; Scrapbook 1, p. 33 (photo and note by LN); Washington, D.C., city directories, 1909–13.

This must be a large painting to judge by the price given in the Cincinnati Art Museum's 1893 catalogue. Richard A. Harlow, the previous owner, was a lawyer associated with railroad companies in Helena, Montana, until 1909, and was then listed in the Washington, D.C., city directories until 1913. There is a sketch for this work in H–11.

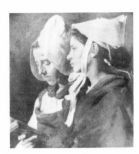

B–48
Etude
Oil on canvas
Unlocated
Exhibition: New Salon 1892, no. 777.
Reference: Scrapbook 1, p. 30 (photo and note by LN).

LN noted that this work was sold in Philadelphia.

B–49
The Reader
ca. 1892
Oil on canvas
Unlocated
Exhibitions: Munich 1892; Chicago, "World's Columbian Exposition," 1893, no. 843 (awarded medal); CAM 1893, no. 5; Fischer 1894, no. 4; New York, "National Academy of Design Annual Exhibition," 1894, no. 117.
References: Annotated CAM 1893 (price, $400); Lord 1893.

Caroline Lord's review of the 1893 exhibition describes this work as "a lady . . . reading a letter, the light comes over her shoulders and is reflected from the paper to her expressive face."
 For this painting, B–37, and B–42, EN received a medal at the Palace of Fine Arts, World's Columbian Exposition, 1893.

B–50
Sewing by Lamplight
ca. 1892
Unlocated
Previous owner: Dudley Porter, Haverhill, Mass., in 1893.
Exhibition: CAM 1893, no. 19, loaned by Dudley Porter.
Reference: Reception 1893.

The Cincinnati reviewer (Reception 1893) remarked that "the way the hair shows through the mull cap is incomparable."

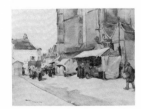

B–51
Houdan marché
1894
Watercolor on paper; 13 × 18 (33 × 45)
Signed lower left: *Houdan/ E. Nourse 1894*
Owner: Private collection, Cincinnati.
Previous owners: Clement J. Barnhorn, Cincinnati, in 1926; Charles F. Williams, Cincinnati.
Exhibition: CAM 1926, no. 171, loaned by Clement J. Barnhorn.

Houdan is a small town sixty-three kilometers north of Paris. Clement J.

Barnhorn (1857–1935), the first owner, was a Cincinnati sculptor who studied at McMicken with EN and later was an instructor for many years at the Cincinnati Art Academy. Barnhorn and EN became close friends and over the years she gave him several paintings, including A–90, B–140, C–104, and C–108.

B–52
Ker Fagot
1894–95
Oil on canvas; 29 × 39½ (73.6 × 100.3)
Signed lower left: *Elizabeth Nourse/ "Ker Fagot"*
Owner: Private collection.
Previous owner: Estate 1938.
Reference: Medora 1895.

In the Breton language, "ker" means "the home of," so this is presumably the interior of the Fagot cottage. It was painted at Keraudrin, a village near Saint Gildas in Brittany.

B–53
La première communion (The First Communion)
1895
Figure 38
Oil on canvas; 61½ × 56 (155.6 × 142.3)
Signed lower left: *E. Nourse 1895*
Owner: Private collection, Cincinnati.
Previous owner: Mrs. Frederick W. Hinkle, Cincinnati, 1904–45.
Exhibitions: New Salon 1895, no. 950; AIC 1895, no. 256; PAFA 1895–96, no. 242.
References: MacChesney 1896, p. 6 (illus.); Scrapbook 1, p. 46 (photo and note by LN).

This painting and *Vendredi Saint* (B–37) are the largest known of the artist's works. Mrs. Hinkle, the previous owner, loaned *La première communion* to the Cincinnati Art Museum from 1936 to 1945. H–12 contains a single sketch for this painting and B–54 is an oil study for it. C–103 and C–106 are portraits of the child models in the painting.

B–54
Study for La première communion
1894
Oil on canvas; 12½ × 9 (31.8 × 22.8)
Signed lower left: *E. Nourse '94*
Owner: Private collection, Cincinnati.

This is a study for B–53.

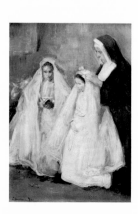

B–55
Vache bretonne, Saint Gildas
1894–95
Watercolor
Unlocated
Exhibition: New Salon 1903, no. 445.

B–56
Le berceau
ca. 1895
Watercolor
Unlocated
Exhibition: Orientalistes 1906.
Reference: Scrapbook 1, p. 47 (photo and note by LN).

LN noted that this work was based on sketches made in Russia in 1889. See B–27, B–57, and B–58 for works with a similar theme.

B–57
Les fileuses russes (Russian Spinners)
1895
Oil on canvas; 30 × 40 (76.2 × 101.6)
Signed lower right: *E. Nourse 1895*
Owners: Mr. and Mrs. Randy Sandler, Cincinnati.
Previous owner: H. B. Closson, Cincinnati, in 1913.
Exhibitions: New Salon 1895, no. 951; PAFA 1895–96, no. 238.
Reference: LN in Paris to Sister Monica, O.S.U., location unknown, ca. 1932.

LN sent photographs of seven Nourse paintings to Sister Monica, an American Ursuline nun, with the artist's descriptions of how they were painted. She said that this scene resulted from an episode in Russia, during which the peasants came into one of the cottages on the estate EN was visiting to watch her sketch. They brought their distaffs to avoid wasting time. Thrusting them into the holes bored in the wooden benches that ran the length of the room, they began to spin as they watched her. EN made a sketch of the episode and, after returning to Paris, painted this work by arranging her studio to duplicate the interior light from the tiny Russian windows on the whitewashed walls. Then she posed Italian models in the Russian costumes she had brought back with her.

See B–27, B–56, and B–58 for other Russian scenes. B–58 is a study for this oil.

B–58
Study for Les fileuses russes
ca. 1895
Watercolor
Unlocated
Exhibitions: Orientalistes 1906; Lodge 1907; Antwerp Exposition, 1908.
References: Scrapbook 1, p. 47 (photo and note by LN) and p. 81 (entries for Lodge Art League exhibition, 1907).

This work was sold in Antwerp in 1908. LN noted that it was a study for B–57. The spinner on the far left was changed to figures of a mother and child in the oil version, and the light source was changed from high windows to two bright windows directly behind the figures.
See B–27, B–56, and B–57 for other Russian scenes.

B–59
Les heures d'été (Summer Hours)
1895
Cover, figure 39, and page 149
Oil on canvas; 53¼ × 41¼ (135.3 × 105.4)
Signed lower left: *Elizabeth Nourse*
Owner: The Newark Museum, gift of Mrs. Florence P. Eagleton, 1925.851.
Exhibitions: New Salon 1896, no. 964; The Newark Museum, "Women Artists of America, 1707–1964," 1965.

The peasants in this painting wear the Morbihan costume of Saint Gildas-de-Rhuys in Brittany, where EN worked in 1894 and 1895. There are three sketches for the painting in H–12. See comment, B–60.

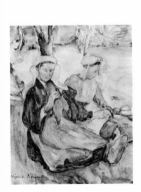

B–60
Les heures d'été (Summer Hours)
1895–1921
Watercolor on paper; 6¹⁵⁄₁₆ × 5¾ (17.5 × 13.7)
Signed lower left: *Elizabeth Nourse*
Owner: Cincinnati Art Museum, gift of the artist, 1980.51.
Reference: Archives, 1910 (letter from LN in Paris to J. H. Gest, Cincinnati, April 1, 1921).

LN enclosed this watercolor in her letter to J. H. Gest, director of the Cincinnati Art Museum, when she offered to sell the oil painting of this subject (B–59) to the museum. She wrote that the price was $1,000, but that EN would take less if it were bought by a museum. EN may have painted the watercolor at the time she wrote Gest in 1921 as a means of promoting the sale of the 1895 oil.

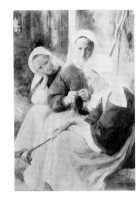

B–61
Le repos des faneuses
1895
Oil on canvas
Unlocated
Exhibition: New Salon 1895, no. 952.
References: Medora 1895; Scrapbook 1, p. 45 (photo).

Medora wrote in her article that this work, painted at Keraudrin in Brittany, shows the peasant women resting from their gleaning. An outlined sketch for this work in H–11 captures the figure with a few broad lines, but a fourth head in the sketch has been eliminated in the painting.

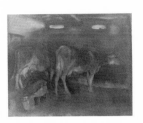

B–62
Woman Milking a Cow
1896
Watercolor on paper; 12¾ × 16 (32.4 × 40.6)
Signed lower left: *E. Nourse 1896*
Inscribed lower right: *Dear Elizabeth Stacey/ From her Aunt Elizabeth Nourse*
Owner: Stacey family.
Previous owner: Elizabeth Nourse Stacey, Fort Thomas, Ky.

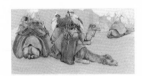

B–63
Camels in Tunis
1897
Watercolor and gouache on paper mounted on paperboard; 10 × 21 (25.4 × 53.3)
Signed lower left: *E. Nourse Tunis 1897*
Owners: Mr. and Mrs. Richard Hodapp, Cincinnati, from 1981.
Previous owner: Ran Gallery, Cincinnati.
Reference: EN in Tunis to Mary Nourse in Covington, Ky., February 1, 1897, in Nourse Family Collection, Cincinnati.

In her 1897 letter to Mary Nourse, EN wrote of her experiences in painting this scene: "I went today to do some camels in a fondue where the masters keep them while they sell their stuff in the markets. The camels were lovely— but how lively! & so big as to make you want to go up the nearest tree (there weren't any) every time they came towards you, but they seemed gentle & so beautiful & brown like their masters. . . ."

B–64
Intérieur arabe à Biskra
1897
Watercolor
Unlocated
Exhibitions: New Salon 1898, no.
1732; Le Havre Exposition, 1912.
Reference: Scrapbook 2, p. 6 (note by
LN).

Biskra is a city in Algeria not far from
the Tunisian border. LN noted that
this work was sold at the Le Havre
Exposition in 1912. B–65 is a similar
scene.

B–65
Intérieur arabe à Biskra
1897
Watercolor
Unlocated
Exhibition: New Salon 1898, no. 1733.

B–64 is a similar scene.

B–66
Place de Bab Soukra
1897
Oil
Unlocated
Exhibition: Orientalistes 1904.
Reference: Scrapbook 1, p. 75 (note by
LN).

See A–34 and B–67 for similar scenes.

B–67
Place de Bab Soukra
1897
Watercolor
Unlocated
Previous owner: Walter S. Schmidt,
Cincinnati, in 1938.
Reference: Estate 1938, no. 44.

See A–34 and B–66 for similar scenes.

B–68
A Shoe Market in Algiers
1897
Watercolor
Unlocated
Previous owner: M. H. Hirschfield,
Helena, Montana, by 1910.
Reference: Wheeler 1910.

The illustration for this entry is a
sketch in H–12 that may be the basis
for this work.

B–69
Tunis Tapestry Weavers (Weavers of
Tunis)
1897
Watercolor
Unlocated
Previous owner: Mary C. Wheeler,
Helena, Montana, in 1910.
References: Wheeler 1910; "Art De-
partment, 1911," newspaper clipping
in Biographical File on Mary C.
Wheeler, Montana Historical Society.

The illustration for this entry is a
sketch of the subject matter in H–12.

B–70
La fête de grand-père (Grandfather's
Birthday)
ca. 1897
Figure 42
Oil on canvas; 34 × 26 (86.4 × 66)
Signed lower right: *Elizabeth Nourse*
Written on verso: *Salons: Paris, Phila-
delphia, St. Louis, Lincoln, Nebraska*
Owner: Mary C. Gores, Cincinnati.
Previous owner: H. Byron Doren,
Cincinnati.
Exhibitions: New Salon 1897; PAFA
1898, no. 327; AIC 1898, no. 271.

There is an outlined sketch for this
work in H–12.

B–71
Humble ménage (A Humble Home)
ca. 1897
Figure 41
Oil on canvas; 39½ × 39½ (100.5 ×
100.5)
Owner: Grand Rapids Art Museum,
gift of Mrs. Cyrus E. Perkins,
1911.1.4.
Exhibitions: New Salon 1897; PAFA
1898, no. 328; AIC 1898, no. 272;
Rouen Exposition, 1909.
References: Thompson 1900; Scrap-
book 1, p. 92 (review of 1909 Rouen
Exposition); *Grand Rapids Press,* Janu-
ary 12, 1911.

There are three sketches for this work
in H–12. The final one is the basis for
this composition.
 Mrs. Cyrus E. Perkins, who gave
the painting to the present owner, was
also the previous owner of A–87.

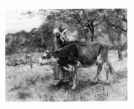

B–72
In the Meadow (Dans le pré)
ca. 1899
Oil on canvas; 30 × 40¾ (76.2 × 103.5)
Signed lower left: *Elizabeth Nourse*
Owner: Private collection, Cincinnati, from 1978.
Previous owner: Ran Gallery, Cincinnati.

There is another signature above the present one on the canvas that reads *E. Nourse 189*[?]. It was probably overpainted by the artist. There are three sketches for this work in H–14.

B–73
Le berceau (Brother and Sister)
1900
Oil on canvas
Signed lower left: *E. Nourse 1900*
Unlocated
Previous owner: Mrs. Webb.
Exhibition: New Salon 1902.
Reference: Scrapbook 1, p. 67 (note by LN).

H–14 contains three sketches made in Penmarc'h for this work. B–74 is a study for it.

B–74
Study for Le berceau (Brother and Sister)
1900
Drawing
Unlocated
Previous owner: American Woman's Art Association, Paris.
Reference: Scrapbook 1, p. 67 (note by LN) and p. 72 (newspaper photo).

This is a study for B–73.

B–75
Dans l'écurie à Saint Léger (In the Stable, Saint Léger)
ca. 1900
Oil on canvas; 23½ × 28½ (59.7 × 72.4)
Signed lower right: *E. Nourse*
Owner: Ran Gallery, Cincinnati.
Previous owners: Edith Noonan Burt, Stuart, Fla.; Frieda and David Wildfever, Tamarac, Fla.
Exhibitions: New Salon 1901, no. 710; AIC 1901, no. 274; PAFA 1902, no. 510; Woman's Art Club of Cincinnati, 1911, loaned by Edith Noonan Burt.
References: Scrapbook 1, p. 66 (American review of 1901 New Salon) and p. 67 (French review of 1901 New Salon).

The American review described this work as having superior light effects

and the French critic remarked that the cow and the horse in it were anatomically correct. The first owner, Edith Noonan Burt, was EN's niece. She was also the previous owner of A–94.

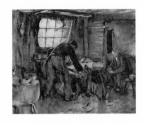

B–76
Les sabotiers (Makers of Sabots)
1900
Watercolor on paper; 15½ × 19½ (39.4 × 49.5)
Signed lower right: *E. Nourse 1900/ "Les Sabotiers"*
Owner: Cincinnati Art Museum, gift of Melrose Pitman, 1970.166.
Exhibitions: New Salon 1902, no. 413; Bordeaux, 1912; Golden Age 1979/80.
References: Scrapbook 1, p. 67 (note by LN) and p. 16 (entries for 1912 Bordeaux exhibition).

LN noted that this painting was done in Normandy.

B–77
Le frère et la soeur, Penmarc'h
ca. 1901
Oil on canvas
Unlocated
Exhibitions: New Salon 1902; PAFA 1903, no. 150.
Reference: Scrapbook 2, p. 38 (page from Closson Gallery sales catalogue, Cincinnati, December 1912).

The Closson Gallery sales catalogue describes the paintings that H. B. Closson brought back from Europe in the summer of 1912. They included four studies of Breton children by EN and an accompanying photograph shows one that fits this title—a young Breton girl seen in profile on the left and behind her a Breton boy, wearing a broadbrimmed black hat, is shown in three-quarters profile. Both figures are bust length and the picture appears to measure about 24 × 18 inches.

B–78
Autour de la crèche
ca. 1902
Oil on canvas
Unlocated
Exhibitions: New Salon 1903, no. 1003; PAFA 1904, no. 202; MACI 1904/5, no. 208; Liège Exposition 1909.
Reference: Scrapbook 1, p. 95 (entries for 1909 Liège Exposition).

B–79
Intérieur breton à Penmarc'h
ca. 1902
Oil on canvas
Unlocated
Exhibitions: New Salon 1903, no.
1005; AIC 1904, no. 319.

B–80
Le lavoir à Saint Léger-en-Yvelines
ca. 1902
Watercolor
Unlocated
Previous owner: Mrs. Ethel Graydon
Rogers, Folkestone, England, in 1926.
Exhibition: New Salon 1903, no. 442.
References: Scrapbook 2, p. 97 (note
by LN); LN in Paris to Mary Nourse
in Covington, Ky., June 13, 1926.

B–81 may be a study for this work.

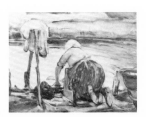

B–81
Le lavoir à Saint Léger (Le lavoir sur
la rivière)
ca. 1902
Watercolor; 11¹²⁄₁₆ × 15¼ (29.8 ×
38.7)
Signed lower right: *Elizabeth Nourse*
Owner: College-Conservatory of Mu-
sic, University of Cincinnati, bequest
of Walter S. Schmidt, 1962.4.32.
Exhibitions: College 1941; U.C. 1974,
no. 30.

This may be a study for B–80. For in-
formation on Walter S. Schmidt's be-
quest to the owner, see comment, A–
60.

B–82
La petite soeur
1902
Figure 52 and page 151
Oil on canvas; 27¾ × 26¼ (70.5 ×
66.7)
Signed left center: *E. Nourse 1902*
Owner: William E. Wiltshire III, Rich-
mond, Va.
Exhibitions: New Salon 1904, no.
1004; Saint Louis Universal Exposi-
tion, 1904, no. 570 (awarded silver
medal).
References: Scrapbook 1, p. 75 (note
by LN and facsimile silver medal
awarded at Saint Louis Universal Ex-
position); Schmidt 1906, p. 249 (illus.).

EN was awarded a silver medal at the
Saint Louis Universal Exposition for
her three entries: this painting, A–53,
and C–119. B–83 is a drawing of the
same subject as in this painting and
was shown with it in the 1904 New
Salon.

B–83
Study for La petite soeur
1902
Work on paper
Unlocated
Exhibition: New Salon 1904, no. 1695;
Woman's Art Club of Cincinnati,
1906, no. 53.

This drawing and B–82 are of the same
subject and were both exhibited in the
1904 New Salon. The drawing is one
of six works on paper that EN donated
to a benefit for the Woman's Art Club
of Cincinnati in 1906 (see comment,
A–61).

B–84
Le repos, Saint Léger
ca. 1902
Watercolor
Unlocated
Exhibition: New Salon 1902, no. 414.

B–85
Dans le jardin
ca. 1903
Pastel
Unlocated
Reference: Scrapbook 1, p. 73 (entries
for the 1903 New Salon).

LN listed this pastel as an entry in the
1903 New Salon but it is not men-
tioned in the official catalogue. She
noted that it shows the baby of a
Mme. Dumergue.

B–86
L'écurie à Champéry
ca. 1903
Watercolor
Unlocated
Exhibition: New Salon 1906, no. 1578.

Champéry is a small town south of
Montreux in Switzerland. EN vaca-
tioned in this town during the summer
of 1903.

B–87
La fileuse de laine, Champéry
ca. 1903
Watercolor
Unlocated
Exhibitions: New Salon 1905, no.
1563; Peinture 1908.
Reference: Scrapbook 1, p. 87 (entries
for 1908 Peinture exhibition).

B–88
Le foyer abandonné, Suisse
ca. 1903
Oil
Unlocated
Previous owner: Mlle. Marguerite
Durand, Versailles, France, in 1924.
Reference: Scrapbook 2, p. 98 (letter
from Mlle. Marguerite Durand in Ver-
sailles to EN in Paris, April 1924).

In a letter of thanks for the gift of this
painting, Mlle. Durand gave her ad-
dress as 73, rue des Bourdounais, Ver-
sailles. B–89 is probably a study of the
interior shown in this work.

B–89
Study for Le foyer abandonné, Suisse
[*without figures*]
ca. 1903
Watercolor on paper; 17 × 20 (43.2 ×
51.4)
Signed lower right: *E. Nourse*
Stolen from the University of Cincin-
nati on December 6, 1967.
Previous owner: College-Conservatory
of Music, University of Cincinnati,
bequest of Walter S. Schmidt,
1962.4.8.
Reference: Records of the University
of Cincinnati Fine Arts Collection.

From its description, this painting ap-
pears to have been a study of the inte-
rior of B–88 without the figures; B–90
may be a similar scene with figures.
 For information on Walter S.
Schmidt's bequest to the previous
owner, see comment, A–60.

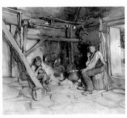

B–90
Le foyer, châlet suisse (Study for Le
foyer abandonné, Suisse [with figures])
ca. 1903
Watercolor on paper; 23½ × 28½
(59.8 × 72.4)
Signed lower left: *E. Nourse*
Owner: College-Conservatory of Mu-
sic, University of Cincinnati, bequest
of Walter S. Schmidt, 1962.4.9.
Exhibition: U.C. 1974, no. 17.

This may be a study for B–88. From
the description of B–89, B–90 appears
to be a similar scene with figures.

B–91
Intérieur suisse, Champéry
ca. 1903
Oil on canvas
Unlocated
Exhibition: New Salon 1905, no. 961.

B–92
The Old Shepherd, Champéry, Suisse
ca. 1903
Watercolor
Unlocated
Previous owner: Mrs. John Fitzpatrick,
Cincinnati.
Exhibition: CAM 1926, no. 169,
loaned by Mrs. John Fitzpatrick.

B–93
*La procession de Notre Dame de la
Joie, Penmarc'h* (Procession of Our
Lady of Joy)
1903
Figure 53 and page 152
Oil on canvas; 49 × 43½ (124.5 ×
109.9)
Signed lower left: *E. Nourse 1903*
Owner: Xavier University, Cincinnati,
gift of the artist, 1921.
Exhibitions: New Salon 1903, no.
1002; PAFA 1904, no. 541; MACI
1904/5, no. 207; Vienna Exposition,
1910.
References: Schmidt 1906, p. 253; *Re-
vue Internationale Illustrée* (Paris) (Janu-
ary 1, 1911); Scrapbook 2, p. 94 (letter
from president of Xavier University in
Cincinnati to Walter S. Schmidt in
Cincinnati, June 19, 1921).

Through Walter S. Schmidt, who
managed her business affairs, EN gave
this painting to Xavier University, the
Jesuit school her brothers had attended.
 For information on Walter S.
Schmidt, see comment, A–60.
 C–128 is a portrait of the young girl
standing on the left in the painting.

B–94
La vieille cuisine de la montagne
ca. 1903
Oil on canvas
Unlocated
Exhibition: New Salon 1905, no. 962.

B–95
Les vieilles crémaillères, Suisse
ca. 1903
Watercolor
Unlocated
Exhibition: New Salon 1905, no. 1562.

B–96
Une heure de loisir
ca. 1904
Work on paper
Unlocated
Exhibition: New Salon 1904, no. 1696.
Reference: Scrapbook 1, p. 74 (entries
for 1904 New Salon).

LN noted in the reference that this
work was sold at the 1904 New Salon.

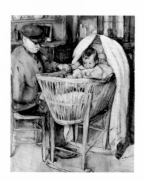

B-97
Le grand-père, Saint Léger (Le berceau)
ca. 1905
Watercolor on paper; 21 × 18 (53.4 × 45.7)
Signed lower right: *E. Nourse*
Owner: University of Cincinnati, gift of the artist, 1932.
Exhibitions: New Salon 1906, no. 1589; Bordeaux Exposition, 1914; Paris, Galerie Manuel Frères, 1920.
References: Scrapbook 2, p. 76 (review of 1914 Bordeaux Exposition), p. 83 (note by LN on 1920 exhibition at Galerie Manuel Frères), and p. 106 (letter from Herman Schneider, president of the University of Cincinnati, to EN in Paris, March 28, 1932).

B-98
Le berceau, Loguivy
ca. 1906
Oil on canvas
Unlocated
Exhibition: New Salon 1907, no. 929.

During the summer of 1906 EN painted in Loguivy, a Breton fishing village in the département of Côte du Nord.

B-99
The Children
ca. 1906
Charcoal and chalk on paper; 10 × 13⅝ (25.5 × 34.5)
Signed upper right: *Elizabeth Nourse*
Owners: Mr. and Mrs. Randy Sandler, Cincinnati.

This appears to be a study of the models for B-101.

B-100
La dentellière
ca. 1906
Oil on canvas
Unlocated
Previous owner: University of Washington, Seattle, gift of Judge and Mrs. Thomas J. Burke, 1932.
Exhibitions: New Salon 1906, no. 938; AIC 1906, no. 235; IAU 1908; Nantes Exposition, 1908.
References: Inventory 1932; Scrapbook 1, p. 88 (entries for 1908 IAU exhibition) and p. 77 ("Painting is in Decay," English-language review of 1906 New Salon); *Nantes Populaire,* February 20, 1908.

This may be a duplication of C-174 or C-177 because the inventory of the eleven paintings given by the Burkes

to the University of Washington lists only generic titles, such as "Girl's Head."

The English-language review of this work, shown in the 1906 New Salon, seems rather sarcastic: "Miss Nourse was born in Cincinnati, and paints in Paris in Scandinavian tonalities, Norman and Dutch lacemakers. It would be impossible to be more cosmopolitan."

For information on the Burkes' bequest to the previous owner, see comment, A-78.

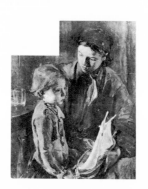

B-101
Les enfants du pêcheur, Hollande
ca. 1906
Oil on canvas
Unlocated
Exhibitions: New Salon 1906, no. 936; AIC 1906, no. 234; IAU 1908.
Reference: Scrapbook 1, p. 88 (entries for 1908 IAU exhibition).

B-99 is probably a study of the models for this painting.

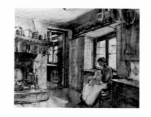

B-102
Intérieur basque, Pyrénées (Basque Interior, Pyrenees)
ca. 1906
Watercolor on paper; 18 × 21 (45.9 × 54.5)
Signed lower right: *Elizabeth Nourse*
Owner: College-Conservatory of Music, University of Cincinnati, bequest of Walter S. Schmidt, 1962.4.30.
Exhibitions: PAFA Watercolor 1907, no. 219; CAM 1910, no. 64; U.C. 1974, no. 28.

For information on Walter S. Schmidt's bequest to the owner, see comment, A-60.

B-103
Le marché à Saint Jean, Basses Pyrénées (Market on a Rainy Day, St. Jean)
ca. 1906
Watercolor on paper; 18 × 24 (45.7 × 61)
Signed lower right: *Elizabeth Nourse/ Saint Jean Pied de Port*
Owner: College-Conservatory of Music, University of Cincinnati, bequest of Walter S. Schmidt, 1962.4.10.

Saint Jean Pied de Port is an ancient fortified town at the foot of the Roncesvalles pass in Basse-Navarre through which medieval pilgrims passed on one of the pilgrimage routes to Santiago de Compostela in Spain.

For information on Walter S. Schmidt's bequest to the owner, see comment, A-60.

B–104
Intérieur breton, Loguivy
ca. 1906
Oil on canvas
Unlocated
Exhibition: New Salon 1907, no. 930.

B–105
Intérieur à Saint Léger, Rambouillet
ca. 1906
Oil on canvas
Unlocated
Exhibitions: New Salon 1906, no. 937;
Lodge 1906.
Reference: Scrapbook 1, p. 81 (Paris
review of 1906 Lodge exhibition).

B–106
Paysannes à l'église
ca. 1906
Watercolor
Unlocated
Exhibition: New Salon 1906, no. 1588.

B–107
Le steppe (Une file de traineaux)
ca. 1906
Unlocated
Exhibition: Orientalistes 1906.
Reference: Scrapbook 1, p. 75 (French
review of 1906 Orientalistes exhibition).

The illustration for this entry, a sketch
marked *Le steppe* in H–8, drawn in
Russia in 1889, may be the basis for
this work.

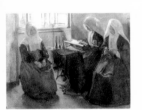

B–108
Les tricoteuses de Saint-Thomas (The
Knitters of Plougastel)
ca. 1907
Oil on canvas
Signed lower left: *Elizabeth Nourse*
Owner: Kingsley H. Murphy, Jr.,
Minneapolis.
Previous owner: Josephine Hopkins
Murphy, Minneapolis.
Exhibitions: New Salon 1908, no. 896;
MACI 1909, no. 200; Nantes, "Exhibition des Amis des Arts," 1912.
Reference: Scrapbook 2, p. 15 (entries
in the 1912 Nantes exhibition).

There is a signed sketch for this work
in H–15.

B–109
Four Breton Girls
ca. 1907–8
Watercolor on paper; 13½ × 19 (34.3
× 48.2)
Signed lower right: *Elizabeth Nourse*
Lost in 1979
Previous owner: College-Conservatory
of Music, University of Cincinnati,

bequest of Walter S. Schmidt,
1962.4.34.
Exhibition: U.C. 1974, no. 32.
Reference: Records of the University
of Cincinnati Fine Arts Collection.

The illustration for this entry is a
signed sketch for this watercolor in H–15.
 For information on Walter S.
Schmidt's bequest to the previous
owner, see comment, A–60.

B–110
*Le marché à Plougastel/Daoulas,
Finistère*
ca. 1907–8
Watercolor on paper mounted on paperboard; 18½ × 24½ (47 × 62.3)
Signed lower right: *Elizabeth Nourse*
Owner: College-Conservatory of Music, University of Cincinnati, bequest
of Walter S. Schmidt, 1962.4.29.
Exhibitions: Closson 1941, no. 12;
College 1941; U.C. 1974, no. 27.

For information on Walter S.
Schmidt's bequest to the owner, see
comment, A–60.

B–111
Le berceau, Penmarc'h
ca. 1908
Watercolor
Unlocated
Exhibitions: Peinture 1908; CAM
1910, no. 104; PAFA Watercolor 1910,
no. 146.
Reference: Lord 1910.

Caroline Lord described this work as a
picture of a baby tucked under the
coverlet in an ancient cradle in an interior where the pervading color scheme
is a warm brown.

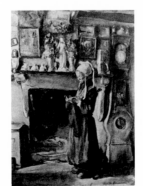

B–112
La bonne menagère (Brittany)
ca. 1908
Watercolor on paper; 29½ × 25 (49.4
× 63.5)
Signed lower right: *Elizabeth Nourse*
Owner: Private collection, Cincinnati.
Exhibitions: New Salon 1909, no.
1543; PAFA Watercolor 1909, no. 131;
IAU 1913, no. 108; Anglo-American
1914, no. 213; Paris, American Art Association exhibition, 1913.
Reference: *New York Herald* (Paris),
February 3, 1913.

The Paris edition of the *New York Herald* article describes the eighteenth annual exhibition of the American Art
Association held at the group's clubhouse at 4, rue de Chevreuse. A prize
of 1,000 francs, given by Mrs. White-

law Reid for the best painting in the exhibition, was divided among four artists: Florence Este, Eleanor Norcross, Anne Goldthwaite, and Elizabeth Nourse. Prizes for sculpture were awarded to Malvina Hoffman and Olga Popoff.

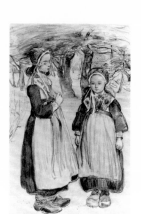

B–113
Enfants debout
ca. 1908
Watercolor and pastel on paper; 21⅝ × 14¼ (55.3 × 36.2)
Signed lower right: *Elizabeth Nourse*
Owner: Private collection, Cincinnati.

Labels on the back of this picture give the title and also list *Salon, 1908* and *Philadelphia Exposition* and *1912,* but no records have been found for these entries.

B–114
Le lavoir dans les champs, Finistère
ca. 1908
Figure 66
Watercolor on paper; 18¼ × 25¼ (46.3 × 64.2)
Signed lower right: *Elizabeth Nourse*
Owner: Sally Bunker Fellerhoff, Cincinnati.
Previous owner: Dorothy Schmidt Bunker, to 1950.
Exhibitions: Peinture 1908; PAFA Watercolor 1910, no. 148; CAM 1910, no. 112.
Reference: Lord 1910.

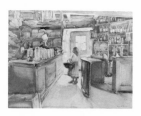

B–115
La vieille boutique, Finistère
ca. 1908
Watercolor on paper; 18½ × 24½ (47 × 62.3)
Signed lower right: *Elizabeth Nourse*
Owners: Mr. and Mrs. Edward A. Foy, Cincinnati.
Previous owners: Mr. and Mrs. Edward A. Foy, Jr., Cincinnati, 1928–63.
Exhibitions: Peinture 1908; CAM 1910, no. 112; PAFA Watercolor 1910, no. 149.
Reference: Lord 1910.

B–116
Le tisserand
ca. 1909
Watercolor on paper; 10¾ × 13½ (27.3 × 34.3)
Signed upper right: *E. Nourse*
Written on verso: *"Horstman" at his loom*
Owner: Stacey family, Cincinnati, from 1975.
Previous owners: Estate 1938, no. 42; Helen Stacey Hunt, Fort Thomas, Ky., 1938–75.

B–117
Le trousseau
ca. 1909
Oil on canvas
Unlocated
Previous owner: Gernard Millier, in 1934.
Exhibitions: New Salon 1910, no. 963; AIC 1910, no. 167; Lodge 1911; Nantes Exposition, 1912.
References: *New York Herald* (Paris), February 5, 1911; Nantes, *Petit Phare* [newspaper], February 12, 1912; EN in Paris to Dorothy Schmidt Bunker in Cincinnati, January 23, 1934.

The Paris edition of the *New York Herald* article described this work as "a young girl . . . bent dreamily over her work by the open window through which the green fields are seen. The use of yellow and mauve tints is very effective." EN wrote to Dorothy Bunker that she gave this painting to a young lieutenant, Gernard Millier, as a wedding present on January 22, 1934, because his mother posed for it.

B–118
The Lilac Silk (La robe de soie)
ca. 1910
Oil on canvas
Unlocated
Exhibitions: CGA 1910/11, no. 61; PAFA 1911, no. 104; Bordeaux Exposition, 1912.
Reference: Scrapbook 2, p. 16 (entries for 1912 Bordeaux exhibition).

The illustrations for this entry are two of the six sketches for the work in H–16. Three of the sketches show a woman seated and three show a standing figure. It is not known which composition was used as the basis for the painting.

B–119
La rêverie (Les poissons rouges)
ca. 1910
Figure 62 and page 154
Oil on canvas; 39 × 39 (99.1 × 99.1)
Signed lower left: *Elizabeth Nourse*
Owner: College-Conservatory of Music, University of Cincinnati, bequest of Walter S. Schmidt, 1962.4.6.
Exhibitions: New Salon 1910, no. 966; Paris, Musée du Luxembourg, "Exposition des Artistes de l'Ecole Américain au Luxembourg," 1919, no. 168; U.C. 1974, no. 2.

B–119 and E–76 are paintings of the still-life elements in this work. There is a sketch for *La rêverie* in H–16 that has been inserted; this sketch is done on

brown paper whereas the others in the sketchbook are on gray paper. There is another sketch on green paper that has been inserted in H–13.

For information on Walter S. Schmidt's bequest to the owner, see comment, A–60.

B–120
Les volets clos (Closed Shutters)
1910
Figure 61
Oil on canvas; 39½ × 39½ (100.5 × 100.5)
Signed lower right: *Elizabeth Nourse*
Owner: National Museums of France, from 1910; in Musée d'Orsay, Paris.
Exhibitions: New Salon 1910, no. 961; Paris, Ecole des Beaux-Arts, "Exposition des Acquisitions du Gouvernement Français," 1910; Paris, Musée du Luxembourg, "Exposition des Artistes de l'Ecole Américain au Luxembourg," 1919, no. 40.
References: Anna S. Schmidt, "Elizabeth Nourse: Great Honor Paid an American by France," *Boston Transcript,* May 11, 1910; L. Mechlin, "Closed Shutters: A Painting by Elizabeth Nourse," *Art and Progress* (July 1911): 262 (illus.); Scrapbook 1, pp. 103–18 (reviews of the 1910 New Salon).

In the *Boston Transcript* article, Anna Schmidt stated that EN used her sister, Louise, as the model for this work done in Alsace, and described how "the green blinds are drawn, and the sunshine filters through bathing her in a pale green light." After World War II this painting, together with other American works owned by the French government, was moved to the Palais de Tokyo. It will be hung in the Musée d'Orsay, Paris's new museum of nineteenth-century art, when it opens in 1983.

There is a single sketch for this work in H–16.

B–121
Le chasseur à cheval
ca. 1911
Gouache
Unlocated
Previous owner: Mr. Durieux, in 1911.
Exhibition: New Salon 1911, no. 1636.
References: Scrapbook 2, p. 2 (note by LN); Jean Claude, "Beaux-Arts Salon," *Petit Parisien*, April 16, 1911.

The Paris review speaks of EN's success in "achieving the military charac-

ter which so many painters of battles have tried to attain all their lives without success."

B–122
Dans le jardin
ca. 1911
Work on paper
Unlocated
Exhibition: New Salon 1911, no. 1638.
Reference: Scrapbook 2, p. 2 (note by LN).

B–123
L'été (Summer)
ca. 1911
Oil on canvas
Signed lower right: *Elizabeth Nourse*
Unlocated
Previous owner: Mrs. G. Herbert (Myrtilla) Jones, Chicago, in 1917.
Exhibitions: New Salon 1912, no. 1010; Quelques 1912, no. 104; CGA 1912/13, no. 191; PAFA 1913, no. 121; CAM 1913, no. 9; San Francisco, "Panama-Pacific International Exposition," 1915, no. 1602 (awarded gold medal).
References: Scrapbook 2, p. 49 (photo and note by LN) and p. 20 (*La Liberté* [newspaper], review of the 1912 New Salon).

The French review praises the "exquisite" effects of light EN achieved by placing a figure in a shadowed interior next to a window, through which one sees the sunny greenery of a garden.

B–124
La fenêtre ouverte (The Open Window)
ca. 1913
Oil on canvas; 40 × 40 (101.6 × 101.6)
Signed lower right: *Elizabeth Nourse*
Owner: College-Conservatory of Music, University of Cincinnati, bequest of Walter S. Schmidt, 1962.4.5.
Exhibitions: New Salon 1913, no. 964; Anglo-American 1914, no. 243; College 1941; U.C. 1974, no. 3.

For information on Walter S. Schmidt's bequest to the owner, see comment, A–60.

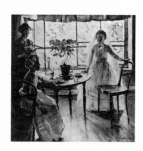

B–125
Les petites filles en blanc (Little Girls in White)
ca. 1913
Oil on canvas
Signed lower right: *Elizabeth Nourse*
Unlocated
Previous owner: Mrs. John W. Carey, Indianapolis, by 1929–38.
Exhibitions: New Salon 1913, no. 965; AIC 1913, no. 248; PAFA 1914, no. 211; MACI 1914, no. 232; John Herron Art Institute, Indianapolis, 1929–38 (long-term loan by Mrs. John W. Carey).
Reference: Registrar's File, Indianapolis Museum of Art.

A two-page sketch for this work in H–17 includes a woman standing on each side of the three little girls in the oil painting. B–126 is a study for this work.

B–126
Study for Les petites filles en blanc
ca. 1913
Work on paper
Unlocated
Exhibition: New Salon 1913, no. 1659.

This is a study for B–125. Both works were shown in the 1913 New Salon.

B–127
Le printemps
ca. 1913
Oil on canvas; 32 × 25½ (81.3 × 64.7)
Signed
Unlocated
Previous owner: Mrs. Samuel Hill, Washington, D.C., in 1913.
References: Scrapbook 2, p. 51 (letter from Mrs. Samuel Hill at Hotel Meurice, Paris, to EN in Paris, September 17, 1931); Sotheby sale catalogue (New York), 1947, no. 877.

The Sotheby sale catalogue describes this work as "a woman sewing, standing in profile before a window and a view of landscape, flowerpots decorate the windowsill and a circular table at the right."

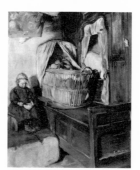

B–128
Breton Girl and Baby
ca. 1914
Oil on canvas; 29 × 23⅞ (73.7 × 60)
Signed lower right: *E. Nourse*
Owner: Mr. and Mrs. William A. Thurner, Cincinnati.
Previous owner: Ran Gallery, Cincinnati.
Reference: Scrapbook 2, p. 55 (photo and note by LN).

The baby's cradle is placed on a linen chest upon which the traditional Breton bed is mounted.

B–129
Le goûter
ca. 1914
Watercolor
Unlocated
Exhibition: New Salon 1914, no. 1567.
Reference: Scrapbook 2, p. 53 (note by LN).

LN noted that this work was painted at the Fontaine Blanche in Plougastel. The illustration for this entry is a sketch of the Fontaine Blanche in H–15.

B–130
La menagère, Plougastel
ca. 1914
Watercolor
Unlocated
Exhibition: Anglo-American 1914, no. 318.

B–131
Le ravitaillement à Senlis
ca. 1915
Unlocated
Exhibition: Paris, Galerie Georges Bernheim, "Exposition des Tableaux de Maîtres Modernes," 1916.
Reference: Scrapbook 2, p. 68 (note by LN).

LN noted that this work sold for 200 francs, about $40, at a benefit to assist prisoners of war.

B–132
French Ambulance Train
ca. 1915–17
Watercolor
Unlocated
Previous owner: Walter S. Schmidt, Cincinnati, in 1941.
Exhibition: College 1941.

B–133
French War Convoy
ca. 1916
Unlocated
Previous owner: Dr. Allen Gros, Paris, in 1916.
Reference: Scrapbook 2, p. 72 (letter from Dr. Allen Gros in Paris to EN in Paris, December 17, 1916).

EN gave this sketch to Allen Gros, who was either an American or English physician in Paris.

B–134
Le rêve
ca. 1917
Unlocated
Exhibition: Latin Quarter Association, Paris, 1917.
Reference: *Paris Daily Mail,* April 11, 1917.

The Latin Quarter Association, a group of artists in Paris, organized this exhibition in 1917 because the Salons were not held that year. This painting was described as "a large canvas, very strong in colour."

B–135
Le lavoir dans les champs, Penmarc'h
ca. 1919
Watercolor
Unlocated
Previous owner: M. Drable, Paris, in 1919.
Exhibition: New Salon 1919.
Reference: Scrapbook 2, p. 76 (entries for 1919 New Salon and note by LN).

LN noted the occupation of the previous owner and his address as "administrateur délegué des Entrepots Frigorifiques, 22 rue des Halles." Although LN noted that this work was exhibited in the New Salon of 1919, neither its title nor EN's name appears in the New Salon's exhibition catalogue for that year.

Undated

B–136
The Bees
Unlocated
Previous owner: Schmidt family, Cincinnati, in 1938.
Reference: Elliston, December 1938.

Elliston described this work as "a Maytime scene with a Holland peasant girl in the sunny foreground, her red

kerchief contrasting with her blue skirt. To the side is a row of beehives in gray."

B–137
Enfant de Choeur
Unlocated
Previous owner: Church at Saint Léger-en-Yvelines.
Reference: Letter from Mme. Isabelle Decroisette in Vanves to Mary Alice Heekin Burke in Cincinnati, January 9, 1980, in possession of M. A. H. Burke, Cincinnati.

Mme. Decroisette remembered this painting, a gift from EN to the parish church in Saint Léger, but stated that it is no longer there.

B–138
In Prayer
Oil on canvas; 28 × 36 (71.1 × 91.5)
Unlocated
Previous owner: Walter S. Schmidt, Cincinnati.
Exhibition: College 1941.
Reference: EN Papers (Inventory of Walter S. Schmidt Estate, 1959).

This painting was described in the Schmidt estate inventory as a picture of a child saying her rosary.

B–139
Le lavoir
Watercolor on paper; 13¾ × 19¾ (35 × 50.2)
Inscribed lower left: *To my dear niece/ Mary/ E. Nourse*
Owner: Private collection.
Previous owner: Mary Nourse, Covington, Ky., to 1959.

B–140
The Old Confessional
Oil on canvas; 13½ × 10½ (34.3 × 26.7)
Owner: Private collection, Saint Martin's, Ohio.
Previous owner: Clement J. Barnhorn, Cincinnati.

For information on the previous owner, see comments, B–51 and C–104.

C *Portraits and Figure Studies*

C–1
Portrait of Adelaide Nourse
1873
Figure 34
Charcoal and chalk on paper; 6½ ×
5½ (15.9 × 14)
Inscribed and signed on bottom: *To
Melrose—Portrait of her Mother/ E.
Nourse*
Inscribed right center: *Adelaide/ Nourse/
Pitman/ Sept/ 1873*
Owner: Cincinnati Historical Society,
gift of Melrose Pitman.

EN made this drawing of her twin
when the two were fourteen and gave
it to Adelaide's daughter, Melrose Pit-
man, many years later.

C–2
Portrait of Caleb Elijah Nourse
ca. 1874
Crayon on paper; 14 × 12 (35.6 ×
30.5)
Inscribed lower right: *C. E. Nourse*
Owner: Marian Thompson Deininger,
Houston, from 1959.
Previous owner: Mary Nourse, Fort
Thomas, Ky.

This is a portrait of the artist's father,
drawn when EN was about fifteen.

C–3
Portrait of Elizabeth Rogers Nourse
ca. 1874
Crayon on paper; 14 × 12 (35.6 ×
30.5)
Inscribed lower right: *Elizabeth Nourse*
Owner: Marian Thompson Deininger,
Houston, from 1959.
Previous owner: Mary Nourse, Fort
Thomas, Ky.

This is a portrait of the artist's mother,
drawn when EN was about fifteen, in-
scribed with her mother's name.

C–4
Portrait of Charles Nourse
ca. 1876
Charcoal on paper (oval); 27 × 21
(68.6 × 53.4)
Owner: Private collection.
Previous owners: Viola Seward
Nourse, to 1905; William Seward
Nourse, 1905–34; Clara Nourse
Thompson, Fort Thomas, Ky., 1934–
80.

Charles Nourse, the last surviving
brother of EN, died in 1876. This por-
trait is believed to be a copy of his
wedding photograph of 1859.

C–5
Child, from life
ca. 1877
Drawing
Unlocated
Exhibition: McMicken 1877, no. 28.

C–6
Jester, from life
ca. 1877
Drawing
Unlocated
Exhibition: McMicken 1877, no. 29.

C–7
Old Man, from life
ca. 1877
Drawing
Unlocated
Exhibition: McMicken 1877, no. 27.

C–8
Portrait of Honorable Peter Zinn
ca. 1877
Crayon on paper
Unlocated
Reference: "The Ladies of the Cincinnati School of Design," *Cincinnati Commercial Gazette,* December 17, 1877.

The newspaper article stated that the subject's friends considered this a perfect and striking likeness.

C–9
Girl
ca. 1878
Drawing
Unlocated
Exhibition: McMicken 1878, no. 129.

C–10
Girl
ca. 1878
Drawing
Unlocated
Exhibition: McMicken 1878, no. 130.

C–11
Head, from life
ca. 1879
Oil
Unlocated
Exhibition: McMicken 1879, no. 628.

C–12
Head of a Girl
ca. 1879
Watercolor
Unlocated
Exhibition: McMicken 1879, no. 491.

This may be a duplicate of C–41.

C–13
Head of an Old Man
ca. 1879
Watercolor
Unlocated
Exhibition: McMicken 1879, no. 492.

C–14
Negro Head
ca. 1879
Watercolor
Unlocated
Exhibition: McMicken 1879, no. 493.

C–15
Study, Head
ca. 1879
Drawing
Unlocated
Exhibition: McMicken 1879, no. 29.

C–16
Study, Head
ca. 1879
Drawing
Unlocated
Exhibition: McMicken 1879, no. 30.

C–17
Retouched photographs
ca. 1879
Unlocated
Exhibition: McMicken 1879, no. 655.

C–18
Old Woman
ca. 1880
Drawing
Unlocated
Exhibition: McMicken 1880, no. 647.

C–19
Old Woman
ca. 1880
Watercolor
Unlocated
Exhibition: McMicken 1880, no. 2045.

C–20
Study, Heads
ca. 1880
Drawing
Unlocated
Exhibition: McMicken 1880, no. 643.

C–21
Study, Heads
ca. 1880
Drawing
Unlocated
Exhibition: McMicken 1880, no. 644.

C–22
Twenty Minute Sketch
ca. 1880
Drawing
Unlocated
Exhibition: McMicken 1880, no. 646.

This is an example of the timed sketch taught at McMicken to encourage rapidity and spontaneity. The illustration for this entry is a sketch of Adelaide Nourse, EN's twin, in H–1 that is marked *Addie—15 min./ E. N.*

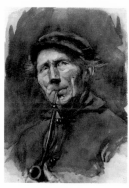

C–23
Head, Old Fisherman
1881
Watercolor on paper; 13½ × 10 (34.3 × 25.5)
Signed lower right: *E. Nourse/ 1881*
Owner: Grace Mendenhall Hunt, Cincinnati.
Previous owners: Mrs. Larz Anderson, Cincinnati; Frances Mendenhall Hunt, Cincinnati.

For information on the first owner, Emma Mendenhall (Mrs. Larz) Anderson, see comment, A–99.

C–24
Head, Study
ca. 1881
Unlocated
Previous owner: F. W. Clarke, Cincinnati.
Exhibition: CIE 1881, no. 332, loaned by F. W. Clarke.

F. W. Clarke had an art supply shop in Cincinnati in which he showed the work of local artists.

C–25
Black Girl, Study from the Back
1882
Oil on paperboard; 16 × 12 (40.7 × 30.5)
Signed lower right: *E. Nourse/ 1882*
Owner: Elizabeth E. Moeller, Cincinnati, from 1979.
Previous owner: Bernard Moeller, Cincinnati, ca. 1949–79.

C–26
Black Girl in Scarf
1882
Oil on canvas; 25 × 19 (63.5 × 48.3)
Signed lower right: *E. Nourse/ '82*
Owner: Private collection, Cincinnati, from 1979.
Previous owner: Western Reserve Historical Society, Cleveland, gift of Mr. and Mrs. Charles A. Bishop.

C–27
Head of a Black Girl
ca. 1882
Oil on canvas; 17 × 12 (43.3 × 30.5)
Signed lower right: *E. Nourse*
Owner: Art Museum of the Cincinnati Public Schools.
Previous owner: Hughes High School, Cincinnati.

C–28
Head of an Indian Girl
ca. 1882
Oil
Unlocated
Exhibition: CIE 1882, no. 241.

There is a watercolor of an Indian woman and her baby in H–4 marked *On board the "Corinthian"/ St. Lawrence R.*

C–29
Head of a Negro Girl
ca. 1882
Figure 6
Oil on paperboard; 18¹¹⁄₁₆ × 16⅛ (47.5 × 40.9)
Signed lower left: *E. Nourse*
Owner: Cincinnati Art Museum, gift of Harley I. Procter, 1924.190.

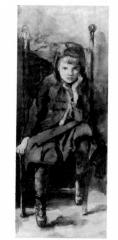

C–30
Little Girl in Chair
1882
Watercolor on paper; 13¾ × 5¾ (35 × 14.6)
Signed lower right: *E. Nourse '82*
Owner: Private collection, Cincinnati.

C–31
Mynheer
ca. 1883
Watercolor
Unlocated
Exhibitions: CIE 1883, no. 46; New York, "American Water Color Society Annual," 1883, no. 526.

C–32
Portrait of Laura and Natalie Barney
ca. 1884
Oil
Unlocated
Reference: Delight Hall, *Catalogue of the Alice Pike Barney Memorial Lending Collection,* National Collection of Fine Arts, Washington, D.C. (1965), p. 21.

There are three sketches for this work in H–1. The illustration for this entry is the third one, marked *Barney Children/ E. N.,* which may be the basis for this painting. Laura and Natalie, daughters of Alice Pike Barney, were seven and nine years old at this time.

C–33
Em Pit
1885
Pencil on paper; 8¾ × 11⅝ (22.3 × 28.6)
Signed lower right: *E. Nourse*
Inscribed lower right: *To my Darling Melrose/ 1929 July*
Inscribed lower left: *"Em Pit"*
Owner: Cincinnati Historical Society, gift of Melrose Pitman.

This drawing of Emerson Pitman, EN's nephew, was given by the artist to Melrose Pitman, her niece, in 1929. See C–34.

C–34
Emerson Pitman
1885
Figure 15
Pencil and white chalk on paper; 10¼ × 13¼ (26 × 33.3)
Signed lower right: *Emerson 8 months/ Elizabeth Nourse*
Owner: Cincinnati Art Museum, gift of Melrose Pitman, 1970.167.

There is an inscription on the reverse: *Emerson, born July 5, 1884, died December 23, 1900, fourth son of Benn Pitman.* The subject was the second child born to Pitman's second wife, Adelaide Nourse Pitman. Their first son, Ruskin, died at birth.

C–35
Portrait of Austin Schmidt
ca. 1885
Oil
Unlocated
Previous owners: Mr. and Mrs. Frederick A. Schmidt, Cincinnati.
Reference: Elliston, December 1938 (illus.).

Austin Schmidt was the second son of EN's close friend, Mimi Schmidt. He became a Jesuit priest and was editor of the Loyola University Press in Chicago. See comment, E–79.

C–36
Sketch, Nude Back of a Girl
1885
Oil on paperboard; 17¹¹⁄₁₆ × 21½ (45.3 × 54.5)
Signed lower left: *E. N. 1885*
Inscribed on verso: *Painted by E. Nourse/ Study*
Owner: Cincinnati Art Museum, gift of Caroline Lord, 1925.547.

EN must have painted this work in the first life class offered to women at

205

McMicken, which was taught by Thomas S. Noble. Caroline Lord and EN were the only students in the class in 1885. Later they were joined by Laura Fry.

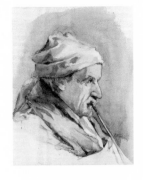

C–37
Head, Old Man
ca. 1886
Watercolor on paper mounted on paperboard; 12 × 10 (30.5 × 25.4)
Signed lower right: *E. Nourse*
Owner: Private collection.
Previous owner: Clara Nourse Thompson, Fort Thomas, Ky.
Exhibition: New York, "American Water Color Society Annual," 1886, no. 270.

This and C–38 were priced at $50 at the America Water Color Society's exhibition.

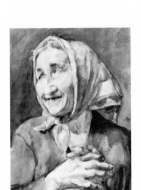

C–38
Head, Old Woman
ca. 1886
Watercolor; 21 × 17½ (53.3 × 44.5)
Owner: Marian Thompson Deininger, Houston, from 1980.
Previous owners: Mary Nourse, Fort Thomas, Ky., to 1959; Clara Nourse Thompson, Fort Thomas, Ky., 1959–80.
Exhibition: New York, "American Water Color Society Annual," 1886, no. 277.

See comment, C–37.

C–39
Old Man Caesar
ca. 1886
Unlocated
Previous owner: Mrs. Larz Anderson, Cincinnati.
Reference: Scrapbook 2, p. 86 (letter from Emma Mendenhall Anderson in Cincinnati to EN in Paris, June 28, 1921).

In her letter, Emma Mendenhall (Mrs. Larz) Anderson, the previous owner, referred to this portrait as one of the Nourses' landlord in Corryville (now Mount Auburn, a suburb of Cincinnati). The illustration for this entry is a sketch of Mr. Caesar, the landlord, in H–4 and may have been the basis for this work. For information on the previous owner, see comment, A–99.

C–40
Study, Head from life
ca. 1886
Oil
Unlocated
Exhibition: CIE 1886.

C–41
Head of a Girl
by 1887
Watercolor on paper on cardboard;
11¼ × 10¼ (28.5 × 26)
Signed lower left: *E. Nourse*
Owner: Marian Tarr Leonard, Cincinnati, from 1960.
Previous owner: Mrs. Clarence Tarr, Cincinnati.

This may be a duplicate of C–12.

C–42
Head of a Little Boy
by 1887
Oil
Unlocated
Reference: Photo.

This portrait is painted in the thick, broad strokes associated with the technique of Frank Duveneck.

C–43
Head of a Little Girl
by 1887
Watercolor on paper; 12 × 9 (30.5 × 22.8)
Signed lower right: *E. N.*
Owner: Helen Chappell, Cincinnati.
Previous owner: Milton Davis, Cincinnati.

C–44
Portrait of Charles Aiken
by 1887
Unlocated
Reference: EN Papers.

Charles Aiken, who was superintendent of music in the Cincinnati public schools, died in 1882. EN painted this portrait from a photograph of a marble bust of Aiken. The bust, now in Music Hall in Cincinnati, was carved by Preston Powers, son of the American sculptor Hiram Powers.

C–45
Portrait of Katherine V. Gano as a Child
1887
Oil on canvas; 17¹⁵⁄₁₆ × 15⅛ (45.6 × 38.2)
Signed lower left: *E. Nourse/ 1887*
Owner: Cincinnati Art Museum, bequest of Katherine V. Gano, 1945.49.
Exhibitions: Golden Age 1979/80, no. 228; Cincinnati Art Museum, "Art Palace of the West: A Centennial Tribute, 1881–1981," March 2–August 30, 1981.

C–46
Portrait of Brother Kennedy
by 1887
Oil
Unlocated
Previous owner: C. Eugene Kennedy, Canal Zone, in 1929.
Reference: Scrapbook 2, p. 99 (letter from C. Eugene Kennedy in the Canal Zone to EN in Paris, February 8, 1929).

C. Eugene Kennedy, the former owner of this work and C–47, wrote to EN that he had taken C–47 back to Cincinnati, but that he had kept this portrait in Panama and had cleaned it according to LN's instructions. Kennedy was EN's cousin.

C–47
Portrait of Grandmother Kennedy
by 1887
Oil
Unlocated
Previous owner: C. Eugene Kennedy, Canal Zone, in 1929.
Reference: Scrapbook 2, p. 99 (letter from C. Eugene Kennedy in the Canal Zone to EN in Paris, February 8, 1929).

See comment, C–46.

C–48
Woman with Harp
1887
Figure 10
Oil on canvas; 35 × 22 (88.9 × 55.9)
Signed lower left: *E. Nourse./ 1887*
Owner: Private collection, Cincinnati.
Previous owners: Dorothy Schmidt Bunker; Henry B. Bunker.

C–49
French Peasant, blue blouse
1888–89
Unlocated
Previous owner: Mrs. Kelley, Cincinnati, in 1893.
Exhibition: CAM 1893, no. 63.
Reference: Annotated CAM 1893 (price, $30).

C–50
Head of Young Boy
1889
Watercolor on paper; 15½ × 11 (39.4 × 28)
Inscribed on mat lower right: *A ma Chère Pheobe* [sic]/ *Paris Mai 28 1889/ E. Nourse*
Owner: Private collection, Cincinnati.
Previous owner: Mrs. Robert L. Resor, Cincinnati.

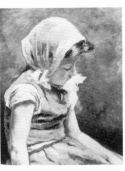

C–51
Peasant Girl in a Pinafore
ca. 1889
Oil on canvas; 15½ × 9½ (39.4 × 24.2)
Signed lower right: *E. Nourse*
Owner: Mrs. Edwin S. McCoach, Columbia, S.C.
Previous owners: William Hasse, Cincinnati, by 1949; Mrs. Georgia T. Vogt, Cincinnati.

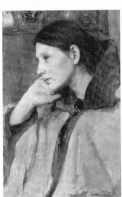

C–52
Le rêve
ca. 1889
Oil on canvas; 21½ × 15 (54.5 × 38.1)
Signed lower right: *E. Nourse*
Owner: Private collection, Cincinnati.
Previous owners: Mrs. Joseph B. Verkamp, Cincinnati; Mrs. Joseph A. Verkamp, Cincinnati, 1940–76.

The title of this painting is written on the back of the canvas. There is also a label marked "no. 10, a Barbizon peasant, Fontainebleau."

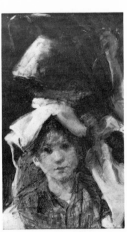

C–53
Abruzzi Peasant
1890
Oil on paperboard; 10½ × 7 (26.7 × 17.4)
Owner: Sara Ware, Covington, Ky., from 1979.
Previous owners: H. Clay Meader II, Cincinnati; H. Clay Meader III, Cincinnati.

There are two sketches for this work in H–10.

C–54
Cappucini [sic] *Monk*
1890
Unlocated
Previous owner: William Howard Doane, Cincinnati, in 1893.
Exhibition: CAM 1893, no. 18.
Reference: Annotated CAM 1893 (price, $75).

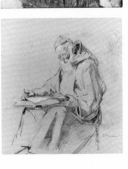

There are three charcoal and white chalk sketches for this work in H–10. The one illustrated here, signed *E. Nourse,* is probably the basis for this painting.

C–55
An Italian Baby
1890
Unlocated
Exhibitions: CAM 1893, no. 22; Fischer 1894, no. 13.
Reference: Annotated CAM 1893 (price, $75; records sale).

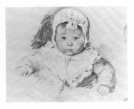

The illustration for this entry, a charcoal and white chalk sketch in H–10, may be the basis for this work.

C–56
Little Baby in Roman Basket
1890
Unlocated
Previous owner: Mrs. Roscoe Rood, Seattle, in 1909.
Reference: Scrapbook 1, p. 91 (note by LN).

LN noted that Mrs. Rood bought this painting for the Children's Home.

C–57
Old Blind Peasant, Assisi
1890
Watercolor
Unlocated
Previous owner: Albert Dubuisson, Paris, in 1909.
Exhibitions: CAM 1893, no. 22; Fischer 1894, no. 13.
Reference: Annotated CAM 1893 (price, $25); Albert Dubuisson in Paris to EN in Paris, December 1909.

There are four letters from Albert Dubuisson, who was given this painting by EN in 1909, in the Elizabeth Nourse Papers, Cincinnati Historical Society. Dubuisson was a friend who encouraged EN and who took lessons in watercolor painting from her. An occasional writer on art subjects, he wrote a book in 1912 about the English watercolorist Richard Bonington, *Bonington et l'influence de l'école anglaise sur la peinture de paysage en France,* which was published by the Walpole Society.
 See also comment, C–144.

C–58
Portrait of Anna Seaton Schmidt
1890
Figure 16
Signed upper left: *À ma Chère Amie Anna Schmidt/ Paris '09 E. Nourse*
Unlocated
Reference: Scrapbook 1, p. 20 (photo and note by LN).

Anna Seaton Schmidt was a close friend of EN's from Cincinnati and visited her frequently in Europe. As a writer and lecturer on art, Schmidt publicized the artist in newspapers in Cincinnati, Washington, D.C., and Boston, and in such magazines as *International Studio* and *Art and Progress.* The date assigned to this portrait, 1890, is from LN's note in Scrapbook

1, p. 20, "Painted in 1890, Paris." The inscribed date, 1909, is regarded as the year the portrait was presented to the sitter by the artist. For another portrait of Anna Schmidt, see C–107.

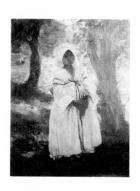

C–59
Babe in the Woods, Borst
1891
Oil on canvas; 30 × 24 (76.2 × 61)
Signed lower right: *Elizabeth Nourse 1892*
Owner: Reeves family, Seattle, Wash.
Exhibitions: London, Royal Academy, 1892, no. 392; CAM 1893, no. 14; Fischer 1894, no. 10.
References: *The World* (London), May 4, 1892; Annotated CAM 1893 (price, $300).

The English review of the Royal Academy exhibition praised this work as "a clever study of sunlight and shadow."

C–60
Borst Head
1891
Unlocated
Exhibitions: CAM 1893, no. 70; Fischer 1894, no. 46.
Reference: Annotated CAM 1893 (price, $25).

C–61
Borst Head, outdoors
1891
Unlocated
Exhibition: CAM 1893, no. 69.
Reference: Annotated CAM 1893 (price, $25).

C–62
Italian Peasant Girl
1891
Oil on wood panel; 19¾ × 8¹¹⁄₁₆ (50.1 × 29.7)
Incised upper right: *E. Nourse '91*
Owner: Minona Stevens Luce, Falmouth Foreside, Maine.
Previous owners: Edward W. Donn, Jr., Washington, D.C.; Minona Donn Smoot, Washington, D.C.

There is a sketch for this work with the figure reversed in H–10.

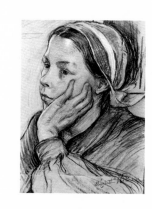

C–63
A Nun
1891
Oil on canvas; 25½ × 18½ (64.8 × 47)
Signed upper left: *E. Nourse '91*
Owner: Private collection.
Previous owners: Estate 1938; Clara

208

Nourse Thompson, Fort Thomas, Ky., 1938–80.

C–64
Breton Head
ca. 1892
Unlocated
Exhibitions: CAM 1893, no. 51; Fischer 1894, no. 35.
Reference: Annotated CAM 1893 (price, $75).

See comment, C–65.

C–65
Breton Head
1892
Oil on canvas; 24½ × 18¾ (62.2 × 47.6)
Signed upper left: *E. Nourse '92*
Owner: M. A. Burke, Cincinnati, from 1979.
Previous owner: Adam A. Weschler & Son, Washington, D.C.
Exhibitions: CAM 1893, no. 51; Fischer 1894, no. 35.
Reference: Annotated Fischer 1894 (price, $75).

EN did not go to Brittany until 1894. She posed the models in Paris for this work, C–64, and C–90 through C–93. It is unknown if the models were actually Bretons or models posed in Breton costume.

C–66
Dutch Girl
1892
Charcoal and chalk on paper; 13¾ × 10 (35 × 25.4)
Signed lower right: *Elizabeth Nourse*
Owner: Mr. and Mrs. Walter S. Bunker, Cincinnati.
Previous owner: Walter S. Schmidt, Cincinnati.

C–67
Dutch Head
1892
Pastel
Unlocated
Previous owner: J. H. Gest, Cincinnati, in 1893.
Exhibition: CAM 1893, no. 95.
Reference: Annotated CAM 1893 (price, $35).

J. H. Gest, the previous owner, was assistant to the director of the Cincinnati Art Museum, Col. A. T. Goshorn, when he organized the 1893 exhibition of the artist's work at the museum. See comment, B–41.

C–68
Girl in Volendam Costume
1892
Unlocated
Exhibition: CAM 1893, no. 55.
Reference: Annotated CAM 1893
(price, $25; records sale).

C–69
Huizen Peasant
1892
Unlocated
Exhibitions: CAM 1893, no. 71;
Fischer 1894, no. 47.
Reference: Annotated Fischer 1894
(price, $30; marked "sold").

C–70
Laaren Head, gold head-dress
1892
Unlocated
Exhibitions: CAM 1893, no. 62;
Fischer 1894, no. 43.
Reference: Annotated Fischer 1894
(price, $25; marked "sold").

See comment, C–72.

C–71
Laaren Head, profile
1892
Unlocated
Exhibitions: CAM 1893, no. 60;
Fischer 1894, no. 41.
Reference: Annotated CAM 1893
(price, $30).

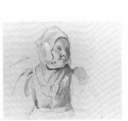

C–72
Laaren Head, silver head-dress
1892
Unlocated
Exhibitions: CAM 1893, no. 59;
Fischer 1894, no. 40.
Reference: Annotated CAM 1893
(price, $30).

The illustration for this entry is a
sketch in H–11 of a woman in the cos-
tume of Laaren, Holland, which is
dated September 1892. See also com-
ment, C–70.

C–73
Laaren Head, young girl
1892
Unlocated
Exhibitions: CAM 1893, no. 61;
Fischer 1894, no. 42.
Reference: Annotated CAM 1893
(price, $25).

C–74
Maarken Head, a child
1892
Unlocated
Previous owner: Mrs. Gamble, Cincin-
nati, in 1893.
Exhibition: CAM 1893, no. 54.
Reference: Annotated CAM 1893
(price, $25).

The illustration for this entry is a
sketch in H–11 of a Maarken girl and
boy in the costume of the region. EN
went to Maarken from Volendam in
early August, 1892, during her stay in
Holland.

C–75
Maarken Head, profile of a woman
1892
Unlocated
Previous owner: Mrs. [L. B.] Harri-
son, Cincinnati, in 1893.
Exhibition: CAM 1893, no. 66.
Reference: Annotated CAM 1893
(price, $30); Archives (letter from Mrs.
Larz Anderson in Cincinnati to J. H.
Gest in Cincinnati, November 13,
1893).

In her letter to Mr. Gest, assistant di-
rector of the Cincinnati Art Museum
in 1893, Mrs. Anderson listed the
names of the women who would serve
on the reception committee for the
opening of the Elizabeth Nourse exhi-
bition at the museum. The nine
women included herself and Mrs. L.
B. Harrison, who must have bought
this painting.
 For additional information on Gest,
see comment, B–41.

C–76
Maarken Head, a woman
1892
Unlocated
Previous owner: Mrs. Ives, Cincinnati,
in 1893.
Exhibition: CAM 1893, no. 65.
Reference: Annotated CAM 1893
(price, $30).

C–77
North Hollander
1892
Unlocated
Exhibitions: CAM 1893, no. 72;
Fischer 1894, no. 48.
Reference: Annotated CAM 1893
(price, $25).

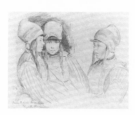

C–78
Peasants from Maarken
1892
Pencil on paper; 9¼ × 12¼ (23.5 × 31.2)
Signed lower left: *Peasants from Maarken/ Elizabeth Nourse*
Owner: College-Conservatory of Music, University of Cincinnati, bequest of Walter S. Schmidt, 1962.4.25.
Exhibitions: College 1941, no. 4; U.C. 1974, no. 22.

For information on Walter S. Schmidt's bequest to the owner, see comment, A–60.

C–79
Portrait of Louise Nourse
1892
Figure 30
Pastel on paper; 23½ × 17¼ (59.6 × 43.8)
Signed center right: *E. Nourse/ Paris '92*
Owner: Louise Settle Talley, Stockton, Calif.
Previous owner: Mary Louise Settle, Stockton, Calif.
Exhibition: College 1941, no. 18.

Louise Nourse was thirty-nine years old when EN painted this portrait in 1892, the same year she painted her own self-portrait, C–80.

C–80
Self Portrait
1892
Figure 1
Oil on canvas; 39 × 29½ (99.1 × 75)
Signed lower left: *E. Nourse July/ 1892*
Owner: Mr. and Mrs. Walter S. Bunker, Cincinnati.
Previous owner: Estate 1938; Walter S. Schmidt, Cincinnati, 1938–62.
References: Walsh 1922 (illus.); Goldman 1921, p. 7.

This mirror image, painted when EN was thirty-three, makes her appear to be left-handed. C–81 is a study for this painting.

C–81
Study for Self Portrait
1892
Oil on paperboard; 13½ × 9¾ (34.3 × 24.8)
Inscribed upper right: *A Ma Chere Soeur/ Portrait De Sa Soeur/ Paris 189*[2]
Owner: Private collection, Cincinnati.
Previous owners: Estate 1938; Elizabeth Nourse Stacey, Fort Thomas,

Ky., 1938–61; Helen Stacey Hunt, Cincinnati, 1961–80.

This is a study for C–80.

C–82
Volendam Baby
1892
Unlocated
Previous owner: Mrs. Rogers, Cincinnati, in 1893.
Exhibition: CAM 1893, no. 32.
Reference: Annotated CAM 1893 (price, $50).

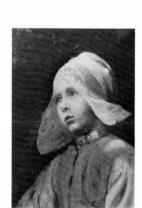

C–83
Volendam Head, little girl
1892
Oil on canvas; 17½ × 12½ (44.5 × 31.7)
Signed upper left: *E. N. '92*
Owner: Mary Brett Heermann, Los Angeles, from 1972.
Previous owners: John Uri Lloyd, Cincinnati, 1893–1936; Mrs. James Brett, Cincinnati, 1936–72.
Exhibition: CAM 1893, no. 52.
Reference: Annotated CAM 1893 (price, $60).

C–84
Volendam Head, "Maertje"
1892
Unlocated
Previous owner: John Uri Lloyd, Cincinnati, in 1893.
Exhibition: CAM 1893, no. 54.
Reference: Annotated CAM 1893 (price, $35).

C–85
Volendam Head, "Steenie"
1892
Unlocated
Exhibitions: CAM 1893, no. 53; Fischer 1894, no. 36.
Reference: Annotated CAM 1893 (price, $50).

C–86
Volendam Head, woman with bonnet
1892
Unlocated
Exhibitions: CAM 1893, no. 34; Fischer 1894, no. 20.
Reference: Annotated CAM 1893 (price, $80).

C–87
Volendam Head, young girl with bonnet
1892
Unlocated
Exhibitions: CAM 1893, no. 33; Fischer 1894, no. 19.
Reference: Annotated Fischer 1894 (price, $80; marked "sold").

C–88
Volendam Peasant
1892
Oil on board; 13 × 19 (33 × 25.5)
Signed and dated *'92*
Unlocated
Previous owner: V. G. Fischer Art
Gallery, Washington, D.C.
Reference: Anderson Galleries (New
York), *Sale of the Collection of the V.G.
Fischer Art Company, Inc.,* February
1912, no. 336.

Fischer, whose gallery was located on
Fifteenth Street, N.W., in Washington,
D.C., held an exhibition of EN's work
in 1894 and acted as her dealer until
1912. This painting may be one of the
works previously listed from the 1894
catalogue, but it is impossible to deter-
mine which one. According to the de-
scription in the 1912 sale catalogue,
"Against a window with a background
of green shrubbery, an old woman in a
white cap with a red kerchief about her
neck is seen; her eyes dimmed by age
look down in contemplation."

C–89
Volendam Peasant, out-of-doors
1892
Unlocated
Exhibitions: CAM 1893, no. 56;
Fischer 1894, no. 38.
Reference: Annotated CAM 1893
(price, $25).

C–90
Breton Head
1893
Pastel on paper; 18½ × 13½ (47 ×
34.3)
Signed upper right: *E. Nourse 1893*
Owner: Private collection, Cincinnati.
Previous owner: Mr. Sexton, Cincin-
nati, in 1893.
Exhibitions: CAM 1893, no. 93; Indian
Hill 1978, no. 53.
Reference: Annotated CAM 1893
(price, $50).

See comment, C–65.

C–91
Breton Head
1893
Pastel
Unlocated
Previous owner: Mrs. Duhme, Cincin-
nati, in 1893.
Exhibition: CAM 1893, no. 94.
Reference: Annotated CAM 1893
(price, $35).

See comment, C–65.

C–92
Breton Peasant
1893
Unlocated
Exhibitions: CAM 1893, no. 28;
Fischer 1894, no. 18.
Reference: Annotated Fischer 1894
(price, $100; marked "sold").

See comment, C–65.

C–93
Springtime, Breton Peasants
1893
Unlocated
Previous owner: Mrs. Zenner, Cincin-
nati, in 1893.
Exhibition: CAM 1893, no. 24.
References: Annotated CAM 1893
(price, $150); Lord 1893.

Caroline Lord described this work as
showing the heads of two young girls.
 See comment, C–65.

C–94
Portrait of Miss Mary N.
1893
Figure 11
Pastel on paper; 24 × 18 (61 × 45.8)
Inscribed and signed lower right: *To
My Dear Neice* [sic]/ *E. Nourse '93*
Owner: Marian Thompson Deininger,
Houston, from 1980.
Previous owners: Mary Nourse, Fort
Thomas, Ky.; Clara Nourse Thomp-
son, Fort Thomas, Ky., 1959–80.

Mary Nourse, niece of the artist, was
twenty-three when she posed for this
portrait.

C–95
Portrait of Benn Pitman
1893
Figure 35
Pastel on paper; 36½ × 31 (92.7 ×
78.8)
Signed upper left: *To my Dear Brother/
Benn Pitman/ E Nourse 1893*
Owner: Cincinnati Historical Society,
gift of Melrose Pitman.
Exhibition: CAM 1893, no. 90.

When she returned to Cincinnati in
1893, EN executed three family por-
traits: this painting of her brother-in-
law, C–94, and C–96.

C–96
Portrait of Melrose Pitman
1893
Figure 36
Pastel on paper; 19¼ × 14 (48.9 × 35.5)
Inscribed upper right: *Melrose 4 yrs/ '93/ E. Nourse*
Owner: Private collection.
Previous owner: Melrose Pitman.
Exhibition: CAM 1893, no. 91.

Melrose Pitman was the daughter of EN's twin sister, Adelaide, and Benn Pitman.

C–97
Portrait of Dr. Elmira Howard
1894
Pastel on paper; 24 × 18 (61 × 45.6)
Signed upper left: *E. Nourse 1894/ Cin.*
Owner: Ernst S. Howard, Cincinnati.
Previous owners: Dr. Elmira Howard, Cincinnati; Jerome B. Howard, Cincinnati.
Reference: Interview, Mary Alice Heekin Burke with Ernst S. Howard, June 1980.

The subject of this portrait, Elmira Howard, was widowed during the Civil War when her husband, an artist and writer, died in Andersonville prison. She then went to Vienna to study medicine and became a general practitioner in Cincinnati. She may have attended Adelaide Pitman in her last illness. Her son, Jerome B. Howard, became associated in 1881 with Benn Pitman's Phonographic Institute, which published texts for instruction in the Pitman shorthand method.

C–98
Saint Gildas Peasant Girl
1894
Oil on paperboard; 9 × 5 (22.9 × 12.7)
Signed lower right: *E. Nourse '94*
Owner: John W. Bunker, Saint Louis, Mo.
Previous owner: Henry Bunker, Cincinnati.

C–99
Sous les arbres (Little Peasant of Brittany)
1894
Oil on canvas; 40 × 30 (101.6 × 76.1)
Unlocated
Previous owners: Nebraska Art Association, Lincoln, 1900; Sheldon Memorial Art Gallery, University of Nebraska, Lincoln, to 1951.
References: MacChesney 1896, p. 9 (il-

lus.); Schmidt 1902, p. 334 (illus.); Registrar's File, Sheldon Memorial Art Gallery.

Clara T. MacChesney wrote that the model was a little Breton girl named Lisa in Saint Gildas and that the painting was finished in five sittings.

C–100
Fillette bretonne
ca. 1895
Oil on canvas
Unlocated
Exhibition: New Salon 1895, no. 954.

C–101
Fillette bretonne
ca. 1895
Oil on canvas
Unlocated
Exhibition: New Salon 1895, no. 955.

C–102
The First Communicant
ca. 1895
Watercolor
Unlocated
Previous owner: Frank M. Clark, Kalamazoo, in 1912.
Reference: Scrapbook 2, p. 30 (letter from Frank M. Clark in Kalamazoo to EN in Paris, March 27, 1912).

The previous owner, Frank M. Clark, also owned D–83.

C–103
La petite communiante
1895
Oil on canvas; 13 × 9¾ (33 × 24.8)
Signed upper right: *E. Nourse*
Owner: Patricia Williams Niehoff, Cincinnati, from 1962.
Previous owner: Mrs. Henry Rattermann, Jr., Cincinnati, 1913–62.

This is a portrait of one of the figures in B–53.

C–104
Portrait of Clement J. Barnhorn
1895
Oil on canvas; 18⅛ × 10⅝ (49.9 × 26.8)
Signed upper left: *E. Nourse to her friend/ Mr. Barnhorn 1895*
Owner: Cincinnati Art Museum, bequest of Clement J. Barnhorn, 1935.319.

For information on Clement J. Barnhorn, see comment, B–51.

C–105
Study of Baby in High Chair
1895
Oil on wood; 8 × 4¼ (20.3 × 10.8)
Signed upper right: *E. Nourse/ 1895*
Written on verso: *To dear Elizabeth and Walter/ With love from Elizabeth/ 1896*
Owner: Schmidt family, Cincinnati.
Previous owners: Elizabeth and Walter S. Schmidt, Cincinnati.

C–106
Two First Communicants
ca. 1895
Unlocated
Previous owner: Couvent de Notre Dame de Sion, Paris, in 1922.
Reference: Scrapbook 2, p. 88 (letter from Soeur Marie Louis de Sion in Paris to EN in Paris, December 27, 1922).

Sister Marie Louis of the Daughters of Sion thanked EN in her letter for the gift of this painting. The convent of Our Lady of Sion was across the rue d'Assas from the artist's studio. Figure 38 shows this painting on the easel in EN's studio.

C–107
Portrait of Anna Seaton Schmidt
1896
Pastel on paper; 19½ × 14½ (49.5 × 36.8)
Signed upper right: *Anna Paris 1896 E Nourse*
Owner: College-Conservatory of Music, University of Cincinnati, bequest of Walter S. Schmidt, 1962.4.12.

For another portrait of Anna Schmidt, see C–58.
 For information on Walter S. Schmidt's bequest to the owner, see comment, A–60.

C–108
Head of an Algerian (Moorish Prince)
1897
Figure 44
Oil on canvas; 32 × 23¾ (81.3 × 60.4)
Signed upper right: *To my dear friend Mr. Barnhorn/ E Nourse. Paris.*
Owner: The New Britain Museum of American Art, Conn., from 1981.
Previous owners: Clement J. Barnhorn, Cincinnati, by 1921; Xavier University, Cincinnati; Jeffrey R. Brown Fine Arts gallery, North Amherst, Mass.
Reference: Scrapbook 2, p. 81 (note by LN).

LN noted that this work was painted in Algiers in 1897 when she and EN went to Biskra from Tunis.

C–109
The Masquerader
1897
Oil on wood; 9 × 5 (22.6 × 12.9)
Signed upper right: *E. Nourse/ Tunis 1897*
Owner: Elizabeth Bunker Howland, Asheville, N.C., from 1962.
Previous owner: Schmidt family, Cincinnati.

C–110
Peasant Girl
by 1897
Unlocated
Previous owner: Max Weyl, Washington, D.C.
Exhibition: "Society of Washington Artists Loan Exhibition," Washington, D.C., 1897, no. 33, loaned by Max Weyl.

Max Weyl, the former owner, was a well-known landscape artist in Washington, D.C.

C–111
Portrait of a Bedouin
1897
Oil on canvas; 14 × 10½ (35.5 × 26.7)
Signed lower right: *To Dear Eleanor & Waldo/ E. Nourse 1905*
Owner: Midwestern Galleries, Cincinnati, from 1981.

C–112
Tête bédouine
1897
Oil on wood panel; 9 × 5 (22.5 × 12.8)
Signed upper right: *E. Nourse '97*
Owner: Private collection, Cincinnati.
Exhibition: Orientalistes 1904.
Reference: Scrapbook 1, p. 75 (entries for 1904 Orientalistes exhibition).

See comment, A–35.

C–113
Tête négresse
1897
Oil on wood
Unlocated
Previous owner: Dr. C. Chauveau, Paris.
Exhibition: Orientalistes 1904.
Reference: Scrapbook 1, p. 75 (entries for 1904 Orientalistes exhibition and note by LN).

LN noted that this portrait was yellow with a blue veil to distinguish it from C–114, also shown in the 1904 Orientalistes exhibition. See comment, A–35.

C–114
Tête négresse
1897
Oil on wood; 8¼ × 4⅜ (20.7 × 12)
Signed lower right: *E. Nourse '97/ A Henriette/ Tunis*
Owner: Mrs. Frederick W. Stern, Cincinnati, from 1928.
Previous owner: Henriette Wachman, Cincinnati.
Exhibition: Ortientalistes 1904.
References: Scrapbook 1, p. 75 (entries for 1904 Orientalistes exhibition and note by LN); interview by Mary Alice Heekin Burke with Mrs. Frederick W. Stern, Cincinnati, 1980.

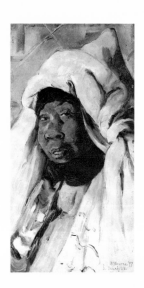

Mrs. Stern traveled in Europe with Louise Wachman Strauss, niece of Henriette and Laura Wachman, in 1928. They brought the Wachman sisters from Rome to Paris where they visited the Nourses. At that time EN gave this painting to her friend, Henriette.

For information on Henriette Wachman, see comment, A–32.

See also comment, A–35.

C–115
Tunisian Woman
1897
Watercolor on paper mounted on paperboard; 14 x 10 (35.5 × 25.4)
Signed lower left: *E. Nourse Tunis '97*
Owner: Private collection, Cincinnati.
Previous owners: Edith Baker, Cincinnati, in 1964; Faye S. Eastman, Cincinnati, 1964–74.

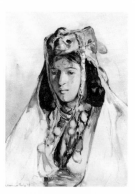

C–116
Portrait of Cécile
1898
Pastel on paper; 18 x 12 (45.7 × 30.5)
Signed lower left: *Cécile/ E. Nourse*
Written on verso: *Cécile à l'age de 8 ans/ Donné à M. Georges Brochet/ le jour de son mariage avec Cécile Léthias Juillet 25 1911*
Owner: Mme. Isabelle Decroisette, Vanves.
Previous owners: Elizabeth Nourse, 1898–1911; M. Georges Brochet, in 1911.

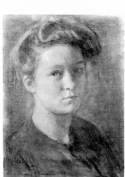

This portrait of Cécile, the daughter of Mme. Marie Saget-Léthias, EN's friend and model in Saint Léger, was given by the artist to Cécile's husband,

Georges Brochet, as a wedding gift. LN was Cécile's godmother. C–133 is another portrait of Cécile Léthias.

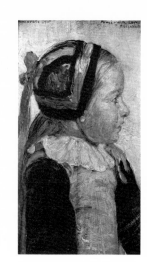

C–117
Breton Child
1900
Oil on wood; 9 × 5 (22.6 × 12.9)
Inscribed upper left: *Penmarc'h 1900*
Inscribed upper right: *To/ Mimi—with Love/ Elizabeth*
Owner: Sally Bunker Fellerhoff, Cincinnati.
Previous owner: Mrs. Frederick A. Schmidt, Cincinnati.

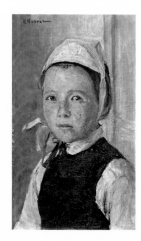

C–118
Breton Girl
ca. 1900
Oil on wood; 9 × 5 (22.6 × 12.9)
Signed upper left: *E. Nourse*
Owner: Patricia Williams Niehoff, Cincinnati, from 1959.
Previous owner: Mrs. Henry Rattermann, Jr., 1913–59.

C–119
Enfants de Penmarc'h (Children of Penmarc'h)
1900
Figure 50
Oil on canvas; 24 × 19 (61 × 48.3)
Signed lower left: *E. Nourse 1900*
Unlocated
Exhibitions: New Salon 1901, no. 711; PAFA 1902, no. 94; MACI 1901/2, no. 175; Saint Louis Universal Exposition, 1904, no. 571.
References: Scrapbook 1, p. 75 (note by LN); Schmidt 1906, p. 252 (illus.); Gaston Sevrette, "Au Pays des Bigoudènes," *Femina* (ca. 1902) (illus.); *Woman Citizen* (January 13, 1923) (cover illus.); Photo.

On the back of a photograph left in EN's estate, LN noted the dimensions of this work and its price of $250. There are two sketches for it in H–14. The first shows the two girls side-by-side; the second is the more interesting composition EN chose for this painting, which at first glance looks like a single figure and its mirror image.

EN was awarded a silver medal at the Saint Louis exposition for her three entries: this work, A–53, and B–82.

C–120
Little Girl in Red Shawl
1900
Oil on wood; 10 × 12 (15.5 × 30.5)
Signed and inscribed upper right: *E. Nourse/ To my friend Mrs. F. W. Clarke/ Paris 1900*
Owner: Mr. and Mrs. David Bowen, Cincinnati.
Previous owner: Clarke family, Greenwich, Conn.

C–121
Martha Rawson at Menton
1901
Pastel on paper; 12 × 9 (30.5 × 22.5)
Signed lower right: *Martha/ Menton/ 1901/ Elizabeth Nourse*
Owner: J. Rawson Collins, Cincinnati.
Previous owner: Martha Rawson Bayley, Cincinnati.

The subject, Martha Rawson, was the niece of Mary and Helen Rawson, expatriate Cincinnati friends of EN's, who had a home at Menton on the Côte d'Azur. See also C–122, F–21, and comment, D–54.

C–122
Martha Rawson on the Terrace at Menton
1901
Pastel on paper; 9 × 12 (22.5 × 30.5)
Inscribed lower right: *Martha on/ the Terrace/ Menton/ April 1901—E. N.*
Owner: J. Rawson Collins, Cincinnati.
Previous owner: Martha Rawson Bayley, Cincinnati.

See comment, D–54. See also C–121, F–21.

C–123
Paysanne de Penmarc'h, Finistère
(Peasant Child)
ca. 1901
Watercolor
Unlocated
Exhibition: New Salon 1901, no. 1324.
Reference: Scrapbook 1, p. 72 (American newspaper photo and note by LN, ca. 1902).

LN noted that this watercolor was sold in Chicago in 1902. There is a sketch for it in H–14.

C–124
Portrait de Mlle. de C.
1901
Pastel
Unlocated
Previous owner: Mlle. Germaine de Cresantignes, Paris.
Exhibition: New Salon 1901, no. 1322.

Reference: Scrapbook 1, p. 66 (note by LN).

EN painted a double portrait of Mme. de Cresantignes and her daughter in 1904. See also C–131.

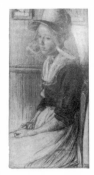

C–125
Jeune fille hollandaise
1902
Pastel on paper; 36 × 18 (91.5 × 45.8)
Signed lower right: *E. Nourse/ 1902*
Owner: The Cincinnati Club, Cincinnati.
Exhibitions: New Salon 1902, no. 415; Woman's Art Club of Cincinnati 1906, no. 58.

See also A–61.

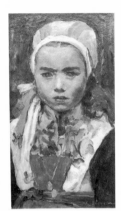

C–126
Little Breton Girl
ca. 1903
Oil on wood; 9 × 5 (22.8 × 12.7)
Signed lower right: *E. Nourse*
Owner: Mr. and Mrs. David Bowen, Cincinnati.

C–127
Enfants Bigoudines, Finistère
ca. 1903
Oil on canvas
Unlocated
Exhibitions: New Salon 1904, no. 964; AIC 1904, no. 321.

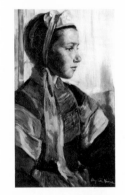

C–128
Paysanne de Penmarc'h
ca. 1903
Oil on canvas; 18 × 11 (45.8 × 28)
Signed lower right: *Elizabeth Nourse*
Owner: J. Rawson Collins, Cincinnati, from 1974.
Previous owner: Joseph Rawson, Cincinnati, ca. 1903–74.
Exhibition: PAFA 1903, no. 621.

This is a portrait of the young girl standing on the left in B–93.

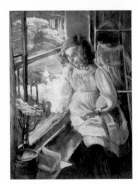

C–129
Fillette
ca. 1904
Pastel on paper; 24 × 19 (61 × 48.3)
Signed lower right: *E. Nourse*
Owner: Marian Thompson Deininger, Houston, from 1980.
Previous owner: Estate 1938, no. 35; Clara Nourse Thompson, Fort Thomas, Ky., 1938–80.
Exhibition: New Salon 1904, no. 1697.

C–130
Fillette
ca. 1904
Work on paper
Unlocated
Exhibition: New Salon 1904, no. 1698.

C–131
Portrait de Mme. de C. et sa fille
1904
Figure 54
Pastel
Signed lower right: *Elizabeth Nourse/
1904*
Unlocated
Previous owner: M. le Docteur de
Cresantignes, Paris.
Reference: Scrapbook 1, p. 97 (photo
and note by LN).

This is a portrait of Mme. de Cresan-
tignes and her daughter. See also C–
124.

C–132
Tête paysanne
ca. 1904
Distemper
Unlocated
Exhibition: New Salon 1904, no. 1699.
Reference: Scrapbook 1, p. 74 (note by
LN).

LN noted that this work showed a
Russian head.

C–133
Portrait of Cécile
1905
Oil; 14 × 10 (35.5 × 25.5)
Owner: Mme. Isabelle Decroisette,
Vanves.
Previous owner: Mme. Cécile Léthias-
Brochet, Saint Léger-en-Yvelines.

See C–116 for another portrait of the
same subject.

C–134
Bébé Bigoudine, Finistère
ca. 1906
Watercolor
Unlocated
Exhibitions: New Salon 1906, no.
1590; Nantes, "Exposition des Amis
des Arts," 1908, no. 440.
Reference: Scrapbook 1, p. 87 (French-
language review of Nantes Exposi-
tion).

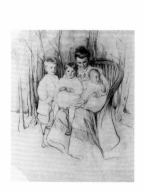

C–135
Family Group
1906
Charcoal and watercolor on paper;
18 × 16¼ (45.7 × 41.3)
Signed lower right: *Elizabeth Nourse/
1906*
Owner: Cincinnati Historical Society.

C–136
Fillette
ca. 1906
Pastel
Unlocated
Exhibition: New Salon 1906, no. 1591.

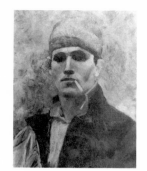

C–137
Head of a Basque
ca. 1906
Oil on canvas; 20½ × 15⁷⁄₁₆ (54 × 39)
Owner: Daniel Saget-Léthias, Soissons,
from 1920.
Reference: Letter from Daniel Saget-
Léthias, Soissons, to his niece, Mme.
Isabelle Decroisette, Vanves, February
6, 1980, in possession of Mary Alice
Heekin Burke, Cincinnati.

EN gave this painting as a wedding
gift in 1920 to Daniel Saget-Léthias
who had modeled for her as a baby
(see A–31). He recalls seeing it in her
studio in Paris around 1907.

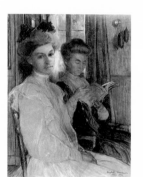

C–138
*Portrait of Mrs. James W. Bullock
and her daughter Marguerite*
1906
Pastel on paper; 24 × 18¼ (61 × 46.4)
Signed lower right: *Elizabeth Nourse/
Paris 1906*
Owner: Private collection, Cincinnati.
Previous owner: Mrs. James W. Bul-
lock, Cincinnati.

EN used the same composition for this
double portrait as for C–131, with the
mother bent over a book and the
young girl facing the viewer.

C–139
Près de la fenêtre
ca. 1906
Pastel
Unlocated
Exhibition: New Salon 1906, no. 1592.

C–140
Jeune fille de Plougastel (Head of a
Breton Woman)
1907
Oil on canvas; 16⅛ × 12⅞ (40.9 ×
32.7)
Signed lower right: *Elizabeth Nourse*
Owner: Cincinnati Art Museum, be-
quest of Ethel McCullough in memory
of Blanche P. McCullough and Caro-
line E. Phipps, 1970.369.
Exhibitions: New Salon 1908, no. 900;
AIC 1908, no. 199; Golden Age, 1979/
80, no. 221.
Reference: Scrapbook 1, p. 84 (photo).

C–141
Bébé de Plougastel (Bébé de Pen-
marc'h)
ca. 1908
Oil on canvas
Unlocated
Exhibition: New Salon 1908, no. 899;
AIC 1908, no. 198.

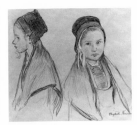

C–142
Fillette de Plougastel
ca. 1908
Watercolor
Unlocated
Exhibition: Peinture 1908.
Reference: Scrapbook 1, p. 87 (entries for 1908 Peinture exhibition).

The illustration for this entry is a signed sketch in H–15 that may be the basis for this portrait or for C–143.

C–143
Fillette de Plougastel
ca. 1908
Watercolor
Unlocated
Exhibition: Peinture 1908.
Reference: Scrapbook 1, p. 87 (entries for 1908 Peinture exhibition).

See comment, C–142.

C–144
Portrait de Mlle. D.
ca. 1908
Pastel
Unlocated
Exhibition: New Salon 1908, no. 1608.
Reference: Scrapbook 1, p. 84 (note by LN).

LN noted that the subject was Mlle. Dubuisson, probably the daughter of Albert Dubuisson (see comment, C–57).

C–145
Portrait de Mme. H.
ca. 1908
Pastel
Unlocated
Exhibition: New Salon 1908, no. 1607.
Reference: Scrapbook 1, p. 84 (note by LN).

LN noted that the subject of this portrait was a Mrs. Hammond.

C–146
Portrait de Miss P.
ca. 1908
Pastel
Unlocated
Exhibition: New Salon 1908, no. 1609.
Reference: Scrapbook 1, p. 84 (note by LN).

LN noted that the subject was a Miss Palmer, probably EN's friend Isobel Palmer, who lived in Paris and was in charge of the artist's funeral arrangements in 1938.

C–147
Portrait de M. Jean S.
ca. 1908
Pastel
Unlocated
Exhibition: New Salon 1908, no. 1610.
Reference: Scrapbook 1, p. 84 (note by LN).

The subject of this portrait was M. Jean Sortais. The Sortais family lived in the same apartment building at 80, rue d'Assas as the Nourses. See also C–160.

C–148
Jeune Fille
ca. 1910
Pastel
Unlocated
Exhibition: New Salon 1910, no. 1618.
References: Scrapbook 1, p. 103 (note by LN); LN in Haute Alsace to "Lizzie" in Cincinnati, September 17, 1909.

LN noted that the subject of this work was Mlle. Mireille Durieux. In her 1909 letter she wrote that Mireille Durieux and the children were staying with the Nourses at the Château de Trücksess in the Vosges mountains.

C–149
Peasant Head
by 1910
Unlocated
Previous owner: Dr. Maria M. Dean, Helena, Montana, in 1910.
Reference: Wheeler 1910.

C–150
Portrait of Marjorie Dyrenforth
by 1910
Unlocated
Previous owner: Mrs. P. C. Dyrenforth, Chicago and California.
References: "Elizabeth Nourse," *Chicago Sunday Tribune,* June 12, 1910; LN in Paris to Dorothy Schmidt Bunker in Cincinnati, November 19, 1913.

The *Chicago Tribune* article listed the names of owners of EN paintings who lived in Chicago. In her letter to Dorothy Bunker, LN wrote that Mrs. Dyrenforth and Marjorie visited them in Paris in 1913.

C–151
Portrait de Miss Louise H.
ca. 1910
Pastel
Unlocated
Exhibition: New Salon 1910, no. 1616.
Reference: Scrapbook 1, p. 103 (note

by LN); Linda Simon, *The Biography of Alice B. Toklas* (1977), pp. 14, 69, 129, 206, 253, 279.

LN noted that the subject was Louise Hayden. For information on Hayden, see note 202, p. 86.

C–152
Portrait de Miss Olga P. en costume russe
ca. 1910
Pastel
Unlocated
Exhibition: New Salon 1910, no. 1617.
Reference: Scrapbook 1, p. 103 (note by LN).

LN noted that the subject of this portrait was Miss Olga Popoff, a sculptor and fellow member of EN's in the American Woman's Art Association of Paris.

C–153
Le petite communiante
ca. 1911
Gouache
Unlocated
Exhibitions: New Salon 1911, no. 1635; Quelques 1912, no. 107.

C–154
Portrait de Mme. B.
ca. 1911
Gouache
Unlocated
Exhibition: New Salon 1911, no. 1537.
Reference: Scrapbook 2, p. 97 (note by LN).

LN noted the subject was a Mrs. Burke and that the work was owned by "Raymond."

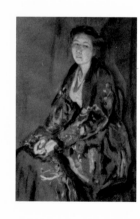

C–155
Le vieux châle
ca. 1911
Gouache
Unlocated
Exhibition: New Salon 1911, no. 1638.

C–156 is a study for this work.

C–156
Study for Le vieux châle
ca. 1911
Gouache; 21 × 15 (53.4 × 38.1)
Written on verso: *Elizabeth Nourse/ Le vieux châle (Etude)/ Salon 1911*
Owner: Reeves family, Pasadena, Calif., from 1950.
Previous owners: Estate 1938; Nellie Nourse Reeves, Seattle.

This is a study for C–155.

C–157
Fillette de Plougastel
ca. 1912
Watercolor
Unlocated
Exhibitions: Lodge 1912; PAFA Watercolor 1912, no. 126.
Reference: *Argus de la Presse* (Paris), February 11, 1912.

C–158
Baby in Bed
ca. 1913
Charcoal, pastel, and gouache on paper; 10 × 13 (25.5 × 33)
Signed lower right: *Elizabeth Nourse*
Owner: Private collection, Cincinnati.

C–159
Bébé Besnard
ca. 1913
Figure 64 and page 156
Pastel on paper; 12 × 19 (30.5 × 48.3)
Signed lower right: *Elizabeth Nourse*
Owner: William E. Wiltshire III, Richmond, Va.
Exhibition: New Salon 1913, no. 1656.

This may be a portrait of a grandchild of Albert and Marie Besnard, close friends of EN's in Paris. They were both painters and ceramists who showed in the New Salon with her.

C–160
Mlle. Marcelle S.
ca. 1913
Pastel
Unlocated
Exhibition: New Salon 1913, no. 1658.
Reference: Scrapbook 1, p. 40 (note by LN).

LN noted that the subject was Mlle. Marcelle Sortais. See comment, C–147.

C–161
Portrait of Isabelle
1913
Pastel on paper; 13¾ × 10⅞ (35 × 27.5)
Signed lower right: *Isabelle à 8 mois/ E. Nourse*
Owner: Mme. Isabelle Decroisette, Vanves.
Previous owner: Mme. Cécile Léthias-Brochet, Saint Léger-en-Yvelines.

The subject is Isabelle Brochet, daughter of the subject of C–116 and C–133.

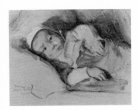

C–162
Breton Baby
ca. 1915
Watercolor on paper; 12¼ × 15 (31.1 × 38.1)
Signed lower left: *Elizabeth Nourse/ Penmarc'h*
Owner: College-Conservatory of Music, University of Cincinnati, bequest of Walter S. Schmidt, 1962.4.28.
Exhibition: U.C. 1974, no. 25.

For information on Walter S. Schmidt's bequest to the owner, see comment, A–60.

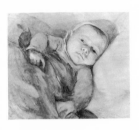

C–163
French War Orphan
ca. 1915
Watercolor on paper; 12⅛ × 14½ (31.2 × 36.8)
Signed lower left: *Elizabeth Nourse*
Owner: Cincinnati Art Museum, bequest of Walter Wichgar, 1925.5.

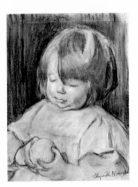

C–164
Petit Joseph (Child with Orange)
ca. 1915
Pastel on paper; 11⅝ × 9⅜ (29.5 × 23.7)
Signed lower right: *Elizabeth Nourse*
Owner: Mr. and Mrs. Walter S. Bunker, Cincinnati.
Previous owners: Estate 1938; Walter S. Schmidt, Cincinnati, 1938–62.

The title of this work is written on the back.

C–165
Baby Asleep
ca. 1916
Figure 65 and page 157
Pastel and gouache on paper; 10 × 12 (25.5 × 30.5)
Signed lower left: *Elizabeth Nourse*
Owners: Mr. and Mrs. David Bowen, Cincinnati.

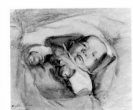

C–166
L'enfant, Penmarc'h
ca. 1919
Watercolor on paper mounted on paperboard; 12½ × 15¾ (35.7 × 40)
Signed lower left: *Elizabeth Nourse/ Penmarc'h*
Owner: College-Conservatory of Music, University of Cincinnati, bequest of Walter S. Schmidt, 1962.4.27.
Exhibitions: New Salon 1919; Paris, Galerie Manuel Frères, 1920; U.C. 1974, no. 24.
Reference: Scrapbook 2, p. 76 (entries for 1919 New Salon) and p. 83 (entries

for 1920 exhibition at Galerie Manuel Frères).

The title of this work and the Salon date (1919) are written on the back of this canvas together with the price, 150 francs. Although LN noted that this work was exhibited in the New Salon of 1919, neither its title nor EN's name appears in the New Salon's exhibition catalogue for that year.

For information on Walter S. Schmidt's bequest to the owner, see comment, A–60.

C–167
Sleeping Baby
ca. 1919
Colored chalks on paper; 9⅓ × 12 (23.8 × 30.5)
Signed lower right: *Elizabeth Nourse*
Owner: Cincinnati Art Museum, gift of Mrs. Thomas Warrington, 1980.
Previous owners: Edith Baker, Cincinnati, by 1964; Fay S. Eastman, Cincinnati, 1964–74; Mrs. Thomas Warrington, 1974–80.
Exhibition: Cincinnati Art Museum, "New Acquisitions—Graphics," December 1980.

C–168
Paysanne russe
ca. 1920
Distemper
Unlocated
Exhibition: Paris, Galerie Manuel Frères, 1920.
Reference: Scrapbook 2, p. 83 (entries for 1920 Galerie Manuel Frères exhibition).

C–169
Portrait of Baby Henri Perrier
1930
Unlocated
Reference: EN in Paris to Winfield Kennedy in Ann Arbor, Mich., March 9, 1930, in Kennedy Family Collection, Malvern, Pa.

EN reported in her letter to her cousin, Winfield Kennedy, that she was working on this portrait in March 1930 and added, "I am glad that I can still work as of old." Monsieur Henri Perrier was listed as a reference on EN's French residence visa. He and EN lived in the same apartment building at 80, rue d'Assas, and his position was given as Chef de la Construction aux Chemins de l'Etat.

Undated

C–170
Child's Head
Oil; 14 × 16 (35.5 × 40.5)
Unlocated
Previous owner: University of Washington, Seattle, bequest of Judge and Mrs. Thomas J. Burke, 1932.
Reference: Inventory 1932.

For information on the Burkes' bequest to the previous owner, see comment, A–78.

C–171
Child Study
Oil; 13 × 16½ (33 × 41.8)
Unlocated
Previous owner: University of Washington, Seattle, bequest of Judge and Mrs. Thomas J. Burke, 1932.
Reference: Inventory 1932.

For information on the Burkes' bequest to the previous owner, see comment, A–78.

C–172
Child Study
Oil on canvas; 23 × 27 (58.5 × 68.6)
Unlocated
Previous owner: University of Washington, Seattle, bequest of Judge and Mrs. Thomas J. Burke, 1932.
Reference: Inventory 1932.

For information on the Burkes' bequest to the previous owner, see comment, A–78.

C–173
Girl and Mirror
Oil on canvas; 33 × 39 (83.8 × 99)
Unlocated
Previous owner: University of Washington, Seattle, bequest of Judge and Mrs. Thomas J. Burke, 1932.
Reference: Inventory 1932.

For information on the Burkes' bequest to the previous owner, see comment, A–78.

C–174
Girl's Head
Oil; 14 × 16 (35.5 × 40.5)
Unlocated
Previous owner: University of Washington, Seattle, bequest of Judge and Mrs. Thomas J. Burke, 1932.
Reference: Inventory 1932.

This or C–177 may be a duplicate of B–100. See comment, B–100.

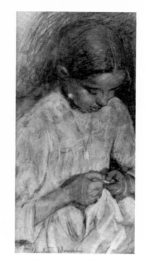

For information on the Burkes' bequest to the previous owner, see comment, A–78.

C–175
Girl in Pink Dress
Pastel on paper; 18⅝ × 9¾ (47.3 × 24.8)
Signed lower center: *Elizabeth Nourse*
Owner: Stacey family.
Previous owners: Estate 1938; Elizabeth Nourse Stacey, Fort Thomas, Ky.

C–176
Head of Little Peasant Girl
Oil on paperboard; 9 × 5 (22.6 × 12.9)
Owner: John W. Bunker, Saint Louis, Mo.
Previous owners: Estate 1938; Henry Bunker, Cincinnati.

C–177
Old Woman
Oil; 13½ × 16½ (34.3 × 42)
Unlocated
Previous owner: University of Washington, Seattle, bequest of Judge and Mrs. Thomas J. Burke, 1932.
Reference: Inventory 1932.

This or C–174 may duplicate B–100. See comment, B–100.

For information on the Burkes' bequest to the previous owner, see comment, A–78.

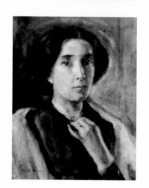

C–178
Petit Jean
Crayon and charcoal on paper; 12 × 9½ (30.5 × 24.2)
Signed and inscribed upper right: *Petit Jean—11 mois/ Elizabeth Nourse*
Owner: Mr. and Mrs. Walter S. Bunker, Cincinnati.
Previous owner: Walter S. Schmidt, Cincinnati.
Exhibition: Closson 1941.

C–179
Portrait of a Married Woman
Watercolor on paper; 17½ × 13¾ (44.6 × 35)
Signed lower left: *Elizabeth Nourse*
Owner: Mrs. Patricia Williams Niehoff.
Previous owners: Estate 1938; Mrs. Henry Rattermann, Jr., Cincinnati.

D *Landscape and Architecture*

D–1
A House
1872
Drawing for an engraving
Signed lower left: *E N*
Unlocated
Reference: Scrapbook 1, p. 15 (print).

EN was thirteen when she made the drawing, known through this print in Scrapbook 1.

D–2
A Cottage
1873
Drawing for an engraving
Signed lower right: *E. Nourse*
Inscribed lower right: *E N/ 1873*
Unlocated
Reference: Scrapbook 1, p. 7 (print).

EN was fourteen when she made the drawing, known through this print in Scrapbook 1, and had probably begun her studies with Cincinnati artist Mary Spencer (1835–1923). The format is similar to that used in her 1880 engravings for the *National Repository*, D–14, D–15, and D–18.

D–3
The Old Homestead
1878
Ink on paper
Unlocated
Exhibition: McMicken 1878, no. 358.

D–4
Mr. Bullock's Residence
1879
Ink on paper
Unlocated
Exhibition: McMicken 1879, no. 582.

D–5
Dock Yards, Fulton
1879
Ink on paper
Unlocated
Exhibition: McMicken 1879, no. 589.

Fulton was an area in eastern Cincinnati on the Ohio River bank.

D–6
Mr. Hostetter's Residence
1879
Ink on paper
Unlocated
Exhibition: McMicken 1879, no. 583.

D–7
House
1879
Ink on paper
Unlocated
Exhibition: McMicken 1879, no. 580.

D–8
House
1879
Ink on paper
unlocated
Exhibition: McMicken 1879, no. 581.

D–9
Landscapes from nature
1879
Watercolor
Unlocated
Exhibition: McMicken 1879, no. 496.

D–10
Ohio River from the Pitman House
1879
Watercolor
Unlocated
Exhibition: McMicken 1879, no. 495.
Reference: EN Papers (photo).

A photograph of this landscape is marked *A view of the Ohio from Benn Pitman house at 1852 Columbia Avenue.* On the left in this scene one sees under construction the stone house that EN's future brother-in-law, Benn Pitman, designed and built. The road on which it is situated overlooking the Ohio River is today the Columbia Parkway.

D–11
Rawson House, Clifton
ca. 1879
Ink on paper; 8⅝ × 11⅝ (21.9 × 29.9)
Signed lower right: *E. Nourse*
Owner: M. A. Burke, Cincinnati.
Previous owner: J. Rawson Collins, Cincinnati.

This drawing, D–4, and D–6 are examples of one kind of commission that EN undertook during her student days to earn money.

D–12
Scene, from nature
1879
Ink on paper
Unlocated
Exhibition: McMicken 1879, no. 579.

D–13
A Cabin
1880
Watercolor on paper; 10¼ × 14¾ (26 × 37.5)
Inscribed on verso: *Painted by Elizabeth Nourse Millville, Indiana 1880*
Owner: Marian Thompson Deininger, Houston, from 1959.
Previous owner: Mary Nourse, Fort Thomas, Ky.

D–14
Carroll Hall, Confinement Place of Jefferson Davis
1880
Drawing for an engraving
Signed lower right: *E. Nourse*
Unlocated
Reference: "Around Old Point Comfort," *National Repository* (February 1880): 106.

EN traveled to Hampton Roads, Virginia, to illustrate an article for the *National Repository,* a monthly publication of the Methodist Episcopal church in Cincinnati, Chicago, and Saint Louis. Illustrated here and in D–18 are two of the four engravings taken from drawings she executed for this article.

D–15
Flirtation Walk
1880
Drawing for an engraving
Signed lower left: *E N*; signed lower right: *E. Nourse*
Reference: "West Point," *National Repository* (April 1880): 307.

The illustration for this entry is one of two engravings taken from drawings EN executed for an article on West Point Military Academy, published in the *National Repository.* The work is signed twice, indicating that EN probably made the engraving as well as the drawing. See comment, D–14.

D–16
Landscape (Old Barnyard)
1880
Watercolor
Unlocated
Exhibition: McMicken 1880, no. 2046.

D–17
Landscape (Sunset)
1880
Watercolor
Unlocated
Exhibition: McMicken 1880, no. 2047.

D–18
National Cemetery
1880
Drawing for an engraving
Signed lower right: *E. Nourse*
Unlocated
Reference: "Around Old Point Comfort," *National Repository* (February 1880): 108.

The illustration for this entry is an engraving made from EN's drawing. See comments, D–14 and D–15.

D–19
Road in the Woods
1881
Watercolor and gouache on paper; 10¾ × 6 (27.3 × 15.2)
Signed lower right: *E. Nourse '81*
Owner: Helen Hern McDermott, Hillsboro, Ohio, from 1951.
Previous owner: Ruth Redke Hern, Hillsboro, Ohio.

D–20
At the Mouth of Black Channel
1882
Watercolor on paper; 13 × 19 (33 × 48.3)
Signed lower right: *E. Nourse/ '82*
Owner: Private collection, Saint Louis, Mo.
Exhibition: CIE 1882, no. 394.
Reference: City of Cincinnati, *Official Illustrated Catalogue of the Art Department of the Cincinnati Industrial Exhibition* (Cincinnati, 1882).

The illustration for this entry is an engraving of the watercolor, made for the catalogue of the 1882 Cincinnati Industrial Exhibition.

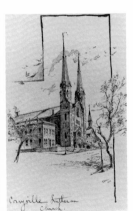

D–21
Corryville Lutheran Church
Drawing for an engraving
Signed lower right: *E. Nourse/ 1882*
Unlocated
Reference: Scrapbook 1, p. 20 (print).

The illustration for this entry is a print in Scrapbook 1 of the drawing EN made for an engraving.

D–22
Country Road in Northern Ohio
1882
Watercolor on paper; 9 × 12 (22.5 × 30.5)
Owner: Cincinnati Historical Society, gift of Melrose Pitman.

D–23
In the Marsh
1882
Signed lower left: *E. Nourse/ '82*
Unlocated
Exhibition: CIE 1882.
Reference: EN Papers (print).

The illustration for this entry is an engraving of the work, which was probably a watercolor similar to D–20.

D–24
Mountain Stream
1884
Watercolor on paper; 15 × 22 (38.1 × 55.9)
Signed lower left: *E Nourse '84*
Owner: Thomas Jones, Cincinnati, from 1981.

D–25
Sailboats in Sandusky
1884
Watercolor on paper; 13 × 10¾ (33 × 27.4)
Signed lower right: *E. Nourse Sandusky/ 1884*
Owner: Sara Ware, Covington, Ky.
Previous owners: H. Clay Meader II, Cincinnati; H. Clay Meader III, Cincinnati.

D–26
Landscape of Eastern Cincinnati
1885
Watercolor on paper; 15⅛ × 22⅝ (38.3 × 57.4)
Signed lower left: *E. Nourse/ 1885*
Owner: Cincinnati Art Museum, 1968.6.
Exhibition: Golden Age, 1979/80.

D–27
Woodland Scene
1885
Watercolor, crayon, and chalk on paper; 7 × 6 (17.5 × 15.2)
Signed lower right: *E. Nourse '85*
Owner: Private collection, Edgewood, Ky.
Previous owner: Midwestern Galleries, Cincinnati.

D–28
Erie Canal
1886
Watercolor on paper; 13 × 20 (33 × 50.8)
Signed lower right: *E. Nourse 1886*
Owner: Private collection, Park Hills, Ky., from 1946.

Previous owner: Mrs. John T. Boulton, Covington, Ky., 1926–46.

Mrs. Boulton, the previous owner, received a letter from EN in which she gave the work this title.

D–29
Convent of the Sisters of Notre Dame de Namur
by 1887
Work on paper
Signed lower right: *E. Nourse*
Unlocated
Reference: Scrapbook 1, p. 7 (print).

The illustration for this entry is a print of a drawing EN made of a convent building, now razed, in Reading, Ohio. EN's older sister Catherine, who took the name Sister Antoinette, was a member of the religious order that originally inhabited the building. Since Catherine died in 1885, the drawing probably was made by then and certainly before EN sailed for France in 1887, but the exact date of its execution is unknown.

D–30
New York Harbor
ca. 1887
Unlocated
Previous owner: Schmidt family, Cincinnati, in 1938.
Reference: Elliston, December 1938.

Elliston described this work as having three-masted schooners in the foreground, but does not indicate the medium.

D–31
Rocky Mountain Stream
by 1887
Watercolor; 18 × 26 (45.8 × 66)
Unlocated
Previous owner: Hotel Alms, Cincinnati, in 1926.
Reference: Scrapbook 2, p. 99 (clipping, Cincinnati newspaper, 1926).

The newspaper clipping gave the title and dimensions of this work at the time it disappeared from the lobby of the Hotel Alms in 1926.

D–32
Cathedral at Antwerp
ca. 1887
Watercolor
Unlocated
Exhibitions: CAM 1893, no. 76; Fischer 1894, no. 52.
Reference: Annotated Fischer 1894 (price, $75; marked "sold").

The illustration for this entry is a watercolor in H–6, a view of the cathedral at Antwerp painted by EN when she visited that city en route from New York to Paris, and may be the basis for this work.

D–33
Paris Roofs
ca. 1887–93
Unlocated
Exhibitions: CAM 1893, no. 39; Fischer 1894, no. 24.
Reference: Annotated CAM 1893 (price, $20).

D–34
La rue Chanoinesse
ca. 1889
Watercolor
Unlocated
Exhibition: New Salon 1890, no. 1131.

The subject is a narrow, winding street near the cathedral of Notre Dame on the Île de la Cité in Paris.

D–35
The Bargello, Florence
1890
Watercolor; 12 × 8 (30.5 × 20.3)
Signed lower left: *E. Nourse '90*
Owner: Midwestern Galleries, Cincinnati.

D–36
Assisi Gate
1890
Unlocated
Exhibitions: CAM 1893, no. 75; Fischer 1894, no. 51.
Reference: Annotated CAM 1893 (price, $20).

D–37
Assisi Roofs on a Rainy Day
1890
Unlocated
Exhibitions: CAM 1893, no. 40; Fischer 1894, no. 25.
Reference: Annotated CAM 1893 (price, $35).

D–38
Old Castle at Assisi
1890
Unlocated
Exhibition: CAM 1893, no. 73; Fischer 1894, no. 49.
Reference: Annotated CAM 1893 (price, $20).

D–39
Olive Trees
1890
Unlocated
Exhibitions: CAM 1893, no. 74;
Fischer 1894, no. 50.
Reference: Annotated CAM 1893
(price, $20).

D–40
Orchard at Grotta Ferrata
1890
Unlocated
Exhibitions: CAM 1893, no. 49;
Fischer 1894, no. 33.
Reference: Annotated CAM 1893
(price, $20).

D–41
Sketch on the Grand Canal, Venice
1891
Unlocated
Exhibitions: CAM 1893, no. 43;
Fischer 1894, no. 28.
Reference: Annotated Fischer 1894
(price, $75; marked "sold").

D–42
Venice
1891
Watercolor on paper; 12½ × 18 (31.6
× 45.7)
Signed lower right: *E. Nourse Venice*
Owner: Private collection, Stuart, Fla.
Previous owner: Edith Noonan Burt,
Cincinnati.

There are four sketches and three wa-
tercolors of Venice in H–10, all differ-
ent views than this work and D–43.
For information on the previous
owner, see comment, A–94.

D–43
Venice
1891
Watercolor
Signed lower right: *E. Nourse. Venice*
1891
Unlocated
Previous owner: Walter S. Schmidt,
Cincinnati, in 1941.
Exhibition: Closson 1941, no. 9.

See comment, D–42.

D–44
Borst, Southern Austria
1891
Unlocated
Exhibition: CAM 1893, no. 68.
Reference: Annotated CAM 1893
(price, $20).

D–45
The Dry Dock, Volendam
1892
Unlocated
Exhibition: CAM 1893, no. 45.
Reference: Annotated CAM 1893
(price, $25).

D–46
A Gray Day, Volendam
1892
Unlocated
Exhibitions: CAM 1893, no. 35;
Fischer 1894, no. 21.
Reference: Annotated CAM 1893
(price, $50).

D–47
Volendam, Holland
1892
Pencil and chalk on paper; 9¼ × 12¼
(23.5 × 31.1)
Signed lower left: *Vollendam* [sic] *Hol-*
land/ Elizabeth Nourse
Owner: College-Conservatory of Mu-
sic, University of Cincinnati, bequest
of Walter S. Schmidt, 1962.4.24.
Exhibitions: Closson 1941, no. 3; U.C.
1974, no. 21.
Reference: Scrapbook 1, p. 34 (photo
and note by LN).

LN noted that the house behind the
trees in this scene is the one in which
the Nourses and the Wachmans lived
during their stay in Volendam in 1892.
 For information on Walter S.
Schmidt's bequest to the owner, see
comment, A–60.

D–48
Windmill, Holland
1892
Unlocated
Previous owner: Mrs. Duhme, Cincin-
nati, in 1893.
Exhibition: CAM 1893, no. 44.
Reference: Annotated CAM 1893
(price, $35).

A drawing in H–11 may be the basis
for this work.

D–49
Cimetière arabe à Biskra
1897
Watercolor on paper; 14 × 20 (35.6 ×
50.8)
Signed lower right: *Biskra/ Elizabeth*
Nourse
Owner: Mary Louise Settle, Stockton,
Calif., from 1938.
Previous owner: Estate 1938.

See comment, C–108.

D–50
Une mosquée à Tunis
1897
Unlocated
Reference: Scrapbook 2, p. 68 (note by LN).

LN listed this work as a donation to a benefit for prisoners of war in June 1915 and marked it *500 francs.*

D–51
Les toits de Tunis (Terrasses de Tunis)
1897
Oil on canvas; 19 × 25 (48.3 × 63.5)
Signed lower left: *E. Nourse 1897 Tunis*
Owner: College-Conservatory of Music, University of Cincinnati, bequest of Walter S. Schmidt, 1962.4.2.
Exhibitions: New Salon 1904, no. 965; Orientalistes 1904; Nogent-sur-Marne, Colonial Exhibition, 1905; "Three Women Artists of Cincinnati; Elizabeth Nourse, Agnes Potter Lowrie, and Emma Mendenhall," Cincinnati Art Museum, April 30–May 11, 1969, no. 5; U.C. 1974, no. 7.
References: Scrapbook 1, p. 75 (French review of 1904 Orientalistes exhibition) and p. 78 (entries for 1905 Colonial Exhibition).

For information on Walter S. Schmidt's bequest to the owner, see comment, A–60.

D–52
Menton Cottage
1901
Watercolor and gouache on paper; 9 × 12 (22.5 × 30.5)
Signed on verso: *E. Nourse*
Owner: M. A. Burke, Cincinnati, from 1979.
Previous owner: J. Rawson Collins, Cincinnati.

D–53
View of Menton
1901
Unlocated
Previous owner: Mrs. Ida M. Hollaway, Cincinnati, in 1911.
Exhibition: Woman's Art Club of Cincinnati exhibition, 1911, loaned by Mrs. Ida M. Hollaway.

The previous owner, Ida M. Hollaway, was director of Miss Doherty's School in Cincinnati, a private school for girls that has now merged into the Seven Hills Schools. She was a member of the Woman's Art Club of Cincinnati.

D–54
View from the Rawson Villa, Menton
1901
Figure 51
Ink and wash on paper; 4½ × 7 (10.8 × 17.5)
Signed lower right: *Menton—/ E. Nourse 1901*
Owner: Nolan R. Humler, Louisville, Ky.
Previous owner: Helen Rawson, Menton, France.

EN visited Helen Rawson, the former owner, who attached a note to this sketch that describes the view from the west and south of the villa. Included are the bay, old town, pier, the long, low point of Cap Martin and the blue mountains behind. Miss Rawson wrote: "Elizabeth makes a sketch like this in a few minutes. It gives an idea of the coloring which cannot be seen in a photograph." For similar subjects, see C–121, C–122, and F–21.

D–55
La chapelle de la Madeleine, Finistère
1901
Oil on canvas; 22 × 22 (55.9 × 55.9)
Signed lower left: *E. Nourse 1901*
Owner: Mapel Knoll Village, Cincinnati.
Previous owner: Bodman Widows' and Old Men's Home, Cincinnati.
Exhibition: New Salon 1902.
Reference: Scrapbook 1, p. 72 (American review of 1902 New Salon).

The review praises the harmony of the yellow-stained walls with the touches of vivid blue and green in the canvas.

D–56
Alps
ca. 1903
Watercolor
Inscribed: *To Melrose*
Unlocated
Previous owners: Melrose Pitman, Cincinnati; Mrs. Charles Towsend, Cincinnati, in the 1960s.
Reference: EN Papers.

D–57
Dans le haut patûrage en Suisse
ca. 1903
Oil on canvas
Unlocated
Exhibition: New Salon 1905, no. 964.

D–58
Châlet suisse
1903
Watercolor on paper; 15¼ × 20 (38.8 × 50.8)
Signed lower right: *E. Nourse to/ Her niece Mary*
Inscribed lower left: *Our little Châlet on the "Dent du Midi"*
Owner: Private collection.
Previous owner: Mary Nourse, Fort Thomas, Ky., to 1959.

D–59 is a study for this watercolor. EN slightly altered the final composition and added rich colors of blue, yellow, and green with touches of deep red and purple.

D–59
Study for Châlet suisse
1904
Pencil on paper; 9 × 12 (22.5 × 30.5)
Signed lower right: *1904/ Elizabeth Nourse*
Owner: Cincinnati Historical Society, gift of Melrose Pitman.

EN vacationed in Champéry, a village south of Montreux, Switzerland, in 1903. This is a study for D–58.

D–60
Paysage. Petit chemin creux, Finistère
ca. 1904
Oil on canvas
Unlocated
Exhibition: New Salon 1904, no. 966.
Reference: Estate 1938, no. 966.

It is impossible to determine whether the work having this title listed in the inventory of EN's estate is this painting or a study for it.

D–61
Jardin du Luxembourg
ca. 1905
Oil on canvas
Unlocated
Exhibition: New Salon 1905, no. 954.

D–62 is a study for this work. Eleven other paintings (or studies) of the subject are known. The large window in EN's studio on the rue d'Assas faced the Luxembourg Gardens.

D–62
Jardin du Luxembourg, Etude
1905
Oil on canvas; 24 × 24 (61 × 61)
Signed lower right: *E. Nourse*
Owner: Private collection, Cincinnati, from 1950.
Previous owner: Estate 1938; Walter S. Schmidt, Cincinnati, 1938–50.
Exhibition: Closson 1941, no. 21.

This view of the Luxembourg Gardens in autumn is a study for D–61. The title *Jardin du Luxembourg, Etude* and *1905* are inscribed on the back of the painting.

D–63
Sur la bruyère
1905
Oil on canvas; 27⁹⁄₁₆ × 35½ (70 × 90)
Signed lower left: *A Cécile/ Sur le Bruyère/ E. Nourse/ '05*
Owner: Mme. Isabelle Decroisette, Vanves, France.
Previous owner: Mme. Cécile Léthias-Brochet, Saint Léger-en-Yvelines.

This is one of the few examples of a landscape that EN painted in oil rather than in watercolor. She painted it in Saint Léger and gave it to her friend there, Cécile Léthias. For information on the previous owner, see comments, C–116 and C–133.

D–64
Landscape (Street Scene)
ca. 1906
Watercolor on paper; 18 × 12½ (45.7 × 31.8)
Signed lower right: *Elizabeth Nourse*
Owner: Private collection, Cincinnati, from 1959.
Previous owner: Walter S. Schmidt, Cincinnati.

This may be a street scene in Spain or southern France, or a view taken from one of the buildings surrounding EN's studio in Paris on the rue d'Assas, as was D–62.

D–65
Le pont sur le torrent, Pyrénées
ca. 1906
Watercolor on paper; 13⅝ × 19¾ (34.7 × 50.3)
Signed lower right: *Elizabeth Nourse*
Owner: Mr. and Mrs. Walter S. Bunker, Cincinnati, from 1962.
Previous owner: Walter S. Schmidt, Cincinnati.
Exhibitions: New Salon 1909, no. 1546; Closson 1941, no. 18.

Le pont sur le torrent, Pyrénées is written on the back of this painting. The subject is painted in primary colors of deep blue and vivid green with touches of red and ochre.

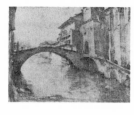

D–66
Le printemps sur la rivière, Basses Pyrénées
ca. 1906
Watercolor
Unlocated
Previous owner: Martha Rawson Bayley, Cincinnati, in 1910.
Exhibitions: New Salon 1907, no. 1547; Peinture 1908; CAM 1910, no. 109.
References: Caroline Lord, "Paintings by Elizabeth Nourse," Cincinnati newspaper, ca. May 1910 (illus.), in EN Papers; Scrapbook 1, p. 86 (note by LN); Archives (letter from LN in Paris to J. H. Gest in Cincinnati, March 1, 1910).

LN priced this work at $150 in the 1910 exhibition and noted that it was purchased by Martha Rawson. For information on the previous owner, see comment, C–121.

D–67
La vieille route de l'Espagne, Basses Pyrénées (The Old Spanish Road)
ca. 1906
Watercolor on paper; 17½ × 23½ (44.5 × 59.6)
Signed lower left: *Elizabeth Nourse*
Owner: Private collection.
Previous owner: Blanche Chapman Gamble, Watertown, N.Y.

The previous owner, Blanche Gamble, was the sister of Minerva Chapman (1858–1947), an artist friend of EN's in Paris who painted two miniature portraits of EN in 1910.
The old Spanish Road was a medieval pilgrimage route through southern France to Santiago de Compostela in Spain.

D–68
Le vieux pont, Saint Jean, Basses Pyrénées
ca. 1906
Watercolor
Unlocated
Exhibitions: New Salon 1907, no. 1548; CAM 1910, no. 110.
References: Lord 1910; Archives (letter from LN in Paris to J. H. Gest in Cincinnati, March 1, 1910).

In her letter to Gest, LN priced this work at $150.

The illustration for this entry is a sketch from H–15 of the fifteenth-century walled town of Saint Jean Pied-de-Port, which is north of Roncevaux on the pilgrimage road to Spain. Caroline Lord praised the watercolor for "the glow of sunshine warm upon the ancient walls that flank the stream."

D–69
Dans la forêt de Rambouillet: la vieille chaumière
ca. 1906
Oil on canvas
Unlocated
Exhibition: New Salon 1906, no. 939.

D–70 is a study for this painting.

D–70
La vieille chaumière
ca. 1906
Oil on paperboard; 23¾ × 28¾ (60.3 × 73)
Signed lower right: *Elizabeth Nourse*
Owner: Private collection.
Previous owners: Estate 1938, no. 54; Mary Nourse, Fort Thomas, Ky., 1938–59.

This is a study for D–69.

D–71
Les bateaux, Loguivy
ca. 1906
Watercolor on paper; 19 × 25 (48.2 × 63.5)
Signed lower right: *Elizabeth Nourse*
Owner: Schmidt family, Jacksonville, Fla.
Previous owner: Walter S. Schmidt, Cincinnati.
Exhibitions: New Salon 1907, no. 1546; Peinture 1908; PAFA Watercolor 1910, no. 915; CAM 1910, no. 106; CAM 1923, loaned by Walter S. Schmidt.
References: Lord 1910; Archives (letter from LN in Paris to J. H. Gest in Cincinnati, March 1, 1910).

LN wrote Gest that this work was priced at $200 for the 1910 exhibition. Caroline Lord described it in her review as an example of EN's ability to blend diversity of form and multiplicity of detail into a harmonious whole. Lord also noted EN's ability to portray the reflections of the boats as they were distorted in the translucent water. For a similar subject, see D–104.

D–72
Le paysage à Loguivy
ca. 1906
Figure 56
Watercolor on paper; 18½ × 25½ (47 × 64.9)
Signed lower right: *Elizabeth Nourse/ Loguivy*
Owner: Mr. and Mrs. Walter S. Bunker, Cincinnati, from 1962.
Previous owner: Estate 1938, no. 24; Walter S. Schmidt, Cincinnati, 1938–62.
Exhibition: New Salon 1919, no. 2219.

The fact that EN exhibited this 1906 work in the 1919 New Salon is evidence of how little she painted during World War I.

D–73
Le port, Loguivy
ca. 1906
Watercolor
Unlocated
Exhibition: New Salon 1909, no. 1548.

D–74
Le vieux calvaire, Loguivy
ca. 1906
Figure 57
Watercolor on paper; 17¼ × 24½ (43.9 × 61.6)
Signed lower left: *Elizabeth Nourse*
Owner: Private collection.
Previous owners: Estate 1938, no. 51; Clara Nourse Thompson, Fort Thomas, Ky., 1938–80.
Exhibition: New Salon 1909, no. 1547.

H–15 contains a charcoal study inscribed *Loguivy, 1906* and initialed *E.N.* that is the basis for this work.

D–75
La chapelle de Sainte-Christine
ca. 1907
Oil on canvas
Signed lower right: *Elizabeth Nourse*
Unlocated
Previous owner: Frederick A. Schmidt, Cincinnati, in 1910.
Exhibitions: New Salon 1908, no. 897; PAFA 1909, no. 149; CAM 1910, no. 108.
References: Lord 1910; Archives (letter from LN in Paris to J. H. Gest in Cincinnati, June 10, 1910).

LN wrote J. H. Gest, director of the Cincinnati Art Museum, that Frederick Schmidt had paid EN $200 and could therefore choose any picture he wanted from the 1910 Cincinnati museum exhibition.

In her 1910 review, Caroline Lord described this work as a scene of the interior of a poor church in Brittany with a number of gaudily colored sacred images ranged along the walls. She wrote of the "subdued lighting from two different directions, causing an intricacy of shadows . . . and then, the beautiful radiance of the dominating light from the window above the shrine, where the day literally shines through, so overpowering the other lights that the whole complexity of shadows, crude colors and odd assemblage of disconnected objects is reduced to a pleasing and harmonious whole."

D–76
La chapelle de Saint Guénolé
ca. 1908
Oil on canvas; 29 × 36 (73.7 × 91.5)
Signed lower right: *Elizabeth Nourse*
Owner: Ran Gallery, Cincinnati, from 1982.
Previous owner: Estate 1938, no. 6.
Exhibitions: New Salon 1909, no. 913; Nantes 1914; Paris, "Peintres d'Armor," Galerie de Goupil & Cie., 1919; Closson 1941, no. 25.

Gallery labels on the reverse indicate that this work was exhibited in Nantes. The title of the Paris exhibition, "Peintres d'Armor," refers to the ancient name of Brittany, "Armor," meaning "country of the sea," given to it by the Gauls in the sixth century B.C. The area became known as Little Britain following the invasion of the Celts in 460 A.D., and the name later became shortened to Brittany.

D–77
La chapelle Saint-Jean (Brittany)
ca. 1908
Watercolor
Unlocated
Exhibitions: New Salon 1909, no. 1544; PAFA Watercolor 1910, no. 129.

The chapel of Saint Jean, built at the end of the fifteenth century, is in Finistère, Brittany.

D–78
Place de l'église, Plougastel-Daoulas, Finistère
ca. 1908
Watercolor on paper mounted on paperboard; 18½ × 23 (27 × 58.5)
Signed lower right: *E. Nourse*
Owner: Private collection.
Previous owners: Estate 1938; Mary Nourse, Fort Thomas, Ky.

A label on the reverse gives the title.

D–79
Haute Alsace, Trücksess
1909
Watercolor
Unlocated
Exhibition: CAM 1926, no. 170.

D–80
Landscape with Willows, Trücksess
1909
Oil on canvas; 24 × 28½ (61 × 72.5)
Signed lower right: *E. Nourse*
Owner: Private collection.
Previous owners: Estate 1938; Mary Nourse, Fort Thomas, Ky., 1938–59.

The title and date of this work are written on the reverse. There is a charcoal and white chalk sketch for it in H–16.

D–81
The Old Farm House, Haute Alsace
1909
Oil on canvas; 22 × 23 (55.9 × 58.5)
Signed lower right: *E. Nourse*
Owner: University of Washington, Seattle, gift of Judge and Mrs. Thomas J. Burke, 1932.

Like D–67, this landscape depicts a country lane leading into the distance past white farm buildings. A color scheme of purple, mauve, and bright green indicates the sunset light in the Vosges mountains.
 For information about the Burkes' gift to the owner, see comment, A–78.

D–82
The Poppy Field
by 1910
Unlocated
Previous owner: R. M. Atwater, Helena, Mont., in 1910.
Reference: Wheeler 1910.

D–83
A Corner in a Brittany Church
by 1912
Watercolor
Unlocated
Previous owner: Frank M. Clark, Kalamazoo, in 1912.
Reference: *Kalamazoo Gazette,* April 21, 1912.

The former owner of this work also owned C–102.

D–84
L'étang
ca. 1912
Oil on canvas; 25¾ × 29¼ (65.4 × 74.3)
Signed lower left: *Elizabeth Nourse*
Owner: University of Iowa Museum of Art, gift of Dr. and Mrs. W. S. Davenport, 1933.8.
Exhibitions: New Salon 1912, no. 1014; Lodge 1913.
Reference: *New York Herald* (Paris), September 2, 1913.

D–85
Les saules
1912
Watercolor; 17½ × 22 (44.5 × 56)
Signed lower right: *Elizabeth Nourse*
Written on verso: *Les Saules, St. Léger en Yvelines 1912*
Owner: College-Conservatory of Music, University of Cincinnati, bequest of Walter S. Schmidt, 1962.4.11.
Exhibitions: Anglo-American 1914; U.C. 1974, no. 19.

EN exhibited two oils and four watercolors at the Anglo-American Exposition in London in 1914. Judging from the label on the reverse, this watercolor was probably one of the works selected by Joseph Pennell for the exhibition.
 For information on Walter S. Schmidt's bequest to the owner, see comment, A–60.

D–86
Le village de Saint Léger
1912
Figure 63 and page 155
Watercolor on paper; 17¼ × 21¾ (43.9 × 55.3)
Signed lower right: *Elizabeth Nourse*
Written on verso: *à St. Léger en Yvelines 1912*
Owner: Mr. and Mrs. W. Roger Fry, Cincinnati.
Previous owner: Estate 1938, no. 39; Walter S. Schmidt, Cincinnati, 1938–62.
Exhibition: New Salon 1914, no. 1568.

This work and D–87 are evidence that in 1912 and 1913 EN had begun experimenting with brighter colors and flat patterns in her landscapes as well as in her figure painting, such as B–119.

D–87
Jardin du Luxembourg, le printemps
ca. 1913
Oil on canvas; 29¾ × 24 (75.5 ×61)
Signed lower left: *E. Nourse*
Owner: Louise Settle Talley, Stockton, Calif., from 1975.
Previous owners: Estate 1938, no. 7; Mary Louise Settle, Stockton, Calif., 1938–75.
Exhibition: Bagatelle 1913.
Reference: Scrapbook 2, p. 45 (entries for 1913 Bagatelle exhibition).

This view of the Jardin du Luxembourg differs from others by EN in that it features a close view of the garden pavilion built around the turn of the century. See comment, D–61.

D–88
Jardin du Luxembourg, l'hiver
ca. 1913
Oil on canvas
Unlocated
Exhibition: Bagatelle 1913.
Reference: Scrapbook 2, p. 45 (entries for 1913 Bagatelle exhibition).

D–89 is probably a study for this work. See comment, D–61.

D–89
Study for Jardin du Luxembourg, l'hiver (Landscape in the Snow)
ca. 1913
Oil on paperboard; 23½ × 28½ (59.9 × 72.4)
Signed lower right: *E. Nourse*
Owner: College-Conservatory of Music, University of Cincinnati, bequest of Walter S. Schmidt, 1962.4.3.
Exhibitions: College 1941; U.C. 1974, no. 5.

This is probably a study for D–88. See comment, D–61. For information on Walter S. Schmidt's bequest to the owner, see comment, A–60.

D–90
Eglise, Barry
ca. 1915
Watercolor on paper; 6 × 9¼ (15.2 × 23.5)
Signed lower right: *Elizabeth Nourse*
Inscribed upper right: *Guerre de 1914 Bataille de la Marne/Eglise Barry—Bombardées par les Allemands/6–Septembre*
Owner: Private collection.
Previous owner: Edith Noonan Burt, Stuart, Fla.

For information on the former owner, see comment, A–94.

D–91
Environs de Meaux
1915
Watercolor on paper; 6½ × 9¾ (16.5 × 24.8)
Signed lower left: *Elizabeth Nourse Sept 1915*
Inscribed lower right: *Tombée des soldats morts au champs d'honneur une année après la bataille de la Marne*
Owner: Private collection, Cincinnati.

D–92
Senlis, Marne
1915
Watercolor
Unlocated
Previous owner: Mme. Dupont Dubost, Paris, in 1917.
Reference: Scrapbook 2, p. 72 (letter from the American Art Association in Paris to EN in Paris, April 12, 1917).

This watercolor was auctioned at a war benefit to aid French artists and their families.

D–93
War Memorial
1915
Watercolor on paper; 5¾ × 9¼ (14.6 × 23.5)
Signed lower right: *Elizabeth Nourse*
Inscribed upper right: *Varreddes— 1915—September— /Les tombes des soldats morts au champs d'honneur*
Owner: Mrs. Scott Adamson, Wayne, Pa.

D–94
La côte à Penmarc'h
ca. 1917
Watercolor; 21 × 14 (53.3 × 35.5)
Signed
Unlocated
Previous owners: Estate 1938, no. 49; Melrose Pitman, Cincinnati.
Reference: EN Papers (note by Melrose Pitman).

A drawing in colored chalks, inscribed *La côte à Penmarc'h*, is in H–17 and may be the basis for this work.

D–95
Jardin du Luxembourg, le printemps
ca. 1920
Watercolor on paper; 8 × 23¼ (20.2 × 59)
Signed lower right: *Elizabeth Nourse*
Owner: Schmidt family, Sacramento, Calif.
Previous owners: Estate 1938, no. 13; Walter S. Schmidt, Cincinnati, 1938–62.

See comment, D–61.

D–96
Jardin du Luxembourg in the Morning, Printemps
1920
Watercolor on paper; 11½ × 26 (29.3 × 66)
Signed lower right: *Elizabeth Nourse*
Inscribed on verso: *Jardin du Luxembourg/in the Morning/Printemps 1920*
Owner: Reeves family, Seattle, from 1950.
Previous owner: Nellie Nourse Reeves, Seattle, 1920–50.

This watercolor was a gift from EN to her niece. See comment, D–61.

D–97
Jardin du Luxembourg
1921
Figure 67
Watercolor on paper; 9¼ × 24 (23.5 × 61)
Signed lower right: *Elizabeth Nourse Luxembourg 1921*
Inscribed lower left: *For my darling Louise Hayden Addis*
Owner: Dr. and Mrs. Alan Manzler, Cincinnati.

This was probably a wedding gift for Louise Hayden, the subject of C–151, when she married her first husband, Emmet Addis. The work is filled with fresh light and the color of early spring. For information on Hayden, see note 202, p. 86.

D–98
Jardin du Luxembourg at Night
ca. 1921
Watercolor on paper; 10 × 29 (25.5 × 73.7)
Signed lower left center: *Elizabeth Nourse*
Owner: William Harrison Hunt, Marshall, Minn.
Previous owner: Elizabeth Stacey Hunt, Fort Thomas, Ky.

See comment, D–61.

D–99
Le Luxembourg, la nuit
ca. 1921
Charcoal and watercolor on paper; 9 × 24 (22.4 × 61)
Signed lower right: *Elizabeth Nourse/Le Luxembourg*
Owner: Dr. and Mrs. Thornton I. Boileau, Birmingham, Mich.

This view of the Luxembourg Gardens is as freely brushed as that of D–97 but with a range of dark, Fauve-like tones and contrasts. See comment, D–61.

232

D–100
Jardin du Luxembourg
ca. 1922
Watercolor
Unlocated
Previous owner: Charles E. Stratton, Boston, in 1922.
Reference: Scrapbook 2, p. 92 (letter from Charles E. Stratton in Boston to EN in Paris, May 29, 1922).

Mr. Stratton, who had apparently spent time in Paris, thanked EN in his letter for the gift of this painting, which, he said, "recalls delightfully the brave days when I was twenty-one." See comment, D–61.

D–101
Jardin du Luxembourg
ca. 1924
Oil on canvas
Unlocated
Previous owner: M. Boucheron, Paris, in 1924.
Reference: Scrapbook 2, p. 97 (note by LN).

See comment, D–61.

D–102
Le pont
1924
Oil on canvas; 20⅞ × 13 (53 × 33)
Signed lower right: *E. Nourse 1924*
Owner: Mme. Isabelle Decroisette, Vanves, France.
Previous owner: Mme. Cécile Léthias-Brochet, Saint Léger-en-Yvelines.

This was a gift from EN to her friends, the Léthias family, in Saint Léger.

D–103
Saint Bruno Villa
ca. 1929
Watercolor
Unlocated
Previous owner: Miss Margaret Woods, Saint Louis, Mo., in 1929.
Reference: Scrapbook 2, p. 103 (letter from Margaret Woods in Saint Louis to EN in Paris, July 1929).

This watercolor was a gift to Miss Woods, according to her letter of thanks to EN. The scene is of a villa in the garden of the Convent of Sion across the rue d'Assas from the artist's studio in Paris. D–105 also shows the convent garden.

D–104
Fishing Boats
Watercolor; 13 × 19 (33 × 48.2)
Signed and inscribed lower right: *Dear Walter Schmidt/from Elizabeth Nourse*
Owner: Schmidt family, Jacksonville, Fla., from 1962.
Previous owner: Walter S. Schmidt, Cincinnati.

This scene is possibly related to D–71.

D–105
Jardin du Couvent de Sion
Oil on board; 23½ × 23½ (59.7 × 59.7)
Signed lower right: *E. Nourse*
Owner: College-Conservatory of Music, University of Cincinnati, bequest of Walter S. Schmidt, 1962.4.4.
Exhibition: U.C. 1974, no. 4.

For information on Walter S. Schmidt's bequest to the owner, see comment, A–60.

D–103 also shows the convent garden.

E *Still Life, Birds, and Animals*

E–1
Autumn Leaves
1876
Unlocated
Exhibition: McMicken 1876, no. 69.

This, E–2, and E–3 were listed as "industrial designs" in the 1876 Mc-Micken exhibition catalogue.

E–2
Pansies, from nature
1876
Unlocated
Exhibition: McMicken 1876, no. 55.

See comment, E–1.

E–3
Watercolor panel
1876
Unlocated
Exhibition: McMicken 1876, no. 53.

See comment, E–1.

E–4
Antiquities, still life
1877
Drawing
Unlocated
Exhibition: McMicken 1877, no. 34.

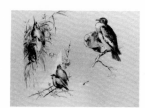

E–5
Birds, from nature
1877
Drawing
Unlocated
Exhibition: McMicken 1877, no. 31.

The illustration for this entry is one of several sketches of birds in H–4.

E–6
Flower-pot, from nature
1877
Drawing
Unlocated
Exhibition: McMicken 1877, no. 32.

E–7
Fruit
1877
Drawing
Unlocated
Exhibition: McMicken 1877, no. 30.

E–8
Grandfather's Story
1877
Unlocated
Exhibition: McMicken 1877, no. 41.
Reference: Scrapbook 1, p. 11 (clipping, unidentified Cincinnati newspaper, ca. 1877).

This was described in the 1877 newspaper article as "a picture as comical as it is 'realistic.' A railroad laborer threw away an old shoe, covered with mud. Miss Nourse picked it up, took it and a battered old tin lantern such as our grandfathers used to carry sixty years ago, added to these a bunch of old dead leaves, tied them all together and hung them on a nail and painted them just as they were."

E–9
Spinning Wheel
1877
Crayon on paper
Unlocated
Exhibition: McMicken 1877, no. 20.

E–10
The Studio
1877
Unlocated
Exhibition: McMicken 1877, no. 26.

E–11
Tapestry, still life
1877
Drawing
Unlocated
Exhibition: McMicken 1877, no. 33.

E–12
Chicken
1878
Drawing
Unlocated
Exhibition: McMicken 1878, no. 131.

E–13
Duck
1878
Ink on paper
Unlocated
Exhibition: McMicken 1878, no. 354.

E–14
Eagle
1878
Drawing
Unlocated
Exhibition: McMicken 1878, no. 132.

E–15
Morning Glories, from nature
1878
Ink on paper
Unlocated
Exhibition: McMicken 1878, no. 352.

E–16
Panels from the Organ
1878
Ink on paper
Unlocated
Exhibition: McMicken 1878, no. 421.

Many of EN's friends at McMicken participated in a project to adorn the organ at Music Hall in Cincinnati with decorative carvings for the hall's opening in 1878. The project was supervised by Benn Pitman and Henry Fry. This is probably a drawing that EN made of the carvings.

E–17
Rose
1878
Ink on paper
Unlocated
Exhibition: McMicken 1878, no. 353.

E–18
Scene on Eden Park
1878
Drawing
Unlocated
Exhibition: McMicken 1878, no. 464.

Eden Park in Cincinnati was developed after the Mount Adams "incline" (cable trolley) was built in 1875. The Cincinnati Art Museum building opened in Eden Park in 1886.

E–19
Scene on Mount Auburn
1878
Drawing
Unlocated
Exhibition: McMicken 1878, no. 463.

Mount Auburn was the first hillside suburb in Cincinnati to be connected to the city's center by "inclines" (cable trolleys). EN lived in Mount Auburn from 1873 to 1878.

E–20
Study from Armor
1878
Ink on paper
Unlocated
Exhibition: McMicken 1878, no. 355.

E–21
Study of a Drum
1878
Ink on paper
Unlocated
Exhibition: McMicken 1878, no. 356.

E–22
Study of a Hat
1878
Ink on paper
Unlocated
Exhibition: McMicken 1878, no. 357.

E–23
Study from nature
1878
Drawing
Unlocated
Exhibition: McMicken 1878, no. 465.

E–24
Flowers
1879
Watercolor
Unlocated
Exhibition: McMicken 1879, no. 488.

E–25
Quails
1879
Oil
Unlocated
Exhibition: McMicken 1879, no. 627.

E–26
Sketches from nature
1879
Ink on paper
Unlocated
Exhibition: McMicken 1879, no. 584.

E–27
Study, Cats
1879
Drawing
Unlocated
Exhibition: McMicken 1879, no. 31.

E–28
Study, Skeleton
1879
Drawing
Unlocated
Exhibition: McMicken 1879, no. 32.

E–29
Study, still life
1879
Watercolor
Unlocated
Exhibition: McMicken 1879, no. 494.

E–30
Illuminated panel
1880
Oil on wood
Unlocated
Exhibition: McMicken 1880, no. 2503.

This panel was a decoration for a cabinet bracket carved by EN's sister, Adelaide.

E–31
Original designs from illustrated works
1880
Drawing
Unlocated
Exhibition: McMicken 1880, no. 678.

E–32
Owls
1880
Watercolor
Unlocated
Exhibition: McMicken 1880, no. 2044.

The illustration for this entry is a series of sketches of owls that EN made on the back of 1878 bank deposit slips, now in the EN Papers. One or more of these sketches may have been the basis for this work.

E–33
The Pedlar's Story
1880
Drawing
Unlocated
Exhibition: McMicken 1880, no. 601 (awarded gold medal).

The concept of this drawing is probably similar to that of E–8.

E–34
China painting
1881
Watercolor on paper; 7 × 10 (17.8 × 25.5)
Owner: Cincinnati Historical Society, gift of Melrose Pitman.

This watercolor may show EN's designs for Rookwood blanks (EN's monogram has been found on at least one Rookwood vase). Although EN was never on the pottery's payroll, she probably decorated a few pieces, as Henry Farny and other Cincinnati artists did.

E–35
*"Decorative Pottery of Cincinnati"
Illustrations*
1881
Drawings
Unlocated
Reference: Mrs. Aaron F. Perry, "Decorative Pottery of Cincinnati," *Harper's New Monthly Magazine,* April 1881, pp. 840–41.

As president of the Woman's Art Museum Association of Cincinnati, Mrs. Aaron F. Perry wrote a history of ceramic decoration in Cincinnati for *Harper's*. EN illustrated this history with drawings of at least two vases, one made by her sister Adelaide and the other by Mrs. Jane Porter Dodd.

E–36
Cincinnati Carving in the Pitman House
1883
Drawings
Unlocated

The illustration for this entry shows an engraving of two drawings made by EN of decorative carving on objects in Benn Pitman's house, used by Pitman to publicize his views on home decoration. The engraving, now in the Benn Pitman Papers, Cincinnati Historical Society, is identified as an illustration for "Home Decoration" in *The Art Amateur.*

E–37
Daisies
ca. 1883
Gouache on paper; 18½ × 25½ (47 × 64.8)
Signed lower right: *E. Nourse*
Owner: Mr. and Mrs. Walter S. Bunker, Cincinnati.
Previous owner: Walter S. Schmidt, Cincinnati.

E–38
Field of Daisies
1883
Watercolor on paper; 19¼ × 25¼ (49 × 64.2)
Signed lower right: *E. Nourse/ '83*
Owner: Mrs. Robert Schmidt, Cincinnati, from 1960.
Previous owners: Mrs. James R. Murdoch, Cincinnati, to 1948; Florence Murdoch, Cincinnati, 1948–60.

E–39
Flock of Geese
ca. 1883
Oil on wood panel; 25⅞ × 55⅞ (65.8 × 142)
Owner: National Museum of American Art, Washington, D.C., gift of Laura Barney Dreyfus and Natalie Barney, 1952.13.89.
Previous owner: Alice Pike Barney, Washington, D.C.

This panel is one of the decorative commissions EN undertook in Cincinnati. The previous owner, artist Alice Pike Barney, took the panel with her when she left Cincinnati and for many years it hung over her mantel in Barney Studio House in Washington, D.C. Barney also commissioned E–60 and E–63. Another version, in a vertical format, was one of three panels painted by EN that were installed above the mantel in Benn Pitman's dining room. See E–40 and E–43 for other decorative panels by EN.

E–40
Marguerites
ca. 1883
Oil on wood panel; 17¼ × 12¼ (43.7 × 31.3)
Signed lower right: *E. N.*
Owner: Becker family, Cincinnati.
Previous owners: Benn Pitman, Cincinnati, 1883–1911; Melrose Pitman, Cincinnati; Marion Rombauer Becker, Cincinnati, to 1954.

This painting and E–42 are in carved frames formerly inset above a mantel in Benn Pitman's house overlooking what is now Columbia Parkway. The carved mantel was further embellished with facings of hammered copper and carved marble tiles. See E–39 for another decorative panel by EN.

E–41
Nasturtiums
1883
Watercolor and gouache on paper; 10 × 14 (25.5 × 35.5)
Signed lower right: *E. Nourse/ '83*
Owner: Connie Lockwood, Cincinnati.

E–42
Roses
1883
Gouache on paper; 16¼ × 11½ (41.3 × 29.2)
Signed lower right: *E. Nourse/ '83*
Owner: Lesley Lockwood Siani, Cincinnati.

237

E–43
Swallows
ca. 1883
Oil on wood panel; 17½ × 12¼ (44.4 × 31.3)
Signed lower left: *E. N.*
Owner: Becker family, Cincinnati.
Previous owners: Benn Pitman, Cincinnati, 1883–1911; Melrose Pitman, Cincinnati; Marion Rombauer Becker, Cincinnati, to 1954.

See comment, E–40. See E–39 and E–40 for other decorative panels by EN.

E–44
Vase of Pansies
ca. 1883
Watercolor on paper; 8½ × 10½ (21.5 × 26.7)
Signed lower right: *Elizabeth Nourse*
Owner: Schmidt family, Asheville, N.C.
Previous owner: Schmidt family, Cincinnati.

E–45
Vase of Pansies
ca. 1883
Watercolor on paper; 19 × 24 (48.5 × 61)
Owner: Art Museum of the Cincinnati Public Schools.
Previous owner: Woodward High School, Cincinnati.

E–46
Magnolias
ca. 1884
Watercolor on paper; 24½ × 18 (62.3 × 45.7)
Owner: Tweed Museum of Art, University of Minnesota, gift of Mr. and Mrs. Herbert Dancer, 1953.

E–47
Magnolia Branches
1884
Watercolor and gouache on paper mounted on paperboard; 19½ × 15½ (49.5 × 39.4)
Signed lower left: *E. Nourse/ '84*
Owner: Private collection, Cincinnati, from 1948.
Previous owner: Walter S. Schmidt, Cincinnati.

E–48
Nasturtiums
1884
Watercolor on paper; 12 × 19 (30.4 × 48.2)
Signed lower right: *E. Nourse/ '84*
Owner: Noonan family, Stuart, Fla.
Previous owner: Edith Noonan Burt, Stuart, Fla.

For information on the previous owner, see comment, A–94.

E–49
Dog
1886
Oil on canvas; 24 × 52 (61 × 132)
Signed lower right: *E. Nourse/1886*
Owner: L. C. Glass, Cincinnati, from 1978.
Previous owner: Ran Gallery, Cincinnati.

E–50
Apple Blossoms
by 1887
Watercolor and gouache on paper; 26 × 18 (66 × 46.8)
Signed lower left: *E. Nourse./With Love to/Mimi.*
Owner: Private collection, Cincinnati.
Previous owner: Mrs. Frederick A. Schmidt, Cincinnati.

EN gave this painting to her friend Mimi (Mrs. Frederick A.) Schmidt.

E–51
Autumn Flowers
by 1887
Oil on canvas; 33 × 24 (83.5 × 61)
Signed lower right: *Elizabeth Nourse*
Owner: Reeves family, Seattle.
Previous owner: Nellie Nourse Reeves, Seattle.

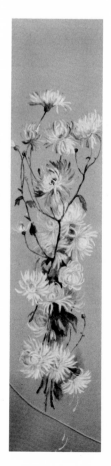

E–52
Chrysanthemums
by 1887
Watercolor on paper; 41½ × 9 (105.4 × 22.5)
Owner: Marian Thompson Deininger, Houston, from 1959.
Previous owner: Mary Nourse, Fort Thomas, Ky.

The long narrow format of this work is reminiscent of a Japanese scroll. It may date from 1882, a period during which EN was experimenting with oriental designs.

E–53
Hibiscus
by 1887
Watercolor on paper; 21½ × 17 (54.5
× 43.2)
Owner: Marian Thompson Deininger,
Houston, from 1959.
Previous owner: Mary Nourse, Fort
Thomas, Ky.

E–54
Hydrangeas
by 1887
Oil on canvas; 19 × 17 (48.3 × 43.2)
Signed lower right: *Elizabeth Nourse*
Owner: Reeves family, Seattle.
Previous owner: Nellie Nourse Reeves,
Seattle.

E–55
Lilacs, Paris
1888
Watercolor and tempera on paper; 20½
× 26 (54 × 66)
Signed lower left: *E. Nourse/Paris 1888*
Owner: John W. Fischer, Cincinnati.
Previous owner: Mrs. Cassily, Cincin-
nati, in 1893.
Exhibition: CAM 1893, no. 82.
Reference: Annotated CAM 1893
(price, $50).

E–56
Lilacs, Paris
ca. 1888
Watercolor
Unlocated
Previous owner: White, Cincinnati, in
1893.
Exhibition: CAM 1893, no. 83.
Reference: Annotated CAM 1893
(price, $50).

This work was probably about the
same size as E–55.

E–57
Spray of Lilacs
ca. 1888
Watercolor on paper; 18½ × 34½ (47
× 87.6)
Owner: Schmidt family, Asheville,
N.C.
Previous owner: Walter S. Schmidt,
Cincinnati.

E–58
Almond Blossoms, Rome
1890
Watercolor
Unlocated
Exhibitions: CAM 1893, no. 84;
Fischer 1894, no. 55.
Reference: Annotated Fischer 1894
(price, $20; marked "sold").

E–59
Lilacs, Rome
ca. 1891
Watercolor
Unlocated
Previous owner: Mrs. Rogers, Cincin-
nati, in 1893.
Exhibition: CAM 1893, no. 81.
Reference: Annotated CAM 1893
(price, $50).

E–60
Lilacs, Rome
1891
Opaque watercolor and watercolor on
paper mounted on paperboard; 38¼ ×
29⅜ (97.1 × 74.6)
Signed lower left: *E. Nourse 1891/Rome*
Owner: National Museum of Ameri-
can Art, Washington, D.C., gift of
Laura Barney Dreyfus and Natalie
Barney, 1952.13.90.
Previous owner: Alice Pike Barney,
Washington, D.C.
Reference: Delight Hall, *Catalogue of
the Alice Pike Barney Memorial Lending
Collection* (Washington, D.C.: National
Collection of Fine Arts, 1965).

This and E–63 are companion pieces
that were probably commissioned by
Alice Pike Barney, the previous
owner, who also commissioned E–39.

E–61
Lilies, Venice
1891
Watercolor
Unlocated
Exhibitions: CAM 1893, no. 87;
Fischer 1894, no. 58.
Reference: Annotated Fischer 1894
(price, $25; marked "sold").

E–62
Rhododendrons, Rome
1891
Watercolor
Unlocated
Exhibitions: CAM 1893, no. 85;
Fischer 1894, no. 56.
Reference: Annotated Fischer 1894
(price, $25; marked "sold").

E–63
Snowballs
1891
Opaque watercolor and watercolor on
paper mounted on paperboard; 38¼ ×
29⅜ (97.1 × 74.6)
Signed lower left: *E. Nourse/Rome '91*
Owner: National Museum of Ameri-
can Art, Washington, D.C., gift of
Laura Barney Dreyfus and Natalie
Barney, 1952.13.91.

Previous owner: Alice Pike Barney, Washington, D.C.
Reference: Delight Hall, *Catalogue of the Alice Pike Barney Memorial Lending Collection* (Washington, D.C.: National Collection of Fine Arts, 1965).

See comments, E–39 and E–60.

E–64
Apple Branches
1884–93
Gouache on paper; 19 × 24 (48 × 61)
Signed lower right: *E. Nourse*
Owner: Private collection, Boston, from 1982; promised gift to the Museum of Fine Arts, Boston.
Previous owners: Clifton Wheeler, Cincinnati; Jeffrey R. Brown Fine Arts gallery, North Amherst, Mass., 1979–82.

This gouache is undated but the careful draftsmanship and the fact that it is painted on brown paper relate it to EN's early work.

E–65
Bluets
ca. 1888–93
Watercolor
Unlocated
Previous owner: Gates, Cincinnati, in 1893.
Exhibition: CAM 1893, no. 89.
Reference: Annotated CAM 1893 (price, $20).

E–66
Field Flower
ca. 1888–93
Watercolor
Unlocated
Exhibitions: CAM 1893, no. 88; Fischer 1894, no. 59.
Reference: Annotated Fischer 1894 (price, $20; marked "sold").

E–67
Lavender Flowers
1888–93
Oil on canvas; 48¼ × 20½ (122.5 × 52)
Destroyed due to extensive damage.
Previous owner: National Museum of American Art, Washington, D.C., gift of Laura Barney Dreyfus and Natalie Barney, 1952.

This and E–68 were apparently companion pieces bought by Alice Pike Barney, who also owned E–39, E–60, and E–63.

E–68
Poppies
1888–93
Oil on canvas; 48½ × 20½ (122.5 × 52)
Destroyed due to extensive damage.
Previous owner: National Museum of American Art, Washington, D.C., gift of Laura Barney Dreyfus and Natalie Barney, 1952.

See comment, E–67.

E–69
Poppies, France
1888–93
Watercolor
Unlocated
Exhibitions: CAM 1893, no. 86; Fischer 1894, no. 57.
Reference: Annotated Fischer 1894 (price, $25; marked "sold").

E–70
Seven Owls
1898
Oil on unsized linen; 24 × 47½ (61 × 120.6)
Signed lower right: *E. Nourse '98*
Owner: Private collection, Cincinnati.
Previous owner: Mrs. Henry Rattermann, Jr., Cincinnati.

EN called her paintings on fabrics "tapestry paintings" and hung such decorative objects in her own home. E–71 is another example of this kind of work.

E–71
Night Scene with Owls
1903
Oil on unsized linen, in three sections: (a) 32 × 21 (81.2 × 53.3); (b) 32 × 30 (81.2 × 52); (c) 32 × 28½ (81.2 × 72.3)
Signed lower right (section c): *E. Nourse 1903*
Inscribed on verso (section b): *Then nightly sings the stariny* [sic] *Owl tuwhit-tuwhoo! Cin/Cin/Nati*
Owner: Cincinnati Art Museum, gift of Melrose Pitman, 1970.161.(a)(b)(c).
Reference: *Golden Age,* 1979/80, no. 223.

The fabric of this work has become very brittle and the tapestry painting is now cut into three pieces. The illustration for this entry is the central section (b). The inscription on the reverse of the central section is also inscribed on the back cover of H–9. E–70 is another example of EN's painting on fabric.

E–72
Wallflowers
by 1908
Unlocated
Reference: Scrapbook 1, p. 89 ("Work of Former Sandusky Artists Shown at Exhibit," Sandusky [Ohio] newspaper, ca. 1908).

The newspaper review described this as a painting of deep-red field flowers.

E–73
Azalea and Carafe
ca. 1910
Oil on canvas; 18¾ × 12¼ (73 × 58.7)
Signed on verso: *Elizabeth Nourse*
Owner: Stacey family, Cincinnati, from 1975.
Previous owners: Estate 1938; Elizabeth Nourse Stacey, Fort Thomas, Ky., 1938–61; Helen Stacey Hunt, Cincinnati, 1961–75.

E–74
Chrysanthemums
by 1910
Unlocated
Previous owner: Charles Whitely, Helena, Mont., in 1910.
Reference: Wheeler 1910.

E–75
Iris
by 1910
Unlocated
Previous owner: Mrs. H. W. Child, Helena, Mont., in 1910.
Reference: Wheeler 1910.

E–76
Etude, Fleurs
ca. 1911
Oil on canvas; 25½ × 25½ (64.7 × 64.7)
Signed lower right: *Elizabeth Nourse*
Owner: Edward Ryan, Cincinnati, from 1980.
Exhibition: New Salon 1911, no. 1015.

This is a picture of the still-life elements in B–119. E–78 is a study for this work.

E–77
Etude, Fruits
ca. 1911
Oil on canvas
Unlocated
Exhibition: New Salon 1911, no. 1016.

E–78
Le poisson doré (Study for Etude, Fleurs)
ca. 1911
Oil on canvas; 18 × 15 (45.7 × 38)
Signed lower right: *E. Nourse*
Owner: Stacey family, Maysville, Ky., from 1961.
Previous owners: Estate 1938, no. 34; Elizabeth Nourse Stacey, Fort Thomas, Ky., 1938–61.

This is a study for E–76.

E–79
Cover Design
1912
Drawing
Unlocated
Reference: *Loyola University Magazine* 12, no. 1 (November 1912).

This stylized design of intertwined trees in Art Nouveau style was drawn by EN for Austin Schmidt, S.J., son of EN's old friend, Mimi Schmidt, when he was editor of the Loyola University Press. See C–35.

E–80
Hydrangeas
by 1912
Watercolor on paper; 8 × 10⅝ (20 × 27)
Signed lower right: *E. Nourse*
Owner: Mme. Isabelle Decroisette, Vanves, France.
Previous owner: Mme. Cécile Léthias-Brochet, Saint Léger-en-Yvelines, France.

E–81
Etude, Fleurs
ca. 1913
Oil on canvas
Unlocated
Exhibitions: New Salon 1913, no. 966; Paris, Galerie Manuel Frères, 1920.
Reference: Scrapbook 2, p. 83 (entries for Galerie Manuel Frères exhibition, 1920).

LN noted that this painting was a study of roses.

E–82
Flower Study
ca. 1929
Watercolor on paper; 20 × 15 (50.8 × 38)
Signed lower right: *Elizabeth Nourse/ To dear Mary Louise/Paris 1929*
Owner: Mary Louis Settle, Stockton, Calif., from 1929.

This painting was a gift from EN to her niece, Mary Louise, during a visit by the latter in 1929 to her aunts in Paris.

F *Miscellaneous*

F–1
Diana and Stag
ca. 1876
Drawing
Unlocated
Exhibition: McMicken 1876, no. 44.

This, F–2, F–4, and F–5 are drawings of antique casts owned by the Mc-Micken School of Design.

F–2
Venus de Milo
1876
Drawing
Unlocated
Exhibition: McMicken 1876, no. 72.

See comment, F–1.

F–3
Copper-plate engravings
1877
Unlocated
Exhibition: McMicken 1877, no. 1.

EN became a member of the Cincinnati Etching Club in 1882.

F–4
Gladiator, antique
1877
Drawing
Unlocated
Exhibition: McMicken 1877, no. 5 (awarded honorable mention).

See comment, F–1.

F–5
Laocöon
1878
Drawing
Unlocated
Exhibition: McMicken 1877, no. 2 (awarded silver medal).

See comment, F–1.

F–6
Marguerite, from the Jewel Scene in Faust
ca. 1879
Crayon on paper
Unlocated
Exhibitions: McMicken 1879, no. 2; Detroit Art Loan, 1883, no. 1034a.

F–7
The Present
1879
Ink on paper
Unlocated
Exhibition: McMicken 1879, no. 586.

F–8
Sketches
1879
Watercolor
Unlocated
Exhibition: McMicken 1879, no. 489.

F–9
Sketches
1879
Watercolor
Unlocated
Exhibition: McMicken 1879, no. 490.

F–10
Study from life
1879
Oil
Unlocated
Exhibition: McMicken 1879, no. 626.

F–11
Ajax
1880
Drawing
Signed lower right: *E. Nourse*
Unlocated
Reference: *Beltrasco* (February 1880): 6 (illus.).

The illustration for this entry is an engraving of this unlocated drawing by EN. It shows two views of a bust (G–5) that EN carved in Louis Rebisso's sculpture class at McMicken. The reference, *Beltrasco,* was a periodical published monthly by the students of the University of Cincinnati.

F–12
Industry
1882
Oil
Unlocated
Exhibition: CIE 1882, no. 179.

F–13
Painted Decoration on Carved Hanging Cabinet
1883
Oil on metal
Unlocated
Exhibition: CIE 1883.
Reference: CIE 1883, p. 78.

EN painted these heads on gold discs to decorate a hanging cabinet carved by her sister, Louise. F–14 is another example of EN's decorations for furniture.

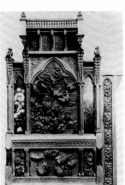

F–14
Painted Decoration on Carved Bedstead
1883
Figure 13
Oil on metal
Unlocated
Exhibition: CIE 1883.
Reference: CIE 1883, p. 80.

The two heads, *Morning* and *Night,* were painted on gold discs to decorate a mahogany bedstead carved by EN's twin, Adelaide. *Morning* is embellished with white azaleas and *Night* with balloon vines. F–13 is another example of EN's decorations for furniture.

F–15
Across the Meadow
1884
Watercolor
Unlocated
Exhibition: American Water Color Society, "Annual Exhibition Held at the National Academy of Design," New York, *American Watercolor Society Annual,* 1884, no. 85.

F–16
Down South
1884
Oil
Unlocated
Exhibition: CIE 1884, no. 167.

F–17
The Bellini Brothers
ca. 1887–93
Oil on canvas
Unlocated
Previous owner: Schmidt family, Cincinnati, in 1938.
Exhibition: CAM 1893, no. 27.
References: Annotated CAM 1893 (price, $100); Elliston, December 1938.

This is a copy after an unidentified painting by the Bellini brothers in the Louvre, probably made while EN was a student at the Académie Julian. It was identified in the CAM 1893 catalogue only as "The Bellini Brothers."

F–18
Marriage of the Virgin, after Lorenzo di Viterbo
ca. 1887–93
Oil on tapestry canvas
Unlocated
Exhibitions: CAM 1893, no. 96; Fischer 1894, no. 60.
Reference: Annotated CAM 1893 (price, $150).

F–19
Spring, after Botticelli
ca. 1887–93
Oil on tapestry canvas
Unlocated
Exhibitions: CAM 1893, no. 97;
Fischer 1894, no. 61.
Reference: Annotated CAM 1893
(price, $100).

F–20
Angel with Lute, after Raphael
by 1892
Oil on tapestry canvas
Unlocated
Previous owner: EN.
Reference: Scrapbook 1, p. 32 (C. G.
M., "Lizzie Nourse and Her Success in
Paris," Cincinnati newspaper, 1892).

The newspaper article described this
work and F–21, figures taken from Ra-
phael's painting *The Coronation of the
Virgin,* as hangings in EN's studio at
80, rue d'Assas. F–20 can be seen in
figure 37.

F–21
*Angel with Tambourine, after Ra-
phael*
by 1892
Oil on tapestry canvas
Unlocated
Previous owner: EN.
Reference: Scrapbook 1, p. 32 (C. G.
M., "Lizzie Nourse and Her Success in
Paris," Cincinnati newspaper, 1892).

See comment, F–20.

F–22
Dutch Milk Maid
1892
Ink and wash on paper; diameter: 3½
(9)
Inscribed lower left: *Miss Rawson*
Owner: J. Rawson Collins, Cincinnati.
Previous owner: Helen Rawson, Paris
and Menton.

This drawing, outlined and designed to
resemble a Delft plate, was sent to He-
len Rawson by EN. For information
on the previous owner, see comment,
D–54.

F–23
Disillusioned
by 1910
Watercolor
Unlocated
Previous owner: Mr. J. W. Cory, Hel-
ena, Mont., in 1910.
Reference: Wheeler 1910.

F–24
Madonna
by 1910
Painting on tapestry canvas
Unlocated
Previous owner: Sidney M. B. Young,
Helena, Mont., in 1910.
Reference: Wheeler 1910.

F–25
Madonna, after Botticelli
by 1910
Painting on tapestry canvas
Unlocated
Previous owner: Mrs. Peter Larson,
Helena, Mont., in 1910.
Reference: Wheeler 1910.

F–26
*Adoration of the Magi, after Gentile
da Fabriano*
by 1912
Cartoon for a tapestry
Unlocated
Reference: Anderson Galleries (New
York), *Sale of the Collection of the V.
G. Fischer Art Company, Inc.,* February
1912, no. 903.

This, F–27, F–28, and F–29 were car-
toons for tapestry work included in the
Fischer Art Gallery's sale at the time
that EN's dealer, V. G. Fischer, went
out of business in 1912. Mr. Fischer
commissioned the four cartoons and
probably had EN paint them on a can-
vas with a larger mesh designed for
needlework. All four were exhibited in
ebony frames.

F–27
La Fortezza, after Botticelli
by 1912
Cartoon for a tapestry
Unlocated
Reference: Anderson Galleries (New
York), *Sale of the Collection of the V.
G. Fischer Art Company, Inc.,* February
1912, no. 904.

See comment, F–26.

F–28
Madonna with Infant, after Botticelli
by 1912
Cartoon for a tapestry
Unlocated
Reference: Anderson Galleries (New
York), *Sale of the Collection of the V.
G. Fischer Art Company, Inc.,* February
1912, no. 904.

See comment, F–26.

F–29
Marriage of the Virgin, after Lorenzo di Viterbo
by 1912
Cartoon for a tapestry
Unlocated
Reference: Anderson Galleries (New York), *Sale of the Collection of the V. G. Fischer Art Company, Inc.,* February 1912, no. 902.

See comment, F–26.

F–30
Breton Doll
ca. 1915–20
Wire and papier-mâché; 12¼ × 5 × 4½ (31.1 × 12.7 × 11.4)
Signed on back of base: *Elizabeth Nourse*
Owner: Private collection, Richmond, Ky., from 1921.
Reference: Scrapbook 2, pp. 70, 73 (reviews of expositions des Jouets Français in 1915, 1916, and 1917).

This was a gift from EN to the owner, who visited her in Paris in 1921. The illustration for this entry shows similar dolls of the type that EN made and costumed for three toy exhibitions held in Paris during World War I. Other exhibitors were ten women and four men who were colleagues of EN's at the New Salon. In an effort to raise money for war charities, the 1916 entries were exhibited in Chicago and Southampton (Long Island), and in the New York City studio of Janet Scudder, a sculptor who had been trained at the Cincinnati Art Academy and whom EN probably knew in Paris, where Scudder also worked.

F–31
Saint Bernardin, Conf.
ca. 1918
Watercolor and charcoal on paper; 24 × 17 (61 × 43.2)
Signed lower right: *Elizabeth Nourse/ Penmarc'h—*
Owner: College-Conservatory of Music, University of Cincinnati, bequest of Walter S. Schmidt, 1962.4.22.
Exhibition: U.C. 1974, no. 15.
Reference: EN Papers (typescript of lecture by Walter S. Schmidt at the College-Conservatory of Music, University of Cincinnati, December 1955).

In his lecture, Schmidt stated that this and eight other paintings of saints left in EN's estate were studies for oil paintings commissioned by the French government. The subjects are statues

in an ancient Breton church in Penmarc'h that the government wished to have recorded because many ancient artifacts had been destroyed in Brittany during World War I. The title for this work refers to Saint Bernardin as a *conférencier,* or religious speaker. The other paintings are entitled *La Charité; Sainte Marthe; Sainte Anne; Sainte Claire; Saint Eutro; Sainte Barbe; DNB Nouvell;* and *Pietá.*

For information on Walter S. Schmidt's bequest to the owner, see comment, A–60.

Undated

F–32
"899"
Oil; 24½ × 28½ (62.2 × 72.4)
Unlocated
Previous owner: University of Washington, Seattle, gift of Judge and Mrs. Thomas J. Burke, 1932.
Reference: Inventory 1932, no. 899.

Although the measurements and medium of this work are listed in the 1932 Inventory, the subject is unknown.

For information on the Burkes' gift to the former owner, see comment, A–78.

F–33
Study of Two Cats
Oil on unsized linen; 27 × 23 (68.6 × 58.4)
Signed lower left: *E. Nourse/after/Steinlen*
Owner: Cincinnati Art Museum, gift of Melrose Pitman, 1970.162.
Reference: *Golden Age,* 1979/80, no. 230.

This is after a work by Théophile Alexandre Steinlen (1859–1923), a well-known painter and illustrator in Paris.

F–34
Moses in the Bulrushes
Painting on tapestry canvas
Unlocated
Previous owner: Schmidt family, Cincinnati, in 1938.
Reference: Elliston, December 1938.

245

G Sculpture

G–1
Carved Bracket
1876
Wood, carved
Unlocated
Exhibition: McMicken 1876, no. 23.

This bracket was made by EN in the carving class taught by Benn Pitman at McMicken. The course was so popular (particularly with women) that there were 249 entries of carvings in the annual student exhibition in 1877.

G–2
Bust of Miss Hosea
1877
Unlocated
Previous owner: Judge and Mrs. Lewis Hosea, Cincinnati, in 1918.
Reference: Scrapbook 2, p. 70 ("A Notable Social Event," Cincinnati newspaper, April 1918).

The former owners, the Hoseas, were old family friends of the Nourses. They held a benefit in their home in 1918 to raise money for EN's war work. This bust and several watercolors painted by EN were in their home at the time of the benefit.

G–3
Group of Blackberries
1879
Unlocated
Exhibition: McMicken 1879, no. 11.

This was probably a plaster made during EN's first year of study in sculpture with Louis Rebisso at McMicken.

G–4
Hand, from Silenus
1879
Unlocated
Exhibition: McMicken 1879, no. 12.

A copy of one of the antique casts at McMicken, this was probably a plaster.

G–5
Ajax
1880
Unlocated
Exhibition: McMicken 1880, no. 2122.
Reference: *Beltrasco* (May 1880): 3 (illus.).

An engraving of a drawing of this sculpture by EN (F–11) was reproduced in *Beltrasco,* a periodical published by the students of the University of Cincinnati.

G–6
Bust of Mary Noonan
1880
Figure 7
Unlocated
Reference: Scrapbook 1, p. 10 (photo).

Mary Noonan, the subject, was EN's cousin. She lived in Covington, Ky.

G–7
Bust of Caleb Nourse
ca. 1881
Plaster; 3¼ × 7 × 3¼ (8 × 17.8 × 8)
Signed on back: *Elizabeth Nourse*
Inscribed on front: *Caleb E. Nourse*
Owner: Private collection.
Previous owner: Melrose Pitman, Cincinnati.
Exhibition: McMicken 1881, no. 620.
Reference: *American Art Review* 2, no. 8 (June 1881): 135.

The *American Art Review*'s report on the 1881 McMicken exhibition stated that some heads in clay and terra cotta modeled from life by EN and Caroline Lord were considered by general consent to be noteworthy entries. See C–2 for a portrait of Caleb Nourse.

G–8
Relief, from life
1881
Unlocated
Exhibition: McMicken 1881, no. 620.

This relief was made in the second-year sculpture class at McMicken with EN and Caroline Lord the only two daytime students. The following year (1882) Laura Fry, a skilled wood-carver who later worked as a decorator at the Rookwood Pottery, joined them.

G–9
The Broken Pitcher
ca. 1882
Unlocated
Previous owner: Mrs. Thomas J. Emery, Cincinnati, in 1882.
Exhibitions: McMicken 1882, no. 919; CIE 1882, no. 461, loaned by Mrs. Thomas J. Emery.

G–10
Louise Nourse
1899
Plaster bas-relief; diameter: 5 (12.7)
Bronze cast; diameter: 5 (12.7)
Incised at top: *Louise by Elizabeth Nourse '99*
Owner: Mary Louise Settle, Stockton, Calif., from 1938.
Previous owner: Estate 1938.

247

This bas-relief was cast in bronze by a Mr. Frey.

G–11
Le Père et la Mère Léthias
1899
Plaster bas-relief; diameter: 7¼ (18.4)
Incised left center: *E. Nourse '99*
Incised upper right: *Le Pere et la Mère Lethias*
Owner: Mr. and Mrs. Walter S. Bunker, Cincinnati.
Previous owners: Estate 1938; Walter S. Schmidt, Cincinnati.

This bas-relief is marked *second cast by Valsnanni.* The first cast is owned by the Léthias family in Vanves, France.

G–12
Madonna and Child
1926
Clay sculpture: 12 × 8 × 3 (30.5 × 20.4 × 7.6), on base 2 × 8½ × 3½ (5.1 × 21.5 × 8.9).
Incised on front of base: *Elizabeth Nourse/19[?]6*
Owner: Jule Laughlin, Cincinnati.
Reference: LN in Paris to Mary Nourse in Fort Thomas, Ky., June 13, 1926.

In her letter to her niece LN described this statue and G–13 as being made of a clay from Moulena that became hard as stone when exposed to the air. This sculpture was described by LN in her letter as holding a book in its hand.

G–13
Notre Dame de la Bonne Nouvelle
1926
Clay sculpture; approx. 36 inches high (91.4)
Unlocated
Reference: LN in Paris to Mary Nourse in Fort Thomas, Ky., June 13, 1926.

See comment, G–12.

Undated

G–14
Crucifix
Plaster; 19¼ × 9½ (48.9 × 24.2)
Owner: Private collection.
Previous owner: Estate 1938.

This crucifix may be a copy made by EN or an earlier work by an unidentified French artist.

G–15
Hanging cabinet
Wood carving; 10 × 27½ × 8¾ (50.8
× 69.8 × 22.3)
Incised on left: *E. N.*
Incised on right: *L. N.*
Owner: Stacey family, Cincinnati,
from 1975.
Previous owners: Estate 1938; Eliza-
beth Nourse Stacey, Fort Thomas,
Ky., 1938–61; Helen Stacey Hunt,
Cincinnati, 1961–75.

This cabinet was carved by EN and
LN to use in their Paris apartment. It
shows a scene of the Annunciation
carved in high relief in which the angel
appears to Mary, who is in an aedic-
ula.

H Sketchbooks

H–1

Sketchbook 1 (1874–1885)
Fifty-one pages plus one inserted sheet
Works on paper; each 6 × 12 (15.2 × 30.4)
Inscribed on cover: *1874–1885/Tennessee Mountains*
Owner: Private collection, Cincinnati.

The sketchbook contains forty-six pencil drawings, one ink sketch (C–22, illus.), four watercolors, and one loose watercolor inserted opposite the back cover. All works are on gray paper. Subjects include Tennessee mountain scenes and figure studies, drawings of Austin Schmidt and Emerson Pitman as infants, studies for the portrait of Laura and Natalie Barney (C–32, illus.), sketches of members of the Nourse family, and a watercolor of a sailboat that may have been painted in Sandusky in 1882 (inserted).

H–2

Sketchbook 2 (January 1882)
Thirty-four pages
Works on paper; each 7 × 10 (17.7 × 25.5)
Inscribed on cover: *January, 1882*
Owner: Cincinnati Historical Society, gift of Melrose Pitman.

The sketchbook contains thirty watercolor studies and four charcoal sketches, all on gray paper. The subjects are mainly scenes and figure studies from EN's trip to Sandusky, Ohio, in the summer of 1882.

H–3

Sketchbook 3 (by 1887)
Eighteen pages
Works on paper; each 9 × 12 (22.8 × 30.4)
Inscribed on cover: *Before Going Abroad*
Owner: Cincinnati Historical Society, gift of Melrose Pitman.

The sketchbook contains black-and-white watercolor studies of birds and flowers with the exception of one watercolor and two charcoal sketches of Tennessee scenes. All works are on gray paper.

H–4

Sketchbook 4 (1882–1885)
Forty-one pages
Works on paper; each 10 × 14 (25.5 × 35.5)
Inscribed on cover: *1882–1885/ Mt. Vernon/ Cincinnati/ Montreal/ Quebec/ Emerson Pit[man] Walter [Schmidt]/ Tennessee Mts.*
Owner: Private collection, Cincinnati.

All sketches are charcoal heightened with white chalk except for eight watercolor studies, of which two are inscribed *Mount Vernon* and two are inscribed *Oakland*. All works are on gray paper. Subjects include Mount Vernon; Oakland; sketches of Emerson Pitman and Walter Schmidt as infants; and scenes and figure studies from Cincinnati, Montreal, Quebec, Niagara Falls, and Tennessee (B–10, illus.). Also included are drawings of Mimi Schmidt; Charles Curran (EN's classmate at McMicken); Mr. Caesar, one of the Nourse family's landlords (C–39, illus.); and studies of birds and animals (E–5, illus.).

H–5

Sketchbook 5 (1885–1886)
Fifty-four pages
Works on paper; each 9 × 12 (22.8 × 30.4)
Inscribed on cover: *1885–1886/ Cincinnati/ Mt. Nebo—Tennessee/ Mountains*
Owner: Private collection, Cincinnati.

Except for two watercolors of Mount Nebo, Tennessee, all works are charcoal, often heightened with white chalk, on gray paper. Subjects include animal and figure studies, scenes of Cincinnati, portrait sketches of Luella Perkins and Mary Nourse, and landscape and figure studies made in Tennessee (fig. 2). Inside the front cover is a drawing of a little girl asleep signed and inscribed *L. C. Lutz/ Pine Mountain, Tenn/ 1886*. It was drawn by Lewis Cass Lutz (1855–1893), a Cincinnati friend of EN's who studied at McMicken from 1875 to 1878 and began teaching there in 1877, the year before he graduated.

H–6

Sketchbook 6 (1887)
Forty-eight pages
Works on paper; each 10 × 13 (25.5 × 33)
Inscribed on cover: 1887 *Enroute to Paris/Steamer/Antwerp/Paris/Villa des Dames*
Owner: Private collection, Cincinnati.

Except for three watercolors that include a view of a cathedral at Antwerp (D–32, illus.), all sketches are charcoal, often heightened with white chalk, on gray paper. Subjects include scenes of life on board the *Westernland* and sketches of Antwerp, Ghent, Bruges, Paris, Saint Germain-en-Laye, and the Villa des Dames where EN and LN lived when they first arrived in France.

The sketchbook also includes sketches and figure studies that EN made at the Académie Julian (fig. 18).

H–7
Sketchbook 7 (May–October 1888)
Sixty-three pages
Works on paper; each 9¼ × 12½ (23.5 × 31.8)
Inscribed on cover: *1888—May to/October/Paris & Barbizon*
Owner: Private collection, Cincinnati.

Except for four watercolor sketches made in Barbizon, all works are charcoal, often heightened with chalk, on gray paper. Sketches one through ten were drawn in Paris. The remaining fifty-three, which include the four watercolor studies, were made in Barbizon and include drawings of Millet's house, and scenes and figure studies drawn in Barbizon (fig. 22), Chailly, Milly, and Fleury (B–17, illus.).

H–8
Sketchbook 8 (December 1888–May 1889)
Forty-four pages
Works on paper; each 9½ × 12½ (24.2 × 31.8)
Inscribed on cover: *1888–1889 Dec. to May/Russia*
Owner: Private collection, Cincinnati.

The first three sketches, made in Paris, include a portrait study of Alice Pike Barney (fig. 13) and are drawn in charcoal heightened with chalk on gray paper. These are followed by twenty-three sketches made during EN's trip to Russia, of which twenty-two are charcoal, often heightened with chalk, on gray paper (B–27, illus.; B–107, illus.), and one is a watercolor. The remaining drawings are all charcoal and chalk on paper. With the exception of one sketch of the Luxembourg Gardens dated April 21, 1889, all were made in Barbizon (fig. 24 and study for B–16).

H–9
Sketchbook 9 (1889–1890)
Sixty-four pages
Works on paper; each 9½ × 12½ (24.2 × 31.8)
Inscribed on cover: *1889—Paris/Lille/ Auvers/Etaples/Le Portel/1890—Italy*
Owner: Private collection, Cincinnati.

The sketchbook contains forty-one charcoal and chalk drawings and one watercolor sketch of Le Portel made in France. There are also twenty-two

charcoal and chalk drawings made in Italy. Inscriptions on the French sketches include *Reubens' Presentation in the Temple; Mons; Auvers; the second stage of the Eiffel Tower; Etaples* (study for A–6); *Le Portel* (B–24, illus., study for B–26); *Camiers; Boulogne; Equihen; Avignon; Tarascon; Arles;* and *Marseilles.* Inscriptions on the Italian sketches include *Genoa; Livorno; Naples; Pompeii; Sorrento; Capri; Rome; Grotta Ferrata; Tivoli; Assisi;* and *Florence.* All works are on gray paper.

On the back cover of the sketchbook is the inscription *Then nightly sings the staring Owl Tuwhit-tuwhoo! Cin/Cin/ Nati,* which also is inscribed on the reverse of the central section of E–71.

H–10
Sketchbook 10 (1890–1891)
Sixty pages
Works on paper; each 9¼ × 12½ (23.5 × 31.8)
Inscribed on cover: *1890. Italie/Florence/1891—Borst— Austria/ & Nurenburg*
Owner: Private collection, Cincinnati.

The sketchbook contains forty-three charcoal and chalk drawings, including studies for B–37, C–53, C–54 (illus.), C–55 (illus.), and C–62, as well as two watercolors painted in Venice as studies for D–42 during EN's trip to Italy. The Italian sketches are inscribed *Sistine Chapel; Florence; Pisa; Borgo Mazzano; San Gimignano; Siena; Venice; Chiggia;* and *Assisi* (studies for B–29, B–32). There are eight sketches in charcoal and chalk inscribed *Borst,* which include studies for A–11, B–39, and B–42, and two charcoal and chalk drawings made in Nuremberg, two along the Rhine river (one of which was the basis for A–13), one marked: *Le Portel,* one showing Laura Wachman in Volendam costume, and three studies for A–9 on a single sheet. All works are on gray paper.

H–11
Sketchbook 11 (1892–1894)
Forty-six pages
Works on paper; each 9⅝ × 12½ (24.5 × 31.8)
Inscribed on cover: *1892—Holland/ 1893—America U.S.A./1894—St. Gildas—/(Brittany)/Concarneau/Pont-Aven*
Owner: Private collection, Cincinnati.

EN made twenty-two sketches during her trip to Holland, including studies for A–14, B–43, B–47, and D–48. Of

these drawings, some are inscribed *Volendam; Maarken* (C–74, illus.); *Laaren* (C–72, illus.); and *Huizen.*

EN made four sketches on board the *S.S. Amsterdam* during her return voyage to New York in 1893; three sketches of her niece, Melrose Pitman, when she returned to Cincinnati; and a study for A–18. The remaining sixteen drawings were made in Brittany in 1894 and include a study for B–61. Some of these are inscribed *Saint Gildas; Locmariaquer; Quimper; Concarneau;* and *Pont-Aven.*

All sketches are charcoal and chalk on tan paper.

H–12
Sketchbook 12 (1895–1896)
Fifty pages plus four inserted sheets
Works on paper; each 9½ × 12¾ (23.5 × 32.4); inserted sheets range from 8 to 12¼ × 4½ to 12¾ (20.3 to 31 × 11.5 to 32.3)
Inscribed on cover: *1895. Brittany, St. Gildas./1897—La Tunisie./1896—Paris*
Owner: Private collection, Cincinnati.

The sketchbook contains fifty pages of sketches and four loose sheets, which have been inserted, all with drawings in charcoal and chalk on tan paper. Of these, twenty-one sketches were made in Africa and are inscribed *Tunis* (including studies for A–35 and A–36); *Keirouan; Boussa; Carthage; Sousa;* and *Algeria* (B–68, illus.; B–69, illus.). The remaining twenty-nine drawings were done in Saint Gildas and Paris, and include studies for A–21, A–24, A–26, B–53, B–59, B–70 (fig. 43), and B–71. There are a few detailed drawings, but in general this sketchbook marked the beginning of a freer approach to draftsmanship by EN and most of her preliminary studies are reduced to a few bold outlines that capture only the poses of the models.

H–13
Sketchbook 13 (1897–1899)
Sixty-three pages plus four inserted sheets
Works on paper; each 7½ × 10 (19 × 25.5); inserted sheets are approximately 7¼ × 10¼ (18.4 × 26)
Inscribed on cover: *1897 St. Léger-en-Yvelines/ 1896/ 1896 St. Léger/ '97/ '98/ '99*
Owner: Private collection, Cincinnati.

The sketchbook contains sixty-three charcoal and chalk drawings on tan paper. Four drawings in charcoal and chalk on green paper are inserted, in-

cluding a study for B–119. At this time EN began making many sketches for individual paintings; there are four sketches for A–29, one for A–30, four for A–37, over thirteen for A–39, four for A–41, and four for A–42.

H–14
Sketchbook 14 (1899–1902)
Forty-eight pages plus five inserted sheets
Works on paper; each 9¼ × 12¼ (23.5 × 31.2); inserted sheets range from 6⅛ to 8⅝ × 6 to 12 (15.5 to 21.9 × 15.2 to 30.4)
Inscribed on cover: *1899. St. Léger-en-Yvelines/1900/'01 Penmarc'h/'02 Finistère*
Owner: Private collection, Cincinnati.

The sketchbook contains forty-eight drawings in charcoal and chalk on gray paper. Five loose sheets of charcoal and chalk drawings in various sizes on tan paper have been inserted, including three studies for A–79. About half the sketches were done in Saint Léger, including a study for A–49 (illus.),and the rest were made in Penmarc'h, including studies for A–48 (one sketch), B–73 (three sketches), C–119 (two sketches), and C–123 (one sketch). There are three studies for A–45 and three studies for B–72 as well.

H–15
Sketchbook 15 (1906–1908)
Fifty-nine pages
Works on paper; each 9¼ × 12¼ (23.5 × 31.2)
Inscribed on cover: *1906 Basses Pyré-nées/ St. Jean Pied-de-Port./ 1906 Fall at Loguivy./ 1907 Plougastel/ 1908—Plou-gastel—Brittany/ St. Michel*
Owner: Private collection, Cincinnati.

The sketchbook contains eighteen sketches of landscapes of Saint Jean Pied-de-Port (D–68, illus.), Fuentara-bia, Burgos, and Toledo. The remaining forty-one drawings were made in Brittany. Some are inscribed: *Plougas-tel; Camaret; Ouessand; Folgöet; Goul-ven; Rumengol; Châteaulin; Pleyben; Pontivy; St. Theozonnec; St. Guénolé; Mont Saint Michel;* and *Loguivy* (D–74). The sketchbook includes studies of paintings of Plougastel such as A–73, B–108, B–109 (illus.), B–129 (illus.), and C–142 (illus.).

EN noted her palette on the cover of the sketchbook.

H–16
Sketchbook 16 (1909)
Thirty-one pages plus one inserted sheet
Works on paper; each 7¾ × 10½ (19.6 × 26.7); inserted sheet 9⅝ × 12¼ (24.5 × 31.2)
Inscribed on cover: *1909 Paris/ Alsace-Loraine* [sic]/ *"Oberelsass"*
Owner: Private collection, Cincinnati.

The sketchbook contains charcoal drawings on gray paper, often height-ened with colored chalk. One oversize sketch in charcoal and chalk on brown paper has been inserted (study for B–119). The drawings include landscapes inscribed *Haute Alsace; Drei Exen;* and *Voklinshofen,* made during EN's visit to the Trücksess (see study for D–80). The sketchbook also includes many sketches for figural compositions, among them studies for A–83 (A–84 and A–85, illus.), A–86, A–96, A–102, A–105, B–118 (illus.), and B–120. EN often drew two or more sketches on the same page.

H–17
Sketchbook 17 (1912–1920)
Twenty-seven pages plus five inserted sheets
Works on paper; each 12⅜ × 9½ (31.5 × 24.2); inserted sheets range from 10 to 11⅞ × 8 to 9½ (25.4 to 30.1 × 20.3 to 24.1)
Inscribed on cover: *1912—Paris. (1st Communion) 1916/1917 Penmarc'h/ 1918 Brittany/ 1915 & 1916. Senlis. (War S.)/ 1919 Paris/ 1920*
Owner: Private collection, Cincinnati.

This sketchbook contains twenty-five charcoal drawings, often heightened with colored chalk, and two watercol-ors on gray paper. There are five in-serted sheets, of which three are very detailed watercolor sketches on gray paper of frogs and flowers that appear to have been painted at a much earlier date. However, a number of charcoal and colored chalk studies of landscapes dated 1916 and 1919 are much more detailed than most of the sketches EN made after 1892. These include draw-ings inscribed *Penmarc'h* (study for D–94); *Loc-Tudy; St. Guénolé; Ploueour; Arras; Albert;* and *Senlis.*

The sketchbook also contains six studies for A–108 and a two-page study for B–125.

H–18
Sketchbook 18 (1900–1918)
Ten pages
Works on paper; each 7¾ × 10½ (19.6 × 26.7)
Inscribed on cover: *Odd Sketches*
Owner: Private collection, Cincinnati.

The sketchbook contains ten charcoal and colored chalk drawings on white paper, all of figure studies, including preliminary sketches for A–64, A–17, and A–80. Inscribed on the inside of the front cover are the following names and dates: *1900—1901—1902: Penmarc'h; 1902—1903: St. Léger; 1904—1905: Suisse; 1906—Loguivy l'été/Sept & Oct.; 1906—Winter—Basses Pyrénées/Jan. Feb. Mar. Avril.; 1907—1908—Plougastel; 1909: Haute Alsace; 1910: St. Léger.; 1911–1912—1913—1914: Paris; 1915: Paris; 1916—1917—1918: Penmarc'h.* Judging from the number of places listed, the sketch-book once contained more drawings than it presently contains.

Bibliography

Books and Catalogues are arranged alphabetically. Interviews, Newspapers, and Periodicals are arranged chronologically. Unpublished sources are arranged alphabetically by city in which the material is deposited. References to Scrapbook 1 (1880 to 1911) and Scrapbook 2 (1911 to 1932) pertain to scrapbooks maintained by Louise Nourse containing newspaper clippings, photographs of paintings, and notes by Louise about the exhibition and sales of her sister's work.

Books

American Art Annual. 1898, 1903–14, 1915–38. Editions for 1898 through 1918 ed. Florence N. Leavy. Editions for 1919 through 1938 published by American Federation of Arts.

Anderson, Emma Mendenhall. *Elizabeth Nourse: A Sketch.* Cincinnati: Privately printed, 1922.

Austerlitz, E. H. *Cincinnati from 1800 to 1875.* Cincinnati: Bloch and Co., 1975.

Beaux, Cecilia. *Background with Figures: Autobiography of Cecilia Beaux.* Boston and New York: Houghton Mifflin Co., 1930.

Boime, Albert. *Thomas Couture and the Eclectic Vision.* New Haven and London: Yale University Press, 1980.

Bryant, Linda Munson. *American Pictures and Their Painters.* New York: John Lane, 1917.

City of Cincinnati. City Directories. Cincinnati: City of Cincinnati, 1859–89.

City of Washington. City Directories. Washington, D.C.: City of Washington, 1909–15.

Clark, Edna Maria. *Ohio Art and Artists* (pp. 196–200). Richmond, Va.: Garrett and Massie, 1932.

Clement, Clara Erskine. *Women in the Fine Arts from the Seventh Century B.C. to the Twentieth Century A.D.* New York: Hacker, 1974.

Dictionnaire des églises de France, Belgique, Luxembourg, Suisse. Paris: R. Laffont, 1966–71.

Ford, Henry A. and Mrs. Kate B. *History of Cincinnati, Ohio.* Cleveland: L. A. Williams and Co., 1881.

Goss, Charles F. *Cincinnati: The Queen City, 1788–1912.* Vol. 2. Cincinnati: F. J. Clarke, 1912.

Graves, Algernon. *Dictionary of Artists Who Have Exhibited in the Principal London Exhibitions from 1760 to 1893.* 3d ed. New York: Burt Franklin, 1970.

——————. *The Royal Academy of Arts, 1769–1904.* Vol. 1. New York: Lenox Hill, 1972.

Helias, Pierre-Jakez. *The Horse of Pride: Life in a Breton Village.* New Haven: Yale University Press, 1978.

Howe, Henry. *Historical Collections of Ohio.* Vol. 1. Cincinnati: C. J. Krehbiel and Co., 1888.

International Auction Records (p. 38). Paris: Editions Mayer, 1978.

Kenny, D. J. *Illustrated Guide to Cincinnati and the World's Columbian Exposition.* Cincinnati: Robert Clarke and Co., 1893.

Landgren, Marchal E. *Years of Art: The Story of the Art Students League of New York.* New York: Robert M. McBride and Co., 1940.

Pitman, Benn. *A Plea for an American Decorative Art, with Illustrations and Designs.* Cincinnati Souvenir for the Cotton States and International Exposition, Atlanta, Georgia, 1895. Privately printed. On file in Benn Pitman Papers, Library of the Cincinnati Art Museum.

Simon, Linda. *The Biography of Alice B. Toklas.* New York: Doubleday, 1977.

Stranahan, Clara H. *A History of French Painting.* New York: Scribner's, 1888.

Washington, D.C. Artists Born Before 1900: A Biographical Dictionary. Washington, D.C.: Virgil E. McMahan, 1976.

Waters, Mrs. Clara Erskine Clement. *Women in the Fine Arts.* Boston: Houghton, Mifflin Co., 1904.

Catalogues

Exhibitions and Museum Collections

American Water Color Society (New York). *Annual Exhibition Held at the National Academy of Design.* 1883, 1884, 1886, 1911. On microfiche in Library of the National Museum of American Art/National Portrait Gallery, Smithsonian Institution, Washington, D.C.

Anglo-American Exposition (London). *Illustrated Catalogue of the American Fine Art Section of the Anglo-American Exposition.* 1914. On file in Library of Congress, Washington, D.C.

The Art Club of Philadelphia. *Annual Exhibition of Oil Paintings and Sculpture.* 1891, 1892. On file in Library of Congress, Washington, D.C.

The Art Institute of Chicago. Annual exhibitions of American art. 1895, 1898, 1901, 1904–6, 1908–13.

——————. *Annual Exhibition of Water Colors, Pastels, and Miniatures.* 1912. Exhibition held May 7–June 5, 1912.

——————. *Catalogue of Objects in the Museum.* 1896, 1932.

——————. *Half a Century of American Art.* 1939. Exhibition held November 16, 1939–January 7, 1940.

The Butler Institute of American Art (Youngstown, Ohio). *Catalogue of the Permanent Collection of American Art.* 1951.

Cincinnati Art Museum. *Art Palace of the West: A Centennial Tribute, 1881–1981.* 1981. Exhibition held March 2–August 30, 1981.

——————. Annual exhibitions of works by American artists. 1897, 1898, 1907, 1910, 1912, 1913, 1921, 1923, 1925, 1926.

——————. *Catalogue of the Work of Elizabeth Nourse.* 1893. Exhibition held November 25–December 9, 1893.

——————. *Cincinnati Artists of the Past.* 1942. Exhibition held January–April 1942.

_____. *Fiftieth Anniversary Exhibition of Work by Teachers and Former Students of the Art Academy of Cincinnati.* 1937. Exhibition held November 27, 1937–January 2, 1938.

_____. *The Golden Age: Cincinnati Painters of the Nineteenth Century Represented in the Cincinnati Art Museum.* 1979. Exhibition held October 6, 1979–January 13, 1980.

_____. *The Ladies, God Bless 'Em: The Women's Art Movement in Cincinnati in the Nineteenth Century.* 1979. Exhibition held February 19–April 18, 1979. The chronology of this catalogue gives an excellent account of the role of Cincinnati women in the arts from 1869 to 1895.

_____. *Portraits of Present-Day Cincinnatians.* 1933. Exhibition held February 3–March 5, 1933.

_____. *Retrospective Exhibition of Sculpture by Clement J. Barnhorn.* 1934. Exhibition held January 16–February 11, 1934.

_____. *Three Women Artists of Cincinnati: Elizabeth Nourse, Agnes Potter Lowrie, Emma Mendenhall.* 1969. Exhibition held April 30–May 11, 1969.

_____. *The Work of Thomas S. Noble.* 1907. Exhibition held October 19–November 10, 1907.

City of Cincinnati. *Official Illustrated Catalogue of the Art Department of the Cincinnati Industrial Exhibition.* 1879, 1881–84, 1886. On file in Cincinnati Art Museum and Cincinnati Public Library.

Cleveland Museum of Art. Weisberg, Gabriel P. *The Realist Tradition: French Painting and Drawing, 1830–1900.* 1980. Exhibition held November 12, 1980–January 18, 1981.

Closson Gallery (Cincinnati). *Retrospective Exhibition of Oils, Pastels, Drawings, and Water Colors by Elizabeth Nourse.* 1941. Exhibition held June 2–14, 1941. On file in Elizabeth Nourse Papers, Cincinnati Historical Society.

College of Music (now College-Conservatory of Music of the University of Cincinnati). *Exhibition of Elizabeth Nourse Paintings in the Pine Room.* 1941. Exhibition opened June 1941. On file in Cincinnati Historical Society.

_____. *Paintings of Elizabeth Nourse.* 1941. Exhibition opened October 12, 1941. On file in Cincinnati Historical Society.

Columbus Gallery of Fine Arts. *Painters of the Past.* 1942. Exhibition held March 20–April 12, 1942.

Copenhagen International Exposition. *Catalogue of the International Exposition.* 1897. English-language edition on file in Library of Congress, Washington, D.C.

Corcoran Gallery of Art (Washington, D.C.). *Exhibition of Oil Paintings by Contemporary American Artists.* 1907, 1910/11, 1912/13.

Dayton Art Institute (Ohio). Quick, Michael. *American Expatriate Painters of the Late Nineteenth Century.* 1976. Exhibition held December 1976–January 1977.

Detroit Art Loan (Michigan). *Catalogue of the Detroit Art Loan.* 1883. On file in Library of Congress, Washington, D.C.

Ecole des Beaux-Arts (Paris). *Exposition des Acquisitions du Gouvernement Français.* 1910. Exhibition opened December 1910. On file in Library of Congress, Washington, D.C.

Exposizione Internationale (Rome). *Catalogo del Dipartimiento di Bellas Artes.* 1911. On file in Library of Congress, Washington, D.C.

Galerie Brunner (Paris). *Exposition des Quelques.* 1912. Exhibition held January 4–15, 1912, by a group of twenty-seven women artists in Paris. Title page of catalogue in Scrapbook 2, p. 13.

Goupil Galerie (Paris). *Les Peintres d'Armor* (Bretagne-Vendee). 1919. Exhibition held April 1919. Reviews and invitation to the opening of the exhibition in Scrapbook 2, p. 77.

Indian Hill Historical Museum Association (Cincinnati). *The Golden Era of Art*. 1978. Exhibition held June 1978.

Kenneth Lux Gallery (New York City). *Recent Acquisitions in American Paintings*. 1980. Exhibition held October 14–November 18, 1980; Nourse entry no. 2.

Kentucky Historical Society (Frankfurt, Ky.). *Pageant of the Bluegrass*. 1977. Nourse entry no. 83.

Louisiana Purchase Exposition (Saint Louis). *Catalogue of the Art Department*. 1904. Exhibition held April 20–December 1, 1904. On file in Saint Louis Public Library.

Musée du Luxembourg (Paris). *Exposition des Artistes de l'Ecole Américain au Luxembourg*. 1919. Exhibition held October–November 1919. On file in Library of Congress, Washington, D.C.

Museum of Art, Carnegie Institute (Pittsburgh). Annual exhibitions of international art. 1897/98, 1900/1901, 1901/02, 1904/05, 1908, 1909, 1914, 1923.

National Academy of Design (New York). *Catalogue of the Annual Exhibition*. 1894. Exhibition held April 2–May 12, 1894. On file in Library of the National Museum of American Art/National Portrait Gallery, Smithsonian Institution, Washington, D.C.

National Collection of Fine Arts (now National Museum of American Art, Smithsonian Institution, Washington, D.C.). Delight Hall. *Catalogue of the Alice Pike Barney Memorial Lending Collection*. 1965.

——————. McClelland, Donald R. *Where Shadows Live: Alice Pike Barney and Her Friends*. 1978. Exhibition held January 20–May 21, 1978.

The Newark Museum. Gerdts, William H. *Women Artists of America, 1707–1964*. 1965. Exhibition held April 2–May 16, 1965.

Notre Dame University (Indiana). Gerrer, Dom Gregory, O.S.B. *Catalogue of the Wightman Memorial Art Gallery*. University of Notre Dame, vol. 29, no. 3, 1934.

Panama-Pacific International Exposition (San Francisco). *Catalogue Deluxe of the Department of Fine Arts*. 1915. On file in Library of Congress, Washington, D.C.

Paris International Exposition. *Catalogue of the Department of Fine Arts in Painting*. 1900. English-language edition on file in Library of Congress, Washington, D.C.

Pennsylvania Academy of The Fine Arts (Philadelphia). Annual exhibitions of American art. 1895/96, 1896/97, 1898–1906, 1908, 1909, 1911, 1913, 1914. On file in Library of Congress, Washington, D.C.

——————. Annual Philadelphia watercolor exhibitions. 1907, 1909, 1910, 1912. On file in Library of Congress, Washington, D.C.

Saint Louis Expositions. *Annual St. Louis Exposition and Music Hall Association*. 1895, 1896. On file in Library of Congress, Washington, D.C.

Société Artistique de Picardie (Le Touquet, France). *Société Artistique de Picardie*. 1913. On file in Archives of American Art, Smithsonian Institution, Washington, D.C.

Société Nationale des Artistes Français (Paris). Catalogues of annual Salons. 1888, 1889. A complete set of these catalogues, or reproductions of them, are on file in the Library of The Metropolitan Museum of Art, New York City.

Société Nationale des Beaux-Arts (Paris). Catalogues of annual Salons. 1890–1923. A complete set of these catalogues, or reproductions of them, are on file in the Library of The Metropolitan Museum of Art, New York City.

Society of Washington Artists (Washington, D.C.). *Loan Exhibition*. 1897.

Exhibition held November 20–30, 1897. On file in Library of Congress, Washington, D.C.

Tennessee Centennial Exposition (Nashville). *Catalogue of the Department of Fine Arts*. 1897. On file in Library of Congress, Washington, D.C.

The Toledo Museum of Art (Ohio). *Fiftieth Anniversary Exhibition of Contemporary Oil Paintings Acquired by the Toledo Museum of Art*. 1901–51.

University of Cincinnati. Annual exhibitions of the School of Design (formerly McMicken School of Design). 1875–82. The catalogues are illustrated.

──────────. *The Paintings of Elizabeth Nourse*. 1974. Exhibition held May 1974.

University of Maryland Art Gallery. (College Park, Md.) Landgren, Marchal E. *American Pupils of Thomas Couture*. 1970. Exhibition held March 19–April 26, 1970.

V. G. Fischer Art Gallery (Washington, D.C.). *Catalogue of the Work of Elizabeth Nourse*. 1894. Exhibition held February 5–17, 1894.

Walker Art Gallery (Liverpool). *Autumn Exhibition of Modern Art*. 1909/10. On file in Library of Congress, Washington, D.C.

Woman's Art Club of Cincinnati. Annual exhibitions. 1893–96, 1898, 1899, 1901, 1902, 1906, 1909, 1911, 1913. On file in Cincinnati Historical Society.

Woman's Art Club of New York. Annual exhibitions. 1894, 1902, 1904, 1905, 1911. On file in Library of Congress, Washington, D.C.

World's Columbian Exposition (Chicago). *Catalogue of the Department of Fine Arts*. 1893. On file in Library of Congress, Washington, D.C.

Sales

Anderson Galleries (New York City). *Catalogue of the Sale of the Collection of V. G. Fischer Art Company, Inc.* (Washington, D.C.). February 1912. On file in Library of Congress, Washington, D.C.

Estate Sale of Admiral Harold Lawrence (Saco, Maine). 1980. Catalogue numbers 240 and 185. In possession of Mary Alice Heekin Burke, Cincinnati.

Kende Galleries (New York City). *Kende Galleries at Gimbel Brothers Sale*. January 10, 1947 (catalogue 267, no. 249) and January 24, 1947 (catalogue 269, no. 269). On file in Library of the National Museum of American Art/ National Portrait Gallery, Smithsonian Institution, Washington, D.C., and in Smith College Museum of Art, Northampton, Mass.

Parke-Bernet Galleries (New York City). *Estate Sale of Albert E. McVitty*. 1949. Catalogue number 79.

Sotheby, Parke Bernet and Company (London). *Sotheby, Parke Bernet & Co. Sale*. February 6, 1980. Catalogue number 95.

Interviews

Mary Alice Heekin Burke. With Agnes Fay, Cincinnati artist. July 9, 1979. Mrs. Fay and her husband, William E. Fay, a student of Frank Duveneck's, visited the Nourses in Paris in June 1925.

──────────. With Mary Louise Stacey Settle, Stockton, California, great-niece of Elizabeth Nourse. August 16, 1980. Mrs. Settle corresponded with Elizabeth and Louise Nourse and visited them in Paris in 1929.

──────────. With Mrs. Frederick Stern, Cincinnati. 1980. Mrs. Stern and Louise Wachman Strauss, also of Cincinnati, took the latter's aunts, Henriette and Laura Wachman (close friends of Elizabeth and Laura Nourse's), from Rome to Paris about 1928 and visited the Nourses at that time.

_____. With Florence Burnam Lackey, Richmond, Ky., a relation of the Nourse sisters through their Noonan cousins. April 30, 1980. Mrs. Burnam visited the Nourses in Paris in 1921.

_____. With John D. Wachman, Cincinnati, nephew of Henriette and Laura Wachman. July 2, 1979. Wachman studied in Germany and often visited his aunts in Rome. While visiting them he met their (and the Nourse sisters') close friends, Mary and Helen Rawson.

_____. With Ernst S. Howard, Cincinnati. June 1980. Howard is the great-grandson of Dr. Elmira Howard, whose portrait Elizabeth Nourse painted in 1894.

_____. With Mrs. Robert A. Cline. August 1, 1979. Mrs. Cline is a cousin of Frederick Clasgens's, a Cincinnati sculptor and friend in Paris of Elizabeth Nourse's.

Newspapers

"The First Prize." Clipping from unidentified newspaper, 1873, in Scrapbook 1, p. 132. Discusses the awarding of a medal to Louise Nourse as prize scholar in two Cincinnati high schools.

Clipping from unidentified Cincinnati newspaper, ca. 1877, in Scrapbook 1, p. 11. Review of the 1877 student exhibition at the School of Design (formerly McMicken School of Design), University of Cincinnati.

"The Late Caleb E. Nourse." Clipping from unidentified Cincinnati newspaper, April 1880, in Scrapbook 1, p. 3.

"Art in Decoration: A Cincinnati Lady's Description of the New York Union League Club Rooms." Clipping from unidentified Cincinnati newspaper, 1882, in Scrapbook 1, p. 11.

"Letter from Paris: Art Student Life in Paris." Clipping from unidentified Cincinnati newspaper, 1887, in Scrapbook 1, p. 11. Extracts from a letter written by Elizabeth Nourse in Paris to Adelaide Pitman in Cincinnati, date unknown.

"Artist Life in Fontainebleau." Clipping from unidentified Cincinnati newspaper, 1888, in Scrapbook 1, pp. 18–20. Extracts from a letter written by Louise Nourse in Barbizon to Adelaide Pitman in Cincinnati, June 8, 1888.

"Letter from Paris: Art Student in Russian Poland." Clipping from unidentified Cincinnati newspaper, 1888, in Scrapbook 1, p. 22. Extracts of a letter written by Elizabeth Nourse in Alexandria (enroute to Ukraine) to Adelaide Pitman in Cincinnati.

Sherard, R. H. "Clever Italian Studies by Miss Nourse." *New York Morning Journal*, March 8, 1891.

C.G.M. [probably Charlotte Gibson Miller]. "Lizzie Nourse and Her Success in Paris." Clipping from unidentified Cincinnati newspaper, 1892, in Scrapbook 1, pp. 32–33.

"The Work of Elizabeth Nourse: A Cincinnati Woman Whose Life is an Example of Strong Influence." *Cincinnati Tribune*, August 23, 1892.

"Obituary: Mrs. Benn Pitman." Clipping from unidentified Cincinnati newspaper, September 1893, in Scrapbook 1, p. 3.

"The Social World: A Grand Reception in Honor of Miss Nourse." Clipping from unidentified Cincinnati newspaper, ca. late November 1893, in Scrapbook 1, pp. 36–37.

Carter. "The High Art Exhibit: Miss Nourse's Pictures at the Museum." *Cincinnati Times-Star*, December 8, 1893.

"Miss Elizabeth Nourse Who Carried Off the Honors at the World's Fair." *Cincinnati Enquirer*, ca. 1893. Clipping in Scrapbook 1, p. 38.

Lord, Caroline. "Miss Nourse's Work." Clipping from unidentified Cincinnati newspaper, 1893, in Scrapbook 1, p. 36. Review of 1893 exhibition at the Cincinnati Art Museum.

"From Living Models Does Miss Elizabeth Nourse Paint Her Life-Like Pictures." Clipping from unidentified Washington, D.C., newspaper, 1894, in Scrapbook 1, p. 41.

Mann, Parker. "A Talented Painter." Clipping from unidentified Washington, D.C., newspaper, 1894, in Scrapbook 1, p. 42.

"Miss Nourse's Success." Clipping from unidentified Washington, D.C., newspaper, February 21, 1894, in Scrapbook 1, p. 42.

Newport, E. E. "In a Private Gallery: Mr. Mendonça's Collection." Clipping from unidentified Washington, D.C., newspaper, ca. 1894, in Scrapbook 1, pp. 41–42.

Medora. "Art and Artists in Paris." *Cincinnati Tribune*, July 18, 1895. Clipping in Scrapbook 1, p. 47.

"Award of Art Prizes." Clipping from unidentified Nashville, Tenn., newspaper, May 26, 1897, in Scrapbook 1, p. 55. Mentions silver medal awarded to *The Reading Lesson*.

Chicago Inter-Ocean, July 7, 1897. Clipping in Scrapbook 1, p. 43. An article containing biographical information about Elizabeth Nourse and a discussion of Mrs. Charles E. Culver's gift of Nourse's painting *Le goûter* (under title *Mother and Children*) to The Art Institute of Chicago.

"Emerson Pitman Funeral." Clipping from unidentified Cincinnati newspaper, 1900, in Scrapbook 1, p. 4.

Review of 1901 Salon. Clipping from unidentified French newspaper, 1901. Discusses Elizabeth Nourse's *Retour du travail, St. Léger* and *Dans l'écurie à Saint Léger*.

Schmidt, Anna Seaton. "Elizabeth Nourse: The Work of an Eminent Artist in France." *Boston Evening Transcript* [July 12, 1902]. Clipping in Scrapbook 1, p. 49.

"Art Notes." *Chicago Sunday Record Herald*, September 18, 1902.

"Le bain by Elizabeth Nourse." *Chicago Sunday Record Herald*, September 28, 1902.

Eon, Henri. "Société Nationale Salon de 1903." *Paris Siécle*, April 23, 1903.

Clipping from unidentified French newspaper, 1904, in Scrapbook 1, p. 75. Review of 1904 exposition of Société des Orientalistes in Paris.

Alexandre, Arsène. "Les orientalistes." *Figaro*. February 22, 1904.

Clipping from unidentified French newspaper, August 1904, in Scrapbook 1, p. 75. Describes Elizabeth Nourse's *Paysage. Petit chemin creux, Finistère*.

"Benn Pitman." *Cincinnati Sunday Commercial Tribune*, ca. 1905, in Scrapbook 1, pp. 125–26.

"Les femmes artistes." *Paris Echo*, 1905. Discusses fourteenth annual exhibition of "Les femmes artistes" at Galerie Georges Petit, where Elizabeth Nourse showed her *Dans l'ombre à Penmarc'h*.

"La Vie artistique." Clipping from unidentified French newspaper, 1906, in Scrapbook 1, p. 78. Review of 1906 exposition of Société des Orientalistes with a description of Elizabeth Nourse's *Le steppe*.

"Painting is in Decay." Clipping from unidentified newspaper, 1906, in Scrapbook 1, p. 77. Review of 1906 Salon with criticism of Elizabeth Nourse's *La dentellière*.

"Exhibitions Tastefully Organized in a Studio of the New Building Occupied by Holy Trinity Lodge." Clipping from unidentified English-language newspaper published in Paris, 1907, in Scrapbook 1, p. 81.

"La Tombola en Faveur des Veuves et Enfante d'Artistes." Clipping from unidentified French newspaper, ca. 1907, in Scrapbook 1, p. 81. Mentions Elizabeth Nourse's donation of a wood engraving, *La jeune mère*, at a benefit raffle for widows and orphans of French artists held at the Salon des Abonnés, Paris.

"The Morning Bath by Elizabeth Nourse." *Los Angeles Sunday Times*, May 3, 1908.

"Work of Former Sandusky Artists Shown at Exhibit." Clipping from unidentified Sandusky (Ohio) newspaper, ca. 1908, in Scrapbook 1, p. 89.

"A Great American Artist's Work." *New York Herald* (Paris), February 9, 1910. Clipping in Scrapbook 1, p. 99.

"Peasant Women of Brest [*sic*] and Good Friday." *Cincinnati Commercial Tribune*, March 6, 1910.

Lord, Caroline. "Paintings by Elizabeth Nourse." Clipping from unidentified Cincinnati newspaper, ca. May 1910, in Elizabeth Nourse Papers, Cincinnati Historical Society.

Castellane, Marquis de. "High Praise for Cincinnati Artist." *Cincinnati Enquirer*, May 1910.

Schmidt, Anna Seaton. "Elizabeth Nourse: Great Honor Paid an American by France." [*Boston Transcript*, May 11, 1910.] Clipping in Scrapbook 1, p. 106.

"Elizabeth Nourse Whose Painting, 'The Closed Shutters,' Has Just Been Bought for the French Government." *Chicago Sunday Tribune*, June 12, 1910.

"French Government Honors Miss Nourse." Clipping from unidentified American newspaper, 1910, in Scrapbook 1, p. 107.

Wheeler, Mary C. "An American Artist Honored." Clipping from unidentified Helena, Mont., newspaper, 1910, in Scrapbook 1, p. 114.

Heitkamp, E. M., "Salem Woman Paints Children in Society." *Baltimore American*, June 1910.

"The Painter of Peasant Madonnas." *Cincinnati Commercial Tribune*, July 17, 1910.

"Benn Pitman Dies at Age of 89 Years." Clipping from unidentified Cincinnati newspaper, 1910, in Scrapbook 1, p. 129.

"Twelve Are Given: Mrs. C. E. Perkins Gives a Nourse Canvas." *Grand Rapids Press*, January 12, 1911. Clipping in Scrapbook 1, p. 119.

"Excellent Work by Young American Artists Shown in Canvases at Holy Trinity Lodge." *New York Herald* (Paris), February 5, 1911. Describes Elizabeth Nourse's *Le foyer* (B–88 or B–90?) and *Le trousseau*.

Claude, Jean. "Société Nationale des Beaux-Arts Salon." *Petit Parisien*, April 16, 1911.

"A New Picture for Smith College: 'La Becquée' by Elizabeth Nourse." *Springfield* (Mass.) *Sunday Republican*, April 30, 1911.

Heitkamp, E. M. "Artist Shows the Simple Life of the Peasants of the Vosges." *Detroit Free Press*, June 4, 1911.

"International Art Union Exhibition." *New York Herald* (Paris), February 3, 1912.

"Frank M. Clark to Permit Valuable Pictures in his Possession to be Exhibited." *Kalamazoo Gazette*, April 21, 1912. Two of Elizabeth Nourse's watercolors, *The First Communion* and *A Corner in a Brittany Church*, were exhibited.

"Some of the Water Colors in 'Democratic' Art Exhibition." *Chicago Tribune*, May 11, 1912.

"Works of American Artists at Luxembourg." *New York Herald* (Paris), May 19, 1912.

"Americans in the Luxembourg." *Philadelphia Public Ledger*, June 19, 1912.

"Season's First Art Display at Academy of Fine Arts." *Philadelphia North American*, November 10, 1912.

"La Bonne Ménagère by Elizabeth Nourse." *Philadelphia Sunday Public Ledger*, 1912.

Schmidt, Anna Seaton. "Our Artists at the Corcoran Show." Clipping from unidentified Boston newspaper, ca. 1912, in Scrapbook 2, p. 31.

Clipping from unidentified Washington, D.C., newspaper, ca. 1913, in Scrapbook 2, p. 47. Discusses Washington art collections; reproduction of Elizabeth Nourse's *Sur la digue à Volendam*.

Lord, Caroline. "Paintings by Three American Women Shown at Art Museum." *Cincinnati Times-Star*, June 1913.

Moseley, Helen. "Tendresse by Elizabeth Nourse." *Grand Rapids Herald*, ca. 1913.

Harmon, Selena Armstrong. "Washington Women Worth While: Mrs. John Jacob Rogers." Clipping from unidentified Philadelphia newspaper, ca. 1914, in Scrapbook 2, p. 55.

"Extracts from the Diary of an American Artist in Paris." *Cincinnati Enquirer*, January 3, 1915. The extracts are from a diary maintained by Elizabeth Nourse during World War I.

"A Review of Cincinnati's Past in the Field of Art." *Cincinnati Enquirer*, May 9, 1915.

"News and Notes." Clipping from unidentified Washington, D.C., newspaper, 1915, in Scrapbook 2, p. 67. Discusses gift of Elizabeth Nourse's *Fisher Girl of Picardy* to the National Gallery of Art, Smithsonian Institution, Washington, D.C. The painting is in the collection of the Smithsonian's National Museum of American Art.

"The Evening Hour by Elizabeth Nourse." *Springfield* (Mass.) *Republican*, April 9, 1916.

"Work of Cincinnati Woman Artists Being Shown." *Cincinnati Times-Star*, May 1916.

Schmidt, Anna Seaton. "A Letter from Elizabeth Nourse." *Boston Evening Post*, September 2, 1916.

"The Week in Art Circles." *Cincinnati Enquirer*, October 8, 1916. Reminiscences of John Rettig, Cincinnati artist, about the McMicken School of Design. Rettig was a fellow student of Elizabeth Nourse's.

"A Notable Social Event." Clipping from unidentified Cincinnati newspaper, 1918, in Scrapbook 2, p. 74. Describes two Nourse watercolors and her *Bust of Miss Hosea*.

"Bread Like Dried Mud." *Boston Evening Transcript,* August 10, 1918. Extracts from a letter written by Elizabeth Nourse in Penmarc'h, Brittany, to an unidentified person, July 14, 1918.

"Notable Painting by Local Artist is Gift to Museum." Clipping from unidentified Cincinnati newspaper, ca. 1919, in Scrapbook 2, p. 80.

Alexander, Mary L. "Fine Example of the Work of Miss Nourse Is at Museum." *Cincinnati Times-Star*, March 14, 1921.

Flannery, H. W. "Laetare Medal to a Woman Painter." *Catholic News*, March 19, 1921.

Goldman, Marcus Selden. "In the World of Art." *New York Herald* (Paris), October 1, 1921. Describes the Laetare Medal ceremony in Paris.

Alexander, Mary L. "New Book Reveals Unselfish Service of Artist in France." *Cincinnati Times-Star*, November 14, 1922.

"Noted Critic of Art Dies at Home in D.C." Clipping from unidentified Cincinnati newspaper, January 9, 1924, in Scrapbook 2, p. 110.

Conteur. "An Interesting Letter Concerning Ancestry of the Nourse Family of Cincinnati." *Cincinnati Enquirer Sunday Magazine*, February 1, 1925.

Alexander, Mary L. "In Memory of Mrs. David B. Gamble." *Cincinnati Enquirer*, March 8, 1930.

"World-Renowned Cincinnati Artist Dies in Paris Studio Apartment." *Cincinnati Times-Star*, October 8, 1938.

"Art Museum to Receive Paintings." *Cincinnati Enquirer*, October 25, 1938.

Elliston, George. "Noted Artist Living in Paris But Never Forgot Cincinnati." *Cincinnati Times-Star*, November 3, 1938.

——————. "Cincinnati Museum to Share in Distribution of Art Treasures Left by Native-Born Artist." *Cincinnati Times-Star*, November 18, 1938.

——————. "Artist Niece of Famed Woman Urged to Write Her Biography." *Cincinnati Times-Star*, November 25, 1938. An interview with Mary Nourse, niece of Elizabeth Nourse.

——————. "Famous Artist Leaves to Cincinnati Realtor Largest Private Collection of Her Paintings." *Cincinnati Times-Star*, December 27, 1938.

Alexander, Mary L. "Full Range of Paintings Now on Display by Cincinnati's Most Noted Woman Artist." *Cincinnati Enquirer*, June 2, 1941.

Lyford, Cherry Greve. "New Gallery of Art Opening Sunday." *Cincinnati Times-Star*, October 9, 1941.

Periodicals

"Around Old Point Comfort." *National Repository* (February 1880): 101–8. A monthly magazine published by the Methodist Episcopal Church in Cincinnati, Chicago, and Saint Louis.

Belastrasco 1, no. 1 (February 1880): 6; no. 8 (November 1880): 10. University of Cincinnati student publication.

"West Point Military Academy." *National Repository* (April 1880): 307.

American Art Review 1 (1879–80); 2, no. 8 (June 1881): 135–36.

"A Wood Carver's Home." *Art Amateur* (April 1883): 112–16.

Keyser, Frances. "Some American Artists in Paris." *International Studio* 4, no. 6 (June 1889): 246–52.

Schmidt, Anna Seaton. "Le Repas en Famille." *Harper's Bazaar* 25, no. 34 (August 20, 1892).

Hooper, Lucy H. "Art Schools of Paris." *Cosmopolitan* (November 1892): 59–62.

Tyrell, Henry. "The Paris Salon." *Frank Leslie's Popular Monthly* 26 (July 1893): 14–30.

Art Amateur 29, no. 3 (August 1893): 72. Illustration of the Cincinnati Room in the Woman's Building at the World's Columbian Exposition in Chicago, 1893.

Anderson, Emma Mendenhall. "Some Successful Woman Artists." Part 3. "Elizabeth Nourse." *Young Ladies' Magazine* (August 1896): 51–54. The magazine was published in Buffalo. Parts 1 and 2 are about Cincinnati artists Laura A. Fry and Christine Bredin.

MacChesney, Clara T. "An American Artist in Paris: Elizabeth C. Nourse." *Monthly Illustrator* 13, no. 1 (August 1896): 3–11.

"The Century's American Artists Series: Elizabeth Nourse." *Century* 59, no. 3 (January 1900): 481; etching by Charles Baude of Elizabeth Nourse's *La veillée*.

Thompson, Vance. "American Artists in Paris." *Cosmopolitan* (May 1900): 17–26.

Schmidt, Anna Seaton. "Elizabeth Nourse: An American Artist." *Donohoe's* (Easter 1902): 329–38.

Sévrette, Gaston. "Au Pays des Bigoudènes." *Femina* (ca. 1902): 370.

de Montaigu, Comtesse. "American Women Artists in the Paris Salon of 1902." Clipping from unidentified periodical in Scrapbook 1, p. 71.

Schmidt, Anna S[eaton]. "The Paintings of Elizabeth Nourse." *International Studio* (January 1906): 247–53.

Donohoe, Madge. "The American Woman in Paris." *Strand* (London) (October 1906): 259–69. Discusses artists Elizabeth Nourse, Ann Klumpke, and Elizabeth Gardner Bouguereau.

"Recent Acquisitions: 'Happy Days' by Elizabeth Nourse Arrives from Paris." *Bulletin of the Detroit Institute of Arts* 3, no. 4 (October 1909): 46.

Tietjens, Emma H. "An American Woman Painter Who Has Been Honored in Paris." *Current Literature* (February 10, 1910): 90–93.

L. Mechlin. "Closed Shutters: A Painting by Elizabeth Nourse." *Art and Progress* 2, no. 9 (July 1911): 262.

Schmidt, Anna Seaton. "The Paintings of Elizabeth Nourse." *Art and Progress* 3, no. 12 (October 1912): 746–47; reproduction of Nourse's *Close of Day*.

MacChesney, Clara T. "Mothers and Children: The Inspiration of Two Famous American Women Artists." *Vogue* (November 1912): 39.

McAdoo, W. G. "The Kind of Man Woodrow Wilson Is." *Century* (March 1913): 747.

Cartault, A. "Les Salons de la Société Nationale des Beaux-Arts et de la Société des Artistes Français." *La Revue de Mois* (June 10, 1913): 724.

MacChesney, Clara T. "American Artists in Paris." *International Studio* (November 1914): xxiv-xxviii.

"Extracts from the Diary of an American Artist in Paris, August and September, 1914." *Art and Progress* 6, no. 2 (December 1914): 41–48.

"More Pages from the Diary of an American Artist in Paris." *Art and Progress* 6, no. 8 (June 1915): 274–77.

Benedite, Léonce. "L'Ecole Américaine au Musée du Luxembourg." *La Revue de l'Art Ancien et Moderne* (November 10, 1919): 197.

"The American Artists at the Luxembourg Museum." *France* 1, no. 11 (November 1919): 463.

Tierney, M. Joseph. "Miss Elizabeth Nourse Laetare Medalist." *Notre Dame* (Indiana) *Scholastic* 54, no. 19 (March 5, 1921).

Goldman, Marcus Selden. "Elizabeth Nourse." *Paris Review: The Illustrated American Magazine in France* (November 20, 1921): 7–10, 31.

Walsh, James J. "An American Woman Artist: Painter of the Poor." *Extension Magazine* (August 1922).

Woman Citizen (January 13, 1923). Elizabeth Nourse's *Enfants de Penmarc'h* reproduced on cover under title *Les Petites Bigoudines*.

Literary Digest 89 (June 12, 1926). Elizabeth Nourse's *Le goûter* reproduced on cover under title *Mother and Children*.

Verkamp, Mrs. Joseph. "Miss Elizabeth Nourse." *Catholic Women's Club News* (Cincinnati) (June 1926): 17.

Schmidt, Walter S. "Elizabeth E. Nourse." *Catholic Women's Club News* (Cincinnati) (April 1932): 105.

"Elizabeth Nourse Dies." *Art Digest* 13, no. 4 (November 15, 1938): 18.

Walsh, Julia C. "Elizabeth Nourse: A Reminiscence." *Ave Maria* 49, no. 18 (May 6, 1939): 560–62.

Garretson, Mary Noble Welleck. "Thomas S. Noble and His Paintings." *New-York Historical Society Quarterly Bulletin* 24, no. 4 (October 1940): 113–23.

Kysela, John D., S.J. "Sara Hallowell Brings 'Modern Art' to the Midwest." *Art Quarterly* 27, no. 2 (1964): 150–67.

Antiques 97, no. 3 (January 1970): 42. Elizabeth Nourse's *Maternité* reproduced.

Trapp, Kenneth. "Rookwood and the Japanese Mania in Cincinnati." *Cincinnati Historical Society Bulletin* 39, no. 1 (Spring 1981): 51–75.

Unpublished

Cincinnati Archives of the Cincinnati Museum Association: Autobiographical notes by Thomas A. Noble; correspondence of Thomas A. Noble; correspondence of Louise Nourse with J. H. Gest; Donation Blotter No. 1; letter from Mrs. Larz Anderson to J. H. Gest, 1893.

Mary Alice Heekin Burke: Letters from Daniel Saget-Léthias and Mme. Isabelle Decroisette.

Cincinnati Art Museum: Artist File for Elizabeth Nourse.

Cincinnati Historical Society: Elizabeth Nourse Papers and Sketchbooks 2 and 3; Benn Pitman Papers.

Nourse Family Collection: Elizabeth and Louise Nourse correspondence; Scrapbook 1 (1880 to 1911, maintained by Louise Nourse).

Private Collections: Scrapbook 2 (1911 to 1932, maintained by Louise Nourse); Elizabeth Nourse Sketchbooks 1 and 4 through 18; photographs of paintings by Elizabeth Nourse (identified on backs).

Fort Wright, Kentucky Meader Family Collection: Louise Nourse correspondence.

Helena, Montana Montana Historical Society: Biographical File for Mary C. Wheeler.

Houston, Texas Nourse Family Collection: Elizabeth Nourse correspondence.

Lincoln, Nebraska Sheldon Memorial Art Gallery: Registrar's File.

Malvern, Pennsylvania Kennedy Family Collection: Elizabeth and Louise Nourse correspondence.

Northampton, Massachusetts Smith College Museum Records.

Sandusky, Ohio Upper Sandusky Historical Society: Follett House Museum biographical file for Mrs. John J. Hudson.

Seattle, Washington University of Washington: Inventory of Paintings given by Judge and Mrs. Thomas J. Burke, 1932.

Washington, D.C. Archives of American Art, Smithsonian Institution: General Index; Records of the Department of Fine Arts, Carnegie Institute.

National Museum of American Art, Smithsonian Institution: Registrar's File; Artist File for Elizabeth Nourse.

Corcoran Gallery of Art: Artist File for Elizabeth Nourse.

Index of Titles

Formal portraits are listed by last name of subject.

A

B

266

C

F

G

H

I

J

N

Q

R

S

T

Volendam Peasant, out-of-doors, C–89
Volendam Woman and Child, A–15
Les volets clos (Closed Shutters), B–120

W

Wachman, Laura (sketch), H–10
Waiting (L'attente), A–112
Wallflowers, E–72
War Memorial, D–93
Wash-house at Fleury, B–17; *see also* listings under Lavoir
Watercolor panel, E–3
Weavers of Tunis (Tunis Tapestry Weavers), B–69
Westernland, S. S. (sketches on board), H–6
Windmill, Holland, D–48
Woman Milking a Cow, B–62
Woman Sewing (Femme qui coud), A–105; *see also* A–81
Woman with Harp, C–48
Woodland Scene, D–27

Y

The Young Mother (Mère et bébé), A–17

Z

Zinn, Portrait of Honorable Peter, C–8